FROM MIND, HEART, AND HAND

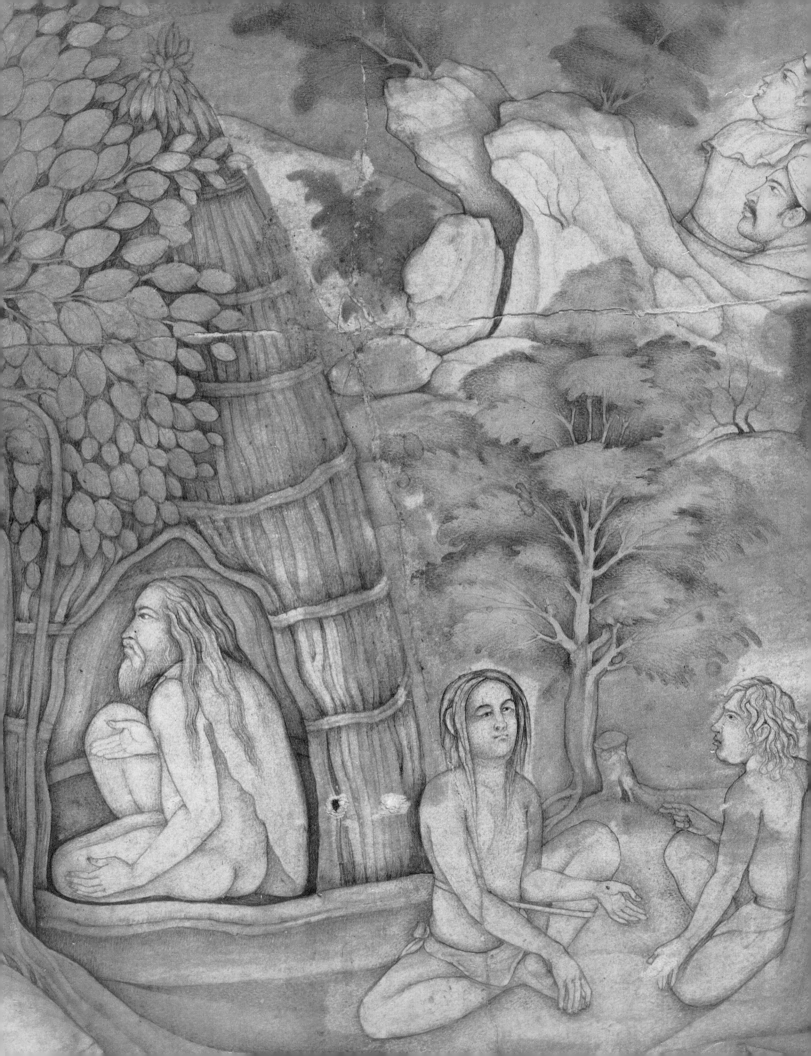

Stuart Cary Welch and Kimberly Masteller

With Essays by Mary McWilliams and Craigen W. Bowen

From Mind, Heart, and Hand

Persian, Turkish, and Indian
Drawings from the Stuart Cary
Welch Collection

YALE UNIVERSITY PRESS
New Haven and London

HARVARD UNIVERSITY ART MUSEUMS
Cambridge, Massachusetts

Funding for the catalogue has been provided by the
Andrew W. Mellon Publication Fund.

With the exceptions noted, all photography is by Katya
Kallsen and Allan MacIntyre, Department of Digital
Imaging and Visual Resources, Harvard University Art
Museums, published by permission. The following are
published by permission:

Figs. 2 and 3: Photograph © 2003 Museum of Fine
 Arts, Boston.
Figs. 13, 14, 16, 17, 20: Courtesy of Harvard University
 Archives.
Fig. 15: Courtesy of Peabody Museum of Archaeology
 and Ethnology, Harvard University.
Fig. 15.2: Brooklyn Museum of Art.
Fig. 23.1: The Royal Collection © 2003, Her Majesty
 Queen Elizabeth II.
Figs. 66.1, 66.2: Courtesy of the National Museum,
 New Delhi.

This catalogue is published in conjunction with
the exhibition *From Mind, Heart, and Hand: Persian, Turkish,
and Indian Drawings from the Stuart Cary Welch Collection,*
organized by the Arthur M. Sackler Museum, Harvard
University Art Museums, Cambridge, Massachusetts.

Asian Art Museum of San Francisco—Chong-Moon Lee
Center for Asian Art and Culture of San Francisco
September 17–November 28, 2004

Arthur M. Sackler Museum, Harvard University Art
Museums
March 19–June 12, 2005

Edited by Joseph N. Newland, Q.E.D., and Susan Laity
Designed by Leslie Fitch
Printed in Singapore by CS Graphics

Cover illustrations: (front) *Arabesque with Dragon and
Parrot* (detail), cat. 1; (back) *Maharana Amar Singh II at
Worship;* cat.61
Frontispiece: Attributed to Miskin, *Akbar Observing an
Animal Combat while Hunting* (detail), cat. 20.

Library of Congress Cataloging-in-Publication Data
Welch, Stuart Cary.
 From mind, heart, and hand: Persian, Turkish, and
Indian drawings from the Stuart Cary Welch collection/
Stuart Cary Welch and Kimberly Masteller ; with essays
by Mary McWilliams and Craigen W. Bowen.
 p. cm.
 Catalog of an exhibition organized by the Arthur M.
Sackler Museum and held at the Asian Art Museum of San
Francisco, Sept. 17–Nov. 28, 2004.
 Includes bibliographical references and index.
 ISBN 0-300-10473-1 (YUP; cloth)—
 ISBN 1-891771-38-8 (HUAM; pbk.)
1. Drawing, Iranian—Exhibitions. 2. Drawing, Turkish—
Exhibitions, 3. Drawing, Indic—Exhibitions. 4. Welch,
Stuart Cary—Art collections—Exhibitions. 5. Drawing—
Private collections—Massachusetts—Cambridge—
Exhibitions. 6. Drawing—Massachusetts—Cambridge—
Exhibitions. 7. Arthur M. Sackler Museum—Exhibitions.
I. Masteller, Kimberly. II. McWilliams, Mary. III. Bowen,
Craigen W. IV. Asian Art Museum of San Francisco.
V. Arthur M. Sackler Museum. VI. Title.
 NC321.W45 2004
 741.95—dc22 2004003619

A catalogue record of this book is available from the
British Library.

10 9 8 7 6 5 4 3 2 1

CONTENTS

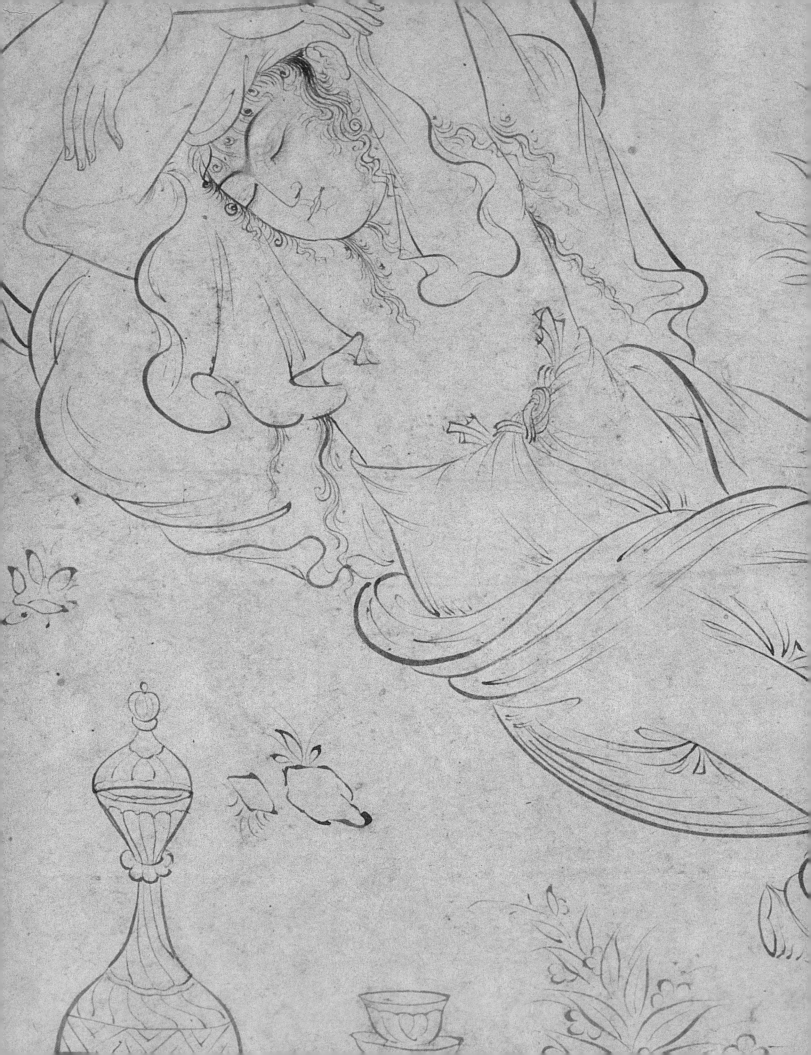

Directors' Forewords

FROM A current perspective, recent advances made in the expanding study of Persian, Indian, and Turkish painting and drawing seem prodigious, even heady. A new generation of scholars is uncovering—and, in many instances, beginning to understand—the fundamental historical processes underlying some of the world's most distinctive forms of visual representation. Despite their undeniable importance and impact across much of visual history, these traditions still remain largely misunderstood and in some cases even studiously ignored. Today increasing numbers of trained researchers— generally the products of rigorous university systems in Europe, the United States, India, and the Islamic world—are working to change that widespread perception, drawing from an impressive array of sophisticated, broad-based methodologies to effect nothing less than the extension of the reach and focus of art history itself.

As impressive as these new achievements are, though, they struggle in many respects to match the daring discoveries of earlier scholars who worked without a net, in virtual anonymity and isolation, in nearly empty arenas. With the increasing complexity and formalization of the field, we could easily overlook and misjudge the worth and enduring importance of earlier leaps forward. Cary Welch was and remains today one of those early explorers. Driven by a deep, abiding intellectual curiosity and a heightened visual sense, he has brought intense observation and meditation to bear on the study of visual phenomena, whatever their form or origin. This lifetime of a deep engagement with a far-flung visual world has enabled him to, in effect, leap across time and space. Relying on his own discerning eye has allowed him to see and understand what others could not and still cannot, and to open doors for colleagues and students. This present catalogue not only demonstrates the startling results of that lifetime of endless looking and seeing but also underscores Cary Welch's enduring commitment to the goals and purposes of Harvard's teaching mission.

Paradoxically, that seemingly requisite but elusive ability to see remains a rarity today in much of the field. Yet in repeated instances it has helped establish the baselines from which current research departs, perhaps nowhere better demonstrated than in the study of Safavid painting and drawing, a field virtually invented and shaped by Cary Welch. That remarkable achievement can in many respects easily be extended to the allied fields of Mughal, Deccani, and Rajput art—testimony to the reach and effect of the "poetic" eye. To study today the

OPPOSITE
Detail of cat. 9

VII

graphic traditions of what has been called the Turko-Iranian-Indian universe is to confront what is at best an uneasy coexistence of past and present critical approaches. The future will undoubtedly see canons shift, data accumulate, new and previously unimaginable tools and methods emerge and be implemented; perhaps a completely new perspective and sensibility toward the subject will even arise from within the "collected" cultures themselves. Such a future will look very different from the world in which Cary Welch gathered this stunning group of drawings, but it will be difficult, if not impossible, to imagine it without his legacy.

THOMAS W. LENTZ
Elizabeth and John Moors Cabot Director
Harvard University Art Museums

HOW OFTEN, when I was a fledgling paper conservator, would Stuart Cary Welch set his little Louis Vuitton case on my mat-cutting table and pop the latches! Their click was a promise of marvels, an "Open sesame." Cary would draw out a package of chamois or silk, or a little tin case, or a paper envelope. From this he would unwrap a dagger with a steel blade as sleek as its jade hilt, or a school of golden fish, or a bronze panther of infinite coils, or a tiny painting glistening with iridescent beetle wings. These wonders imply a taste for luxury, an appreciation of rich color and tactile pleasures, and yet just as often Cary would withdraw from his magic case a drawing—pure line, simply black on white or, rather, on the warm buff of Indian, Persian, or Turkish paper. Over the years, from the beginning of the 1960s until the construction in the mid-1980s of the Sackler Museum and the removal of the Islamic and Later Indian Art Department from the fourth floor of the Fogg, I learned that all manner of beauty, spirit, elegance, force—even complex intimations of color, substance, and surface—resided in those drawings.

I was seeing these marvels one by one because Cary was acquiring them at that time, taking advantage of the ignorance or indifference of the collecting world. Whether private or institutional, it seems that other collectors considered these drawings to be only the spume, the froth of more fluent, fully painted works (by masters who themselves were hardly known by name). Cary remembers the dealers in Islamic and Indian art asking him, "How do you

know they are genuine?" The dealers could not imagine that knowledge in their terms—secure attribution and manifest value on the art market, for example—was not in play. Knowledge in Cary's terms—a certainty of the quality of the art, and of intelligence, character, and soul in its maker—was all he needed to justify an acquisition.

Now the acquiring is done, and also the work of connoisseurship: the sorting, pairing, grouping, naming, dating, and above all contemplating and conversing. For Cary, to look and to show are practically synonymous. As I learned to my delight (and instruction), he cannot own something without wanting instantly to share it. Thus in an easy gesture over the years, his private collection became the Fogg's and then the Sackler's collection, in fact if not in legal status, so that it could be used without impediment in teaching and exhibition.

Finally, now that his stream of acquisitions has to a large extent dried up, Cary has generously altered his drawings' legal status. They are, or are becoming, fully ours, and it is our turn to give to the larger world through this catalogue and exhibition the delight (and instruction) that Cary gave to his friends, to colleagues, to students, and even to the young woman who made the "silk suits"—the mats and frames—for his new acquisitions. In the conservation department thirty and more years ago, I never dreamed I would have an opportunity for public gratitude. Time passes. Thank you, Cary, for including me in your adventure.

MARJORIE B. COHN
Acting Director
Harvard University Art Museums
(December 2002–November 2003)

Carl A. Weyerhaeuser Curator of Prints
Fogg Art Museum

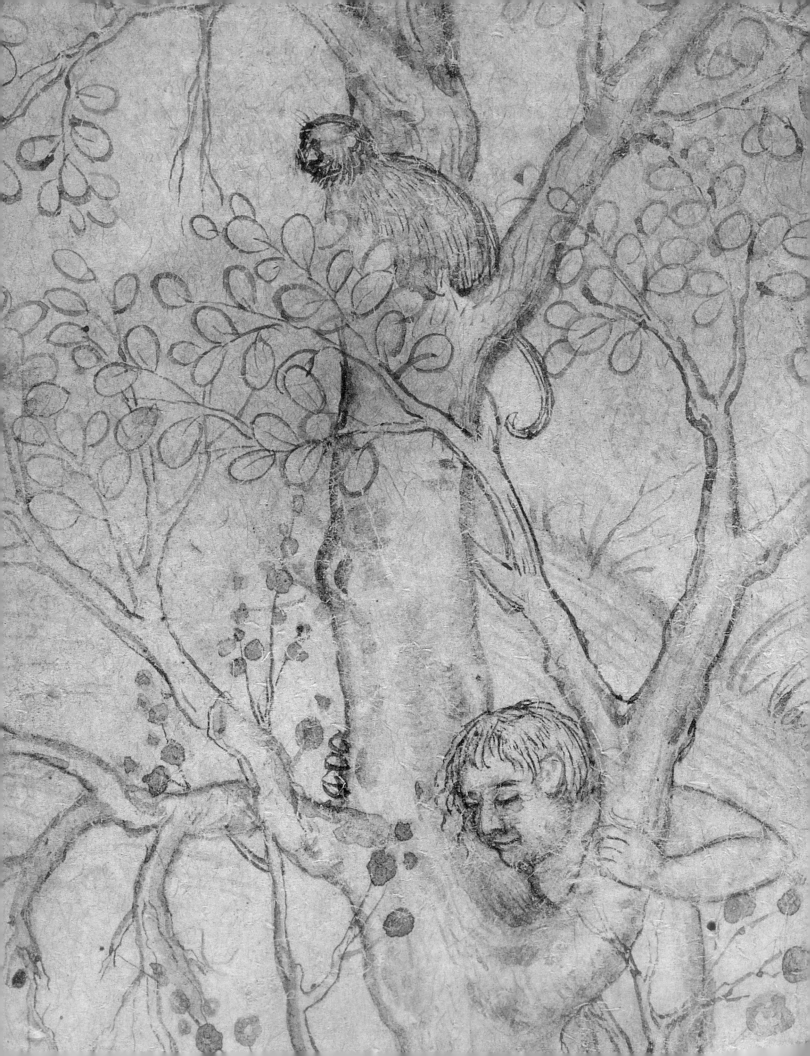

ACKNOWLEDGMENTS

A SMALL army of helpful friends deserve infinite gratitude from the gatherer and partial cataloguer of this selection of drawings. The pictures could not have been acquired without the help and inspiration of family, friends, and colleagues. Had my mother's father, Norman E. Mack, not recouped the family fortunes by founding a newspaper at the age of fourteen and selling it at the age of seventy-two, these works of art would not have been discovered and acquired. And had it not been for my architect father, a talented painter whose name I share, I might not have known the delights of visual art. When he introduced me at sixteen to Paul J. Sachs, the Fogg's associate director and founder of its drawing department, my mania for drawing and drawings gained momentum. My aesthetic sense was further nurtured in 1940 when he took me to see the Museum of Modern Art's retrospective exhibition of Picasso and gave me the catalogue. Although I have since realized that thoughtful, spiritual Matisse far surpassed brilliantly clever Picasso, for many years I was entranced by the power of the Spanish master's portrait drawings and experienced works of art through eyes he had guided. I am also beholden to Daniel Cressop McNab Brown, art teacher at the Fessenden School, who provided civilizing encouragement not only by introducing me to the music of Bach but by allowing me to roam freely in the Boston Museum of Fine Arts, where I first examined carefully Indian, Persian, and Turkish pictures.

At Harvard, brilliant Eric Schroeder, Honorary Keeper of Islamic Art, welcomed me as a kindred spirit, offered stimulating conversation about art and literature, and further pried open my eyes. Several of his impromptu maxims stuck, such as "Never trust professionals." Eric's example, for which I am profoundly grateful, encouraged independence of spirit and opinion. Like me at Harvard, where no courses were taught in my "specialties," Oxonian Eric was fortunate in having been an autodidact.

Wise, delightful, and often sparklingly funny John Rosenfield, whom I met when he was a graduate student, stands out as another blessing from Harvard, along with Benjamin Rowland and John Coolidge, who welcomed Eric's suggestion in about 1955 that I become his assistant. Further invaluable welcomings came from a sequence of permanent and temporary directors, especially Agnes Mongan, Rosenfield, Seymour Slive, James Cuno, and Jerry Cohn. Also at Harvard, Philip Hofer, a family friend who became my freshman advisor and ultimately a valued colleague, lavishly shared vital facts and drolleries about the world of collectors, museum curators, and dealers. One learns best, it seems, with laughter.

OPPOSITE
Detail of cat. 19

For decades Harvard provided me with a mighty launching pad for artistic aspirations. At the Fogg our cycles of uncatalogued departmental exhibitions, often of drawings, were sketches for larger and more comprehensive shows staged, with published catalogues, at the Asia Society of New York and at The Metropolitan Museum of Art. How beholden I am to the late George Montgomery, Gordon Washburn, and Alan Wardwell of the Asia Society Galleries, and to Philippe de Montebello of the Metropolitan, where my major exhibition project, *India: Art and Culture, 1300–1900* (1985), generously enabled me to reexplore most of the world's collections of Indian art. Without the active support of Prime Minister Indira Gandhi, Pupul Jayaker, and their protégés Martand Singh and Jyotindra Jain, I should have seen far fewer great Indian drawings.

Collectors would languish without dealers. Nasli and Alice Heeramaneck, mentioned several times in this volume, provided a small, informal university of connoisseurship at their museum of a house near the mighty Met on 83rd Street. To stimulate guests, they enjoyed ransacking the closets for exciting drawings and other works of art. These were aired with flourishes, wine, and opinions as richly spiced as their gastronomic urban specialty, curried gefilte fish. For me, they and a mutual friend, Adrienne Minassian, deserve especially high marks among sellers of Indian and Iranian pictures. One fared at least as well, however, at traditional London firms, such as Maggs Brothers of Berkeley Square, where H. Clifford Maggs and Miss Margaret Erskine led one to a table piled high with paintings and drawings. At Maggs Brothers, degrees of artistic quality bore little relationship to price, and, refreshingly, their offerings were made with more politesse than comment. Others among the world's providers of the kinds of drawings gathered here smiled eagerly but silently while encouraging buyers to paw through their billowing accumulations of paper.

It has been my good fortune that my wife, Edith, and children, Adrienne, Thomas, Samuel, and Lucia, invariably tolerated—and usually encouraged—my collectomania. "These are Daddy's toys," cautioned Edith, whose in-house protectiveness ranks with that of Harvard's museum staff. In my grateful mood, a parade of benevolent, smiling, responsible fellow curators, registrars, and conservators files past. In "Lis'l" Strassman's office, every scrap of paper or object was registered and photographed. Equally effective and devoted to the cause were Jane Montgomery and her successors Andrea Notman, Maureen Donovan, Rachael Vargas, and Francine Flynn.

On the top floor of the Fogg Museum, interested "art doctors" cared for my often scrappy bits of paper. Their zeal was—and is—such that the Department of Conservation warranted another name: the Department of Conversation. While Betty Jones, Jack Washeba, Jerry Cohn, and Craigen Bowen "museumized" my bits of paper, flattening, unfolding, cleaning, sometimes bathing, mounting, and eventually framing them, in-house and out-house (sic) "news" (i.e., gossip) eased away all traces of potentially grim seriousness of purpose. How grateful I am to the careful women sometimes known to me, in deep Bostonese, as "the paper dolls."

Thanks to funding from Eric and Margaret Schroeder and to Stan and Norma Jean Calderwood, the Department of Islamic and Later Indian Art has grown. Once the bailiwick of volunteers—of Eric, the astoundingly helpful Miggie (Mrs. Horace) Frost, and myself—the staff is now commensurate with those of longer established departments. Creatively industrious, effective, and always a joy to work with are Mary McWilliams, Kimberly Masteller, and Stephanie Beck, each of whom has organized, edited, and written for this significant—and personally most gratifying—project. While I write this in Paris, their words, and mine, are being polished by our admirable editors, Joseph Newland and Evelyn Rosenthal. Without the dedication and hard work of everyone mentioned above and more, this exhibition and catalogue could not be. Bless them all!

SCW

THIS PUBLICATION could not have been realized without the engaged interest and kind support of several individuals and institutions. I first need to thank Cary Welch himself for his vision and generosity in assembling and sharing this magnificent group of drawings. I have always been an admirer of Cary's beautiful and enlightening publications and was honored by his invitation to participate in the catalogue as a co-author. Cary's keen eye and witty discourse are legendary, and it is a pleasure to work with him and his collection. I have learned much. I also wish to thank all of the contributors to the catalogue who have graciously shared their time, wisdom, and love of the material.

I am grateful to the Harvard University Art Museums for organizing this catalogue and exhibition, and particularly to Mary McWilliams, Norma Jean Calderwood Curator of Islamic

Art and head of the department of Islamic and Later Indian Art. Mary brought me into this project and has served as a constant source of intellectual and collegial support. I am blessed to have Mary as a friend and mentor, and I can't imagine a better environment in which to take on such a project. I am also deeply indebted to Stephanie Beck, curatorial assistant in the department. Stephanie assumed a major portion of the organization of the catalogue and compiled the historical appendixes; she is a talented and indispensable part of this endeavor. I am enormously grateful to Sunil Sharma, Lata Parwani, Mahdokht Banoo Homaee, and Afsaneh Firouz-Ardalan, our Calderwood Intern for Islamic Art, for translating inscriptions and poetic verses on the drawings and the backs of their mountings, and to András Riedlmayer for kindly lending us his bibliographical expertise for the index. This publication and exhibition have also benefited from the active support of three museum directors: former Elizabeth and John Moors Cabot Director James Cuno, Acting Director Marjorie B. Cohn, and current Elizabeth and John Moors Cabot Director Thomas W. Lentz. The production of this catalogue has been supported by the Andrew W. Mellon Publication Fund.

I also wish to acknowledge the efforts of Evelyn Rosenthal, Head of Publications, and Andrew Gunther, Head of Photography, and their excellent staffs at the Harvard University Art Museums for facilitating the development of this publication and its beautiful images. Evelyn has also served as in-house coordinator of the catalogue, and her input has been invaluable. The eloquent discussions about Cary and his beautiful objects were enhanced by our careful and thoughtful editor, Joseph N. Newland, whose masterly skills are excelled only by his diplomacy. The paper conservation department in the Straus Center for Conservation under the attentive leadership of Deputy Director Craigen W. Bowen has devoted numerous hours to the examination, restoration, and care of the drawings, a gift that will enable these fragile works to be appreciated for generations to come. Finally, at Harvard, Rebecca Wright, Susannah Hutchison, and Francine Flynn all deserve recognition for their efforts in scheduling and organizing the movement of this exhibition to San Francisco.

Several other scholars, though not directly involved in the catalogue, have offered their advice and support to the project. Among them I would like to thank David Roxburgh, Pramod Chandra, John and Susan Huntington, and John Seyller. John Seyller, in particular, has been

my mentor in the study of Indian painting, and I am indebted to him for his wisdom and his careful approach. While I give credit to all of these scholarly influences I must assert that any mistakes in my contributions are mine alone.

I am grateful to our colleagues at the Asian Art Museum and Chong-Moon Lee Center for Asian Art and Culture who have enthusiastically supported this exhibition and catalogue. Foremost, I want to thank Emily J. Sano, Director, for her interest in this material and for bringing the exhibition to San Francisco. I also want to extend acknowledgments and gratitude to Forrest McGill, Chief Curator and Wattis Curator of South and Southeast Asian Art, and Tushara Bindu Gude, Assistant Curator of South Asian Art, as well as Nancy Kirkpatrick, Director of Museum Services, all at the Asian Art Museum.

Finally, I need to thank those closest to me who have been a constant source of support and inspiration during this project: my parents, Rosemary and Louis Masteller, and my husband, Donovan Dodrill.

KM

FOREWORD

THE NAME is Stuart Cary Welch, and it appears most often before or after scholarly articles on Islamic painting and on the handsome covers of luxuriously produced museum catalogues. These are all about the same subject, of which no one knows more, or more minutely, than he: Persian, Mughal, Deccani, and Turkish painting, as well as Rajput, court by court, from the deserts of Rajasthan and the lush Pahari hills and beyond to the peaks of Tibet. He is to be found most often on a peak himself—first on one, then another: peaks of fearless attribution, attained by way of his imagination combined with his detective skills. He has come to have a mythic invincibility for other collectors, both private and public (with whom he shares his knowledge unstintingly), as well as for scholars in his fields of interest.

His is the great eye, the most discerning eye of all eyes; also his the greatest passion for images like the ones on these pages; and the long, long memory for a picture or an object once seen and retained for decades; and then the ingenuity and unflagging energy in stalking it down. No wonder his name is so often spoken in a tone of awe (and sometimes rage, because he has gotten there before anyone else). And now, for readers of this book, Cary's generosity can only be a subject of awe as well. Here in this catalogue are seventy-six drawings from his gift of nearly three hundred or so of his "favorite things," as he calls them, to Harvard. He has remarked somewhat ruefully that making these bequests was like "cutting off my right arm"; but then, as he points out, he has had them to enjoy for a long time. Up to now he has been modest, even secretive, about the treasures he has bestowed on the Harvard University Art Museums. But his generosity as a donor and friend has never been modest and need be a secret no longer. "Fresh from mind, heart, and hand" applies not only to the beautiful and varied drawings to be found in this catalogue—Persian, Turkish, and Indian—but also to Cary's munificence in sharing his life's passion and achievements.

Note on the Catalogue

DATES, TRANSCRIPTION, AND TRANSLITERATION

The year 1 in the Islamic calendar corresponds to A.D. 622. Throughout the catalogue, dates are given in A.D. years unless otherwise indicated. When A.H. (*hijrī*) dates are provided, they are placed first.

Persian, Turkish, and Arabic

Foreign words and proper nouns that have entered the language or have a generally recognized English form are anglicized in the text. Place names follow English usage, and false English plurals for Persian, Arabic, and Turkish words are used. Place names and names of historical personages with no English equivalent are transliterated, but aside from 'ayn (') and hamza (') diacritical marks are omitted. Only quoted passages, titles of published works, and local terminology are fully transliterated. *Izāfas* have been omitted from the spelling of personal names unless they appear in a transliterated passage.

Arabic and Persian are transliterated according to the system used in the *Encyclopaedia of Islam*, with the omission of subscript bars and dots and with the substitution of *q* for *k* and *j* for *dj*. Diphthongs are indicated by *aw* and *ay*. For Ottoman Turkish, authors are given the choice of the EI system or the use of modern Turkish orthography. In any case, each individual author is responsible for the consistency and accuracy of the system he or she has applied to the transliterations provided; minor variations may therefore appear. Translations are the work of the individual authors unless otherwise indicated.

Sanskrit, Hindi, and Rajasthani

Indian terms from Sanskrit and later Indian languages such as Hindi or Rajasthani are transliterated to the closest approximate spelling, with no diacritical marks except for the macron to indicate long vowels. We have chosen to use the historical spelling for the kingdom of Kotah, which retains the final "h." Foreign words that have been incorporated into the English language are presented in their modern, popular forms.

GEOGRAPHICAL AND PLACE NAMES

In catalogue captions and entries, the names of modern countries have been used in place of older cultural and dynastic designations. Thus, objects from Persia have been assigned to Iran, Ottoman drawings to Turkey, and Mughal and Indian drawings to North India or Pakistan.

IDENTIFICATION, ATTRIBUTION, AND DATING

Unless otherwise indicated, the attribution and dating of unsigned and undated works of art at the beginning of each catalogue entry are the work of Stuart Cary Welch. Any differences of opinion among the contributors are expressed in the individual entries.

MISCELLANEOUS

The names Welch, Cary Welch, Stuart Cary Welch, and Stuart Cary Welch, Jr., all refer to the same individual.

The dimensions given in the captions for drawings indicate the object size rather than the image size, dimensions of the entire sheet, or, for drawings mounted as album pages, the entire page, including borders.

OPPOSITE
Detail of cat. 62

FRESH FROM MIND, HEART, AND HAND

DRAWING, looking at drawings, and gathering drawings have preoccupied me since childhood. When barely old enough to hold a pencil, I filled school notebooks with portraits of family, teachers, and classmates. Later, when bored in classes or study hall, I sketched everything seen or imagined. Always attracted to people of pronounced character, I focused attention upon my mother's mother, Mrs. Norman E. Mack, whose house included a special room filled with trunks prepacked for most of the world's climates (fig. 1). From her, perhaps, I inherited my zeal for travel and for acquisition. At the outset of the war against Japan, fearing that silk stockings would be in short supply, she bought one hundred dozen pairs.

When she died she left behind more than seven hundred pairs of shoes, many of which had never been worn. I craved other things: works of art, phonograph records, and books, mostly about paintings and drawings. By today's standards, these were cheap. For two dollars and fifty cents one could buy the Phaidon Press's *Holbein*, amply illustrated with many of his paintings and sensitive portrait drawings. At ten or eleven, I collected prints, and gave a small, etched portrait by Rembrandt to the perceptive art teacher at the Fessenden School who shepherded art-minded pupils to the Boston Museum of Fine Arts. Velázquez's early portrait of Gongora, the mysterious, cliff-browed metaphysical poet, moved me most (fig. 2).

But I was also delighted by Ananda K. Coomaraswamy's stunning acquisitions and installations of Indian and Persian paintings and drawings. Whatever remained of my modest allowance after buying recordings of Bach was lavished upon Coomaraswamy's five-volume catalogue of the museum's Indian pictures. Scrutinizing their illustrations of superb Mughal and fine Rajput drawings whetted my appetite for closer contact with the originals. If any picture moved me as much as Velázquez's portrait, it was the haunting study by Govardhan of Emperor Jahangir's dying courtier Inayat Khan (fig. 3).

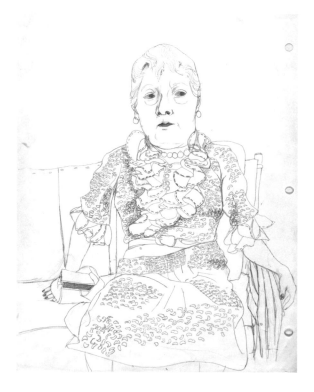

FIG. 1
Stuart Cary Welch, *Mrs. Norman E. Mack, My Mother's Mother*, 1945. Ink on paper, 11 × 8½ in. (28 × 21.6 cm).

OPPOSITE
Detail of cat. 48

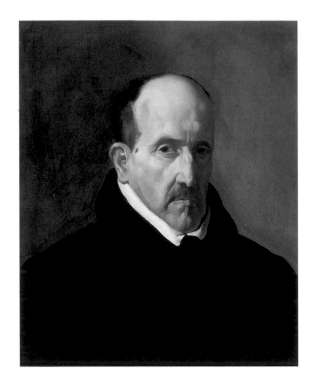

FIG. 2
Diego Rodriguez de Silva y
Velázquez, *Portrait of Luis de
Gongora y Argote*, 1622.
Oil on canvas, 19¾ × 16 in.
(50.2 × 40.6 cm). Museum
of Fine Arts, Boston, Maria
Antoinette Evans Fund,
32.79.

IN PURSUIT OF DRAWINGS

After my father introduced me to Kirk Askew, one
of New York's most knowledgeable dealers in old
master drawings, I was hooked. Like my architect
father, Askew had graduated from Harvard in art
history, after which he became director of Durlacher
Brothers. When he offered me superb drawings
by Giovanni Battista Tiepolo from the album of Con-
sul Smith, their price—less than three thousand dol-
lars—was utterly impossible for one whose monthly
allowance at fourteen was twenty-five.

Fortunately, I found another dealer on the oppo-
site side of 57th Street, H. Khan Monif, who sold
Iranian and Indian works of art for affordable sums.
Attuned to the starkly abstract elegance of Persian
silhouetted outline, I eagerly gathered ancient bronze
objects from Luristan as well as Persian and Indian
paintings and drawings. In those days, folios from
major Mughal manuscripts cost $250.

From Khan Monif, thanks to another introduction
by my father, I progressed to the grander hunting
preserve of Nasli and Alice Heeramaneck, New York's
preeminent dealers in many of the exotic traditions
I most admired. A burgeoning friendship began

FIG. 3
Dying Inayat Khan, Indian,
Mughal, 1618–19. Ink and
light wash on paper,
3¾ × 5¼ in. (9.5 × 13.3 cm).
Museum of Fine Arts, Boston,
Francis Bartlett Donation
of 1912 and Picture Fund,
14.679.

when Nasli and Alice sighted my small collection of
animal-style bronzes, African and Eskimo objects,
and wood carvings from the glorious tradition of the
Northwest Coast Indians. I was amused and flattered
when Nasli asked if I would sell him a seductively
weathered, lightly polychromed, long-beaked bird
in Haida style. It had been shaped from a piece of
driftwood with my own thumbnail! A few years later,
Nasli and Alice were happy to offer a more prosper-
ous me Indian miniatures and drawings, which were
not then of much interest to others. Had I been
greedier—and willing to go into debt—I could have
bought the superb Mughal pictures that eventually
went to the Los Angeles County Museum, along with
other Heeramaneck treasures. One of their works of
art that I craved, *Satirical Portrait of Four Ascetics* (cat.
22), came to me as a present from Alice and Nasli, to
whom the drawing had been given many decades
before by an uncle in Mumbai. The figures in this
picture, which has defied attribution, recall carica-
tures by Max Beerbohm. Dare we smirk? And suspect
that the usually tolerant Emperor Akbar shared our
amusement?

I also met Adrienne Minassian, who offered pic-
tures and objects inherited from her father, the well-
known dealer Kirkor Minassian. From the ample
shelves and huge central table of her large storage
room in the Manhattan Warehouse, Adrienne sold
exceptional Islamic ceramics, calligraphies, bronzes,
textiles, and pictures. She generously enabled me to
buy several especially vital early Mughal drawings.
Occasionally things go wrong, however, even among

friends. Several pictures Adrienne promised to hold for me were sold to another, better-heeled client; and on one occasion several years later, she again failed me when I had sighted in an auction catalogue and asked her to buy for me a stunning Mughal drawing of buffaloes in combat, drawn in around 1585 by Miskin, a major Akbar-period artist. The estimate was a mere seven hundred dollars. Although it was sold for the amount anticipated, she bought it for someone else. In the 1980s, when I was in charge of The Metropolitan Museum of Art's Islamic department, this great picture again surfaced at auction. I strongly urged the museum to buy it. When director Philippe de Montebello, sharing my enthusiasm, asked me how high the museum could go without seeming foolish, I suggested a hefty sum—nearly two hundred times the price at which I had failed to buy it. The museum bought it, and in 1985 it appeared in an exhibition we staged there, *India: Art and Culture, 1300–1900*.

Another remarkable drawing of the Akbar period, also by Miskin, turned up in Paris during the rewarding decades when few others sought Indian or Persian pictures. Earlier the same day I had found a splendid portrait of one of Akbar's Rajput courtiers, an event I celebrated with a fine luncheon and a good bottle of wine. Slightly tiddly, I wobbled toward the antique dealers of the Left Bank. By chance, I ventured into an unpromising shop, crammed with trendy French bric-à-brac. "Have you any Indian or Persian pictures?" I asked. Astonishingly, they did. Unbeknownst to me, the shop to which I was magically drawn belonged to the Hindamians, rivals of the Kevorkians, Kelekians, and Minassians in the pre–World War I decades when the Rothschilds, Henri Vever, Louis J. Cartier, and other discriminating Parisians eagerly bought Persian and "Indo-Persian"—that is, Mughal and Deccani—works of art. From a cupboard emerged the glorious early Mughal drawing by Miskin of Emperor Akbar interrupting a hunt to observe an animal combat (cat. 20). (Perhaps I should drink too much wine at luncheon more often!)

Because in those days there were so few rivals, one could explore dealers' stocks in New York, Paris, London, and beyond, confident of finding marvelous Indian and Iranian pictures and related objects. Every trip to Paris was rewarded with masterpieces. Until recently, the international art market was a cornucopia for those interested less in Western art than in my sort of "exotica." Drawings from the Turko-Indo-Iranian world were so little appreciated that they could be acquired for the proverbial song. My eagerness often surprised dealers. "Why do you want such things?" they would ask. "How do you know they are genuine?" On several occasions, I sorted out those I wanted from huge "laundry bundles" bursting with Rajput sketches that had been bought by the seller as scrap paper.

Gradually the styles of individual painters became apparent to me. Just as I had singled out work by such then forgotten or little-known Safavid and Mughal artists as Sultan Muhammad, Mir Sayyid 'Ali, Aqa Riza, Basawan, or Govardhan, so did I now assemble and attribute pictures by the genius known to me as the Kotah Master. After years of research, I wrote not only about the personalities and styles of Safavid and Mughal artists but also about several great talents employed in the Deccan and in Rajasthan.

PLEASURES OF THE CHASE

Every picture in this catalogue kindled delight, whether it was discovered suddenly, stalked, or long awaited. *A Maiden Reclines* (cat. 9) rustled into my life when I saw a tattered black-and-white photograph taken in 1940 that was lent by the dealer Henri Kevorkian to an exhibition in New York at the Iranian Institute. It delighted me just as a Puccini aria heard, barely recognizable, through static on a car radio once did. Eager to see the original and if possible acquire it, I made an appointment with Mr. Kevorkian, who received me politely. Because I was young and unknown, he was disinclined even to discuss the picture. Instead, he brought out paintings he thought I could afford, awkward Ilkhanid miniatures, as uninteresting to him as to me. For decades, hungry as a tomcat before the lair of a mouse, I awaited the *Maiden*. At last, she appeared in an auction and came to me. As usual, I scrutinized the picture in every

location and at every degree of magnification. From bedroom to museum gallery to bathroom, it accompanied me, always bringing enlightenment and pleasure.

Showing pictures to appreciative friends is often catalytic. One day in a corridor of the Fogg Museum, I stopped Sidney Freedberg and aired a recent Persian arrival, *Sprig of Rose Blossoms* (cat. 15). Sidney rose to the occasion. "A Leonardo fleshed out!" he proclaimed. The lustrously black late picture had caught my eye in Paris, where it was offered to me by Charles Ratton, the legendarily perceptive dealer specializing in tribal art, to whom I had been introduced by George Ortiz. He was also the indirect source of *Two Sufis: Two Temperaments* (cat. 26). After a superb luncheon with George at his parents' house, during which I met Bruce Chatwin, who was to become a close friend, I urged Bruce to accompany me to Charles Ratton's nongallery, an apartment filled with enticing African, Pacific Island, and American Indian objects.

Monsieur Ratton, whose eyes opened widely to all art, brought out, and immediately sold to me, a superb early-seventeenth-century Mughal portrait of an infant, signed by Emperor Jahangir's omnitalented artist Abu'l-Hasan. Ten days later, Bruce returned alone to Monsieur R's and was shown *Two Sufis*. He

bought it, and a few days later sold it to a mutual friend, Howard Hodgkin. Howard soon sent me a photograph, with a letter asking my opinion of the picture and of its attribution to Dawlat. Moved by the picture's humanity and extraordinary conjunction of mystics with a metaphor-laden sarus crane devouring a fish, I replied at once, not only agreeing with the attribution, but adding that if he ever became bored by it, I should be thrilled to have it. A year or so later, this unusually intense psychological analysis of two temperamentally opposite holy men—one edging upon masochism, the other on sadism—came to me (fig. 4).

I had admired two remarkable Persian drawings, *Proud Prince, Humble Sufi* by Sultan Muhammad (cat. 3) and Mir Sayyid 'Ali's *Tethered Camel and Rider* (cat. 2), for many years when I saw them in a book by a previous owner, Arménag Sakisian's *La miniature persane du XIIe au XVIIe siècle*. One day they were offered to me out of the blue by Annie Kevorkian, the Parisian dealer, niece of reluctant Henri. The large Ottoman drawing of a dragon (cat. 6), as rare as it is splendid, also turned up as a happy surprise, in a Sotheby's auction during the years before the sale catalogues of Oriental drawings were illustrated. I sighted it in the galleries, unattractively presented in the golden oak frame it had occupied long before its owner gave it to

his public school. Before being consigned for sale, it probably enlivened a dark corridor for half a century. Dazzled by its élan and ornamental power, I was as keen to acquire it as I was fearful that the British Museum, Freer Gallery of Art, or Metropolitan Museum would outbid me. Because it had been correctly catalogued, with the advice of B. W. Robinson, I attended the sale nervously. It came to me almost unopposed. A few weeks later, in our mews flat, the great *Dragon in Foliage* was much admired by my late friend—and potential rival for it—Dr. Richard Ettinghausen.

If Iranian and Turkish drawings were neglected during the 1950s, 1960s, and early 1970s, Mughal and other Indian drawings were in still less demand. One rarely saw them in the hands of prestigious dealers, and when they turned up at Sotheby's and Christie's there were few bidders. In earlier years they had been sought by the enterprising and creative art deco jeweler Louis J. Cartier, Barons Edmond and Maurice de Rothschild, and other discerning French collectors. From Monsieur Cartier's extraordinary collection of miniature paintings, most of which were donated to Harvard by John Goelet and others, came *Woman Playing a Zither* (cat. 25), a finely drawn, lightly tinted copy of an engraving probably by Jacopo Francia of Bologna, who worked between 1486 and 1546.[1] This sheet had come to me in the aftermath of awakening from a deep sleep inspired to ask Claude Cartier, an acquaintance from school, whether he would like to part with the Persian and Indian works of art inherited from his father. My timing was propitious. In those days, soon after the Second World War, jewelry lagged in the marketplace; moreover, Claude, about to be married to an heiress from Monte Carlo, needed cash. Harvard and I benefited, and so did Claude, who later assembled an extraordinary collection of postage stamps.

The drawing of the zither player, a painted version of which I later admired in the Gulshan Album (Tehran), taught me a great deal about art during the reign of discriminating Emperor Jahangir, as serious a collector as a patron. From his father, Akbar, he inherited the imperial workshop of painters, hundreds of them. He chose to keep only those whose work he truly admired; the rest, in their search for employ-

ment, scattered and thereby spread the imperial style far into Rajasthan and beyond. Always eager to attribute pictures, I eventually sensed that the lady with zither was an early work by one of my favorite Mughal artists, Govardhan. Gratifyingly, many years later, Norbert Peabody, an outstandingly perceptive student, arrived independently at the same conclusion.

From Adrienne Minassian, I later bought *Ascetics Making Bhang* (cat. 19). I saw at once that it was by one of Govardhan's primary mentors, the even more profound artist Basawan. This outstanding picture turned up in the stacks of old stock preserved by Adrienne, who was at least as keen to knit sweaters as gifts for our children as to sell things to their father. It and a splendid conversation piece by the same artist were among the pictures that inspired me to write a monograph about Basawan for *Lalit Kala*, the Indian art journal.[2]

My appetite for the Mughals was further whetted when a close older friend, Philip Hofer, founder of Harvard's Department of Graphic Arts, sold me a great drawing in order to support yet another of his many donations to the university. It was *The Huntsman Anup Rai Freed from a Lion by Emperor Jahangir and Prince Khurram* (cat. 23), which I have long considered a high point of imperial art. For many years, I had known that it was the model for a later painting by Balchand for Shah Jahan's official history of his reign, the *Padshāhnāma*.[3] It now became evident that the artist was one of Mughal art's stellar talents, Abu'l-Hasan, son of Aqa Riza Jahangiri (see cat. 17). One of the "houseborn," he was reared and trained under the emperor's discerning eye.

Perhaps the liveliest study from life of any Turko-Indo-Iranian ruler, Bishndas's sketch of Shah 'Abbas I (cat. 27) came to me through a friendly international network. Like a soccer ball, it was dribbled from one player to the next. Discovered initially by Terence McInerney and Howard Hodgkin, it was booted on to Spink and Sons, who in turn passed it in the direction of alert teammates Robert Alderman and Mark Zebrowski. From them it reached my fortunate self.[4] This circuitous path toward Harvard recalls my answer when suddenly asked how my taste in pictures differs from that of my friend Howard Hodgkin.

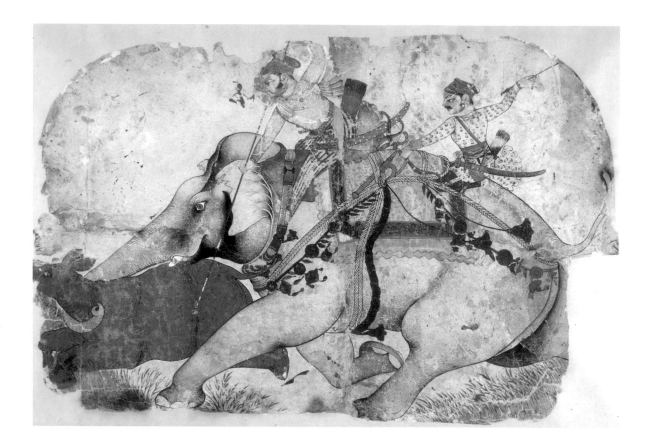

FIG. 5
Attributed to the Kotah
Master, *Rao Ram Singh I of
Kotah Pursuing a Rhinoceros*,
Rajasthan, Kotah, c. 1690.
Opaque watercolor on
paper, 12¾ × 18¾ in.
(32.1 × 47.6 cm). Private
collection.

"He," said I, "prefers bold color and striking composition to psychological nuances," a statement born out by my fervid response to this revealing characterization of Jahangir's admired and detested Persian rival. Chosen by the emperor like a secret service photographer to accompany the Mughal ambassador to the Safavid court, Bishndas strove to please his patron. Standing close to the extraordinary shah, he recorded every royal blemish, from the turkey-wattles of his scrawny neck to his hollow chest, cauliflower ears, and darting falcon eyes.[5]

Fortunately, my devotion to Indian drawings occurred at the right time. Although distinguished Mughal (and Deccani) drawings were never plentiful in the market, Rajput drawings were, especially in the 1950s and early 1960s. Moreover, they had few collectors, public or private. Because I admired not only every sort of European drawing but also Chinese, Japanese, Tibetan, and "primitive" works, my reach was broad. Vitality mattered most, virtuoso accomplishment least. When sifting through pictures, my responses, favorable or not, were—and are—swift.

Indeed, dealers have been impressed and alarmed by the speed with which I examine their wares. Most of the time, alas, our eagerness goes unrewarded. On a few rare occasions, faced with a glut of superb pictures, I have realized that, like editions of exciting books, the supply would soon be exhausted. The message: "Buy now, or never!"

During the later 1950s, a friend showed me a remarkable drawing, *Vilaval Ragini* (cat. 34), the earliest drawing I had seen from Bundi, an important Rajasthani school. Whenever we met, we enjoyed and discussed the coveted picture. A decade later, the owner faced serious health problems. He made a special trip to see me; unforgettably, and touchingly, he brought this favorite picture and sold it to me.

All who know and have worked with me are aware of my admiration for drawings and paintings from Kotah, the Rajput school most deeply rooted in the Turkman and Safavid schools. More than fifty years ago, while pawing through a heap of rubbish, I sighted the torn and battered Kotah painting of Rao Ram Singh I riding the mightiest and speediest of

his elephants in pursuit of a rhinoceros (fig. 5). Now famous, it sparked Kotahmania in me and in generations of my students.[6] Shortly after making this thrilling discovery, I came upon heaps of drawings, many by the same Golconda-trained artist, who had been hired by Jagat Singh of Kotah at Aurangabad. I dubbed this genius "the Kotah Master."

Trained to imbue Turkman, Safavid, and Golconda dragons with divine power, the Kotah Master, enthusiastically nurtured by the raos, his Rajput patrons, brought his talents to bear on the animals and birds of Rajasthan's jungles and forts. How exciting it was when I soon found visual evidence of this brilliant artist's stylistic roots in his *Dragons and Birds from the Chambal River* (cat. 41; fig. 6). Later more substantial proof of the Turkman appeared when I was shown this artistic wizard's *Worldly and Otherworldly Birds*, painted in full flight across the ceiling of Kotah Fort's Chhattar Mahal. Bordering it, moreover, are equally vital Golconda-style arabesques. Further proof turned up still later when I found the Kotah Master's version of *A Hero Topples a Demon*, a fifteenth-century Turkman picture from Tabriz, preserved in the library of the Topkapı Sarayı Müzesi, Istanbul.

If the Kotah Master was unquestionably Kotah's most brilliant artist, the school was not without talent before he was brought to Rajasthan by Rao Jagat in the late seventeenth century. Already at Kotah was another anonymous artist, known to me as "the Master of Elephants." To him I ascribe *Elephant Saluting a Prince* (cat. 37) and *Elephant Combat* (cat. 38), which were probably studied by Rao Jagat's Deccani émigré. Soon after, the Master of Elephant's beasts were recreated by the Kotah Master, with dragonish energy. This can be seen in *The Heat of Battle* (cat. 39), a crowded melee reminiscent in its linear mastery of twelfth- and thirteenth-century Japanese scroll painting. This large drawing came to me shortly after the discovery of the Kotah Master's magnificent, also damaged, *Rao Ram Singh I of Kotah Pursuing a Rhinoceros*. Both transcend every rip and abrasion.

Because most Indian drawings are informal, ephemeral, intended for artists' use rather than patrons' collections, and usually considered commercially valueless, they transport us, more than

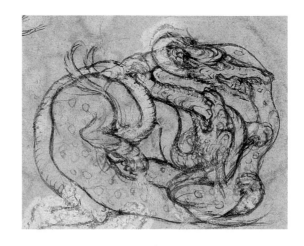

paintings, into their creators' private lives. Many of these drawings capture sparkling moments that are—if not movingly profound—delicious visual caviar.

ON THE NATURE OF DRAWING

Fresh is the key word in the title of my essay, for all of the drawings here were chosen for their spontaneous liveliness. In my view, art—as compared to the counterfeits and pastiches labeled by many as art—is an aspect of nature. True works of art emerge from mind, heart, and hand just as trees or flowers grow from earth. And true artists, unlike hacks, are attuned to nature. They create as naturally as fish swim.

Among the many categories of art, drawings appeal to me especially. These fall into several subdivisions. Often moving are the first sketched, gropingly bold, sometimes awkward stages in the formation of artistic ideas. Not intended for the public—not even for patrons—these scrappy jottings in visual shorthand can be as rewarding as they are challenging. Their almost incoherent rawness often led to their destruction. Most were thrown away, but some of these humble bits of scrawled-upon paper survived in reuse within the studio. Among these a few gained extra power and appeal by the addition of further strokes or complexes of strokes. One such delightful survivor is a ripped sheet of paper upon which a greatly gifted artist at Kotah added two portraits of a genial-looking woman to an uninspired study of a deity (cat. 57). Perhaps the artist and the woman chanced upon each other, and he sketched a studied likeness; but she may have complained of his

presumption, for which he drolly added a mock-savage caricature. On seeing this vital, human sketch, one can almost hear the artist's laughter and the victim's ambiguous squeals.

More likely to be valued, and therefore preserved, are finished working drawings. Pleasing to the eye, these would be put aside for safekeeping by artists even after their initial purposes had been served. Most of the drawings catalogued here were not made as completed works of art but to further projects. A masterfully rendered polo scene (cat. 52), for instance, is a preparatory drawing for a wall painting in Kotah Fort. It was stored for future use, either for another mural or for a miniature painting, in the artist's family archive, where it remained for nearly two hundred years.

Although drawings were produced in every art tradition within the vast Turko-Indo-Iranian world, they were usually made by and for artists, who kept them not only as sources of motifs and enjoyment but for use in educating successive generations in the family profession. Young children copied these hand-me-downs, to which they sometimes added their own infantile scribbles.

A special subdivision of drawings consists of tracings (pounces), or *charbas*, sometimes on gazelle skin. These were pricked along their outlines, through which powdered charcoal was usually rubbed, leaving smudges on a fresh piece of paper or a wall that could be reinforced and refined. By adding tracing to tracing, entire compositions could be created. Sometimes a drawing might merely be pricked to transfer the design (cat. 2).

Portraits from life, usually livelier and more psychologically telling than the paintings for which they were studies, formed another part of an atelier's stock of motifs. A particularly penetrating likeness, previously mentioned, was commissioned by Emperor Jahangir, whose embassy to the Safavid court of Shah 'Abbas at Isfahan included the portrait specialist Bishndas. To assert his importance, Shah 'Abbas kept the Indian ambassador and his entourage waiting; when he finally deigned to receive them, he had barely dismounted after a polo match and was damply malodorous. Bishndas, prompted by Emperor Jahangir's desire for an unflinchingly accurate por-

trait, stood close to the shah and swiftly sketched one of the most candid and convincing royal images in Eastern art (cat. 27). When the shah saw this portrait he protested, and it was replaced by a more conventional likeness.[7] The artist took both back to Mughal India in 1618, where they served as models for depictions of Emperor Jahangir's detested Safavid rival, called in his memoirs "my little brother."

Drawings were usually kept by artists in untidy stacks, wrapped in bandannas. Not until the late fourteenth or the fifteenth century did patrons arrange them in albums for their own edification. Evidence for this is found in Istanbul in the library of the Topkapı Sarayı Müzesi, where many albums have been preserved since early times. The most revered of these, gathered for the Qarā Qoyunlu and Aq Qoyunlu Turkmans and for the Safavids, were taken by the Ottomans when they defeated the Safavids and captured Tabriz in 1514. Unlike all other dynastic royal libraries in the Turko-Indo-Iranian world, the Safavid library's albums remain almost intact in the museum. These fifteenth-century albums contain many drawings, along with calligraphies, illuminations, miniatures, and fragments, European prints, and scraps of Chinese paintings. These were among the models for one of the important later albums in the same library; it was assembled in 1544 by the artist and art historian Sadiqi Beg for Bahram Mirza, a brother of the Safavid shah Tahmasp. It contains comparable, but mostly Safavid, material.

By the end of the sixteenth century, drawings were admired for their own sake. Drawings by Aqa Riza, later known as Riza 'Abbasi, often sketched or even unfinished, were commissioned and collected not only by Shah 'Abbas but by courtiers and even by wealthy merchants. The cult of drawings that developed at Isfahan soon spread to Ottoman Turkey, Uzbek Central Asia, and India. Most of these artfully calligraphic ink sketches were set into superb borders, sometimes enriched by the artists whose work they surrounded. As in the past, these were interspersed with folios of calligraphies, miniature paintings, and such importations as European prints.

Few albums now remain intact, other than in Istanbul and in a few other fortunate old collections;

dealers broke up albums to sell individual folios, and libraries often removed album folios for safekeeping in solander boxes. In the West, curators, conservators, and collectors eagerly protect drawings from the hazards of light and handling. Drawings now receive the same treatment long given to valued engravings and etchings. They are carefully mounted in acid-free mats, stored in climate-controlled darkness, and responsibly exhibited in subdued light. Sketches once stored in heaps or bundled in cloth now receive due respect. But one occasionally longs nostalgically for the livelier—if more hazardous—times, when traditional artists lived with these now institutionalized scraps of paper and used them to make more.

HISTORICAL CONTEXT

Turko-Indo-Iranian drawings are now widely admired and collected. They have also become rare and valuable; because of this, many fakes, mostly inept and ugly, swamp the market. The time has come not for finding new material but for further studying and enjoying works acquired when the going was good. The drawings assembled in this catalogue and exhibition offer not a representative survey but a small sampling.

All seventy-six of the drawings catalogued here are stylistic and cultural cousins, created from the early fifteenth through the mid-nineteenth century within the vast, geographically varied sprawl encompassing Turkey, Iran, parts of Central Asia, and India. A major segment of this part of the world has been described as "Turko-Iranian" by the historian Marshall G. S. Hodgson, a phrase to which "Indo" must be added, lest one omit artistically inventive South Asia. Separate traditions flourished under the Turkish Ottomans; the Iranian Timurids, Safavids, and Qajars; and in India and Pakistan under the Mughals and Deccani sultans and the Rajputs from the plains, the hills, and Central India. Included, too, are a few pictures in westernized style drawn by Indian artists for British patrons. Although most of the patrons were Muslims (sultans, shahs, emperors, princes, and courtiers), many of the Indian patrons were Hindus (raos, rajas, maharajas, maharanas, takurs, and ravats). In India, Hindu artists often worked for Muslim patrons, and Muslims for the Hindu princes of Rajasthan, the hills, and beyond.

It is impossible to understand and fully appreciate any single school of art within this broadly ranging cultural complex without knowing the others. All belong to the same body. Just as the head, trunk, legs, and hands of a human body are interconnected, so are the myriad styles and substyles within the Turko-Indo-Iranian complex. Only after exploring the full gamut of these separately enthralling idioms do their influences upon one another become evident.

Persian traditions grew from earlier indigenous modes, with additional touches from China and Europe. Ottoman Turkish art developed under strong Persian influence and lesser influence from China. Painting and drawing for the Mughal conquerors of India blended earlier imported styles (mostly Safavid Persian, with Chinese and European enhancements) with indigenous ones. The multitude of vivid styles for Hindu Rajputs developed from regional modes, often strongly influenced by the Mughals, whose style already incorporated pre-Mughal Indian ideas and motifs.

Each of the subtraditions within the great family of interrelated styles expressed its own artistic vision. Persian pictures came mostly from a cerebral aesthetic, distilled from the mind and from earlier art rather than from close observation of nature. Only outstandingly innovative Persian masters drew from life. Their drawings reproduced here stress calligraphic line and delight in ornamental flourishes, as can be seen in a fifteenth-century improvisation on the arabesque (cat. 1). Never humdrum, their spirit is poetical and otherworldly. The prince, Sufi, and horse in Sultan Muhammad's poignantly anecdotal, gently satirical confrontation between a proud prince and a humble holy man express imagined essences, with little heed to textures of skin or irregularities of nose (cat. 3). The young fellow rising somewhat haughtily from his saddle stands not for a particular prince but for princeliness. The other denizen of the mind and spirit is the bony, scraggly haired, sharp-elbowed, wisely sympathetic Sufi, who humbles himself before the mounted prince. The later Safavid artist Aqa Riza's reclining woman is also typically Persian

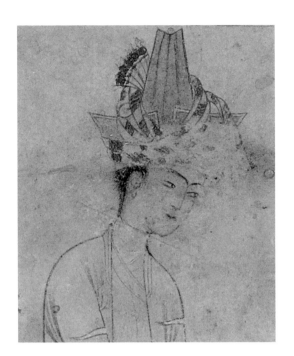

FIG. 7
Head of Shah Abu'l-Ma'ali,
detail of cat. 16

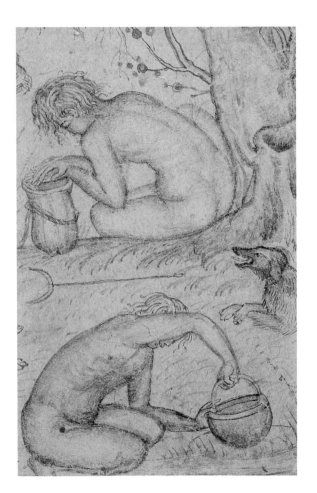

FIG. 8
Kneeling ascetics, detail of
cat. 19

(cat. 9). Representing no particular courtesan, she is the embodiment of her great artist's voluptuously calligraphic fantasy. The much later *Sprig of Rose Blossoms* bloomed not from any botanical garden but from the heart (cat. 15).

The most powerful Ottoman drawing here is a dragon signed by a Persian-born and trained artist, Mir Sayyid Muhammad al-Naqqash (cat. 6). Although datable to the 1560s, the style of this amiably smiling creature of thunderclouds and lightning harks back to fifteenth-century Turkman Tabriz. Both artist and patron, Khan Ahmad al-Husayni II, a disliked cousin of Shah Tahmasp, were from Gilan, an outlying Safavid province bordering the Caspian Sea. In the aftermath of the patron's imprisonment by the shah, the artist found employment at the Ottoman court, where he was joined many years later by the khan. In Constantinople, Mir Sayyid Muhammad's Turkman artistic roots, undervalued as old-fashioned in Safavid Persia, were welcomed at the Ottoman court, whose art also contained remnants from fifteenth-century Tabriz. The artist was enthusiastically encouraged by a series of sultans. Gilan's Turkman survivals were sparked with vigorous new life. Mir Sayyid Muhammad flowered as never before. In addition to drawing, he became one of the most influential designers of textiles, painters of Iznik ceramics, and illuminators.[8]

The Mughal artistic vision was initiated in the *Memoirs of Babur*, written by the first emperor of the dynasty (r. 1526–30). As in the paintings he surely would have commissioned had he reigned longer, Babur's accounts of people, places, and natural history hover between the sensitively observed and the transcendental. When the former Safavid artist Mir Sayyid 'Ali, fresh from the Iranian courts, drew elegant Shah Abu'l-Ma'ali for the next emperor, Humayun, only the characteristic headgear indicates the picture's Mughal origin (cat. 16). The artist avoided the earthbound realities that would have brought him still greater esteem at the Mughal court. He portrayed the handsome youth, the emperor's favorite, not as a flesh-and-blood, ambitiously beguiling courtier but as the silent, scentless, impalpable personification of a romantic concept (fig. 7).

Although the artist Daswanth worked under the supervision of Mir Sayyid 'Ali on a later picture,

drawn soon after the birth of a truly Mughal artistic style, his ascetics are earthily credible (see cat. 18). Mir Sayyid 'Ali's antirealistic calligraphic elegances, gradually pushed aside as Mughal taste progressed, linger only in the trees and in the ornamentally rippling edges of textiles. The central figure and his scrambling apprentices (*chelas*) are tangible characterizations, each with his own quirks. We might come across them in today's India. Basawan, Daswanth's eminent, longer-lived, and happier colleague, drew *Ascetics Making Bhang* even more empathetically (cat. 19). If we can reach for and lightly touch Daswanth's ascetics, Basawan's can be grabbed, held, heard. The close observation of back, ribs, and foreshortened arm impresses us with Basawan's understanding of anatomy, and his appreciation of the supple fullness and feel of skin (fig. 8).

Mughal artists' increasing concern for psychological portraiture is exemplified by Aqa Riza Jahangiri's heartening *Master and Pupil* (cat. 17). It invites us into the august presence of a fourteen-year-old Mughal prince—probably Salim, who ascended the throne in 1605 under the name Jahangir (World Seizer)—who is being taught by his charismatic, cuddly bear of a schoolmaster. We are impressed not only by the precision of Persian-born Aqa Riza Jahangiri's study of their appearances but also by his analysis of their interaction. In the imperial presence, we, as fascinated interlopers within the reverential hush, open our ears to the keen eagerness of master and pupil to teach and to learn (fig. 9).

More than the Ottomans, Safavids, or Rajputs, the Mughals cultivated historical accuracy, tempered by aesthetic concerns that turned events into superbly performed spectacles. Abu'l-Hasan, son of Aqa Riza Jahangiri, bore this out in his reconstruction of the dramatic moment when Emperor Jahangir and his son (who was to rule as Shah Jahan) struggled to save a huntsman's life by killing or driving off a terrifying lion (cat. 23). Like a cat torturing a mouse, the lion toys with the fallen man (fig. 10). Although the artist's portraits of the emperor, crown prince, and hypnotized victim are painstaking and credible, and although the beast is frighteningly huge and menacing, Abu'l-Hasan has composed the drama with a choreographer's attention to rhythm, dramatic placement, and artistic balance.

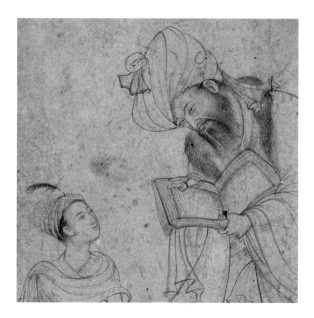

FIG. 9
Faces of master and pupil, detail of cat. 17

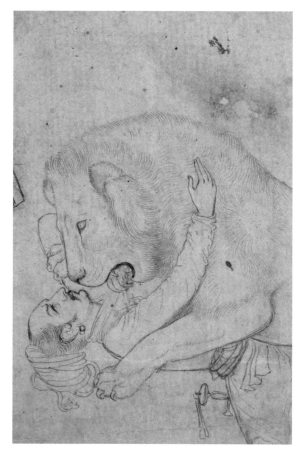

FIG. 10
Anup Rai and the lion, detail of cat. 23

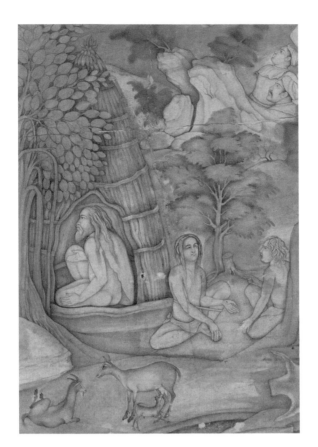

FIG. 11
Mystics and goats, detail of
cat. 20

this book, *Vilaval Ragini*, is also the earliest and most compelling known from the princely state of Bundi, in Rajasthan (cat. 34). Presumably it is one of thirty-six illustrations from a *Ragamala* (*Garland of Melodies*) series, each of which interprets and is appropriate to a particular melody, mood, and time. The composition is yet another version of a standard configuration of architecture and people. Not closely based upon scrutiny of the outer world, its style is akin not to imperial art but to popular Mughal paintings from the bazaars of Agra, where manuscripts and single miniatures were produced in large quantity for lesser patrons. Its date is close to that of the magnificently imperial portrayal by Miskin of Emperor Akbar interrupting a hunt in order to observe an animal combat (cat. 20).

If we compare that master's landscape, animals, and people to those in the far simpler Bundi *Vilaval Ragini*, it is apparent that Miskin often—but not always—drew from nature. We are charmed and amused by his paired encampments of goats and naked yogis, all sensitively sketched from life (fig. 11). And we are also moved by Miskin's supercharged energy in the animals in combat, which fuses Miskin the Mughal's observation with Miskin the Hindu's tapping of inner visions. The combined approaches resulted in pictorial dynamism especially appealing to Akbar, with whose explosive energy it resonated. Miskin compensated for the emperor's uncharacteristically tranquil posture by energizing him with a wiggly line beneath his crossed legs.

Many of the Rajput pictures in this volume were drawn by one of India's—and the world's—greatest artists, the Kotah Master. His art runs the gamut of Turko-Indo-Iranian tradition. Trained in the Deccan at the sultanate of Golconda, he inherited along with indigenous elements the artistic legacies of the Aq Qoyunlu Turkmans from Tabriz and of their Safavid successors. When in the 1680s Emperor Aurangzeb finally defeated the Mughals' Deccani rivals, this genius was forced to find new patronage at Aurangabad, a thriving Mughal outpost that had become the hiring hall for unemployed Deccani men of talent. Mughal and Rajput officers vied there to find gifted craftsmen and artists to bring back to their own feudatories. The brilliance of the Golconda wizard was recognized by Jagat Singh (r. 1658–83), who

In a later historical reconstruction, probably by Payag, we witness the crucial final moment of the epic battle of Samugarh, which in effect ended the long reign of Shah Jahan (cat. 30). The artist enables us to soar with him above the crowded melee in which he noted—sometimes inscribing their names—every officer, soldier, horse, elephant, and princely red tent. On the left, the crown prince, Dara Shukoh, has dismounted, erroneously signaling defeat to his troops. On the upper right, balancing the ill-fated Dara Shukoh, is Prince Aurangzeb, framed by an attentive ring of elephants, horsemen, and infantry. This victory led to his accession as Emperor 'Alamgir, after he imprisoned his father, Shah Jahan, and defeated and slayed his less ruthlessly ambitious brothers.

If Mughal art focused as accurately and sensitively as it could on the world of appearances, Rajput art, patronized by Hindus of the *kshatriya* (warrior and governing) caste, was usually more concerned with an interior vision. Mughals wanted pictures of what they saw: Rajputs preferred those inspired from the mind's eye, from dreams, or from meditations upon gods and goddesses. The earliest Rajput drawing in

transported him back to Kotah, where he soon imbued elephants, lions, and tigers with the visionary power and energy he had previously breathed into Turkman and Safavid dragons and *simurghs* (mythological birds).

The Kotah Master's Persianate linearism was lavished upon commissions to paint and draw the entire range of Rajput subjects: portraits, genre scenes, battles, still lifes, architecture, Ragamala sets, and portrayals of the Hindu gods and goddesses. Like Jahangir's favorite artist, Abu'l-Hasan, the Kotah Master could depict anything and everything. Spurred on by Jagat Singh and his successors—as passionate about the arts as they were about ruling, fighting, hunting, and making love—the Kotah Master reinvented Rajput art at Kotah. Inasmuch as the raos of Kotah served as generals to the Mughals, they had learned to admire imperial art and were influenced by its penchant for naturalism. But the Kotah Master's omnipotent lions (cat. 46) embody both the Persian poetic vision and the Rajput inner view, with few adjustments to Abu'l-Hasan's accurate observation. To delight Rajput patrons and enliven their jungles, the Kotah Master employed his formidable battery of linear techniques. These included the Persian virtuoso Riza 'Abbasi's calligraphic (*nastā'liq*) élan, which lent rhythmic dash to the manes and lethally sharp claws of Rajasthani lions. Vitalized by the Kotah Master and by keen Rajput patronage, the arts of Kotah continued to flourish.

In later years the British who occupied India employed native artists to paint and draw for them. Adjusting their taste only slightly to India's artistic traditions, they found it easier to admire Mughal naturalism, fineness of finish, and subtle coloring than the curry-hot, stronger Rajput modes. With the sharp eyes of outsiders for the picturesque and the curious, these transient overlords commissioned natural-history studies and sets of characteristic occupations. *Man with Two Dogs on a Leash* (cat. 75), a nostalgic souvenir of Indian life, was drawn by an erstwhile practitioner of Mughal naturalism who had adjusted to the mode of British steel engravings.

The drawings assembled in this exhibition and catalogue—chosen from the three hundred or so works of art presented to Harvard in 1999 (see the Checklist at the back of this exhibition catalogue)— offer but a small glimpse of the metaphorical body to which I referred above: an eye, a belly button, fingers, a knee, a sampling of toes, a tangle of sinuously elegant hairs, and—to cap it off—a Britisher's toupee, created from some poor Indian's hair.

No matter how rich individuals or institutions might be, collections can be assembled only from the market's offerings. The *Mona Lisa*, Sistine ceiling, and *Guernica* are not for sale; nor were the exhilarating Iranian, Turkish, and Indian drawings that trained and sharpened my eyes in the Victoria and Albert Museum, the British Museum, Topkapı Sarayı Müzesi Library, and other institutions and private collections. When I gathered these drawings, mostly between 1945 and 1965, there were countless thousands joyfully to choose from.

Notes

1. Welch 1963b, 226, fig. 10.

2. See Welch 1961, 7–17. I was once commissioned to write an article called "The Drawings of Basawan" for an encyclopedia, but the article remains unpublished.

3. Beach and Koch 1997, pl. 30. Admirably carried out, Balchand's painting lacks the dramatic immediacy of Abu'l-Hasan's drawing.

4. Hodgkin and McInerney 1983, no. 2.

5. Welch 1995, 260–63, figs. 1, 2 (note that the captions have been switched).

6. See Welch 1997. So enthusiastic was an earlier student, Milo C. Beach, that he generously but prematurely published many of the Kotah pictures I had found and used in teaching. See Beach 1974. The evolution of my thoughts on Kotah art and its development that led to the 1997 exhibition and book can also be traced in S. C. Welch 1976; Welch 1983, 78–93; Welch 1985; and Welch and Sagstetter 1994.

7. Welch 1995, 424, fig. 2. The first portrait is at Harvard; the second, favored version is in the Vatican Library.

8. The genius of Mir Sayyid Muhammad al-Naqqash is seen in several magnificent and justly renowned Ottoman textiles and ceramics, such as the tiles closely related to the drawing of the dragon (cat. 6) in the so-called *naqqash-hane*, a series of blue-and-white animated arabesques now mounted at either side of the entrance to the Circumcision Room in the Topkapı Sarayı Müzesi, Istanbul. For excellent color plates, see Denny 1998, frontispiece, 5, 7, pls. 40–44. For two marvelous dishes by this artist, see Atasoy and Raby 1989, nos. 339, 352. Also see Welch 1972b, 291–98. To this artist I ascribe textile designs that include those employed in making two majestic, indeed transcendental, kaftans; for these see Tezcan et al. 1996, 93–95, color plates. For an equally superb robe, with arabesques against white rather than black, see Atil 1980, pl. 331, fig. 59.

LIFELINE

Sketches in Appreciation of Stuart Cary Welch

ONLY with a kaleidoscope could one present the manifold contributions that Stuart Cary Welch has made to Harvard University. Overlapping and growing out of one another, his varied incarnations have included student, artist, curator, teacher of art history, photographer, author, and lender and donor of incomparable works of art. Through countless exhibitions, catalogues, public lectures, and years of teaching and sharing his own collection of art, he has inspired generations of students and museum visitors to see as never before the wonders of Islamic and Indian art. His many publications and international exhibitions have impelled appreciation of these artistic traditions in audiences far beyond the Harvard community or the cloistered world of specialists. He has captured the attention and imagination not only of art historians but of artists, novelists, and even filmmakers through his writings and colorful life (fig. 12).

With this catalogue, Harvard University celebrates Welch's 1999 gift of 306 works of art from India, Iran, and Turkey, selected from his own extraordinary collection. As a group, they constitute one of the most important acquisitions in the history of the Harvard University Art Museums, but they were neither Welch's first nor his last gift of art to his alma mater. Many of the drawings selected for this catalogue are world-famous masterpieces, familiar to scholars and connoisseurs; others have heretofore been known only to his acquaintances.

I have known Cary Welch since 1941, when we were classmates at St. Paul's School. I don't remember much from those days, except that he was artistic—he drew, painted, and was already collecting art. He had a great fancy for Liederkranz cheese, which he hid among his shirts.

When we were at Harvard, he took me walking in Mount Auburn Cemetery, not for any morbid reasons, but for the beautiful trees and the mood of mystery that comes through. He is an unusual figure, an all-around man, and an extraordinary collector. He studied the field of Islamic art, but his is the poetic approach of the artist. His understanding of art comes through emotion, which is what art is all about. Man projects his essence into his art, and Cary is one of the rare individuals with the gift of perception in his loves.

Cary not only collected Persian and Indian miniatures, but, one might say, in many ways he actually made the field. He took this area of art, which had been esoteric and little known, and with his exhibitions, publications, and teaching, made it into a major area of study and enjoyment.

—GEORGE ORTIZ

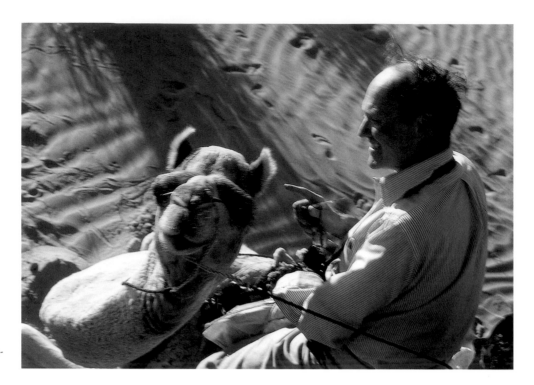

*Collecting is a bit like alcoholism. I try to be the collecting
equivalent of the so-called "social drinker." Sometimes I have
one too many. This vice is a particularly dangerous one as it
is so often disguised as a virtue. Collecting is useful (it often
protects things that might otherwise be lost or broken); it is
financially "sensible" if kept within one's economic limits—
it is even a form of savings. However, collecting can warp
a person. It can create as much jealousy as sex and can lead
to an especially nasty twisting of values, in which objects
become more important than people. For these reasons, I try
to keep my mania under control.*

—STUART CARY WELCH

Welch's collection of Persian, Turkish, and most
particularly Indian paintings and drawings has been
called "arguably the finest private collection . . . ever
made."[1] Assembled, in the informed opinion of the
noted scholar Robert Skelton, by "a collector with
great flair and a discriminating eye,"[2] the Welch col-
lection could be regarded as the crowning achieve-
ment of any mortal life. For Cary Welch, however,
it is but one of many accomplishments, although it
must have required his most sustained effort.

If a single thread can be found running through
Welch's long, creative life, it is surely the line made
by a drawing tool—pen, pencil, charcoal, or brush.
Peculiarly attuned to the expressive qualities of line,
Welch is himself an accomplished, although largely
unknown, draftsman. From childhood he found in
graphic art the perfect vehicle to communicate his
idiosyncratic vision and preoccupations. Tellingly,
his earliest and most enduring art teachers have been
seashells and butterflies, living embodiments of
linear elegance. With an eye informed by the hand's
practice, Welch has devoted a lifetime to searching
out and acquiring masterpieces of drawing.

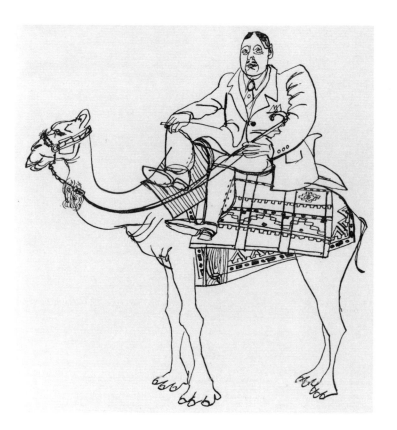

FIG. 13
Stuart Cary Welch, *The Explorer*. Ink on paper. *Harvard Advocate*, Winter 1947, 19.

Captivated at an early age by the intimacy and immediacy of drawings, the fourteen-year-old Welch found to his dismay that he was unable to afford works by European old masters on his monthly allowance. Acquainted with the arts of the Islamic world and India from childhood visits to museums, he shifted his sights eastward and discovered drawings of equal power and quality in the more affordable, but at the time little known, world of Islamic and Indian art. Collecting in this largely uncharted field required an adventurous spirit, an independent mind, and an unfailing eye. Thus Welch embarked on a collecting career that required the talents and temperament not only of a connoisseur and scholar but also of an explorer.

It is perhaps no coincidence, then, that explorers, as well as ethnologists and ordinary travelers, appear frequently in the witty drawings that Welch published in Harvard's literary and humor magazines while an undergraduate. A tightly trussed European sitting astride a camel illustrates one of Welch's recurrent themes—the meeting of the "twain" (fig. 13). The camel is here rendered with more sympathy than his

Art appreciation has its prodigies: and there is a touch of the prodigy (as well as the prodigal) in great and idiosyncratic collectors like Coomaraswamy and Welch. Welch's taste ranges from the most finished Mughal work to the roughest sketch from Kotah, a scrap of paper on which the nineteenth-century palace artist, after pointing his brush in a cloud of black spirals, does some swift little drawing. Welch is a looker in every way. He is the collector as explorer; he brings back news. And there is something of this explorer's excitement in his writing.

—V. S. NAIPAUL

FIG. 14
Stuart Cary Welch, *Popular Professions Illustrated: III. The Ethnologist*. Ink on paper. *Harvard Lampoon*, 6 May 1950, 262.

FIG. 15
Tapa Figure, Easter Island, c. 1850. Bulrush, mulberry bark, wood, and pigments. Peabody Museum, Harvard University, Photo T4268.1.

To this undergraduate in the 1940s, the Fogg was a paradise of the arts. Virtually addicted to drawings and prints, to Ingres, to ancient Chinese bronzes, Japanese art of all sorts, to Classical art and to the vital artifacts of its "barbarian" neighbors, and to the arts of the Islamic world, I was also a stroll away from the equally stirring collections of the Peabody Museum. There I was enthralled by the traditional arts of the Americas: by the stone sculptures and ceramics of the Olmecs and Mayas, by pipestone carvings and pottery from the Southwest, by Eskimo ivories and polychromed masks, and by the varied but always inspiring arts of the Northwest Coast Indians. Also notable were the Peabody Museum's examples of the powerful, often sparely shaped objects from African and Pacific Island cultures.

—STUART CARY WELCH

We dined on the train, changed at Chicago, and then caught the midnight train to Buffalo. Here we lunched with a most charming and brilliant young man of twenty-three called Cary Welch, who had been asked to entertain us, as his father was away. He had the manner and assurance of a man far older and yet was not conceited. He took us to the Art Gallery and the Niagara Falls in his grandmother's ancient Rolls, and altogether was most helpful and amiable.

—CYNTHIA GLADWYN

human counterpart, as are the dromedaries drawn by Mir Sayyid 'Ali (cat. 2) and Mu'in Musavvir (cat. 14).

Welch's series Popular Professions Illustrated that appeared in the *Harvard Lampoon* and the *Harvard Advocate* caricatured clowns, magnates, and beauty queens, but he found in the depiction of a Western ethnologist contemplating a museum exhibit the ideal target for his irreverent humor (fig. 14). Welch's ethnologist more than a little resembles the object of study, a well-known Oceanic human effigy in Harvard's Peabody Museum of Archaeology and Ethnology (fig. 15). Although concentrating in fine arts in his classwork, Welch spent as many of his undergraduate hours in the Peabody as in the Fogg Art Museum. His boundless interests could never be contained by a conventional definition of the fine arts.

Apart from their wicked undergraduate humor, Welch's drawings from the late 1940s reveal preoccupations that have engaged him for a lifetime. His caricatures of explorers and ethnologists attest to a lifelong enthusiasm for contact with non-Western cultures (fig. 16). Finding that Harvard offered no classes in Islamic or Rajput art during his undergraduate years, Welch improvised, and discovered a

mentor in Eric Schroeder, then Honorary Keeper of Islamic art at the Fogg.

With no formal instruction in the subject available at Harvard in the 1940s and early 1950s, Welch's internal compass guided his study and collecting and propelled him to witness firsthand the cultures whose art so engaged him. With energy matched only by his curiosity, Welch traveled—and continues to travel—extensively throughout the Middle East and Asia. One of his earliest trips to the Middle East, in 1954, was a yearlong journey by jeep from Cairo to Tehran, which he disguised as a honeymoon. Additional and equally adventurous trips would follow as quickly as the demands of his growing family would permit.

Welch made brilliant use of his travels to explore those under-studied and little-published areas of his own particular interest, notably Safavid, Ottoman, Mughal, and Rajput art. In the 1950s he obtained permission to take his own photographs of works of art in far-flung public and private collections—a feat next to impossible in today's copyright-obsessed world. A relentless and determined photographer, he improvised ingenious techniques with a 1930s Leica to capture details of faces, hands, and ornament. As

As an autodidact who had never taken a course and rarely attended lectures (none were given at Harvard) in any of the areas I was collecting in, I learned by traveling and by studying and by photographing public and private collections. . . . Photography was for me a major tool, both for study and for teaching.

Inspired with missionary zeal, I not only took slides at home and at Harvard, but in the Victoria and Albert Museum, the British Museum, and in most of the major private and public collections of England, France, Germany, Iran, and India. I also gave many slides and cameras to friends in the field. I taught all of my students to take slides; and when I found exciting pictures, I often made duplicate slides for them.

—STUART CARY WELCH

FIG. 18
Stuart Cary Welch, *Portrait of Rinchen Tanje*, India, 1973. Ink and colored pencil on paper, 8¼ × 10¼ in. (20.8 × 26 cm).

Cary provided much of his teaching outside the classroom. The prime venue was his corner office at the Fogg. But discussions might flare up almost anywhere: from New Hampshire at Christmas as Edith roasted a goose over an open fire, to an airport in Kashmir with Cary's Louis Vuitton briefcase set up as a mini professorial "chair." You never knew whom you might meet in Cary's office. Sometimes it was a long-lost former graduate student. On one occasion it was Jackie Onassis having a picnic with Cary on the floor. But paintings or objects were always being held up for observation, analysis, and discussion. You had to look at the backs of his paintings, too. There, on the brown paper sealing the frame, Cary would often add stream-of-consciousness observations, art historical conjecture, or even a caricature. Was Cary's approach ever eccentric? Yes. Did a new chapter from your doctoral dissertation occasionally make his eyes glaze over? Yes. Has Cary Welch been an inspiring teacher? Absolutely!

—MICHAEL BRAND

a *Lampoon* drawing of yet another traveler reveals, Welch delighted in photographic equipment (fig. 17). Over the years, his personal slide collection grew immense and served far more than his own research, for he used these otherwise unobtainable images extensively in teaching and lecturing.

Welch's camera was not the only tool he took with him on his travels. On a sojourn to a Buddhist monastery in the Indian Himalayas in the summer of 1973, for example, he packed drawing materials. As in many of his travels, serendipity played more than a minor role in this adventure. While traveling through India the previous year, Welch had happened to hear a tape recording of a *puja* performed at the Upper Tantric College of the Gyuto Monastery near Dalhousie. Entranced, he immediately journeyed to the monastery, witnessed the very ceremony that had so moved him, and secured an invitation to study with the Rinpoche Tara Tulku. He returned the following August armed with a sketchbook, a set of watercolors, and a handful of colored pencils.

Welch quickly filled the pages of the sketchbook with notes from the rinpoche's teachings, impres-

FIG. 19
Stuart Cary Welch, *Portrait of
Geshi Gali*, India, 1973. Ink
and colored pencil on paper,
8¼ × 10¼ in. (20.8 × 26 cm).

sions of the Himalayan landscape, and lyrical water-
color studies of ritual vessels and prayer banners.
Most engaging, however, are the dozens of rapid
sketches he made of the Gyuto monks (figs. 18, 19).
Delighted by his drawings, the monks would line up
to have their likeness taken, then sign their portraits,
sometimes adding their own comments and draw-
ings to the sketchbook.

In their empathy and humanity, these portrait
sketches show that Welch had by then traveled far
indeed since his days at the *Lampoon*, farther perhaps
than his portly explorers could imagine. With feath-
ery pencil strokes and light shading, he deftly
captured the momentary expression of the young
adherent Rinchen Tanje. How differently he rendered
Geshi Gali: the drawing of this senior monk, with
brow knitted in concentration, expresses the inten-
sity of his meditation.

A lifelong interest in monks and holy men in-
spired Welch not only in his own drawings but in
his collecting as well. Glorious or enigmatic in their
eccentricity and fervor, religious ascetics appear in
various media in his collection, from Kevin Bubriski's

*Who are these [sadhus, these] human curiosities whom we
approach nervously, even when encountered through these
sensitively sharp images? To some of us . . . seeing them
so revealed, naked (or more than naked), with pierced skin,
or chains hanging from bits of flesh usually kept hidden,
brings averted glances, or blushes. Sadhus have ambled or
soared from our world of affairs, caste, and familial respon-
sibilities into another one whose freedoms we feebly label
"exotic" or "picturesque.". . . Although unsettling to some,
these admirably shameless human spiritual ornaments are
impervious to embarrassed gawks. . . . They fascinate; and
have done so since ancient times. Visiting Greeks and
Romans, Mughal emperors and artists, seventeenth-century
French jewelers plying the gem route, British colonials,
yesterday's and today's anthropologists, and many of their
fellow Indians have viewed and described them. But they
are as hard to grasp as lightning.*

—STUART CARY WELCH

FIG. 20
Stuart Cary Welch, *The Psychology of Art*. Ink on paper.
Harvard Advocate, 31 March 1949, 20.

Cary taught his students how to look at art and to appreciate its beauty. He would go through his slides in class, as if building momentum, and have us ready to see some actual paintings from the Sackler at the end of the session. He would encourage us to look at each work of art for five, ten, or fifteen minutes and get immersed in it. That's when we learnt the most.

—SALMAN FARMANFARMAIAN

Cary Welch taught me how to look at art and how to live. In his freshman seminar, we spent a lot of time sitting on the floor, passing objects back and forth. He taught us how to handle materials appropriately and how to see with integrity. We looked closely. We looked from far away. We closed our eyes and then opened them suddenly. We looked and looked and looked as he talked us through the experience.

Nabokov said that those who do not reread are doomed to read the same novel over and over again. I think Cary Welch teaches us that if we do not really look then maybe we see the same painting again and again. I know that many times he has introduced me to new things I did not appreciate at first, but inevitably the truth would win out. He was always right.

—JOHN H. FINLEY IV

piercing photographs of Hindu holy men to reverential paintings and drawings of Muslim rulers visiting religious sages. Dervishes, Sufis, sadhus, and diverse ascetics appear in every section of this catalogue, sometimes sketched in homage, sometimes with humor (cats. 10, 18–22, 26, 28, 29, 73). As those who know him will attest, Welch is no ascetic, but he values these inspired individuals standing on the shores of the mainstream.

Yet another of Welch's lifelong interests is hinted at by a telling sketch published in the *Lampoon* (fig. 20). In this 1949 drawing, a child stares fixedly at a canvas set on an easel. The work of art inviting scrutiny is a symmetrical inkblot, surely a reference to the famous Rorschach inkblot protocol, a tool of clinical psychology then at the height of its popularity.

Quite apart from Dr. Rorschach's theories, Welch developed his own psychology of art and an

uncanny ability to "read" visual art and to extract meaning from line, color, and mass. His insights into the graphic expression of personality have allowed him to probe the temperament of the artist. As an example, Welch famously scrutinized the paintings and drawings of the Safavid artist Dust Muhammad, pondering their formal distortions and morbid palette. His conclusion that the artist suffered from some psychic disturbance was confirmed by further research into historical documents that revealed Dust Muhammad to have been alcoholic.

Studying inkblots requires the viewer to confront ambiguity and to project meaning onto unstructured and random events. Artists from both Eastern and Western traditions have long employed aleatoric methods to spark creativity and to gain freedom from the limitations of the conscious mind. The ninth-century Chinese artist Wang Mo found landscape elements in splattered ink; Leonardo da Vinci in his *Treatise on Painting* recommended studying blotches on walls and stones to invent scenery; and Joan Miró looked to his own random scribbles on paper to unlock the unconscious. In a similar fashion, Welch's drawings sometimes incorporate the element of chance. Partial to the feel of antique paper, he has long collected odd scraps while traveling through India—sometimes the sheets are blank, sometimes they are marked by earlier usage. For a drawing of a block of ice (fig. 21) executed in the summer of 1996, he overlapped sheets of cream-colored Indian paper bearing water stains, creases, and notations hastily scrawled in Urdu. Built around the cursive script, Welch's ice block is a frozen stream of musings, its translucent surfaces holding fragmented sea- and landscapes conjured from a complex web of stippling and crosshatching. In technique and whimsy, Welch's block of ice recalls the drawings of his undergraduate years, but where the earlier explorers and ethnologists confronted a foreign culture, the ice block is born of it.

The overlap of Welch's interests and abilities and Harvard University's needs resulted in a remarkable, even historic, synergy. At Eric Schroeder's invitation, Welch became the Fogg's Honorary Assistant Keeper of Islamic art in 1956. To a disinterested bystander,

FIG. 21
Stuart Cary Welch, *Block of Ice*, New Hampshire, 1996.
Ink on paper, 17 × 15½ in. (43.2 × 39.3 cm).

We sense a terrible weightiness in the forms of this picture. Shapes gather heavily at its bottom as though to protect against an impending deluge. The seated girls' widespread knees provide massive bases for their narrow shoulders and small heads. Trunks of trees are gigantic at the ground and unnaturally thin toward the top; the rocks on the horizon are piled in pyramids with excessively wide bottoms. . . . The artist has created a mood of dark foreboding. Although the people go about day-to-day tasks, they move despondently, in an unreal atmosphere. Parts of the painting are credible, such as the tree trunks dug in against the storm, but the palace is a fiction of overlapping cutouts. The painter alternates the real and the unreal. . . . Evil is everywhere. We can depend on nothing. Logic has yielded to inconsistency: the ground may soon collapse; the fortress offers no refuge. Nothing fits: turbans, the wrong size, are about to fall off; boots are so small they must pinch. Everyone in the picture seems in a trance.

—STUART CARY WELCH

For me, it has been exciting as a teacher to have been able to show my own works of art to students more riskily than would have been possible with objects from Harvard's collections. In freshman seminars, objects were passed about for every student to handle; and on a few occasions I lent paintings to students to enjoy in their rooms.

It has also been rewarding to exhibit works of art of kinds usually overlooked by curators, and unrepresented in public collections. At Harvard we staged many small, uncatalogued, experimental shows, in effect "sketches" for larger ones in New York and elsewhere. As a lover of white paintings, I greatly enjoyed mounting "Grace of White," the culmination of many decades searching for pictures that would have delighted a Mark Tobey or a Robert Ryman. Its twenty-five or so Mughal, Deccani, and Rajput paintings, all predominantly white, resonated movingly in the company of Mughal marble objects.

—STUART CARY WELCH

Stuart Cary Welch changed my life fifteen years ago. I showed him a carved Mughal emerald that was the finest example of carving that I had ever seen. He looked at the 141 carat stone and said, "Oh, this is from the time of Shah Jahan. Would you be willing to loan this to the Los Angeles County Museum for a show called 'The Romance of the Taj Mahal'?" During the intervening period the gem was displayed at the Asia Society and the Smithsonian for many years, and eventually I was able to trace it to the 1925 Cartier Art Deco Exposition in Paris. A picture of it is on the cover of my novel Green.

When I asked Cary if I could use him as a character in my forthcoming novel White *about Mughal art, he said, "Of course, I would be delighted. I have already appeared as a figure in a Merchant-Ivory film."*

—BENJAMIN ZUCKER

the Department of Islamic Art, operating on a shoestring with two volunteer curators, might not have seemed the most auspicious acorn in the Fogg. But animated with ideas and the energy to turn them into reality, Welch utterly transformed the department, attracting students, collectors, and the financial resources to mount a sustained program of exhilarating exhibitions and stunning acquisitions. At his retirement in 1995, Welch presided over the finest collection of Islamic and later Indian art in a university museum and taught in a world-renowned program of Islamic art history at Harvard.

In the academic year 1960–61, Welch taught Harvard's first class in Near Eastern art. Believing firsthand contact with art to be indispensable, he organized a series of exhibitions in the Fogg galleries to serve as the backbone for this course. Over the years his students ranged from complete novices to doctoral candidates, but he particularly relished teaching freshman seminars on connoisseurship. Believing that eyes and brains are nurtured by close contact with original art, he put large portions of his private collection on loan at Harvard, making works of art available to students and colleagues. Gathering a small group of students in the departmental storage room, Welch enjoyed sitting with them on the floor, working with originals to sharpen their minds and eyes. Bringing his own treasures to class not only gave his students access to unpublished masterpieces, but it allowed them to handle the objects as would an artist or a collector, rather than a museum visitor.

In his teaching and exhibitions at Harvard, Welch charted new art historical territory, using the Fogg classrooms and galleries to test ideas and explore subjects for future studies and grander exhibitions that could be mounted only in larger institutions. In 1963 he curated the first museum exhibition with catalogue ever devoted solely to Mughal art, *The Art of Mughal India: Paintings and Precious Objects*. For the catalogue to his landmark 1985 exhibition at New York's Metropolitan Museum of Art, *India: Art and Culture, 1300–1900*, Welch assembled a group of specialists as eclectic as they were distinguished. In the exhibition and catalogue, he set a high standard with his comprehensive vision of South Asia as well as

with his beguiling prose. Welch wields the writer's pen as well as the artist's pencil—with insight, wit, and grace.

Welch's intense and exhaustive study of the great Tahmasp Shāhnāma resulted in a groundbreaking publication co-written with Martin Dickson, *The Houghton Shahnameh*. This monumental work of connoisseurship and scholarship reconfigured the understanding of Turkman and early Safavid painting, defining the eastern and western Iranian strands of this important and influential style, and charting the complicated lines of transmission. Far more than a study for specialists, Welch and Dickson's successful collaboration resulted in a publication that sorted out, identified, and brought vividly to life more than a dozen court artists whose largely unsigned labors created one of the great masterpieces of Persian art. So thorough and lively was their reconstruction of the world of Safavid painters that it proved foundational for Orhan Pamuk's widely acclaimed Turkish novel *My Name Is Red*.

It is hardly surprising that Welch's writing would capture the imagination of novelists and filmmakers. Having missed—or escaped—the prescribed academic training in Islamic and Indian art, he has always approached these artistic traditions idiosyncratically, diverging from conventional terminology and methodologies. Shying away from the label "art historian," he has instead always thought of himself as a writer who writes about art. In this arena, he has few rivals.

Welch's many influential exhibitions and publications in the field of Islamic and Indian art have been frequently lauded, but his breathtaking acquisitions for Harvard's art museums are rarely mentioned. The patient and diplomatic courting of collectors and donors is an aspect of curatorial work that takes place behind the scenes, and, as all curators know, the credit must always be given to the donors. Welch's accomplishment in the area of acquisitions, however, deserves greater acknowledgment, for he succeeded brilliantly despite considerable handicaps, including the complete absence of acquisition funds.

Although hampered by lack of institutional support, Welch was aided by his own experience as a collector. He pursued the major private collections

In 1981, Stuart Welch and Martin Dickson published a study of [a] strange and amazing book in two volumes so huge and expensive as almost to be unreadable except in the best libraries. For a novel I am working on, I studied, this spring, the volumes of The Houghton Shahnameh *(Harvard University Press) in the New York Public Library, and was astounded and delighted by the writers' eccentric scholarship. By examining and re-examining pictures of countless kings, princesses, soldiers, heroes, servants, horses, camels, rabbits, demons, dragons, birds, balconies, gardens, flowers, trees, leaves, hunters, lions, lovers, dreams and dreamers, Dickson and Welch rebuilt a lost culture and restored a lost history to minute details. The delightful book, with its imaginative and eccentric scholarship, reminds me of Nabokov's translation of and commentary on Pushkin's* Eugene Onegin, *and John Livingstone Lowes's* The Road to Xanadu.

—ORHAN PAMUK

I know, from experience, that you are too alive for the academic world. People like us in fact make the best scholars because we have ideas and earthiness. But the universities are dominated entirely by the cerebral types. In short, DON'T sign yourself up for dreary years of academia. Leave that stuff to the eunuchs.

—STUART CARY WELCH

My friend Stuart Cary Welch, with whom I had traveled in Greece, Iran, and Turkey, was another student at the Fogg, enthusiastic about Indian and Persian miniatures. It is really thanks to his encouragement that I began to collect. With his persistence it was not too long before material from collections made at the beginning of the century at the time of the Iranian revolution began to find their way to the Fogg.

—JOHN GOELET

FIG. 22
A Nayika and Her Lover,
India, Punjab Hills, Basohli,
c. 1660–70. Painting from a
series illustrating the *Rasaman-
jari (Blossom-Cluster of Delight)*
of Banudatta. Opaque water-
color, gold, silver, and beetle-
wing cases on paper,
9¼ × 13 in. (23.4 × 33 cm).
Arthur M. Sackler Museum,
Harvard University Art Muse-
ums, Gift of John Kenneth
Galbraith, 1972.74.

*This is about Cary Welch. I do not on these matters exagger-
ate. I never had such an informed and sensitive advisor on
In any artistic or scholarly matter as I had on Indian paint-
ing from Cary. That included my earliest interest, the begin-
ning of knowledge in this art form. He was counsel on my
book on Indian painting with Mohinder Singh Randhawa,
and, needless to say, the paintings I had acquired over the
years came to the Fogg and, in much smaller number, also
to Smith. In all these matters Cary was not looking for
scholarly distinction or prestige; he helped because he loved
the artistic tradition and wished to add to its preservation,
recognition and the knowledge of its origin and life. This
is an admiring and affectionate comment, but let me assure
you, it is deeply held.*

—JOHN KENNETH GALBRAITH

accumulated by previous generations and sought out
sympathetic souls who could help acquire superb
works of art for Harvard. Working with individuals of
extraordinary generosity, such as Edwin Binney 3rd,
John Kenneth Galbraith, John Goelet, Philip Hofer,
and many others, Welch acquired more than two
thousand objects during his four decades as curator
(figs. 22–24). Through tireless effort and apparently
limitless affability, he vastly enriched Harvard's hold-
ings of Islamic and Indian art.

Perhaps only fellow collectors can fully appreciate
the sacrifice of parting with works of art that one
may have been the first to recognize for their beauty
and importance, lived with for decades, discovered
in unlikely locations, or pursued for years in order to
acquire. Knowing firsthand the duality of possessing
and being possessed by art, Welch persuaded collec-
tors to donate their treasures and, on numerous
occasions, he himself has given rare and remarkable
works to the Harvard art museums (fig. 25). The ob-
jects he has given as well as those he solicited vastly

expanded and wholly transformed the permanent collection at Harvard, and greatly enhanced the university's ability to study and teach from original art.

Because of his generosity and high-mindedness, the Department of Islamic and Later Indian Art now owns essential parts of the famous *Divan of Hafiz* made for Prince Sam Mirza around 1526, most notably the exquisite lacquer covers, text block, and illuminated frontispiece, as well as the magnificent painting by Shaykh Zada, *Incident in a Mosque*. Thanks to Welch, Harvard and the Metropolitan share ownership of one of the most remarkable paintings in the manuscript, *Worldly and Otherworldly Drunkenness*. This unforgettable image of divine and all-too-human revelry is one of only two paintings signed by Sultan Muhammad, a powerfully inventive and expressive artist. In 1995 Harvard acquired from the Welch Collection seventy-seven Rajasthani paintings of exceptional quality, the occasion for an exhibition at

It is Sunday morning and we have just driven in from Gloucester for a quiet day in Cambridge . . . to have another look at the Exhibition of Rajput painting. What a delightful show it is and, what never struck me before, how appropriate for the summer. It reminds me once again of how great a debt the Fogg does owe to you. It is a debt that I feel particularly keenly since Eric Schroeder soon converted me to Islamic art and anything that furthers the study of this subject at Harvard gives me keen personal happiness. Your coming here has done more to further this cause than anything since I've been around. The quality of your own collection, your generosity in lending, your skill in exhibiting it, and the exceptional literacy and interest of what you write, all these are overshadowed by your spectacular contributions to the building up of our collections. We have been very lucky to have had your help. . . . We are all tremendously grateful for what you have contributed so far.

—JOHN COOLIDGE

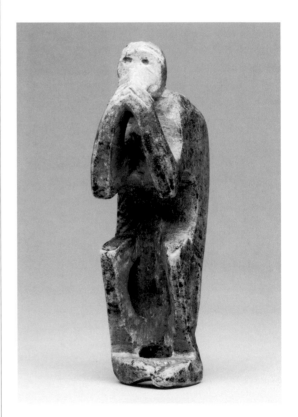

New York's Drawing Center and its accompanying catalogue. In 2002 Welch gave a group of Rajasthani drawings in honor of former director James Cuno.

Harvard's gratitude for these works of art grows with the education and delight of every new student and visitor who views them. As the works inspire the scholarship of future generations, they extend indefinitely Welch's tradition of exploration and appreciation. Tangible and permanent reminders of Welch's scholarship and connoisseurship, the paintings, drawings, and objets d'art are but the visible manifestation of a most remarkable generosity. Time and again, Welch has delighted in sharing his discoveries, his knowledge, and in many ways his life with students and colleagues at Harvard. His is an exuberant legacy of beauty and joy.

Notes

1. Terence McInerney, "On Collecting Indian Miniature Paintings: Twentieth-Century Issues and Personalities," in Mason 2001, 8.

2. Robert Skelton, letter to Mary McWilliams, 27 October 1999.

Quotation Credits

George Ortiz: Personal communication to Mary McWilliams, 8 May 2003.

Stuart Cary Welch, "Collecting is a bit like alcoholism": Letter to John Coolidge, Director of the Fogg Art Museum, 2 December 1960.

V. S. Naipaul: "Indian Art and Its Illusions," *New York Review of Books*, 22 March 1979.

Stuart Cary Welch, "To this undergraduate": Letter to Mary McWilliams, 20 October 1999.

Cynthia Gladwyn, *The Diaries of Cynthia Gladwyn*, ed. Miles Jebb (London, 1995), 143.

Stuart Cary Welch, "As an autodidact": Email to Mary McWilliams, 11 May 2003.

Dr. Michael Brand (Director, Virginia Museum of Fine Arts): Email to Stephanie Beck, 12 June 2003.

Stuart Cary Welch, "Who are these": "Introduction," in Kevin Bubriski, *Sadhu: Hindu Holy Men* (Shaftsbury, Vt., 1996).

Salman Farmanfarmaian (Principal, SCP Private Equity Partners): Email to Mary McWilliams, 4 May 2003.

John H. Finley IV (Head of School, Epiphany School): Email to Mary McWilliams, 28 April 2003.

Stuart Cary Welch, "We sense a terrible weightiness": Excerpt from an analysis of the painting *Haftvad and the Worm* by Dust Muhammad in Martin Bernard Dickson and Stuart Cary Welch, *The Houghton Shahnameh* (Cambridge, Mass., 1981), 1:120–21.

Stuart Cary Welch, "For me, it has been exciting": Letter to Mary McWilliams, 20 October 1999.

Benjamin Zucker (President, Precious Stones Company): Letter to Mary McWilliams, 15 May 2003.

Orhan Pamuk: "International Books of the Year," *Times Literary Supplement*, 7–13 December 1990.

Stuart Cary Welch, "I know, from experience": Letter to Bruce Chatwin, quoted in Nicholas Shakespeare, *Bruce Chatwin* (New York, 2001), 200.

John Goelet: Preface, in *Forty Years On . . . Donations by John Goelet: Sculpture, Paintings and Drawings, Miniatures and Calligraphy, Tankas and Mandala* (New York, 1999), v.

John Kenneth Galbraith: Letter to Mary McWilliams, 8 May 2003.

John Coolidge (Director of the Fogg Art Museum): Letter to Stuart Cary Welch, 26 July 1957.

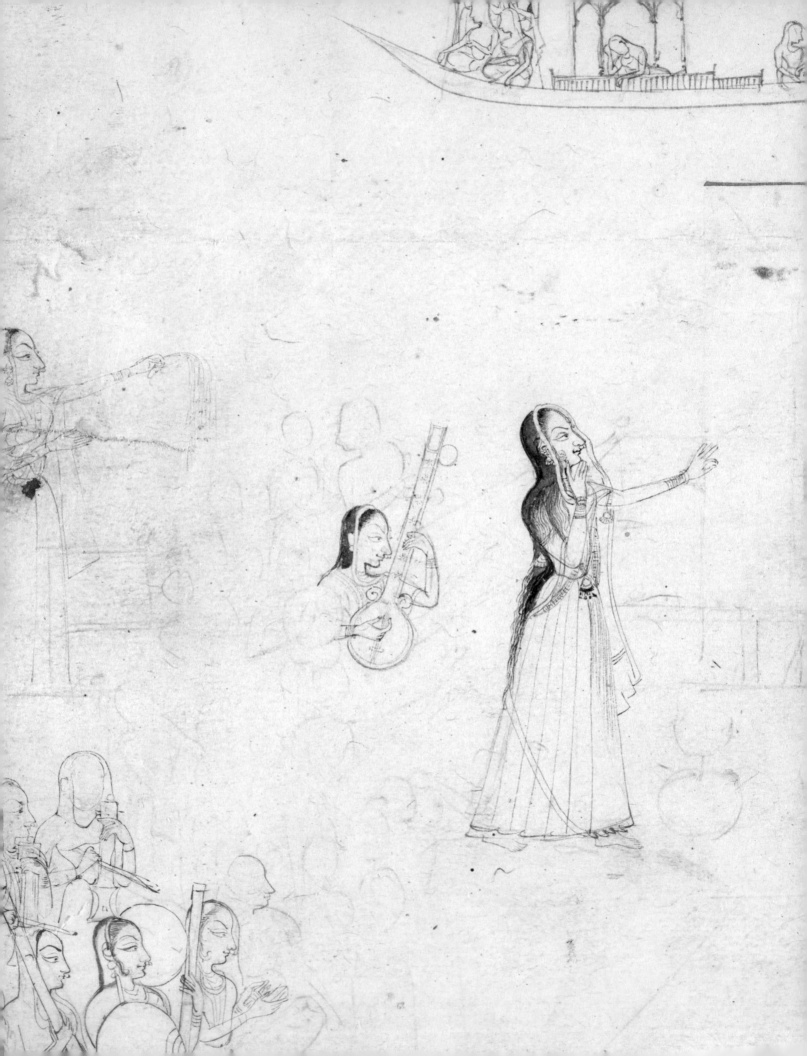

CRAIGEN W. BOWEN

CLOSE LOOKING

Notes on Media and Technique

WHILE there is much general knowledge about papermaking in the Islamic and Indian worlds, it is impossible here to do much more than compare characteristics of some of the individual papers in this exhibition. The materials and techniques of papermaking did not change greatly during the four centuries spanned by these works, and it is difficult to date or place an Islamic or Indian paper with certainty as both lack watermarks and the kinds of written documentation that have proven helpful in the study of European papers. Artists moved as their patrons moved, or when they acquired new patrons, and, presumably, so did papermakers (and their products). Moreover, many of the drawings in this exhibition are mounted as album leaves or simply for support, making it difficult to discern paper characteristics other than color.[1]

Artists did, however, choose papers to suit their expressive and technical needs; a wide range was available, from coarse and textured (cats. 46, 48) to extremely fine (cats. 14, 33). Paper was also manipulated in the workshop to modify its surface and appearance. Dilute white wash might be applied to whiten a sheet, as in The Battle of Samugarh (cat. 30). Paper for a drawing could be burnished to create a smooth, even, glossy surface, as in the case of Maharana Amar Singh II at Worship (cat. 61). Likewise, as the media were added, painting layers were routinely burnished to create a smooth, compressed surface onto which fine details could be gracefully applied.

Paper characteristics such as color and sheen are easily perceived during ordinary viewing, and strong, raking light can illuminate the surface to make textural detail more apparent. In only one case was magnification useful in revealing information about the papers in this exhibition. Royal Pleasures (cat. 56) is on an extremely thin sheet of very pale blue, almost gray-white, paper. When it is viewed with a microscope, brilliant blue particles are visible throughout the sheet (fig. 26).[2] Although I have looked at many drawings from Kotah and other parts of India, I have never encountered such a paper.

Curiosity about the tiny, strongly colored blue particles led to the removal of a minute sample for polarized light microscopic examination, through which the colorant was identified as natural ultramarine blue.[3] Although this extremely thin paper is mounted onto an ordinary medium-weight burnished paper, the irregularity of the mounting allows one to see bits of the verso and confirm the presence of the blue there as well. Frustratingly, the structure of the tissuelike paper cannot be discerned because of the mounting, but its thinness and uniformly smooth surface, and the drawing's date of circa 1840, teasingly raise the question of whether it might be machine-made. However, it is unlikely that expensive ultramarine blue would have been the colorant for a machine-made paper, leaving unanswered a jumble of questions about this drawing.

Examination under magnification of the media of the Welch drawings helps clarify some of the materials and techniques employed by the artists. Ink is the

OPPOSITE
Detail of cat. 66

31

main constituent of most of these images, but its
application was often preceded by an underdrawing
in either reddish ink or, more commonly, a black-
gray particulate material that provides an initial lay-
out of the image. Traditionally the latter has been
assumed to be charcoal; there is no mention in the
literature of an equivalent to the black chalk endemic
throughout Europe at the same time. Chemically,
charcoal and black chalk are made primarily of the
same material—carbon—but their morphology dif-
fers considerably. It should be possible to distinguish
between chalk's heavier, crumblike particles and
charcoal's woody, splintery ones. This often proves
not to be the case, however, with these soft gray-
black lines smudged under other media that perhaps
were burnished as well. Charcoal can be clearly
identified in some of these drawings, but less
positively differentiated in others. The light, smudgy
quality of charcoal is easily observed in *A Little Girl
Dances before Spectators* (cat. 43) below the onlookers'

feet; in *Pet Antelope* (cat. 51), where the right rear leg
has been repositioned; and in *Young Durjan Sal Slays a
Lion* (cat. 46). In *Composite Elephant* (cat. 50) and
Krishna and Radha after Exchanging Clothes (cat. 66), the
sharpness of the black lines in the underdrawing and
the crumblike nature of the particles give rise to the
suspicion of a chalklike material. In this catalogue the
term *charcoal* is used for all friable black particulate
materials not convincingly identified as something
else.

The dry, black media most easily distinguished
from charcoal and black chalk is graphite, a carbona-
ceous material whose particles have a platelike mor-
phology that often causes it to appear shiny gray
under magnification. The best graphite came from
Britain, so it was natural that graphite would eventu-
ally find its way to India. Three nineteenth-century
drawings in this exhibition include graphite among
their media: *Seated Courtesan* (cat. 70), *Man with Two
Dogs on a Leash* (cat. 75), and *A Sketch of the Holroyd*

House from a Different View (cat. 76). Further evidence of European influence can be seen in two of these: *Seated Courtesan* is on European modern laid paper that has a watermark, and *Holroyd House* is on a European machine-made wove paper.

The most common medium encountered in the Welch drawings is black ink. The stylized *Line Drawing of a Horse* (cat. 68) appears to have been created from single long ink lines applied with a brush. Under magnification a more complex construction is evident, with a pale gray ink underdrawing and multiple overlapping lines that swell and taper to form what one perceives as continuous, sinuous lines.

The "black ink" ubiquitously listed in publications on drawings—whether they be Islamic, Indian, or European—does not do justice to the wide range of tones actually found: black, gray-black, brown-black, blue-black. Such subtly toned inks are all encountered in this selection of seventy-six drawings, along with inks of more dramatic colors, as listed in the catalogue entries. What is more remarkable is how the skillful artists were able to manipulate the inks to achieve their expressive ends. *A Lame Man of Arts and Letters* (cat. 4) depends on the careful balance of black and red-brown inks to create the long calligraphic lines. Red ink appears in two tones, one of which is more orange, in the underdrawing of *A Nobleman with Attendants* (cat. 72). With a microscope it is easy to see each color, but without magnification the final image has a complexity and richness whose origin is not immediately apparent. More dramatically, purple-red ink was used to depict *A Polo Game* (cat. 52), a choice trumpeted from afar and requiring no magnification to discern. The vibrancy and action in *Five Views of an Elephant Combat* (cat. 48) are achieved by bold strokes of black and red-brown inks.

Color appears in the ink renderings themselves, but the inks are often augmented by watercolor or opaque watercolor, the term often used to describe the pigment-binder combination encountered in Islamic and Indian painting, where the top layer may be an entirely different color from the paint on which it lies. The colors are applied as opaquely as possible, often not allowing any intermingling of the layers. In contrast, in these drawings pigment and binder are

FIG. 27
Photomicrograph showing the irregular black flecks of now-tarnished silver scattered across the drawing in *Cheetah Trainer* (cat. 12). Note that the tarnished silver is much darker than the delicate gray-black ink lines of the drawing.

most commonly used in transparent form, allowing the lines below to be clearly visible. For this reason, the media descriptions in the catalogue entries try to reflect not just the material but also its manner of use: *watercolor* is used for transparent color and *opaque watercolor* for the thicker color through which one cannot see.

The delicately drawn *La Toilette* (cat. 32) is an example of a work with both transparent and opaque color as well as black ink, but its technique is augmented by the use of metallic pigments, both gold and a metallic silvery pigment. The gold is certainly genuine, but the silver is much more likely to be a metallic pigment intended to appear silver. This was a common practice, but without instrumental analysis it is not possible to accurately determine the pigment's composition.[4] In only one instance was analysis carried out with the works on exhibition, so the remainder of the media descriptions in the catalogue entries include the generic phrase "metallic silver" to indicate a material that looks silver in color.

For many years Cary Welch asserted that the tiny black spots scattered throughout *Cheetah Trainer*

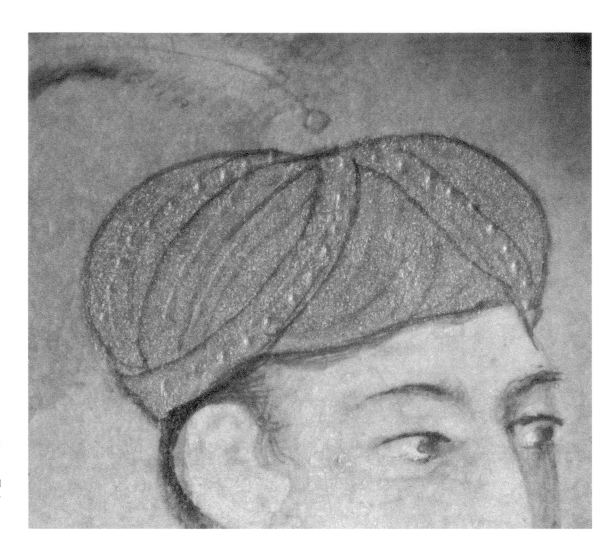

FIG. 28
Photomicrograph showing
the texture of the golden
turban created by applying
a textured ground layer and
then applying gold in *Akbar
Observing an Animal Combat
while Hunting* (cat. 20).

(fig. 27; cat. 12) were silver, but it was only after the work was tested by an X-ray fluorescence spectrometer that could analyze extremely small samples that it was possible to confirm that the spots are indeed silver.[5] That they appear black is due to tarnishing of the silver, a phenomenon that must have been known to the artist. The black spots appear visually stronger than the grayish ink with which this delicate image was drawn. Gold was similarly flecked onto the page of *Small Dragon in Foliage* (cat. 7), though it interferes with the reading of the image far less than in the *Cheetah Trainer*.

A more elaborate use of gold is evident when *Akbar Observing an Animal Combat while Hunting* (cat. 20) is examined with magnification. Several of the golden turbans worn by the beaters at the left are embellished with textured gold (fig. 28), similar to what is found on a much grander scale in early Italian paintings. In the background landscape Miskin used dilute gold paint along with pigment to render the hills.

Some seven of the Welch drawings, spanning the fifteenth to the nineteenth century, are pricked to some degree. Pricking of outlines was done by itself or with charcoal powder (pounce) to transfer an image to another support, effectively reproducing images. The architectural elements in *Bhopali Ragini* (cat. 35) are extensively pricked whereas the figures have not been pricked at all. Conversely, it is primarily the figures that are pricked in *Vilaval Ragini* (cat. 34); the architecture is pricked only minimally. In the

case of *Royal Pleasures* (cat. 56), the entire image has been pricked, which is not surprising given the number of versions of this image known to exist (see catalogue entry). In the elaborate *Arabesque with Dragon and Parrot* (cat. 1) only the dragon has been pricked.

Despite dramatic uses of inks and colors, many artists employed their materials with restraint to produce subtle, yet not simple, drawings. This is true of *La Toilette*, where numerous media combine to form an understated image. The value of close examination lies in seeing how such effects were achieved, and thereby knowing what was important to the artist (or perhaps his patron). Almost invisibly, the spears piercing the elephant in the lower left of *The Heat of Battle* (cat. 39) have a shiny coating, perhaps of gum, to evoke their hard, metallic nature. In this large and busy drawing, filled with line and movement, the addition of a glaze to such a tiny detail is poignant evidence of the artist's care.

Close looking—like that Cary Welch inspired in so many people—nevertheless leaves the viewer with mysteries still to be solved. The discolored and brittle paper of *Sprig of Rose Blossoms* (cat. 15) is reminiscent of European oiled papers intended for tracing. Such an unusual support urges further scrutiny, perhaps by many eyes, before its nature will be fully understood.

Notes

1. Bloom 2001; Karabacek 2001; Loveday 2001; Premchand 1995; Hunter 1939.
2. A Wild M10 stereobinocular microscope was used to examine the drawings. Its zoom magnification ranged from 5× to 50×.
3. Thanks to Narayan Khandekar, Senior Scientist at the Straus Center for Conservation, HUAM.
4. Bowen 1997, 88.
5. Again, thanks go to Narayan Khandekar for the instrumental analysis.

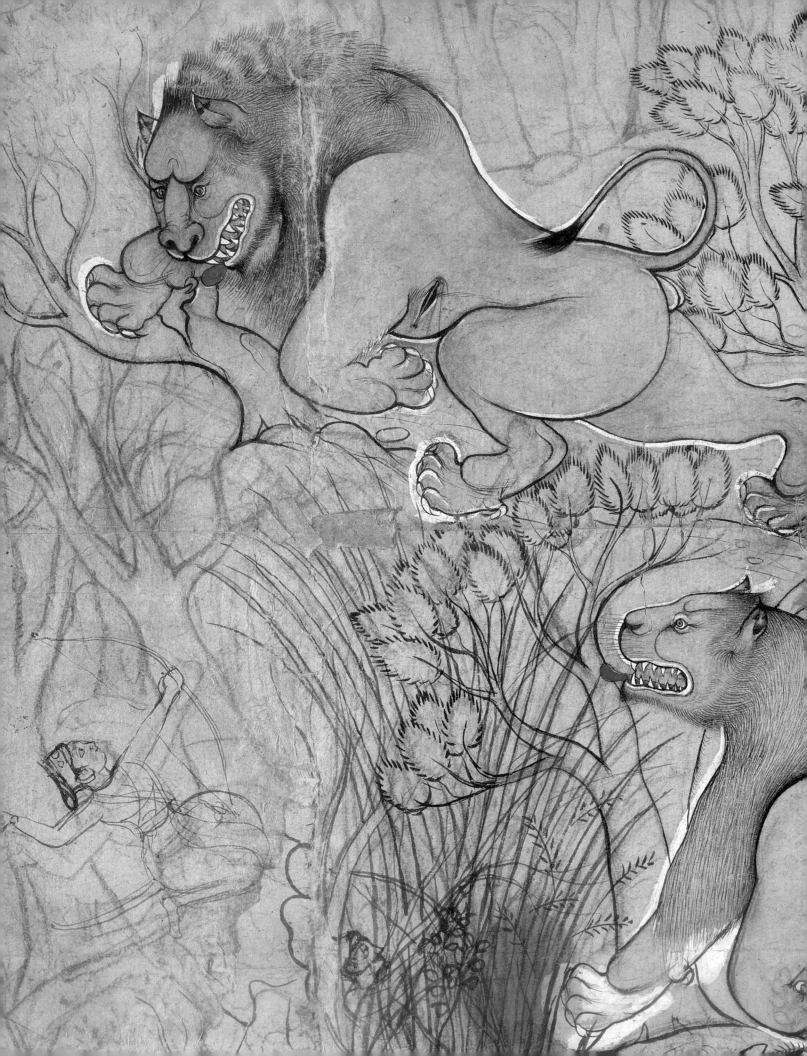

Catalogue of the Exhibition

1 Arabesque with Dragon and Parrot

Western Iran, 15th century
Black ink and watercolor on off-white paper; pricked
(dragon only)
8¾ × 13⅝ in. (22.2 × 34.7 cm)
Gift of Stuart Cary Welch, Jr.
1999.287

THE decorative drawing on this sheet of paper is
unusually complex in its overall layout, and its
dominant design is imbued with an electric vitality
that courses along the pulsing loops of wiry stems and
cloud bands. Beneath these is a gentler, more lyrical
skein of palmette, rosette, and leaf-bearing vines. The
larger loop, dominating the right half of the sheet,
terminates in the head of a dragon that is almost over-
powering in its scale and ferocious mien: a curving
horn sprouts from its forehead, and it has a lowering
eye and wrinkled snout, an open mouth with promi-
nent fangs and tongue, and spirals of beard under the
chin and along the neck. The slightly smaller loop
terminates in a crested bird, hanging as if suspended
from its leaf-shaped tail but without a clear attachment
to a "wire." It has folded wings, a cheek pouch, and
an open, curved bill with a longer upper beak.

Other than the precise dragon head and more
abstract bird, the bulk of the design consists of a vari-
ety of vegetal forms borne on boldly drawn loops or
delicate stems, with occasional cloud bands and cloud
knots. The continuation of the design beyond the
edges and a certain imbalance suggest that the drawing
was trimmed down from a larger sheet. A composite
plant with curving leaves—a forerunner of the *saz* leaf
motif—appears in the upper right and lower left
corners, the top and bottom borders, in front of the
dragon's head, and other places. A large cloud band
bearing knotted and curled forms dominates the top of
the page to the left of center, while a smaller one
appears at the lower right, with the knotted form alone
at the bottom center and a double spiral to its left. The

loops themselves, with doubled bands in the center
where they converge, bear heavy leaf forms in addition
to a double spiral, as well as smaller circular single
spiral leaves and the split palmette of an arabesque.

Persian epic literature is rife with combats between
dragons and heroes, so dragons became a familiar
component of illustrated manuscripts. Their form in
Islamic art originally derived from art from Central
Asia; later it was directly influenced by Chinese proto-
types. In decorative designs the dragon frequently
appeared in conjunction with the phoenix, derived
directly from its Chinese counterpart and identified
with the *simurgh* in Persian art. Some dragons, particu-
larly in the early Timurid period, show the head in an
almost three-quarter view, with both eyes visible, and
occasionally with two horns instead of the more usual
single horn, which alone is visible in profile.[1] The earli-
est dragon I have found with a heavy brow partially
covering the eye—as in this drawing, which also shows
the head in profile, which became the established
norm—is the sea dragon in the *Shāhnāma* of Muham-
mad Juki of about 1440, in the illustration of *The Div
Akvan Throws Rustam into the Sea*.[2]

Finding precise parallels for the "parrot" in Persian
drawings or paintings is more difficult. This bird's
spotted body, cheek pouch, folded wings, and leaflike
tail suggest a distant influence from birds on early
Persian painted ceramics. Birds with crests, particu-
larly the hoopoe—the messenger of Solomon and the
leader of the bird pilgrims in the *Mantiq al-Tayr (The
Conference of the Birds)*—particularly come to mind.[3]
The unusual parrotlike bill of a simurgh in a drawing
in a manuscript of the horoscope of the Timurid prince
Iskandar Sultan dated 1411 bears some resemblance to
the beak of this bird, but the rest of the drawing is very
different in its flowing open forms, and it may be con-
siderably earlier.[4]

The individual elements that form the basis for the
allover scrolling patterns of many decorative designs
can be traced back at least to the twelfth century,
including the so-called *vāqvāq* scrolls bearing human

OVERLEAF
Detail of cat. 46

heads or, more frequently, fantastic and naturalistic animal and bird heads. However, innovations in the genre that began in the second half of the fourteenth century and reached artistic maturity in the fifteenth century in the early Timurid period exhibited a considerable influence from Chinese art.[5] Later the decorative designs became more fully integrated into the overall Persian-Islamic vocabulary of art, lasting throughout the Safavid period and migrating to Mughal India and Ottoman Turkey.

While some drawings appear to stand on their own as pleasing decorative works of art, many others were in the form of working sketches,[6] some of which would be incorporated into finished drawings and paintings. Others appear to be patterns—even cartoons—for the decoration of objects in media other than paper, among them saddles, quivers, bow cases, bookbindings, ceramics, chests, cabinets, and doors. The largest surviving category, however, is of designs for textiles or costumes.[7] Of these, as with other decorative drawings, the majority of the designs were floral or vegetal; a good number incorporated birds and animals, both naturalistic and fantastic, and some included human figures.[8] In a small decorative drawing in The Metropolitan Museum of Art, New York, for example, amid the scrolling foliage, and in spite of considerable damage to its center, thirty-one whole or partial birds, animals, dragons, and humans can be counted.[9] By comparing its components to those in other drawings, the Metropolitan sheet can be dated to the first half of the fifteenth century. The two dragons in it, for example, with their proportionately small heads, which give them a reptilian appearance, closely resemble the dragon in the lower right of a page of sketches in an album in Istanbul, dating from the early fifteenth century.[10] They differ considerably from the more imposing dragon head in the decorative drawing here, which appears stylistically closer to dragons of the later fifteenth and the sixteenth centuries.

Parallels for other components or decorative details of the present drawing may be found, for example, in the form of the rosettes and palmettes in a drawing from the Album of the Emir of Bukhara in the Morgan Library, New York, dating from the late fifteenth or early sixteenth century.[11] The lettucelike outer edges of the cloud bands in a *Bustān* (*The Garden*) of Saʿdi, in the Calouste Gulbenkian Foundation,

Lisbon, dated 1541–59, are not very different from the major leaf forms in this drawing, nor are the minor scattered leaves.[12] Comparable to the cloud bands in this drawing are those illustrating a bookbinding of 1492 made in Herat.[13] Similar cloud bands bearing larger spirals alternating with smaller ones can also be seen in both the cloud bands and the flames surrounding the Prophet in a painting of the Miʿrāj in the manuscript of Jami's *Haft Awrang* (*Seven Thrones*) in the Freer Gallery of Art, Washington, D.C., and in the tight spirals in the clouds themselves in the sky of another Persian manuscript of Jami's dated 1570–72 in the Topkapı Sarayı Müzesi, Istanbul.[14]

These disparate comparisons, selected from among the many that could be made, suggest only that from the particular elements of allover patterns in such drawings, highly traditional as they were, it is almost impossible to assign a definitive date. Of utmost significance are the aesthetic appeal, creative energy, and technical control that contributed to the superb artistic accomplishment of this Persian drawing.

M L S

Notes

1. See, for example, *Bahram Gur Killing the Dragon* from the 1370 *Shāhnāma*, illustrated in Gray 1961, 63; and *Mounted Warrior Fighting a Dragon*, illustrated in Lentz and Lowry 1989, cat. 82, called Herat(?), c. 1425–50, but stylistically still Jalayirid, in my view, and dating to the beginning of the fifteenth century.

2. Gray 1961, 90. This is the type of dragon most often depicted thereafter, as, for example, in the illustration for *Faridun Tests His Sons* in the Shah Tahmasp *Shāhnāma* dating to the 1530s, illustrated in Welch 1972a, 120, fol. 42v.

3. See *Islamic Painting*, The Metropolitan Museum of Art Bulletin 26, no. 2 (Autumn 1978), 3.

4. Illustrated in Lentz and Lowry 1989, cat. 36.

5. See ibid., cat. 36, fig. 53, and cats. 75–77, 79, 90–100.

6. See Aslanapa 1954, 77–84, fig. 6.

7. See note 5 above and Gray 1959, 219–25.

8. Lentz and Lowry 1989, cats. 90–98; incidentally, among the many bird heads in cat. 98 are some that closely resemble a parrot's.

9. Swietochowski and Babaie 1989, cat. 1.

10. Topkapı Sarayı Müzesi no. H. 2152, fol. 86a, illustrated in Lentz and Lowry 1989, fig. 53.

11. Swietochowski and Babaie 1989, fig. 9.

12. Ashrafi-Aini 1979, figs. 155–56.

13. Aslanapa 1979, fig. 29.

14. See Simpson 1997: Freer Gallery of Art, fol. 275a, illustrated in color, p. 210, and fig. 148; Topkapı Sarayı Müzesi, fol. 229a, illustrated in color, p. 243.

2 Tethered Camel and Rider

Attributed to Mir Sayyid 'Ali
Iran, Tabriz, c. 1535
Black ink, watercolor, and gold on off-white paper;
pricked (man and most of camel)
6⅞ × 9 in. (17.5 × 23 cm)
Promised Gift of Stuart Cary Welch, Jr.
259.1983[r]

Published: Sakisian 1929, 118, fig. 176; Welch 1979,
190–91, fig. 73; Dickson and Welch 1981, 1:188, fig. 244

OBSERVED and abstracted forms meet and
combine in this lively tinted drawing of a richly
accoutered tethered camel (or dromedary). Bred for
riding, this elegant creature is approached by his
courtly and slightly apprehensive rider. We cock our
ears to the jangling bells of the somewhat agitated
beast and share with the artist his delight in feeling the
patches of fur on his idealized animal. The would-be
rider, with his unmistakable beaklike nose and open-
mouthed profile, is familiar from pictures by the great
Safavid artist Mir Sayyid 'Ali, son of Mir Musavvir.[1] If
other telltale aids to attribution, such as the mode of
turban tying or the patterns and placement of flowers,
rocks, and grass, did not persuade us of the artist's
identity, the courtier's profile would, for he is one of
Mir Sayyid 'Ali's stock characters, encountered in sev-
eral of his miniatures. We have met him at every stage
of life, from early childhood to old age.[2] Presumably
this pleasant character, always depicted in profile, was
closely linked to the artist. Is the bright-eyed fellow
the artist's father, uncle, friend, mentor, or even a
self-portrait?

Mir Sayyid 'Ali excelled in depicting animals,
to which he seems to have felt closer than to people.
Although he often sketched animals from life, espe-
cially his artfully hennaed pet dog and cat, he also

FIG. 2.1
Signed by Mir 'Ali Haravi, *Calligraphy* (verso of cat. 2),
Iran or Uzbekistan, 16th century. Black ink, opaque
watercolor, and gold with marbled paper border,
9 × 6⅞ in. (23 × 17.5 cm). Promised Gift of Stuart
Cary Welch, Jr., 259.1983[v].

depended upon standardized likenesses, available
from his own or the royal atelier's copies and tracings.
Although the present camel might be one he favored
and rode, its outlines are akin to those in a well-known
picture by Shaykh Muhammad, another important
Safavid court artist, and his contemporary.[3] While both
were great masters of the reed pen, and its calligraphic
thickenings and thinnings, their approaches to camels
differed. Mir Sayyid 'Ali's is more elegantly propor-
tioned, leaner-limbed, and sprightlier than Shaykh
Muhammad's, which is ruggedly compact and less
mobile. Although both animals are shown as nervously
eager, Mir Sayyid 'Ali apparently knew and enjoyed,
even patted, his camel, whereas Shaykh Muhammad
approached his from a distance, without empathy, and
portrayed it less credibly.[4]

SCW

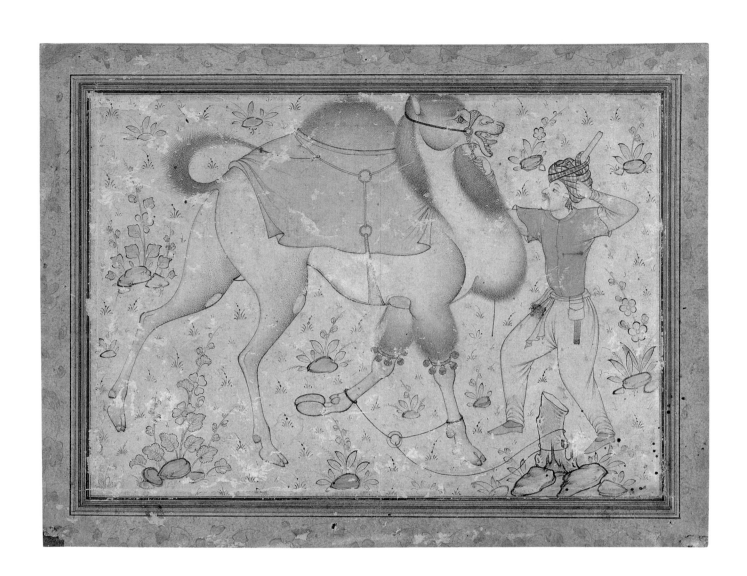

Mir Sayyid 'Ali's drawing was once treasured in an album (*muraqqa'*) containing works of both figural and calligraphic art. Although the album itself has now been broken up and dispersed, the folio on which Harvard's drawing is mounted still preserves a work of calligraphy on the reverse side (fig. 2.1). Mounted within margins of marbled paper is a *qit'a*, or fragment of poetry. Translated, it reads, "Cherish the riches of life as capital and consider submission to God as a windfall. [Do not] trust an inexperienced person."[5]

In the Iranian tradition, the preferred format for the qit'a was, as here, a few couplets of poetry placed diagonally within a vertical composition. Each pair of lines is offset from the next, and the horizontal strokes of certain letters are exaggerated for decorative effect. The slant of the writing naturally creates triangles in the upper right and lower left corners of the composition; usually filled with decoration, these often contain the calligrapher's signature in the lower corner and a short, laudatory phrase in the upper corner (as in fig. 6.1, below).[6]

Written in a powerful and flowing *nasta'liq* script, this qit'a bears the signature of Mir 'Ali Haravi, one of the most famous and prolific calligraphers of sixteenth-century Iran.[7]

MM

Notes

1. See, for example, the profile of the white-bearded man standing in the doorway of the mosque in McWilliams 2000, fig. 12.

2. For Mir Sayyid 'Ali, see Dickson and Welch 1981, 1:178–91: note figs. 238, 239, 242, and detail figs. 241, 243.

3. For Shaykh Muhammad's camel, see Sakisian 1929; Dickson and Welch 1981, 1:166, fig. 235. It is now in the collection of the Cleveland Museum of Art.

4. For further insights into Shaykh Muhammad, see cat. 4 below, *A Lame Man of Arts and Letters*; also see Dickson and Welch 1981, 1:165–77.

5. Translation by Sunil Sharma.

6. See discussion in Safwat 1996, 128.

7. Ibid., 109.

3 Proud Prince, Humble Sufi

Attributed to Sultan Muhammad
Iran, Tabriz, c. 1535–40
Black ink on off-white paper
4⅞ × 7⅞ in. (12.5 × 20 cm)
Promised Gift of Stuart Cary Welch, Jr.
263.1983

Published: Sakisian 1929, pl. LXXXIII, fig. 149;
Dickson and Welch 1981, 1:86, fig. 121

RIDING a splendid stallion, a tall and handsome prince gracefully accepts reverence from a small, kneeling Sufi. The opposite of the young prince, the Sufi is as humble and lean as his emaciated steed, symbolic of the ascetic's triumph over ego, undersoul, and worldly indulgence. The artist projects two messages: first he contrasts the prince's worldly grandeur with the Sufi's spiritual otherworldliness, expressed through a multiplicity of details—in the gestures, the sizes, the faces, the apparel, even the ears of the two horses. A close look at the prince's facial expression, however, brings to light another, less apparent meaning. It hints that this proud prince—like the Safavid shah Tahmasp, in whose court ateliers this was drawn by his greatest and wisest painter—might mature into less worldly seriousness. For the benefit of the prince in the drawing, one hopes that this potential change of spirit was not prompted by the tormenting dreams and other miseries that caused the shah to forsake pleasures, including art patronage, in order to pursue a path of stern religious orthodoxy.[1]

The attribution to the artist named Sultan Muhammad is made on many grounds, including the picture's nuances of meaning, depth of psychological characterization, and mastery of line and proportion. Small, touching, and highly finished, this drawing, probably made for the shah himself or for his knowledgeable brother Bahram Mirza, can be assigned to circa 1540. It would have been made during the years when the artist's major royal project was the magnificent manuscript of the *Khamsa (Quintet)* of Nizami (British Library, London), which contains dates from 1539 to 1543. Strongly supportive of the attribution are the similarities between the prince's stallion here and the stallions in the *Khamsa* in pictures of Sultan Sanjar (fol. 18a) and Khusraw (fol. 53b).[2]

SCW

Notes

1. For Shah Tahmasp's personality and transformation, see Dickson and Welch 1981, 1:44–47, 167.

2. British Library, no. Or. 2265: see Binyon 1928, and for comparisons, see pls. IV, VII. For Sultan Muhammad, see Dickson and Welch 1981, 1:51–86.

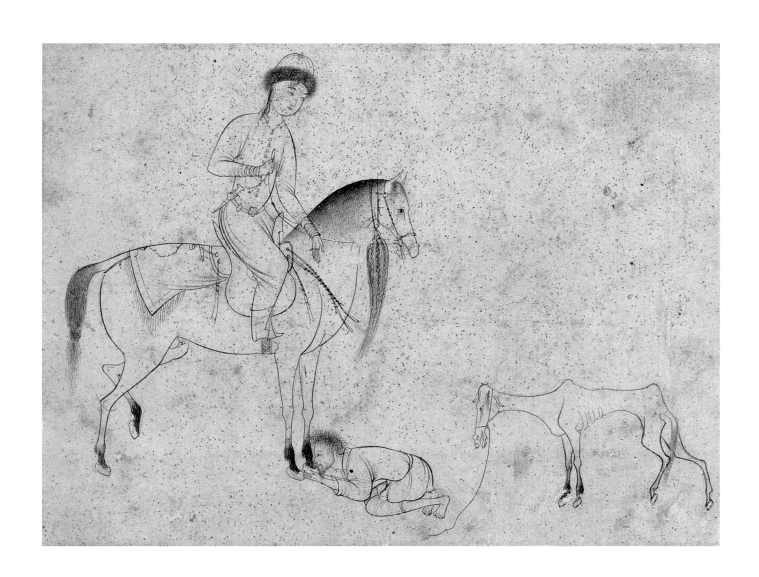

4 A Lame Man of Arts and Letters

Attributed to Shaykh Muhammad
Iran, Tabriz, mid-16th century
Black and red-brown inks, opaque watercolor, and gold
on off-white paper
4 × 3¾ in. (10.3 × 9.5 cm)
Promised Gift of Stuart Cary Welch, Jr.
270.1983

Published: Dickson and Welch 1981, 1:176, fig. 235

S MILING but afflicted, with a book stuffed into
his robe, this uncomfortable man needs the sturdy
crutch to support his frail, bent physique. The small
drawing is entirely characteristic in style of work by
Shaykh Muhammad, a great Safavid artist notable
for his contributions to two major manuscripts: Shah
Tahmasp's *Shāhnāma*, now in The Metropolitan
Museum of Art, and the Freer Gallery of Art's *Haft
Awrang* of Jami, illustrated at Mashhad between 1556
and 1565 for the shah's nephew, occasional favorite,
and son-in-law, Sultan Ibrahim Mirza.[1] As I wrote

FIG. 4.1
Detail of cat. 4

many years ago, this portrait is "atypical only in that
the characterization is so gentle and sympathetic."[2]
If one surveys the artist's small army of people (other
than his many idealized youths, intended primarily for
mystical contemplation), virtually everyone over
twenty-five is portrayed either as blandly conventional
or intriguingly caricatured. The figures seem troubled,
cynical, surly, or just plain evil. This fellow, evidently
admired by the often cynical artist, smiles benevolent-
ly, even sweetly (fig. 4.1). He is rendered more natural-
istically, for the picture was drawn during an earlier
phase in the creation of Sultan Ibrahim's extraordinary
manuscript, before classical restraint and close obser-
vation gave way to increasingly louche mannerism.

Shaykh Muhammad was notable for his brilliant,
crisply linear draftsmanship. It recalls the work of
Bihzad, who moved in 1522 from Herat, the former
Timurid capital, to Safavid Tabriz. By then too old and
tired of eye to paint without assistance, Bihzad strongly
influenced Safavid court artists. One of his gifted
apprentices—along with Mir Sayyid 'Ali—was Shaykh
Muhammad, whose rhythmic, tautly controlled line
closely derives from the Herat master's. Brilliant in
characterization, composition, calligraphic inscrip-
tions, and idiosyncratically somber palette, Shaykh
Muhammad's portrayals of people show peculiarly
flawed individuals. Although they sit, kneel, and lie
down comfortably, they can barely stand up straight.
Without exception, the knees of standing figures fail
to articulate. As here, their arclike legs are jointless,
supported by feet that resemble empty shoes lined up
in a row. Was the subject of this sympathetic portrait
so closely associated with Shaykh Muhammad that his
condition affected the artist's grasp of anatomy? Or
might this poignant picture be a self-portrait by a
highly sensitive middle-aged man who was himself
lame?

S C W

Notes

1. See Dickson and Welch 1981, 1:165–77; Simpson 1997.
2. Dickson and Welch 1981, 1:177.

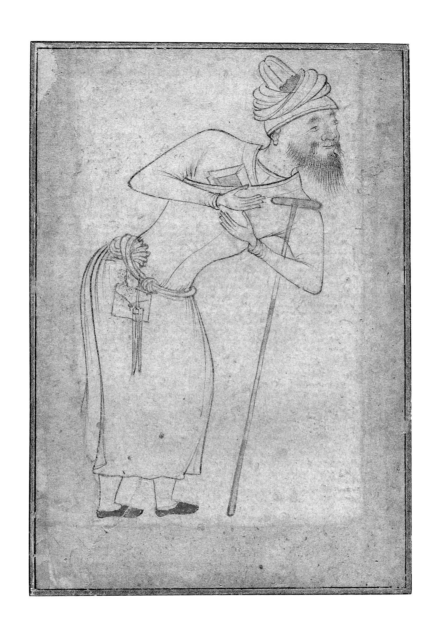

5 A Hero in Combat with a Dragon

Attributed to Mir Sayyid Muhammad al-Naqqash
Iran, Tabriz, c. 1550
Black ink and watercolor on beige paper
12⅝ × 8⅛ in. (32 × 20.6 cm)
Promised Gift of Stuart Cary Welch, Jr.
76.1999.43

6 Dragon in Foliage

Signed by Mir Sayyid Muhammad al-Naqqash
Turkey, Istanbul, c. 1565
Black ink, watercolor, and gold on off-white paper
7⅞ × 13⅝ in. (20.1 × 34.5 cm)
Gift of Stuart Cary Welch, Jr.
1999.288[r]

Published: Stchoukine 1971, 49, fig. 26; Ferber 1975, fig. 92; Grube 1995, 322, fig. 15; Harvard University Art Museums 2000, 34; McWilliams 2000, 12–14, fig. 3; Welch 1972b, 292, fig. 3; Grube 1962, 97–98 and pl. 76

OF THESE two drawings, one is a "masterpiece" signed by a Persian-born Ottoman, Mir Sayyid Muhammad al-Naqqash (*Dragon in Foliage*)—the other a lesser work attributed to the same master before he left Gilan, in Persia, and moved to Constantinople (*A Hero in Combat with a Dragon*). The ornamental yet earthy power of Ottoman art is well represented by *Dragon*. Smiling toothily, expressing the might of clouds, thunder, lightning, rain, and wind, the dragon lunges across the firmament. This sky creature's cheeriness might reflect the fact that the artist—and, many years later, his patron, Khan Ahmad al-Husayni II—was welcomed and encouraged at the Ottoman court.

Life was often difficult at home in Safavid Iran, where Ahmad al-Husayni ruled the delightful khanate of Gilan, bordering the Caspian Sea, from 1537 until 1568. Affairs reached their nadir when Khan Ahmad was jailed by his cousin Shah Tahmasp for his role in an uprising against the royal house. The artist suffered, too. Suddenly unemployed, Mir Sayyid Muhammad al-Naqqash ("the painter") moved to Turkey, where he found favor at the Ottoman court. In 1574, two years before Shah Tahmasp's death, Khan Ahmad was released from the Qahqaha Fort ("cackle house"), and in 1592 he moved to the Ottoman capital, where he joined his former artist and was received at court on 12 January 1593.[1]

In provincial Gilan, the arts had remained old-fashioned under Khan Ahmad. Far removed from Qazvin, the Safavid political and artistic capital under Shah Tahmasp, styles changed slowly. Mir Sayyid Muhammad al-Naqqash's pictures, such as this *Combat*, retained pre-Safavid elements from the art of fifteenth-century Qarā Qoyunlu and Aq Qoyunlu (Black Sheep and White Sheep) Turkmans. Whereas early Safavid art, patronized by Shah Isma'il I, founder of the Safavid political dynasty, had emerged from the royal Turkman style of Tabriz, later Safavid painting had been strongly influenced by the more cerebral, naturalistic, and restrained tradition brought to the Safavid court from Herat in 1522 by the great Timurid painter Bihzad. Because Ottoman art retained more traces of the Turkman court style, its patrons were better attuned than the Safavid court to the more visionary, earthier mode practiced in Gilan by Mir Sayyid Muhammad al-Naqqash.[2]

Ottoman patronage supercharged Mir Sayyid Muhammad al-Naqqash. Not only did he draw such works as this vital, thoroughly Ottoman *Dragon*, which may have been sent to his former patron to enjoy while incarcerated, but he also designed and often carried out magnificent tiles, dishes, and other ceramics at the kilns of Iznik. In addition, he supplied drawings for Ottoman textile makers. To him I ascribe the cycle of blue-and-white tiles that now adorn the entrance to the Circumcision Room at the Topkapı Sarayı Müzesi and a dish. I also attribute to Mir Sayyid Muhammad al-Naqqash designs for some of the most majestic Ottoman kaftans, which rank among the world's glorious

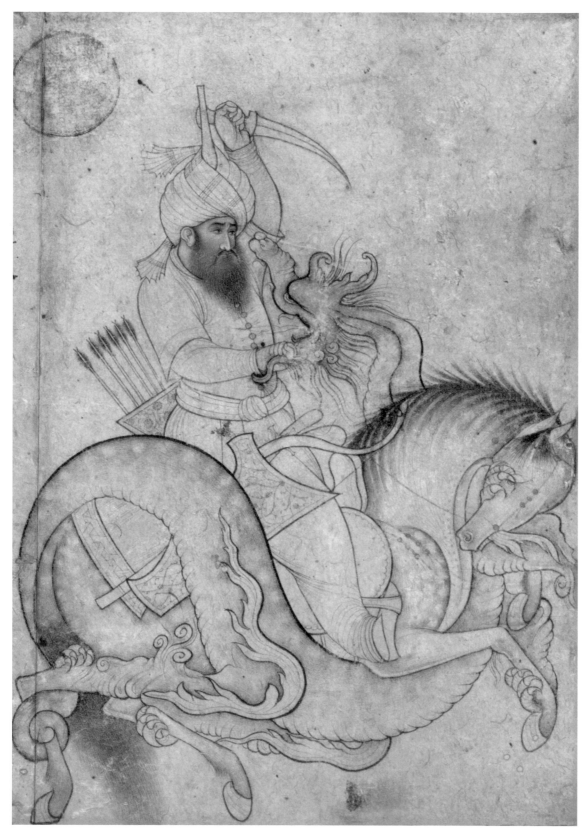

CAT. 5

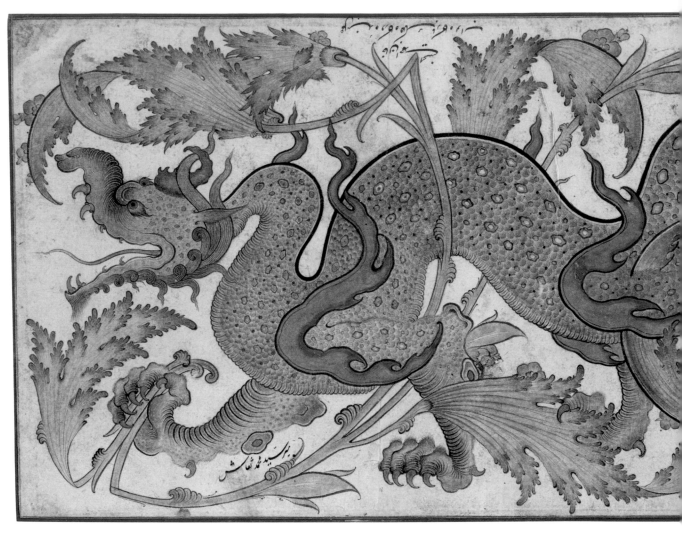

CAT. 6

textiles.[3] All were designed or drawn with the same unmistakably vital and accomplished hand, and with his genius for ornamental power; and all contain the special shapes, uniquely his, within the "negative spaces" surrounding their principal forms.

I attribute *A Hero in Combat with a Dragon* to Mir Sayyid Muhammad al-Naqqash at a time before his artistic peak inspired by Ottoman patronage.[4] The hero, perhaps an idealized likeness of Khan Ahmad al-Husayni II, wears a characteristic Safavid Qizilbāsh turban, with lengthy upright *kula* (baton). A man of peace, the hero relates to the small dragon not as bold killer but as a child enjoying a rocking horse. However excellent the bold curved lines, however fine the work, one misses the extra might found in the artist's ecstatically appealing *Dragon*.

SCW

The reverse of the album folio that bears the *Dragon in Foliage* preserves a richly illuminated *qit'a*, or fragment of Persian poetry (fig. 6.1). The poem is written in a bold *nasta'līq* script and reads, in translation:

Fame is not Jami's purpose,
For he wrote all these luminous verses
For his friends, on the page of the world
He wrote some memorable words.[5]

FIG. 6.1
'Ali al-Katib, *Calligraphy*
(verso of cat. 6), Iran, 16th
century. Ink, opaque water-
color, and gold on paper,
13⅝ × 7⅞ in. (34.5 ×
20.1 cm). Gift of Stuart Cary
Welch, Jr., 1999.288[v].

The lower corner contains the signature of the calligrapher, 'Ali al-Katib (the scribe), and the phrase "May his sins be forgiven and his faults concealed." In the upper right corner is written the laudatory phrase "He is the Powerful," employing one of the "most beautiful names" (*al-Asmā' al-Husnā*), that is, one of the ninety-nine names of God. In Islam, one popular form of devotion is to recite and meditate upon these names.[6]

M M

Notes

1. Welch 1972b, 291–98. I am grateful to Professor Wheeler Thackston for the engaging translation "cackle house," which inspires me to found a hotel bearing this name for "special" friends.

2. For Turkman painting at Tabriz and its relation to the new artistic synthesis under the Safavids, see Dickson and Welch 1981, vol. 1, chaps. 3, 4.

3. This artist's greatest tiles are the series now seen at the entrance to the Circumcision Room in the Topkapı Sarayı Müzesi, best illustrated in Denny 1998, 4, 5, 7, pls. 40–44. For a dish attributable to him, see Atasoy and Raby 1989, no. 352. For two magnificent kaftans made from textiles he designed, see Tezcan et al. 1996, 93–95. For the companion of one textile that Tezcan illustrates, an arabesque against white rather than black ground, see Atil 1980, 331, no. 59. Many other textiles and ceramics could also be attributed to this great Turko-Iranian artist.

4. Three Ottoman sultans reigned during his Turkish years: Süleyman I, Selim II, and Murad III. See Appendix II.

5. Translation by Sunil Sharma; for *qit'a*, see cat. 2.

6. See discussion and bibliography in Gardet 1960 (Reprint 1986), 714–17.

7 Small Dragon in Foliage

Turkey, Istanbul, late 16th century
Black ink on off-white gold-flecked paper
3¾ × 4 in. (9.5 × 10.3 cm)
Promised Gift of Stuart Cary Welch, Jr.
679.1983

ORIGINALLY destined for an Ottoman album, this tiny drawing of an *ejderha*, the Turkish descendant of a Chinese dragon, reflects the court style known as *hatayī*—literally, chinoiserie—that flourished in Istanbul in the last two-thirds of the sixteenth century. The style emphasized superb control of the thickness of an almost calligraphic line, highly animated and energetic design, and swirling, sinuous foliage known in Turkish as *saz*, a term recalling a sort of mythical enchanted forest. One of the characteristics of the style is that in a given composition all the foliage will originate at a single point, in this case a curled root clutched in the dragon's tiny claw in the center of the composition. The artist's skillful use of thickness of outline and overlapping in the design to create a three-dimensional feel and the thick, almost swordlike line forming the dragon's backbone give a sense of nervous intensity to the composition. Details such as the five-petaled blossoms in the right half of the composition, the complex palmette above the dragon's head, and the leaf piercing a blossom at the top right all point toward a later sixteenth-century date for this drawing. The inscription "Bihzad" in the lower left-hand corner refers to the legendary late-fifteenth-century Persian court painter of that name. Added by a later hand, it reflects both an ignorance of the style of this drawing and a tribute to its superb artistry.

WBD

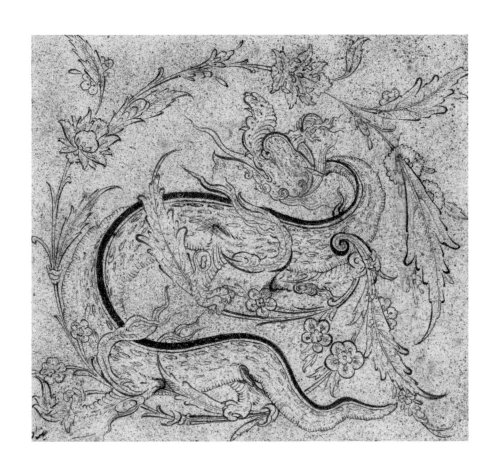

8 Falcons, Dragons, and Other Creatures

Attributed to Sadiqi Beg
Iran, Isfahan, late 16th century
Black ink on off-white laid paper
12⅝ × 8⅛ in. (32 × 20.5 cm)
Promised Gift of Stuart Cary Welch, Jr.
269.1983

Published: Bailey 1994, fig. 6; Martin 1912, pl. 93;
A. Welch 1976, fig. 27; Grube 1962, 119–20 and pl. 99

COLLIDING and interpenetrating with the neck of a dragon, a proud falcon on a rock dominates a group of real and fanciful animals. Is this a true sketch, created for another project, or a consciously artful work conjured up for a patron's or collector's album? When it was drawn another artist, Aqa Riza, was spearheading an increasing interest in spontaneity that brought *nasta'līq* calligraphy and drawing into eye-catching union. With the same reed pen and ink, a man of arts and letters could write a poem or sketch a dragon. This lilting confluence of animals comes from a world of literati that toward the end of the sixteenth century extended from royalty to courtiers and enlightened men of affairs. All fancied fine writing and drawing equally, specimens of which they vied with one another to acquire. As proudly as this falcon they created artistically arranged albums. Dare we imagine aesthetic conversations among these patrons, artists, and calligraphers? "Write me a claw." "Read me a lion!"

Sadiqi Beg, to whom this picture long has been attributed, aptly represents late Safavid sophistication.[1] Born to a well-off Turkman warrior family in 1533–34, he was a well-rounded courtier and a man of parts, with governmental, military, literary, artistic, and spiritual aspirations. Following extensive travels as far as Aleppo and Baghdad, and after apprenticeships to such revered ascetics as Mir San'i, Sadiqi Beg forswore "serving sultans" at thirty-two in favor of becoming a professional artist. For a lofty Turkman to demean himself by espousing an occupation usually associated with Tajiks astonished his contemporaries. To him, however, "Life without art is bleak": "My spirit soared

toward heaven. Like the noble falcon, it would not chase after common quarry."

Sadiqi Beg apprenticed himself in 1568 to Muzaffar 'Ali, one of Shah Tahmasp's admired masters, who was revered late in life for his wisdom and goodness as well as for his often lyrical artistry.[2] Under Muzaffar 'Ali's tutelage, Sadiqi Beg further mastered drawing and painting. A litterateur, painter, and occasional dervish, Sadiqi Beg also sought the royal recognition he considered due to one of this station. This was rewarded briefly, when Shah 'Abbas I in 1596 appointed him director of the royal painting ateliers, a fulfilling position that probably came to an end because of Sadiqi Beg's impassioned opinions, acerbic tongue, and often disliked haughtiness. Driven by both lofty aspiration and competitiveness, this ambitious aesthetic arbiter occasionally rose to great artistic heights. For Shah 'Abbas I's *Shāhnāma*, dated from 1587 to 1597, he painted *The Simurgh Carries Zal to Her Nest*, praised by Anthony Welch as "one of the greatest landscapes in all Iranian painting."[3] One of his calligraphic sketches, *Seated Man* of circa 1595, vivid and hot as a candle flame, ranks toward the peak of later-sixteenth-century Safavid drawing.[4] Its (soldierly?) self-discipline and (dervishlike?) line and spirit stir us deeply, but these same characteristics can be found in *Falcons, Dragons, and Other Creatures*.[5] Brilliance of such a high order probably accounts for Sadiqi Beg's appointment by Shah 'Abbas.

SCW

Notes

1. I am grateful to Anthony Welch for his splendid account of the life and work of Sadiqi Beg in *Artists for the Shah* (A. Welch 1976, 41–149), which is the source of the following quotes. I depend here upon his informative and stimulating account of a remarkable, too-long-neglected artist.

2. See Dickson and Welch 1981, 1:154–64.

3. A. Welch 1976, 120–21, pl. 11, figs. 39, 40.

4. Ibid., figs. 24–26. This noble drawing is in the collection of the Museum of Fine Arts, Boston, no. 14.636.

5. For a companion drawing, see *Man on Horseback Attacked by a Dragon*, from the collection of the late Prince Sadruddin Aga Khan, illustrated in Martin 1912, pl. 93; A. Welch 1976, fig. 28.

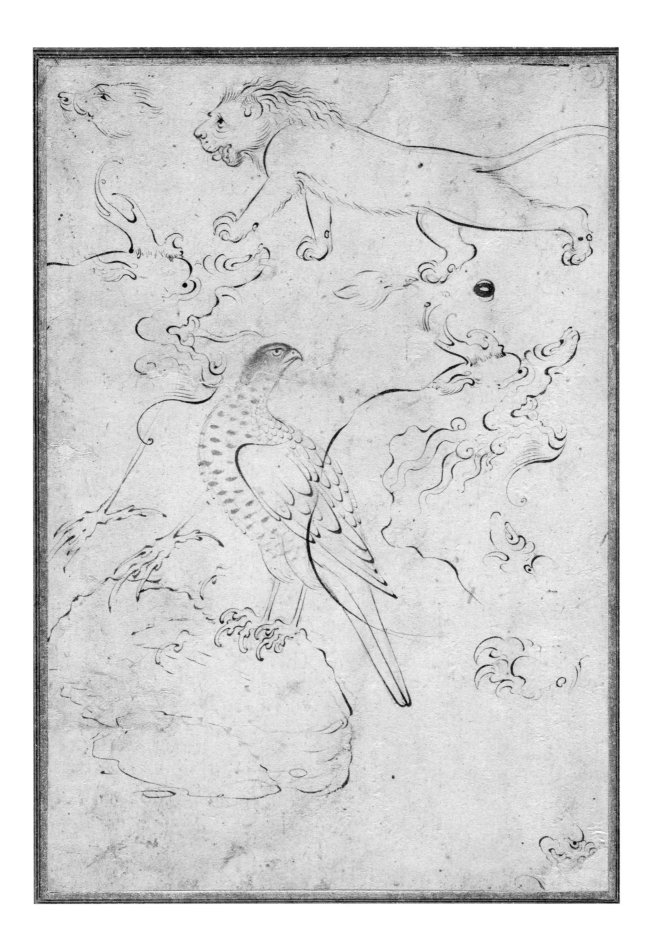

9 A Maiden Reclines

Attributed to Aqa Riza (Riza 'Abbasi)
Iran, Qazvin, late 16th century
Black ink on off-white paper
9⅜ × 13⅜ in. (23.7 × 34 cm)
Promised Gift of Stuart Cary Welch, Jr.
275.1983[r]

Published: Canby 1996, 28, 180, fig. 8

T HIS drawing of a partially dressed woman who reclines elegantly in a landscape is a key work in Aqa Riza's early oeuvre. Having begun his career in the mid-1580s, Riza adhered to the style of painting practiced by his father, 'Ali Asghar, and the circle of Qazvin artists in the royal atelier of the new shah, 'Abbas I, when he came to power in 1588. The handful of Riza's works before 1590 include only one drawing; the paintings of that period exhibit the intense colors, attention to textures, and figures in a slightly swaying stance characteristic of the Qazvin style of the 1580s.[1] By comparison, *A Maiden Reclines* stands out as innovative both for its technique and for its subject matter. The calligraphic, flowing treatment of line combined with faintly drawn strokes used to depict the soft frizz of the sleeping woman's hair demonstrate the virtuosity that Riza's biographers mention.[2]

By using a line of varying thickness, Riza emphasized the lightness of the sleeve lying on the ground and the bulk of the cushions behind the woman's head. Although he presumably learned the technique of varying the thickness of his line from calligraphic training, he was the first Persian artist to employ this for making line drawings. Nonetheless, as a drawing dated 1591–92 indicates, he received guidance from an older court artist, Shaykh Muhammad, a gifted draftsman who had worked in the court atelier from the time of Shah Tahmasp in the 1530s and was still active in the 1580s when he joined Shah 'Abbas's workshop.[3] The scrolling rim of the drapery on the woman's chest and on the ground is closely related to the drapery in several works by Shaykh Muhammad.

Riza's decision to depict such a seemingly risqué subject may also have been inspired by Shaykh Muhammad. In Persian painting and drawing of the fourteenth to sixteenth centuries, nude or seminude depictions of women are extremely rare, except in the sanctioned representation of Khusraw spying Shirin bathing and Iskandar and the bathing maidens from the *Khamsa (Quintet)* of Nizami, and occasional portrayals of Eve with Adam from illustrated *Qisas al-Anbiyā' (Story of the Prophets)* manuscripts. *A Maiden Reclines* marks a conspicuous departure from these nudes inspired by literature. It seems unlikely that the young Riza would have dared to produce such a drawing if he had not seen a prototype or been sanctioned to do so by a mentor or patron.

Despite the pentimento of the woman's eyes, which were first depicted open, then closed, her pose and partial nudity appear to derive from a European print of Cleopatra by Marcantonio Raimondi after an original painting by Raphael (fig. 9.1).[4] The raised arms and crossed legs of Riza's woman both relate closely to those of Cleopatra, though the latter's couch and snake armlets are absent from Riza's drawing. Venetian traders traveled to Iran throughout the sixteenth century, and we can assume that prints were included in the commodities for which they found a market in Tabriz and Qazvin, presumably in exchange for raw silk. Yet the mechanism by which such a print came to the attention of Riza can only be surmised. According to Iskandar Beg Munshi, the historian of Shah 'Abbas, Shaykh Muhammad "introduced the European style of painting in Iran and popularized it, and no one equaled him in the delineation of faces and figures."[5] Unfortunately, none of Shaykh Muhammad's European-style works is extant, but Riza's drawing and several works by Sadiqi Beg, the director of Shah 'Abbas's library, demonstrate that the influence of Europe, which was to be strong in the mid-seventeenth

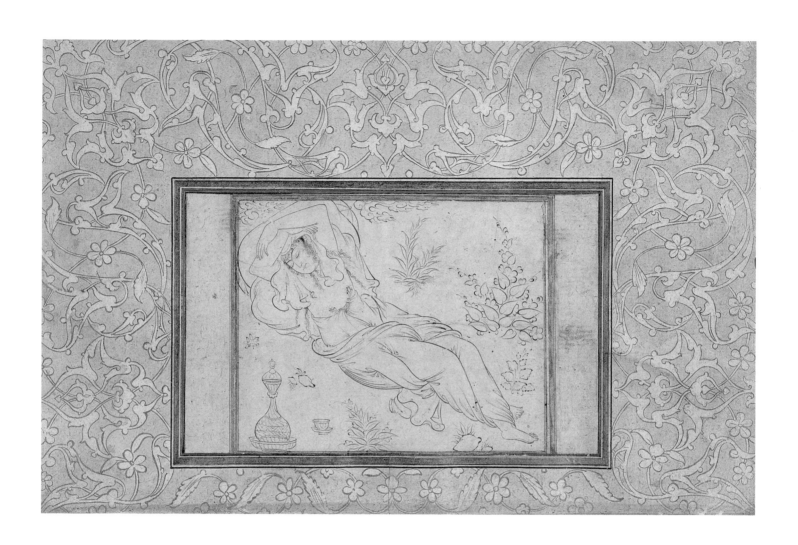

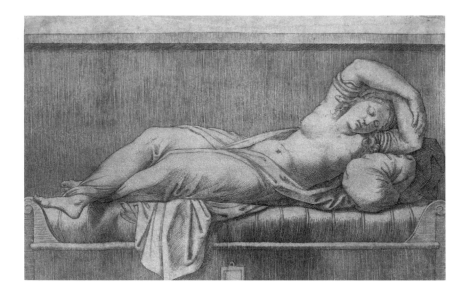

FIG. 9.1
Marcantonio Raimondi
after Raphael, *Cleopatra*, Italy,
16th century. Engraving,
4½ × 6⅞ in. (11.4 × 17.5 cm).
Fogg Art Museum, Gift of
William Gray from the collec-
tion of Francis Calley Gray,
G2501.

century, had already begun early in the reign of Shah 'Abbas (see cat. 13).

If *A Maiden Reclines* were the unique example in Riza's oeuvre of a semiclad sleeping woman, it might be considered an experimental work. However, a painting of the same subject with a somewhat modified composition suggests that the drawing, if not an actual preparatory work, was the first step in the process that led to the painting.[6] Furthermore, numerous later examples of men and women in this pose by artists working generally in the style of Riza attest to the importance of *A Maiden Reclines* and Riza's related painting as prototypes for what became a popular image.[7]

Finally, although the woman in the drawing is no doubt reclining, she probably was no maiden. Late-sixteenth-century Persian artists portrayed proper young women fully dressed, with only heads, necks, and sometimes ankles exposed. Since undressed women were rarely, if ever, depicted before Riza's drawing, one must look into the first half of the seventeenth century to determine the social class of such sitters. In Safavid Isfahan prostitution was tolerated; it enriched its most successful practitioners and generated substantial tax revenue for the city.[8] Even if Riza's drawing was based on a European print and not drawn from life, we can assume that a Safavid viewer would have considered the woman in the picture a prostitute,

for no mother, sister, or wife in respectable society could have been portrayed less than fully dressed.

It seems likely that the Ahmad al-Husayni whose calligraphy appears on the reverse of the folio with the painting (fig. 9.2) can be identified as Mir Sayyid Ahmad al-Mashhadi, a noted sixteenth-century Safavid calligrapher. Identified by Qadi Ahmad as one of the Husayni sayyids of Mashhad,[9] he started his career in Herat working with Mir 'Ali Haravi, whom he joined in Bukhara following the Uzbek conquest in 1507. After the death of the Uzbek ruler 'Abd al-Aziz Khan in 1540, he moved to Mashhad; he later joined Shah Tahmasp's court in Tabriz. After an unspecified length of time, Mir Sayyid Ahmad retired to Mashhad, where for fifteen years he continued to compose calligraphic samples and write inscriptions. At least three examples of his work, signed "Ahmad al-Husayni," are to be found in albums in Istanbul.[10]

SRC

The calligraphy on the reverse of this drawing (fig. 9.2) contains four lines of Persian poetry that can be recognized as a fragment of a larger poem by Amir Khusraw Dihlavi. The complete poem is translated below: the verses not included in Ahmad al-Husayni's calligraphy appear in brackets, and the couplet in italics is the work of an unidentified poet.

> Separation from you is my old friend;
> sorrow for you is my constant companion.

FIG. 9.2
Ahmad al-Husayni (Mir
Sayyid Ahmad al-Mashhadi),
Calligraphy (verso of cat. 9),
Iran, 16th century. Ink, opaque
watercolor, and gold on paper,
9⅜ × 13⅜ in. (23.7 × 34 cm).
Promised Gift of Stuart Cary
Welch, Jr., 275.1983[v].

Grief for you is my daily guest;
[the scar you left is my souvenir.]
[Alas, I will turn to clay
with a heart full of dust.]
[I am drowning in blood since every moment
thorns are pricking my heart.]
O gentle East Wind, bring memories
[from time to time of my longtime beloved.]
On behalf of my humble self
for all a cup of wine, a lover, and oneself.
[Sometimes will you not stroll
over the grave of your old lover?]
[It has been a while since
grief and worry and burden have left my heart.]
How strange! you returned but
stole Khusraw's peace of mind.
Written by the sinner Ahmad al-Husayni (May God
forgive his sins)[11]

Amir Khusraw (d. 1325) was born in Delhi and
is considered the most accomplished Persian poet
of India. He was a prolific writer, and his works were
popular both at the court of the sultans of Delhi and
among the Sufis affiliated with Shaykh Nizam al-
Din Awliya. His *Khamsa (Quintet)* of narrative poems,
modeled after that of his predecessor Nizami, was
popular with readers and poets in the Persianate
world, and was copied and illustrated numerous times.

The corpus of his love lyrics (*ghazals*) has also been
immensely popular, and the poems continue to be
sung by Afghan and Indian singers, although they were
not usually illustrated. This calligraphic specimen
includes some lines from a typical ghazal by Khusraw.
Each line of the poem is considered to be an indepen-
dent unit and therefore couplets from a poem were
chosen to be recited or calligraphed on the basis of
their appeal to a particular audience.

The lines in this poem are uttered by a lover pining
for an absent but longtime beloved, who is ostensibly
similar to the maiden reclining in the miniature. The
effect of the whole piece is to convey an ambiguous
and lyric mode of expression whose subject matter is
earthly as well as mystical love.

SS

Notes

1. Canby 1996, 23–32.
2. Ahmad 1959, 37.
3. Canby 1996, 44.
4. Ibid., 28, 32, 42 n. 8.
5. Monshi 1978, 273.
6. Atil 1978, 56.
7. Topkapı Sarayı Müzesi, no. H2158, fol. 3a; no. H2145, fol. 4a; H2155, fol. 24a.
8. Matthee 2000, 126–30.
9. Ahmad 1959, 139. Sayyids are descendants of Imam 'Ali, son-in-law and cousin of the Prophet Muhammad.
10. Topkapı Sarayı Müzesi, no. H2137, fol. 12b; no. H2140, fol. 22a; H2147, fol. 18b.
11. Translation by Sunil Sharma and Afsaneh Firouz-Ardalan.

10 Seated Sufi

Attributed to Aqa Riza (Riza 'Abbasi)
Iran, Qazvin, c. 1595
Black ink on off-white paper
12⅝ × 7⅞ in. (32 × 20 cm)
Promised Gift of Stuart Cary Welch, Jr.
274.1983

Published: Canby 1996, 63, 183, fig. 28

A SCRIBE, the tools of his trade arrayed before him, sits staring bug-eyed into the distance. His felt hat identifies him as a dervish, and his intent but abstracted gaze suggests that he is meditating. Despite the absence of landscape or architectural details that would place the figure in a physical context, the lightly drawn shawl around his shoulders and the fact that his hands and feet are drawn up into his ample robes imply that the weather is cold.

The small but arresting drawing is unsigned, but its draftsmanship and subject support an attribution to Aqa Riza. The contours of the large, rounded forms of the scribe's back, thigh, knee, and arm are achieved by lines of varying thicknesses that both emphasize the forms' bulk and avoid the static quality of unbroken lines. The beard and stubble on the man's head are produced by hundreds of tiny strokes that enable the artist to vary the textures of hair on and around the sitter's face. Likewise, the faintly drawn shawl suggests the texture of a light, warm wool such as cashmere or pashmina. These varied uses of line are consistent with Riza's drawings of the 1590s, as is the choice of subject.

Throughout the 1590s Riza produced both drawings and paintings. The paintings included single-page portraits as well as manuscript illustrations,[1] while the drawings ranged from portraits of courtiers to depictions of working men and Sufis. That laborers and dervishes were considered appropriate subjects for drawings, and that a market existed for such drawings, have much to do with the changes in art patronage that had taken place after the death of Shah Tahmasp in 1576. Following the death of his successor in 1577, the crown passed to Shah Muhammad Khudabanda, who was half-blind and no patron of the visual arts.

The court artists who had previously worked for members of the Safavid royal family were now compelled to find new ways to ply their trade. Some went to work in the great shrines, such as Mashhad or Qum, and others traveled to India in search of patronage. Yet others shifted from producing illustrated manuscripts to creating single-page paintings or drawings for inclusion in albums (muraqqa's). Collectors or their librarians compiled these albums carefully, placing calligraphies by the same scribes or of the same verses on facing pages, alternating with page-openings of pictures of related subjects or by the same artist.

Because the contents of an album could be collected over a long period of time, the cost to the collector was not as high as that of commissioning an entire illustrated manuscript. Artists who had previously worked for a single patron or in one library now sold their works to anyone who would buy them. Additionally, because the cost of pen and ink was so much less than that of fine polychrome pigments, drawings became far more common than they had been in the first half of the sixteenth century. A work such as Seated Sufi, despite its small size and compositional simplicity, would have been appropriate for an album, particularly if placed on the same page as or opposite a related work.

This portrait may indicate Riza's growing awareness of the mystical path in the 1590s, a strain in his work that became especially pronounced in the first decade of the seventeenth century. Both Riza's drawings of Sufis and his line of varying thickness inspired many emulators. Yet a comparison with a drawing of a bearded scribe by a follower of Riza in the so-called Riza-yi 'Abbasi Album in the Freer Gallery of Art, Washington, D.C.,[2] reveals how much more loosely drawn the Freer figure is than Riza's scribe. The subtle textures of the beard and the intensity and inwardness of Riza's figure are both absent from the later example. While Riza's drawings inspired many Persian artists, their work rarely attained the finesse and power of the original.

S R C

Notes

1. Canby 1996, 30–41.
2. Atil 1978, 87, cat. 52. The author calls the figure a "cloth merchant."

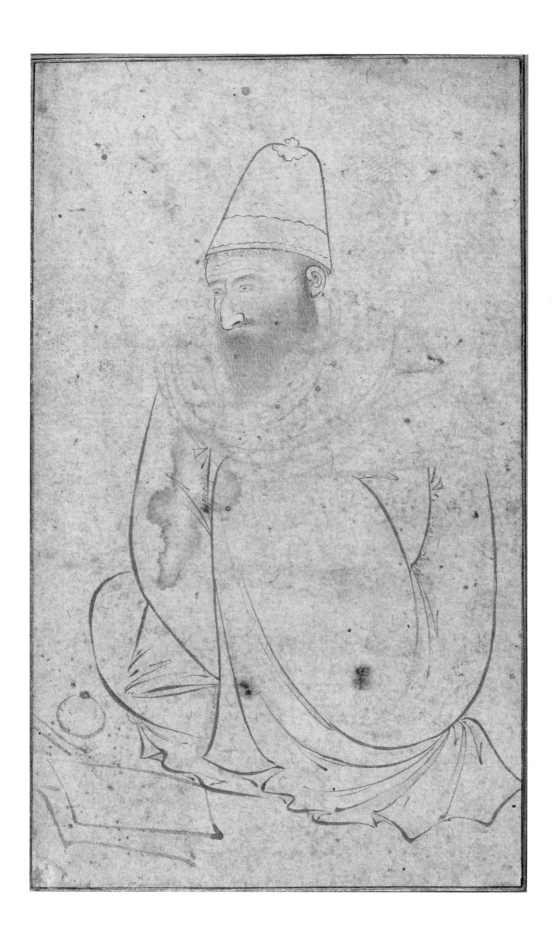

11 The Bagpipe Player

Circle of Aqa Riza (Riza 'Abbasi)
Iran, Isfahan, c. 1600
Black ink and watercolor on off-white paper
14 × 9 in. (35.5 × 23 cm)
Promised Gift of Stuart Cary Welch, Jr.
76.1999.33[r]

A MIDDLE-AGED man sits on a rock playing his bagpipe in a barren landscape. At the upper left clouds tinged with blue streak across the sky. The curving forms of the bagpipe echo those of the figure's arms, thigh, and knee, in contrast to the jutting rocks and pointy-toed boots. His brows tensed with concentration, the piper gazes into the distance as if lost in his music or in thought. While various aspects of this work reveal a debt to the style and subject matter of Aqa Riza's works of the 1590s, certain details suggest that this is the work of one of his followers.

The choice of subject, a bagpiper, is consistent with Riza's oeuvre, in which drawings of working men, such as a man with a goat or a hunter,[1] were produced contemporaneously with those of courtiers and "men of the pen." Genre scenes had entered the Safavid artistic vocabulary during the 1570s and 1580s, as seen in the works of Muhammadi and Siyavush the Georgian. The draftsmanship, with its line of varying thickness that defines the curves of the figure's shoulders and thighs and the bagpipe's contours, also relies on the examples set by Riza.

Despite points in common with Riza's works, however, the treatment of the bagpiper's hands, which appear round and somewhat soft, with short fingers, is at odds with that of Riza's figures, with their leaner, more elongated hands. Likewise, the shape of the piper's head, with a bulge below the turban at the back, is inconsistent with Riza's work. In the first decade of the seventeenth century, the period to which this drawing is assigned, Riza was disaffected by the court atelier, and his alienation was manifested in a more aggressive use of line and compositions in which clouds and landscape elements crowd the figures. Although the clouds in the drawing of *The Bagpipe Player* resemble in shape those in Riza's works of the early seventeenth century, they function more as decoration than as a significant element of the composition. What this drawing does demonstrate in relation to the work of Riza is how strongly and quickly his contemporaries reacted to his influence.

Although bagpipes have been known since ancient Greek times, pictures of bagpipers are extremely rare in Persian painting. As is evident in the drawing, bagpipes were a rustic instrument in no way connected to the types of instruments found at court. In the urban or courtly setting, stringed instruments such as the 'oud or mandolin, the rubab with its long neck and small round box, the kamanga, and the harp were accompanied by the tambourine. Great kettle drums and trumpets were played at processions and in battle. Short flutes or recorders appear in depictions of shepherds, but bagpipes are rarely found in pictures of musical entertainments. Perhaps the difficulty of playing bagpipes and their rural association meant that bagpipe players were scarce and not well known to Safavid artists.

The form of the bagpipe is distinctly different from the Scottish version with which most people are familiar today.[2] The Persian bagpipe consists of the shaved skin of a sheep or goat minus the hindquarters, fitted out with a single blowpipe through which the piper blows to inflate the skin. The melody is provided by the air escaping from the skin and passing over two reeds set in wooden pipes with finger holes. Unlike Scottish bagpipes, no other pipes are attached to the skin to provide the constant sound, or drone, that accompanies the piper's melody. The three blue balls dangling from the bagpipe are most likely bells.

SRC

FIG. 11.1
Shah Mahmud al-Nishapuri,
Calligraphy (verso of cat. 11),
Iran, 16th century. Ink,
opaque watercolor, and gold
on paper, 14 × 9 in.
(35.5 × 23 cm). Promised
Gift of Stuart Cary Welch, Jr.,
76.1999.33[v].

Thirteen fragments of poetry have been pasted in the pale pink margins surrounding *The Bagpipe Player*. These fragments have no apparent relation to one another or to the drawing and seem to be by different hands and in different scripts. On the reverse of this folio, a calligraphic composition (*qit'a*) of poetry is similarly framed by fourteen small, damaged fragments of *nasta'līq* script.

The central work of calligraphy on the reverse (fig. 11.1) consists of three couplets of Persian poetry written in nasta'līq. They read, in translation:

> What are paradise and houris?
> Everything appears fine from afar.
> My glance is only for you.
> I don't look at houris and angels.
> Lifeless, in separation I am sorrowful
> [While] my enemies are rejoicing in assemblies
> of union.[3]

The lower left corner bears the signature "Written by the slave Shah Mahmud."

MM

Notes

1. Canby 1996, 52, cat. 16; and 58, cat. 24.
2. A drawing of a standing bagpiper with an inscription to Riza and a date of 1624 is illustrated in *Treasures from the Fitzwilliam* 1989, no. 55. Although the attribution is probably false, the drawing suggests a lost prototype of this subject by Riza.
3. Translation by Sunil Sharma.

12 *Cheetah Trainer*

Attributed to Aqa Riza (Riza 'Abbasi)
Iran, Isfahan, c. 1590
Gray-black ink on silver-flecked off-white paper
5⅜ × 4 in. (13.6 × 10.1 cm)
Promised Gift of Stuart Cary Welch, Jr.
271.1983

A CHEETAH trainer, his charge, and his mount are here sketched with lines as lively as the creatures they define. The drawing's apparent delicacy belies its intensity: the ink varies in dilution from pale gray wisps of whiskers and bristles to a deep black equine eye. The image is inadvertently camouflaged by the paper support, for the latter is ornamented with silver

flecks, now darkly tarnished. Although unsigned,[1] this drawing of a working man reflects Riza 'Abbasi's interests during the decade of the 1590s, and in its virtuoso line and subtle textures is characteristic of his style. A flowing line ripples along the hem of the trainer's robe, traces his slender, tightly squeezed fingers, and curls into bemusement on the cheetah's muzzle.

This is a taut trio: the trainer is tensed in his saddle, with hands pressed on the pommel and feet thrust forward in the stirrups. The small horse, at a stand with ears pricked backward, is open-mouthed and alert.[2] The cheetah, unhooded and seated on the horse's croup, casts a wide-eyed glance backward (fig. 12.1). The three appear poised for the next development in the hunt—the appearance of the game.

Relying on short bursts of extraordinary speed for a quick kill, cheetahs were usually set on gazelles, rabbits, and other fleet game.[3] The beauty and power of the cheetah's swift hunt inspired the Arab poet Ibn al-Mu'tazz (d. 908) to compare her (hunting cheetahs were always female) to an arrow, "well and truly feathered, sharpened by the long course."[4] Because stamina was not a virtue of the fastest quadruped, however, cheetahs had to be conveyed to the hunt. One of the trainer's more demanding tasks was to teach his charge to ride pillion, as seen in this drawing. A well-trained cheetah could sit firmly on her trainer's horse at any speed. In India the preferred custom was to transport cheetahs to the hunt in small wagons, as seen in *The Ravat Hunts with Cheetah* (cat. 62), thus dispensing with this difficult stage of training.[5]

Hunting with cheetahs is a practice of the remotest antiquity in the Middle East.[6] In the *Shāhnāma*, Firdawsi credits Tahmuras, prince of the legendary dynasty of the Pishdadians, with the idea of training beasts of prey to hunt with men.[7] Because of the vast expense required to capture, train, and keep the animals, only the very wealthy could enjoy the luxury of this sport, and it is thus by poets and artists of the court that the hunt with cheetahs has been represented.

Capturing, training, and keeping cheetahs were difficult tasks, mastered by highly specialized trainers.

Handling the cheetahs on a princely hunt was solely the responsibility of these professionals. All others were mere spectators for the thrilling display of speed and skill:

> There can be no hunting without a bounding [cheetah], flying like motes on four [gazelles].
> When she is slipped from her collar, the dust flies up and the chase is joined in earnest,
> Like a whirlwind, one of the daughters of the winds, she will show you something amazing over the ground. . . .
> If the quarry sees her running behind it, its conscience whispers perdition in its ear.[8]
> MM

Notes

1. The drawing bears the marks of an inscription that has been largely effaced. Located at the center bottom, it appears to have read, "[The work of?] Bihzad in the year [illegible]." Although *Cheetah Trainer* is not the work of Bihzad, the fifteenth-century Persian painter of almost legendary stature, the inscription testifies to the admiration the drawing engendered in an earlier owner. I am grateful to Afsaneh Firouz-Ardalan for help in deciphering the inscription, and to Anne Driesse and Penley Knipe at Harvard's Straus Center for Conservation, for help in viewing the drawing under infrared and ultraviolet light. The attribution to Riza 'Abbasi is made by Stuart Cary Welch.

2. The horse in this drawing is noticeably diminutive. With its deep girth, short back, arched neck, and high-set tail, it may represent a small horse native to Iran, now known as the Caspian pony. Its slightly dished profile, large prominent eyes, and wide nostrils recall the head of the Arabian horse, of which the Caspian pony is thought to have been the fore-runner. Hardy, swift, and an excellent jumper, the Caspian pony is one of the oldest horse breeds, and, until rediscov-ered in 1965, was believed extinct. See Biggs 2002, 66; Silver 1976, 54–55; Edwards 1993, 88–89. My grateful thanks go to Anne Rose Kitagawa for sharing with me her library of equestrian literature.

3. Detailed information on hunting with cheetahs in the Islamic world is found in Viré 1991, 738–43. Images of hunting cheetahs are not rare in Persian art; see, for example, a beautiful drawing by Muhammadi of c. 1580, *Sultan by a Stream*, illustrated in Soudavar 1992, 240–41, no. 94; and a pair of collared cheetahs painted in luster on ceramic tiles from c. 1260–70, illustrated in Canby 1993, 28, fig. 14.

4. Ibn al-Mu'tazz, cited in Smith 1990, 173. He also paralleled the status of cheetahs with that of female slaves: "She has her seat behind the rider like a Turkish woman captured by Arabs" (cited in Smith 1990, 180). The author of many hunting poems, Ibn al-Mu'tazz was an 'Abassid man of letters and caliph for one day. See Seidensticker 2002, 223–24; Heinrichs 1995, 375–79.

5. This Indian practice can also be seen in a Mughal painting of c. 1610–20, showing "a hunting cheetah riding on a bullock cart," in the collection of the British Library, and illustrated in Ashton 1947–48, 156, pl. 133, fig. 702.

6. In addition to the sources cited above, see Schafer 1985, 87–88: "The hunting leopards, or cheetahs, have been tamed and trained by men for a very long time, especially for hunting antelope. The Sumerians used the cheetah, it seems, but the bold Hittites tamed even the true panthers for hunting. Cheetahs appear in Egyptian art of the eighteenth and nineteenth dynasties, wearing costly neckbands. They have been used in India, Persia, Armenia, Abyssinia, and North Africa, in Germany in the seventeenth century, and in France in the eighteenth. A Mongol khan would take a thousand of them on a great hunt. Such was the popularity of the animal in Western and Southern Asia that it was inevitable that it should become known to the Chinese of T'ang."

7. Firdawsi: "He [Tahmuras] chose from them [the wild beasts] the Caracal and the Cheetah. / By artifice he took them from the desert and the mountains" (cited in Viré 1991, 740).

8. Ibn al-Mu'tazz, cited in Smith 1990, 180.

13 Figures from the Annunciation

Sadiqi Beg
Iran, Yazd, c. 1590
Black ink and watercolor on off-white paper
12¼ × 8⅛ in. (31 × 20.8 cm)
Gift of Stuart Cary Welch, Jr.
1999.289[r]

WITHIN an empty square, two robed figures kneel with heads inclined toward each other. Their calm faces belie the agitation expressed in their hand gestures and in the angular contortions of drapery surrounding their lower bodies. Their eyes do not meet, for both figures gaze fixedly at the banderole that curls across the space between them. Except for a ground line that may be inferred from the crumpling of drapery, no setting has been drawn to contain or define the figures. They are, nevertheless, still recognizable as extracts from a northern European representation of the Annunciation, although shorn of religious attributes such as halos, wings, and the requisite enclosed background.[1]

The little banner, which would have carried the biblical text, bears only unintelligible marks derived from Latin letters as it unfurls leftward. Happily, historical context has been provided by the artist himself in a Persian notation written in the bottom center that identifies the artist and his patron: "These two figures are in the manner of the Frankish masters: drawn while in the service of the one giving asylum to those seeking the right path, the Wonder of the Age, Khvaja Ghiyath Naqshband. Written by the servant [of God] Sadiqi, the Librarian."[2]

Sadiqi Beg was one of the best-known artists of Safavid Iran. He followed many callings over the course of a long life: painter, poet, chronicler, courtier, soldier, and sometime mendicant.[3] Sadiqi's varied life and peevish personality were remarked on by the major chroniclers of the Safavid era and are also revealed in his own writings, most notably the *Qānūn al-Suvar (Canons of Painting)* and *Majma' al-Khavāss (Assembly of Worthies)*. Unlike most Safavid artists, Sadiqi was born to a well-connected Turkman family. After serving with apparent success as a courtier and warrior, he changed direction in his early thirties:

> When I first was young my life was spent in the service of sultans. Any other profession I considered beneath me and a discredit to the family tradition. But there were times when, through some inborn instinct for truer things, my inner being could hear a voice, insinuating: "It is yours to forbear the company of these sultans and their ways; it is yours to forswear their cupidity and their partying. Heed my parting words and forget them never more: Your true vocation is art; seek it diligently the rest of your days. Pursue it militantly, and cling to it mightily; for life without art is bleak."[4]

Sadiqi's experiences as an artist spanned the high and low points of Safavid art. His artistic career began and ended during the reigns of two of the greatest patrons of art, Tahmasp I (r. 1524–76) and 'Abbas I (r. 1588–1629), and it bridged the grim and disordered reigns of Isma'il II (r. 1576–77) and Muhammad Khudabanda (r. 1577–88). A master of single-page drawings and paintings, Sadiqi also contributed paintings to manuscripts produced for royal and princely patrons and even painted more than one hundred paintings for a manuscript he commissioned himself.[5] His paintings and drawings ably mirrored the changing styles in vogue at successive royal and princely courts. The "lithe, long-necked" figural style associated with Qazvin painting appears in his mannered drawing of a seated princess of circa 1575, while the *Lion Tamer* of circa 1605 calls forth the more robust expressiveness of Isfahan painting.[6]

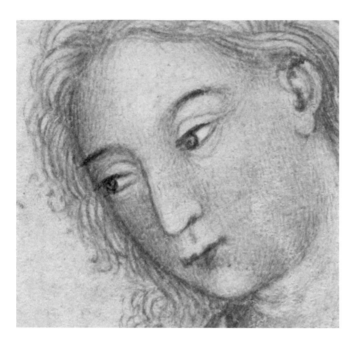

This delicate and surprising drawing of figures from the Annunciation reveals yet another side of Sadiqi's artistic adaptability, for it is one of the earliest extant examples of a Persian artist experimenting with a European idiom.[7] As such, it serves as a bellwether for the profound influence that portable works of European art and itinerant European artists would later exert on Persian art in the course of the seventeenth century.[8] Built from a variety of brushstrokes and techniques, the drawing illustrates Sadiqi's versatility. Barely visible now is the faint black underdrawing in the folds of the robes. The drapery is colored by thin washes of red, blue, and green. Sadiqi darkened the shadowed folds by using greater concentrations of the same pigment and suggested highlights by letting the light color of the paper show through the dilute washes.[9] The hands, faces, and hair are outlined not in black but in darker tonalities of their local colors. Minute strokes of reddish pink, light brown, and white blend into flesh tones. Finely painted lines of opaque white create the highlights on eyelids, noses, and folds of flesh along the neck (fig. 13.1).

In addition to naming the artist, the inscription also identifies Sadiqi's patron at the time, Ghiyath al-Din Naqshband.[10] A celebrity of sorts, Ghiyath al-Din was a wealthy silk weaver and a designer of outstanding artistic ability. A multitalented individual, he was

a generous host who prided himself on his poetic prowess. It appears that Sadiqi entered his service in the early 1580s, and even resided in his home in Yazd.[11]

The drawing is bordered above and below by a couplet of Persian poetry. Although the poet has not yet been identified, the sentiments expressed are apt for a gift to Ghiyath al-Din:

> I have gained experience from every single thought. There is nothing more honorable than generosity.[12]

On the reverse of this folio, which was a page in an album, is mounted a composition in *nasta'līq* script (fig. 13.2). In a clean, spare hand, two couplets of Persian poetry are written in diagonal format. The verses admonish:

> Do not place a letter [character] in ambergris script on a rose petal!
> Do not place a circle of Chinese musk around the moon!
> When you walk, do not trample the tresses [of those] under your feet!
> Do not lay the trap of deceit in the path of men of religion![13]

The laudatory phrase in the upper right corner reads "He is the Giver of Power," which also appears in cat. 25. In the lower left corner, the calligrapher, Muhammad 'Ali, has signed and dated the work 1725.

M M

Notes

1. Gauvin Bailey has identified the probable European sources for this drawing in the works of the Flemish artist identified as the Master of the Banderoles (fl. 1450s–1470s). See Bailey 1994.

2. This translation appears in Skelton 2000, 250. Sadiqi was granted the title *kitābdār*, director of the royal library, at the beginning of the reign of Shah 'Abbas I. He was dismissed from the post in about 1597.

3. Brief accounts of the life of Sadiqi are found in Stchoukine 1964, 76–79; A. Welch 1973, 147; Simpson 1980, 90; and Canby 1998, 69–70. A lengthier discussion of his life and oeuvre appears in A. Welch 1976, 41–149.

4. Sadiqi Beg, *The Canons of Painting*, translated in Dickson and Welch 1981, 1:260.

5. The manuscript was the *Anvār-i Suhaylī* of Husayn Va'iz al-Kashifi, from the collection of the late Prince Sadruddin Aga Khan, no. Ms. 40, illustrated in Canby 1998, 70–72. An illuminating discussion of the typologies, theories, and processes involved in Persian drawing is found in Roxburgh 2002b, 43–57.

6. See Canby 2000, 84, and elsewhere. *A Seated Princess*, c. 1578, ink on paper, collection of the late Prince Sadruddin Aga Khan, no. M. 193, illustrated in A. Welch 1976, fig. 18. *Lion Tamer*, Harvard University Art Museums, no. 1952.6, has been illustrated many times: see, for example, A. Welch 1973, 63, fig. 3.

7. See Sheila R. Canby's discussion in cat. 9, above. Earlier instances of Persian artists experimenting with Eastern models are analyzed in Roxburgh 2002b, 50–53.

8. Gauvin Bailey has assigned to Sadiqi's final years a small group of drawings with European elements in Bailey 2000, 264–65.

9. The first master with whom Sadiqi studied, the renowned calligrapher Mir San'i Nishapuri, was famous for the arts of color washes and gold-sprinkling: see A. Welch 1976, 49. In *Qānūn al-Suvar*, Sadiqi described "the Art of Coloring" and "the Art of Tinting with Washes." For translation and commentary on variant meanings, see Dickson and Welch 1981, 1:263: "Let me now reveal to you the inner secrets behind the art of tinting with color washes (*shustmān*). There are in fact two methods to use, each perfectly proper in its place. The first is known as *dam-shū* [and refers to tinting (*shū*) with the tip (*dam*) of a brush]; the second is *miyān-shū* [and refers to tinting with the flat, that is the "brunt" or "midsection" (*miyān*) of a brush]. For example, if your design is to color in a blossoming rose, then *dam-shū* is the method to apply. In contrast, should you be working the rich expanse of the ground from which the blossom flowers, then *miyān-shū* must be tried."

10. For an excellent treatment of the life of Ghiyath al-Din and sources for him, see Skelton 2000, 249–63.

11. In his *Majma' al-Khavāss*, Sadiqi wrote of Ghiyath al-Din: "He has many skills. Firstly in the art of designing and making silken fabrics he can be called the phoenix of the age and the unique one of his time. The kings and princes of Iran and Turkestan are seekers after the silk cloths of his contriving. In agility, strength and archery he has no equal and with all this he is very gentle and kind. After the defeat at Astarabad I entered his service in Yazd and as well as close friendship with him I had the honour of staying in his house. If he had no guest on any day then food and drink were not agreeable to him. . . . He composes all types of poetry and he has such a flair for composing impromptu verses that he can recite a hundred of them in quick succession without the listeners realizing that it is impromptu. He is one who stays awake all night in prayer" (cited in Skelton 2000, Appendix C, 260).

12. Translation by Sunil Sharma and Afsaneh Firouz-Ardalan. The unidentified poem harmonizes with sentiments expressed in Ghiyath al-Din's own poetry:

> Kinsmen and strangers alike receive a portion According to their need from the table of my hospitality. My table-cloth of hospitality has never been folded up In the face of others. [cited in Skelton 2000, Appendix C, 260]

13. Translation by Sunil Sharma.

14 A Camel Fore and Aft

Signed by Mu'in Musavvir
Iran, Isfahan, c. 1678
Brown-black ink and watercolor on off-white
laid paper
11 × 7½ in. (28 × 19 cm)
Promised Gift of Stuart Cary Welch, Jr.
273.1983

Published: Pope and Ackerman 1967, pl. 924a; Binyon
et al. 1933, 178, no. 375; Rabino 1917, pl. 16; Robinson
1965, 137, pl. 66; A. Welch 1973, 109, fig. 78; Grube
1962, 136 and pl. 120

Inscription: "In the night of Wednesday the 28th of
Shawāl, 1098 A.H. [1678] these two [sic] camels
designed by the late Ustad Bihzad Sultani (Mercy on
him!) were drawn by Mu'in Musavvir."

IF Mir Sayyid 'Ali's camel (cat. 2) invites us to mount
and ride it, Mu'in Musavvir's inspires us to giggle
from afar, in which respect we are joined by the courtier on the horizon, whose gesticulation asks, "What
on earth have we here?" During Shah Tahmasp's many
years of patronage—from the 1520s until the 1550s,
and for a few years before he died in 1576—his artists
usually created serious work. Only on rare occasions
during the 1540s did their miniatures evoke knowing,
somewhat Proustian smiles.[1] Under the patronage of

the shah's nephew and son-in-law, Sultan Ibrahim
Mirza, however, artists at Mashhad were encouraged
to prompt snickers or even guffaws.[2] Almost a century
later, artists of Mu'in Musavvir's generation viewed
life through very different lenses, with results that
sometimes remind us of the distorting mirrors at
amusement parks. Although the artfully awkward hind
legs and tail might have been suggested by the artist's
observation, the camel's forequarters are beyond
belief. The animal's coiffure and lips, implying a recent
visit to a veterinary beauty salon, summon to mind an
overly lipsticked grande dame at an opera opening.

This well-known drawing was created in humorous
mood by Mu'in Musavvir, the last important traditional
Safavid artist, notable for his wit, inventive mise-en-page, and good cheer. His—and Safavid art's—opera
ended not with a bang but with gentle delight and
laughter.

SCW

Notes

1. In Dickson and Welch 1981, 1:130, 133, we discuss the
Proustian ambiance of Mirza 'Ali's *Nushabeh Recognizing
Iskandar from His Portrait*, figs. 179, 183.
2. See Dickson and Welch 1981, 1, fig. 219, for Muzaffar 'Ali's
satirical response to works by his animal-loving colleague,
Mir Sayyid 'Ali, in *"Don't Blame Me for Such Acts," Said the Devil*.
For a color plate, see Simpson 1997, 92, where it is entitled
A Depraved Man Commits Bestiality and Is Berated by Satan.

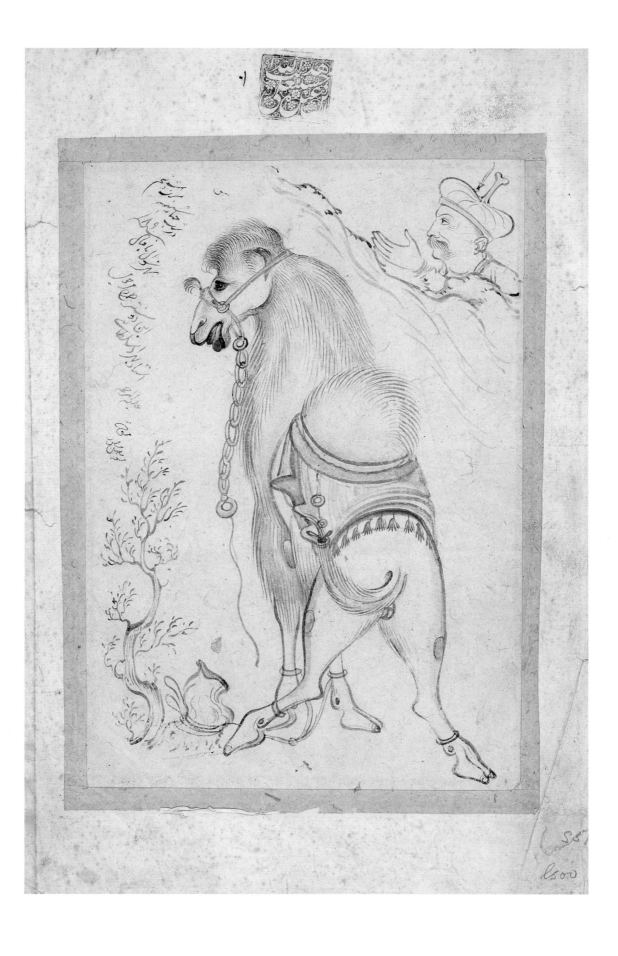

15 Sprig of Rose Blossoms

Iran, first half of 19th century
Black ink on oiled(?) paper
5⅛ × 4⅝ in. (13 × 11.8 cm)
Promised Gift of Stuart Cary Welch, Jr.
728.1983

THE Persians have always delighted in flowers, especially the rose. The most popular work of Iran's most celebrated poet, Sa'di, is entitled *Gulistān* (*The Rose Garden*), and the favorite design among Persian artists was the *gul u bulbul* (rose and nightingale), found on innumerable book covers, mirror cases, and pen boxes. The finest miniatures of the Timurid and Safavid periods lovingly and accurately depict a great variety of flowers and blossoming trees in the landscape compositions. But it was not until the mid-seventeenth century that detailed full-scale drawings and paintings of individual flowers and flowering plants began to appear.

There are, for instance, a number of exquisite paintings of birds, each depicted in brilliant detail and each perched upon a flowering branch. These paintings are mostly signed by their respective artists—such as Riza 'Abbasi and his followers—and sometimes bear dates from the second quarter of the seventeenth century onward.[1] Finally, from the end of that century, we have a group of fine individual flower paintings in the celebrated St. Petersburg Album.[2]

From these sprang the numerous flower paintings and drawings of the Zand and Qajar periods, and toward the end of the eighteenth century the earliest recorded specialist painter of flowers, Mirza Muhammad Hadi, made his appearance at Shiraz. He lived to a good old age, and a number of his works have survived; we are fortunate in having a personal description of him in old age from the pen of Claudius Rich, English resident at Baghdad, writing from Shiraz in September 1821:

I have just had a visit from Mirza Muhammad Hadi, the most distinguished artist in Persia. . . . He was accompanied by a khan, and one or two of his choicest disciples. He enjoys the highest reputation here, and the Persians almost consider him in odour of sanctity. I found him an extremely polite, intelligent, gentlemanlike old man. He is full of the spirit of his art, and is passionately fond of flowers. This *Iranian van Huysum* never works now; and it is almost impossible to procure a specimen of his pencil. They are bought up at any price by the Persians. He has not even preserved a specimen for himself.

A noteworthy successor, also a native of Shiraz, was Lutf 'Ali Suratgar, whose drawings and paintings, on both paper and lacquered objects, ably carried on the tradition, which continued throughout the nineteenth century.[3]

The present work, despite the discoloration of the paper, gives a fine impression of the devoted skill of the Persian flower painter at his or her best. It bears close resemblance to some mid-nineteenth-century works bearing the signature of Baqir, or Muhammad Baqir. But there were quite a few artists of this name during the Zand and Qajar periods, and in any case the style of one flower painter is often so similar to that of another that a confident attribution is not possible.

BWR

Nineteenth-century Persian painting is primarily identified with the life-sized and monumental figural painting produced for the Qajar court. Yet small-scale, bird-and-flower designs—gul u bulbul—were equally popular themes, deeply embedded in Persian poetry as early as the Ghaznavid period (977–1050). The Persian love of flowers, roses in particular, was well-documented, particularly in the Safavid period, when a veritable culture of flowers, featuring rosewater-sprinkling festivals and presentation of floral bouquets, was recorded by European visitors.[4] By the eighteenth and

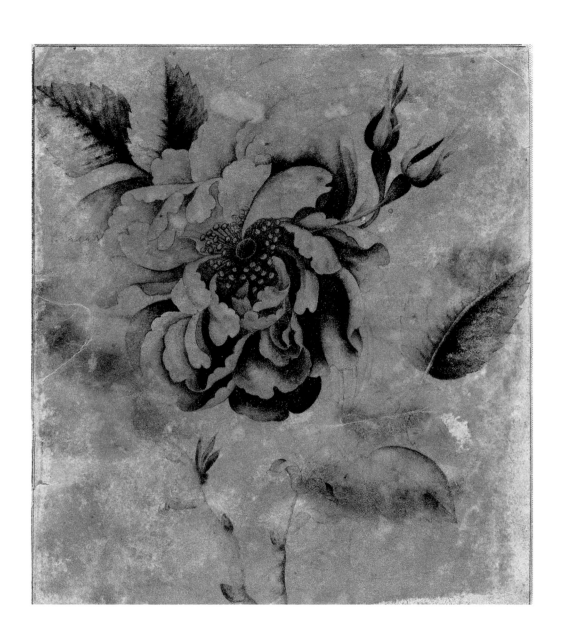

FIG. 15.1
Rose and Nightingale, Iran, 18th–19th century. Opaque water-color on paper, 12⅝ × 8½ in. (32.2 × 21.7 cm). Harvard University Art Museums, Gift of Eric Schroeder, 1969.170.

FIG. 15.2
Mirza Baba, *Rose,* Iran, dated A.H. 1214 / A.D. 1800. Ink wash, 8 × 5½ in. (20.3 × 14 cm). Brooklyn Museum of Art, Gift of the Asian Art Council, 1993.58.

nineteenth centuries this theme was widely used in architectural decoration, as in the carved marble dados of the Vakil Mosque and the tile-work panels of the Qavam family residence in Shiraz. In Tehran the tile-work decoration of the Gulistan Palace and the painted reception rooms of the house of the Qajar statesman Qavam Saltana executed by Lutf 'Ali Suratgar were notable examples of the superb quality work produced by Qajar artists in this mode.[5]

Sprig of Rose Blossoms illustrates the use of this theme in independent drawings and paintings—a genre that emerged in mid-seventeenth-century Isfahan. Such works had been assembled with samples of calligraphy in albums as early as the mid-sixteenth century. However, it was not until the advent of new European models in the form of herbals and pattern books for silk textile production that such naturalistically rendered flowering bushes, bouquets, and plants—sometimes accompanied by butterflies or insects—

flourished. Some of the finest works in this genre combining ink and wash drawing are found in an album in the British Museum by the painter Shafi' 'Abbasi.[6] The mid-eighteenth-century practitioners of this art—Muhammad Hadi, Muhammad Baqir, and Muhammad Zaman II—produced exquisite studies in opaque water-color as well as wash drawings that present clear affinities with this work.

Examples of the multipetaled, full-blown rose spray characteristic of this period include an anonymous study of a rose and a nightingale (fig. 15.1). Another example is a wash drawing in the Brooklyn Museum signed by the court painter, and follower of the above-named artists, Mirza Baba (fig. 15.2) and dedicated to Fath 'Ali Shah, the second ruler of the Qajar dynasty. The sensuously curving petals, rich velvety texture of the washes—ranging from soft gray to darkest black—gnarled stalks, and rendering of the pistils are very similar to the present work, and suggest that in spite of the similarity of nineteenth-century

floral paintings, individual hands may yet be distinguished and works attributed on a stylistic basis. This work may be either a sketch related to the Brooklyn piece by Mirza Baba himself or a later version by an extremely adept follower, such as Lutf 'Ali Suratgar.

Closer examination of *Sprig of Rose Blossoms* reveals that it is composed of two pieces of paper pasted together. A coarse cream-colored paper has been pasted onto the reverse of the page, perhaps to strengthen the support. Under infrared lighting, one can see that the coarse paper bears on its now-hidden face a figural drawing representing a woman with a nimbus, a rabbit, and a deer. This drawing, in a late-nineteenth-century style, seems to be a sketch for a narrative composition, such as Layla and Majnun or Solomon Enthroned with the Queen of Sheba. It appears, then, that this folio was preserved in an artist's working album of sketches and pounces.[7] Persian painters passed on their traditions from generation to generation, often within a single family. The importance of familial and student-teacher relationships is attested by artists' signatures of the seventeenth century featuring patronymics and punning references to teachers. Such albums allowed painters to replicate motifs and compositions with great skill and dexterity, accounting for the excellence and uniformity of Persian painting over long periods. That the figural drawing was pasted onto the back of the *Sprig of Rose Blossoms* supports an attribution to Mirza Baba and the contention that the work was preserved for later generations of painters to study and emulate.

LSD

Notes

1. A good example, in the Bibliothèque Nationale, Paris, is illustrated in color in Blochet 1929, pl. CLXVIII. It is signed by Shafi' 'Abbasi and dated to 1653. Other examples appear from time to time in the sale rooms.
2. See Ivanov and Akimushkin 1962, 93, 94, 103, pls. 87–90. The artists represented are Muhammad Zaman, Hajji Muhammad, and Muhammad Riza Hindi.
3. Rich 1836, 2:224.
4. Diba 2003.
5. Aghdashloo 1977, 138–47.
6. British Museum, no. OA 1988.4-23.056.
7. Riza 'Abbasi Museum and Cultural Center, no. 1299–1309, 1311–1510. For description, see Diba 1989, 157–59.

16 Portrait of Shah Abu'l-Ma'ali

Attributed to Mir Sayyid 'Ali
North India, c. 1545
Black ink, opaque watercolor, and gold on beige paper
10 × 6½ in. (25.3 × 16.5 cm)
Promised Gift of Stuart Cary Welch, Jr.
243.1983

Published: S. C. Welch 1976, 33, no. 6

Sᴀʏʏɪᴅ Abu'l-Ma'ali "was a dullard," as Bada'uni writes in his *Muntakhab al-Tavārīkh (Selected Histories)*—a quite decorative and enterprising dullard, however. Hailing from a Sayyid family in the Kashgar (Kashi) area, he became a favorite of the Mughal emperor Humayun, who even called him a "son." The generalissimo Bayram Khan wrote an acrostic poem about him. Abu'l-Ma'ali was invited to attend Akbar's accession party in 1556 but did not appear. Akbar forgave him owing to his father's friendship with the apparently rather charming young man. For some time Abu'l-Ma'ali was imprisoned in Lahore; after escaping he undertook raids in Kashmir. He was a heavy drinker, however, and cared so little for protocol that some sources claim he tried to overtake the emperor on horseback or refused to alight from his horse while greeting Akbar. After another jail sentence, he performed the pilgrimage to Mecca, and upon his return he went to Kabul to marry the young daughter of Humayun's widow, Mahchuchak, who was ruling the Kabul area. He stabbed his mother-in-law to death, was ultimately overtaken in a battle near Kabul, and hanged on 17 Ramadan 970 (8 May 1563). According to its inscription, a painting published in Milo Beach's *The Grand Mogul* depicts the reckless Sayyid's execution.[1]

Early portraits show Abu'l-Ma'ali as an elegant, charming young man, usually sporting the big, folded turban of Humayun's time, not looking like a person who would be likely to murder anyone, let alone his wife's mother, who had been the favorite of his foster father, Humayun.

A. Schimmel

In Persian painting ink drawings were usually practice sheets or copy models for various media. Yet even more than the painting for which the artist was primarily trained, ink drawing revealed his dexterity in draftsmanship and mastery in design, for it left no room for error or subsequent correction. The lines had

to be made in fluid strokes and with no hesitation. Ultimately, the hand movement was too quick for the eye to control, and as in a meditative state the image flowed almost directly from the mind of the artist onto paper. For the cognoscenti, the elegance of the line compensated for the lack of color; as princes and royal patrons delved into painting, the ink drawing became a prized genre.

Among the most beautiful possessions of Harvard's Arthur M. Sackler Museum is an ink drawing given by Philip Hofer in honor of Stuart Cary Welch (fig. 16.1). Cary published it in 1972 and rightly attributed it to Bihzad,[2] the great Timurid master who joined the royal Safavid library-atelier about 1522 and trained many of the second-generation artists, including Mir Sayyid 'Ali. It is thus most fortunate for the Sackler to receive as a gift Cary's own drawing by Mir Sayyid 'Ali, which illustrates so well the younger artist's indebtedness to the older one. Indeed, the most important features of Mir Sayyid 'Ali's human figures are their well-balanced anatomical proportions and a weight distribution that conforms to the laws of gravity. One really "feels" that this kneeling figure has a natural and comfortable pose.[3]

FIG. 16.1
Attributed to Bihzad, *Two Seated Men*, Iran, Herat, c. 1480–90. Ink on paper, mounted as an album leaf with calligraphy, with ornamental border, 15⅜ × 10⅞ in. (39.1 × 27.5 cm). Gift of Philip Hofer in honor of Stuart Cary Welch, 1972.299[v].

Other characteristics inherited from Bihzad are the last fold of the youth's robe, which is in tubular form, and the folds on the back of the robe that converge at the waist level into a plissé ending. In Mir Sayyid 'Ali's version the folds on the sleeves differ from his master's: they are tighter and cover a wider area, similar to those in a circa 1540 signed drawing of his.[4] Other Mir Sayyid 'Ali characteristics are the pronounced, tight eyebrows and their high distance from the eyes.

The special headgear of the kneeling youth clearly pegs the drawing to the reign of Humayun. And, half a century after Bihzad, the addition of slight washes of paint vouches for the acceptance of the genre, no longer as a valued practice sheet but as a finished product fit to constitute the central element of an album page.

A similar portrait by the artist Dust Muhammad of a handsome youth writing on a sheet of paper names the sitter as Shah Abu'l-Ma'ali of Kashgar, a favorite of Humayun and much reputed for his beauty.[5] The quatrain incorporated into the album page that extols the beauty of the Welch figure further suggests that it may indeed represent Shah Abu'l-Ma'ali:

> An angel cannot be without beauty and Divine
> Splendor
> [And thus he looks] as if God had fashioned him out
> of light.
> Words cannot describe his beauty
> He is beyond any description that I can offer.
> A. SOUDAVAR

Notes

1. Beach 1978, no. 5; also in Welch 1979, 194, no. 75.
2. Welch 1978a, 422.
3. This respect for the laws of gravity was imparted by Bihzad to his students. Mir Sayyid 'Ali and another second-generation artist, Mirza 'Ali, grasped it, but the master's own grandnephew, Muzaffar 'Ali, had difficulty; see, for instance, Soudavar 2000, 60.
4. Arthur M. Sackler Gallery, Smithsonian Institution, Washington, D.C., no. s86.0291, illustrated in Lowry and Nemazee 1988, 192.
5. A. Welch and S. C. Welch 1982, 146–48.

17 Master and Pupil (Prince Salim?)

Attributed to Aqa Riza Jahangiri
North India, late 16th century
Black ink and watercolor on beige paper
10¼ × 6½ in. (26.2 × 16.5 cm)
Promised Gift of Stuart Cary Welch, Jr.
242.1983

Published: Welch 1963a, 164, no. 17

SEVERAL Mughal pictures of schoolmasters and pupils attest to the dynasty's devotion to learning. Although the identification of the amiable, stout, bearded tutor has been elusive, his attentive pupil must be Prince Salim, who was born in 1569 and came to the throne with the regnal title Jahangir upon the death of his father, Emperor Akbar, in 1605. Because this elegantly dressed and plumed young fellow seems to have been twelve to fourteen years old when this picture was drawn, its date would fall between about 1580 and 1585, which is consistent with its style.[1]

On the basis of comparison with works by him, I am convinced that the artist was Aqa Riza, later known as Aqa Riza Jahangiri. He is briefly mentioned in the *Jahāngīrnāma*, the emperor's engagingly candid book of memoirs, in connection with his more admired son, Abu'l-Hasan, "[whose] father was Aqa Riza of Herat, who joined my service while I was prince. Abu'l-Hasan therefore is khanazad to this court. His work, however, is beyond any comparison in any way to his father's; they can't even be mentioned in the same breath."[2]

Because this double portrait is so appealingly sensitive, we speculate that the emperor's unduly harsh judgment might have been prompted by a strain between the artist-father and the paternalistic patron over the brilliant boy's artistic education. Prince Salim's face apparently was sympathetically drawn from life; and the Edward Lear–like schoolmaster appears to be an equally heartfelt likeness. The fact that Prince Salim's robe ties beneath the left shoulder, signifying ordinarily that the sitter is a Hindu rather than Muslim, suggests that the drawing was made soon after the

Persian-born artist had come to join the connoisseur prince's formative ateliers and before he had adjusted fully to Mughal ways. If Aqa Riza Jahangiri failed to observe accurately the position of the ties, he strove particularly hard to please his precocious patron, whom I believe, despite the lack of corroboration from comparably youthful likenesses, to be Prince Salim. No other youth would have been accorded such sensitively nuanced treatment. Not only did the artist anticipate future commissions from him, but he was evidently moved by the prince's intelligent and sensitive face.

Eric Schroeder in his excellent catalogue of Persian and Mughal pictures in the Fogg Art Museum wrote insightfully about the style and artistic personality of Aqa Riza Jahangiri.[3] His extensive documentation and convincing attribution of *A Gentleman with a Gold Wine Cup* enabled us not only to ascribe to Aqa Riza Jahangiri this remarkable double portrait but also to attribute to him two admirable historical subjects in the Art and History Trust Collection.[4] In both, the Persian-born artist has adjusted to imperial taste by emphasizing sculptural roundness of form, especially in faces, a characteristic especially successful in this notable characterization of young Prince Salim.

SCW

Notes

1. For other such depictions, see Kühnel and Goetz 1923, pl. 13 (*Humayun as Master:* the pupil, an unidentified prince, also sporting a black plume in his turban); and pl. 14 (*Shaykh Salim Chishti with Prince Salim*). For a delightful later portrait drawing by Mir Hashim of Prince Sulayman Shukoh with his tutor, see S. C. Welch 1976, no. 20. See also Schroeder 1942, in note 3, below.

2. Thackston 1999, 268. Although Aqa Riza's birthplace is identified in this document as Herat, many authorities believe he was born in or possibly migrated to Mashhad, where his son Abu'l Hasan is said to be from. For a discussion of this discrepancy see Verma 1994, 62–64.

3. Schroeder 1942, *A Gentleman with a Gold Wine Cup*, 109–13, pl. XIX.

4. Soudavar 1992, pls. 128b, *Teymour in the Battlefield*, 128c, *Teymour's Army in Procession* (also, detail facing p. 303). Both are attributable to Aqa Riza Jahangiri.

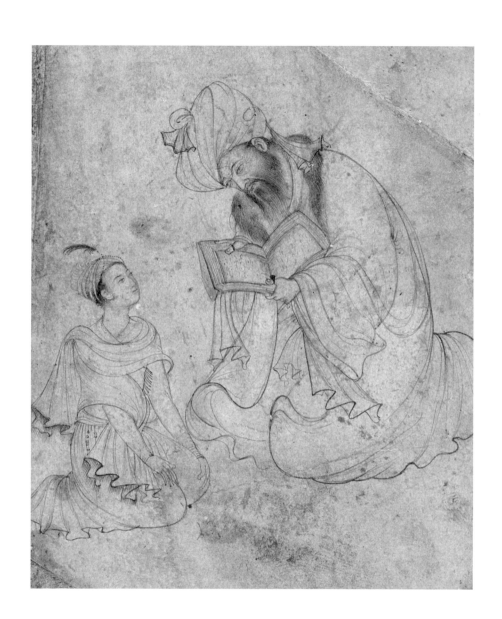

Attributed to Daswanth
North India, c. 1560
Black ink and watercolor over traces of charcoal on
beige laid paper
7¼ × 4¾ in. (18.5 × 12 cm)
Promised Gift of Stuart Cary Welch, Jr.
76.1999.27

MUGHAL artists' studies of holy men are among their outstandingly sensitive and perceptive works. The earliest known to us is this extremely early tinted sketch of a shrine before which an ascetic drowsily meditates, seemingly oblivious to his attendants. He sits in the shade of a tree that is virtually traced from the work of either 'Abd al-Samad or—more likely—Mir Sayyid 'Ali. Both artists were among the extraordinarily gifted and masterful Safavids recruited in Persia by Emperor Humayun during his years of exile from India between 1540 and 1555. Propitiously, Humayun was welcomed at the court of Shah Tahmasp in 1542, at the very time when the shah had lost interest in painting in order to devote himself to religious orthodoxy.[1] Also derived from one or the other of these former Safavid master's works are the sinuously calligraphic outlines of the cast-off robe upon which the holy man sits, along with elements of figure drawing. Regardless of whether a former Safavid master's hand is identifiable in this work, one of them strongly influenced the Mughal painter. He almost certainly was Daswanth, who along with Basawan (see cats. 19, 21) was especially admired among the indigenous artists recruited for the imperial ateliers and trained by the former Safavid artists.

At first glance, nearly fifty years ago, this picture profoundly impressed me with its contrasting characterizations of the calm, almost somnolent holy man, his attentive but quiescent older follower, and the energetically crawling child-cook, each of whom must have been observed from life. Two of these figures are extremely early examples not only of Mughal portraiture but also of Mughal treatment of the nude, which was conveniently and frequently observed only in unclothed holy men. Although nudity is rarely if ever found in Safavid painting before the late seventeenth century, it is occasionally seen in the work of Safavid artists after their arrival in India. The guidance of these émigré artists, however, was not greatly helpful to Daswanth, their Hindu follower, in drawing the ascetic's undraped chest, ribs, and legs, which are in fact awkwardly rendered.[2]

In the absence of signed or inscribed work, my attribution of this engrossing sketch to Daswanth was a daring speculation. It occurred to me soon after discovering the picture, when I noted that the young servant boy in the foreground is almost identical to another scurrying lad in one of the most turbulently designed pictures for the *Dāstān-i-Amīr Hamza* (known as *Tales of Hamza*), the giant-sized set of paintings that were mostly outlined and painted at Fatehpur Sikri for Emperor Akbar. *Songhur Balkhi and Lulu the Spy Are Received by Baba Bakhsha, a Former Spy Living in Aqiqnagar*, surely by the same artists, is one of the *Hamzanāma's* ripplingly energetic masterpieces.[3] In its windswept intensity, that eye-seizing painting conforms to my notion of Daswanth, the van Gogh of Mughal artists. The demonic tree trunk fascinates and stuns, as do the maelstrom of rhythmic patterns, the un-still but majestic still lifes (each object dances), and the menacingly decorative weapons. Dominant at center stage is bejeweled Baba Bakhsha, the dagger-eyed spy emeritus, whose guests will soon be offered (and probably succumb to) the concoction of bhang (hemp) being strained by gently accomplished specialists in the shade of the seething tree. At once fierce, mysterious, fascinating, and supercharged, this finely worked masterpiece conforms to the idiosyncratic personality of ill-starred Daswanth.

Along with the great Basawan, Daswanth was one of two Indian-born artists in Akbar's ateliers accorded individual paragraphs by Abu'l-Fazl 'Allami in his *Ā'īn-i Akbarī (The Statutes of Akbar)*. "He," wrote Abu'l-Fazl,

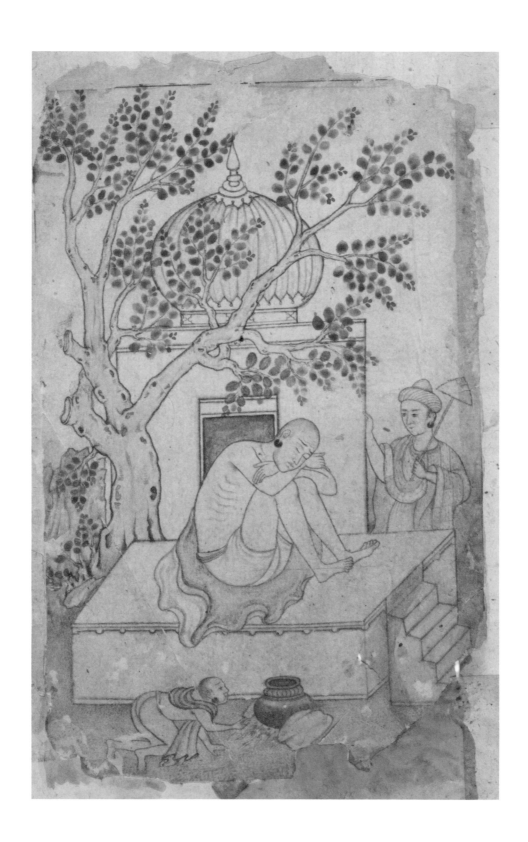

"is the son of a *palkee* [palanquin] bearer. He devoted his whole life to the art, and used, from love of his profession, to draw and paint figures on walls. One day the eye of His Majesty fell on him; his talent was discovered, and he himself handed over to the Khwaja ('Abd al-Samad). In a short time he surpassed all painters, and became the first master of the age. Unfortunately the light of his talents was dimmed by the shadow of madness; he committed suicide. He has left many masterpieces."[4] I am not surprised that his surging talents were recognized and encouraged by the equally dynamic Akbar, who was better positioned to release and express all the painter's potency.

S C W

Notes

1. See Dickson and Welch 1981, 1:178–200. I find the present drawing to be closer to the work of Mir Sayyid 'Ali than to that of 'Abd al-Samad. See a painting by Mir Sayyid 'Ali in my essay about it, "Hark, Hark, the Simurgh! 'Zal in the Simurgh's Nest" (forthcoming in a festschrift for Robert Skelton edited by Rosemary Crill). It was painted by Mir Sayyid 'Ali for a manuscript of the *Shāhnāma* of Firdawsi illustrated for Emperor Humayun.

2. For an extraordinary picture, in effect a Kumbh Mela of naked holy men, designed and partly painted by Mir Sayyid 'Ali, see *Mughals Visit an Encampment of Sadhus*, in von Habsburg et al. 1996, 116–17, pl. 211. During the early seventeenth century, it was acceptable for Mughal artists not only to depict naked holy men but to draw and paint the nude forms of European women, whose bodies were explicitly visible, as though seen at the bath through clingingly wet saris.

3. Glück 1925, pl. 40; Egger 1974, pl. 47; Welch 1977, pl. 3; Seyller 2002, 193, pl. 64. For another drawing attributable to Daswanth, see *A Learned Man* in S. C. Welch 1976, no. 7. Formerly ascribed to Basawan, this monumental portrait with its gargoyle-strong profile, I am now convinced, is by Daswanth. Compare it with Seyller 2002, pls. 53 and 14–15. I have taken the English title of the *Hamzanāma* painting discussed here from Seyller 2002, 98, cat. 64.

4. Abu'l-Fazl 1867–77 (Reprint 1977), 114–15.

19 Ascetics Making Bhang

Attributed to Basawan
North India, c. 1585–1620
Black ink on off-white paper
6⅝ × 3½ in. (16.7 × 8.8 cm)
Promised Gift of Stuart Cary Welch, Jr.
77.1983

Published: Hodgkin and McInerney 1983, fig. 50

IN THIS small drawing we encounter four youths in a wooded setting. Three are handling pots and a basket while a fourth peers down upon their activities from behind a tree. The figures are nude, covered, if at all, only by wavy hair. They are accompanied by a dog, seated to the right, and have a single walking stick between them. All these elements—the nudity, the walking stick, and the dog—are attributes of India's religious ascetics and common to their artistic portrayal. Ascetics renounce life in society to focus on their spiritual development. Their nakedness represents their abandonment of the material world. Religious ascetics often find companionship in dogs, animals that scavenge an existence on the outskirts of Indian society. The small cane with the curving handle is also an attribute associated with these spiritual sojourners.

The activities of these figures are curious. The young men wielding vessels may be in the process of manufacturing bhang, an intoxicating beverage made from the cannabis plant. In the preparation of bhang, cannabis leaves and flowers are collected, cooked, and ground into a paste. The paste can be seasoned with nuts, spices, and water, often with milk filtered through it. This concoction is used by Hindu sadhus, particularly in the rituals and festivals associated with the god Shiva. Bhang is also used by Sufis to help them achieve a state of religious ecstasy.

Stylistically, this drawing is quite similar to the work of Basawan, and may be attributed to him. Basawan is known for his exquisite *nīm qalam* drawings. These were drawings tinted with transparent, usually tan, washes, and many of them were based upon European engravings.[1] Basawan's playful translation of the print medium into his own drawings is evident in his use of hatched lines and stippling to indicate shading. Basa-

wan also adopted a Westernized treatment of the body in his work, evident in the swelling volumes and underlying musculature exhibited by our industrious ascetics. The cockeyed face of the figure on the far left of the composition is similar to the rendering of faces in other works inscribed by Basawan, including the drawing *Kanphata Yogi and Dog* published here (cat. 21).[2] Other details that are closely related to works from Basawan's hand include the quick, curving brushstrokes used to create wisps of hair and fluttering leaves.

KM

Notes

1. For more on Basawan, see Okada 1991; Verma 1994, 83–94.
2. Note, also, the similarity in facial features between the present drawing and the allegorical study *Jeune femme et vieillard* in the collection of the Musée Guimet, no. 3619,J,b, illustrated in Okada 1989, 190–91, cat. 55; Okada 1989, no. 55.

Attributed to Miskin
North India, c. 1585
Black ink, watercolor, opaque watercolor, and gold
(with punchwork) on off-white paper
12⅜ × 8⅛ in. (31.5 × 20.6 cm)
Gift of Stuart Cary Welch, Jr.
1999.297

Published: Welch 1963b, pl. 4, fig. 7; Welch and Beach 1965, 164, fig. 12; Quraeshi 1988, 72

IN THIS sumptuously detailed scene, we are invited to witness a battle pitting a predatory lion against a powerful bull. The struggle is set in the wilderness, but not terribly far from a town whose spires break the horizon. The Mughal emperor Akbar, seated on the bank of a stream, intently watches the sparring animals. The fight is framed by a ring of figures, many of them beaters from a hunting party. It is possible that they did not just encounter the fight but staged it by driving together a wild lion and a domesticated bull. Images depicting struggles between carnivores, usually lions, and herbivores have appeared in Near and Middle Eastern art since ancient times. Just like the hunt for large game, the animal fight was a royal prerogative. It is fitting that Akbar is shown witnessing an event of such regal importance.

Although the main subject of the drawing is the animal fight at the center of the composition, the viewer's eye is also drawn to the figures of Hindu ascetics in the foreground. This group of matted-haired yogis and their young disciples is completely removed, visually and emotionally, from the activity nearby. In Mughal painting ascetics like these became an iconographic fixture of the wilderness, just like the foliage and animals that surround them. Akbar himself was fascinated by the beliefs and practices of Hindu sadhus, and they became a common subject in paintings and drawings executed in his school.

This late Akbari-period drawing has been attributed to the artist Miskin,[1] who is perhaps best known for his densely packed scenes for the circa 1590 illustrated manuscript of the *Akbarnāma*. Miskin is also associated with several *nīm qalam*, or tinted drawings,

similar to this one.[2] Indeed, many of the hallmarks of Miskin's oeuvre are here. The multitiered composition with foreground, middle ground, and distant background separated by cascading rocks is common in his work. His evolved landscapes successfully achieve a sense of depth not found in their Persianate predecessors. At the same time, Miskin employed a traditional, tipped-up perspective incorporating multiple vantage points, so that the viewer peers down into a scene, but encounters the actors frontally. Miskin's sinuous line and careful observation imbue his figures with a sense of vitality.

Miskin was particularly adept at rendering animals in a natural setting. This is evident in his wonderfully vibrant and busy scenes of *The Great Hunt near Lahore* in 1567 for the *Akbarnāma*, now in the Victoria and Albert Museum, for which Miskin was the designer.[3] Another later Miskin painting adopts the setting and theme of the animal combat pictured here. In *The Assembly of Animals*, for an illustrated manuscript of the *Anvār-i-Suhaylī* dated 1596, Miskin provided a lush and varied landscape populated with a range of animals, both predators and prey.[4] Near the center of the composition of *The Assembly of Animals* a panting lion presides. He peers down upon a bull, whose hunched pose is almost identical to that of the embattled animal in this elegant tinted drawing.

KM

Notes

1. For a list of this prolific painter's work, see Verma 1994, 281–87.

2. In previous publications, Cary Welch has cited several other comparable paintings and tinted drawings, including a scene depicting Prince Salim being attacked by a wounded lion, signed by Miskin; see Welch 1963b, 224, which cites Basil Gray in Ashton 1947–48, 157, pl. 134. There Welch also points to several related images from other collections that may also be the work of Miskin. These include *Beasts, Real and Mythological on a Rocky Hillside*, in the Chester Beatty Library, no. Ms 73 (1), and the British Museum, no. 1920-9-17-05; and *The Animal Kingdom* in the Freer Gallery of Art, no. 45.29, to name a few.

3. These pages, acc. nos. I.S. 2.1896 55 and 56/117, are illustrated and discussed in Vaughan 1991, 24–26, fig. 7.

4. This painting, in the collection of the Bharat Kala Bhavan, Varanasi, is also illustrated in Vaughan 1991, see 34–35, fig. 16.

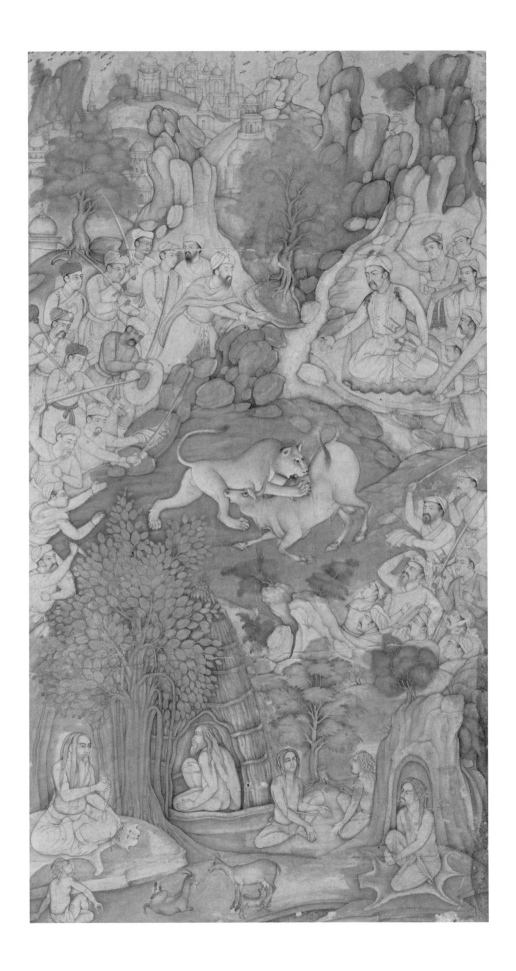

Attributed to Basawan

North India, c. 1590

Black ink and watercolor on beige paper

10¼ × 10½ in. (26.2 × 26.6 cm)

Promised Gift of Stuart Cary Welch, Jr.

628.1983

Published: Welch 1963b, pl. 3, fig. 6

WITHIN the bounds of this tiny composition, we encounter yet another finely drawn ascetic. Leaning on his staff, this open-mouthed mendicant gestures at the sky, as if caught in the middle of a divine conversation. Set against a blank background except for a light wash to suggest a ground plane, the holy man is clearly the singular interest of the artist.

This rich image was produced by building up layers of delicate ink strokes, used to create the fur in the ascetic's animal-skin cloak, the hairs of his beard, and the modeling of his skirt. The final work exhibits a manual refinement and broad tonal range indicative of a master draftsman. This work is almost certainly from the hand of Basawan.

Basawan was one of the most accomplished artists of Akbar's painting school, ranked among the top four painters in the atelier in Abu'l-Fazl's record, which describes his ability to accurately draw the features of his subject.[1] Basawan actively experimented with foreign sources and recombined elements of Indian, Persian, and European art to create his own vocabulary. He is well known today for his monochromatic drawings based upon European engravings. These studies pushed the genre of drawing to a level of detail and naturalism unknown in the Persianate styles of early and pre-Mughal India.[2]

A signed drawing of a dervish in the Musée Guimet, Paris, is a close companion to the present image.[3] The two holy men share many details. They wear similar skirts and animal-skin cloaks and carry many of the same objects, including the begging bowl, staff, and crescent-shaped horn. Each ascetic is also accompanied by a bristly haired, weasely dog. These animals are so close in appearance that they could have come from the same litter. The similarities in the rendering of the holy men's features are most striking. The Guimet and the Harvard ascetics both have gaunt, expressive faces, shown in a three-quarter view. In these portraits, Basawan's dexterity and sensitivity are evident.

The gesturing figure of the present drawing has been identified as a *Kanphata*, or *Nath siddha*, associated with the *Gorakhpanthi* lineage of Hindu ascetics.[4] The order takes its name, *kan* (ear) *phata* (split), from the large holes that the guru bores into practitioners' ears during their initiation into the sect.[5] These piercings hold the large earrings that are one of the sect's identifiable attributes. Earrings are clearly visible in the present drawing; however, several other attributes, like the crescent horn, are more generic and may also be associated with Sufi practice.[6] Mysticism and asceticism are acceptable religious paths in both Hindu and Muslim traditions, and during the Mughal period these spiritually advanced practitioners were objects of veneration and curiosity for rulers and artists alike.

KM

Notes

1. This oft-cited list is recorded in Abu'l-Fazl 1867–77 (Reprint 1977), 114.

2. For a detailed list of Basawan's paintings and drawings, see Verma 1994, 83–94.

3. See, for example, Okada 1991, 15, fig. 15; also discussed in Chandra 1984, 314.

4. *Kanphata* is a common term used to describe the *Natha* order in North India. For an attribution of the figure, see Welch 1963b, 225.

5. For a detailed discussion of the history, beliefs, and practices of the *Nath siddhas*, see White 1996, 122, 321. For a discussion of the iconography of various Shaivite sects, see Chandra 1984, 312–16.

6. See Okada 1991, 13.

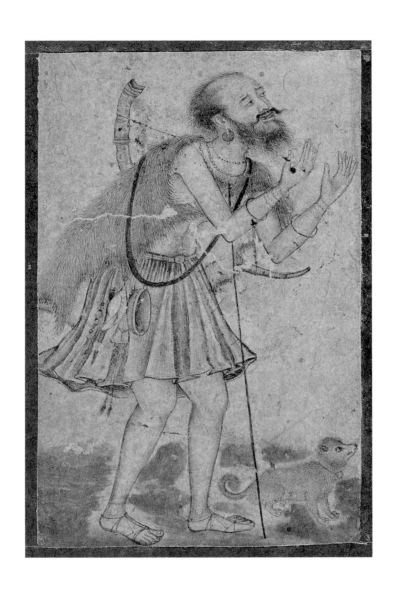

22 Satirical Portrait of Four Ascetics

North India, c. 1600
Gray-black ink, watercolor, and gold over traces of
charcoal on off-white paper
8½ × 8 in. (21.7 × 20.2 cm)
Promised Gift of Stuart Cary Welch, Jr., in memory of
Nasli and Alice Heeramaneck
616.1983

As WE approach a lone tree, suggestive of a wilderness setting, we come upon a very strange sight. A group of four ascetics of various ages have made this their post. Two accomplished yogis sit in the center of the composition, attended by younger disciples. The eldest, most serious yogi has long, matted hair and a beard. He sits in silent meditation, completely withdrawn. The two disciples, however, are ignoring his example and have turned their attention to the younger master in the foreground. This sadhu has little in common with his steadfast companion. He is seductively posed in a reclining position, not a yogic posture expected of a true practitioner of the science. He dips his head demurely, while gently fingering his prayer beads. With his idealized face and swelling muscular form, he is certainly one of the most attractive yogis to be found in Mughal art. Perhaps this fact is not lost on the young disciples, who fawn over him: as one fans him the other offers him the bounty from his own beg-

ging bowl. Both acolytes are young, and their newly shaved heads may indicate recent vows of renunciation. In contrast with the supple figure of their chosen master, they appear physically awkward, though each shows the swollen, breath-filled belly associated with the practice of yoga.

This comical image is clearly indebted to examples of European art present at the Mughal court. An obvious appropriation is the blue swag of cloth that falls loosely across the lounging ascetic's lap. Its crisply defined folds are reminiscent of the drapery found in European engravings, like the classicizing depictions of the Virtues copied by the artist Basawan. The exploration of flesh and musculature is also derived from European models, as is the more naturalistic shading. Basawan's famous study of ascetics in the India Office Library collections of the British Library offers a good comparison to the present drawing.[1] Through soft, expressive lines and exaggerated features Basawan gave comic personalities to a well-fed wandering master and his scrawny disciple. That early achievement has been transformed by this unknown artist, whose fuller figures act out a scene that is less reserved in its critique of those who pursue earthly rather than spiritual fulfillment.

K M

Notes

1. Illustrated in various sources, including S. C. Welch 1976, no. 9.

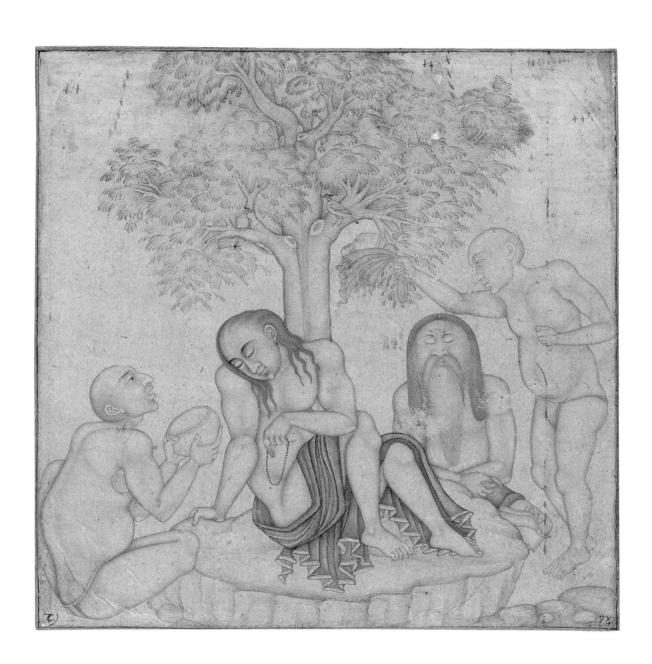

23 The Huntsman Anup Rai Freed from a Lion by Emperor Jahangir and Prince Khurram

Attributed to Abu'l-Hasan
North India, c. 1610
Black ink over charcoal on beige laid paper
7 × 7¼ in. (17.9 × 18.5 cm)
Gift of Stuart Cary Welch, Jr., in memory of Philip Hofer
1999.301[v]

Published: Welch 1985, 186–87, fig. 117; Thackston 1999, 117; Harvard University Art Museums 2000, 35; McWilliams 2000, 12–14, fig. 4

Inscriptions: (top left border) in Arabic script, "b[p?]ādshāh jahāngīr," and in *Devanagari* script, "jahāngīr pātishāh"; (top right border) in Arabic script, "b[p?]ādshāh zādah khuram," and in *Devanagari* script, "shāh jādā shāh jihān kh[?]urram"; (bottom middle border) in *Devanagari* script, "anīrāy v—[?] jar jamīdār anop fāhar," and in Arabic script, "anīrāī sub k[g?]ūjar zamīndār ānup shaher"

ARTISTS working for the Mughal court were entrusted with the duty of documenting significant moments in court life and valorizing and legitimizing their patrons. This impressive drawing fulfills these functions. The inscriptions in the borders identify the three figures as Emperor Jahangir, Prince Khurram, and Anup Rai. In both lower inscriptions, Anup Rai is referred to by his name, and his later title, "anī rāī."[1] The *Devanagari* inscriptions appear to be later additions.[2]

The event depicted here is documented in the *Tuzuk*, the history of Emperor Jahangir, and the *Pād-shāhnāma*, the history compiled by Jahangir's son and successor, Shah Jahan.[3] According to these records, an unfortunate lion attack occurred during the fifth year of Jahangir's reign when Jahangir and Prince Khurram, the future Shah Jahan, were on an afternoon hunt. The hunting party included Anup Rai, a courtier and friend of Jahangir. The party encountered a large lion, and Jahangir set off in pursuit. The dramatic passage goes on to describe how Jahangir got off three shots at the

charging lion. In the frenzy of the attack, several members of the party fled, knocking Jahangir down. Turning toward the lion, Anup Rai dropped his gun, and at that moment the wounded animal lunged upon him. Rai is portrayed valiantly fighting the lion unarmed, not succumbing even when his arms are pinned in the angry animal's mouth. However, the true heroes of the day were Prince Khurram and two attendants, Ram Das and Hayat Khan. These three hunters struck the lion and drove him away from Anup Rai. Rai suffered serious wounds in his arms and chest but after he recovered Jahangir honored him by bestowing on him the title *ani rai singhdalan*, "the commander of lion slayers."

This depiction of Anup Rai's harrowing escape differs slightly from its description in prose. The sketch provides little contextual information, disregarding several key figures of the hunting party as well as the setting of the attack. The bare ground is broken only by the powerful silhouettes of Jahangir, Prince Khurram, the fallen Rai, and the lion. Intended to extol the actions of the imperial patrons, this economical depiction omits Ram Das and Hayat Khan, who joined with Khurram in fighting off the lion.

The drawing is also visually sparse. Most of the forms are rendered in contour line, with little interior delineation or shading. However, the faces of Jahangir and Prince Khurram show much sharper detail: their profiles are heavily worked and their features conform to other portraits of them. The composition is carefully arranged. Jahangir and Prince Khurram are placed at the same height, while Rai and the attacking lion wrestle between them, creating a powerful triangular composition. The drawing presents a well-constructed template rather than a quick sketch inspired by the live event.

Whatever this drawing may lack in detail, it makes up for in its visual clarity and power. Few Mughal artists achieved such a perfect balance between understated line and vivid portraiture. Perhaps the greatest master of imperial portraits was Abu'l-Hasan, to whom

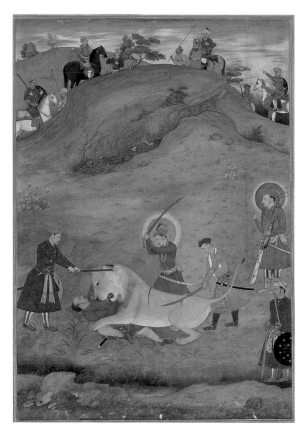

this drawing is attributed here. Abu'l-Hasan was the
son of the Persian artist Aqa Riza Jahangiri of Mashhad.
Like his father, Abu'l-Hasan painted for Jahangir, but
his works evoked a realism far beyond that of his Per-
sianate heritage. Abu'l-Hasan's first known work is an
emotional figure study based upon an engraving of
Saint John by Albrecht Dürer.[4] In rendering the figure
of the apostle, Abu'l-Hasan easily navigated between
careful facial modeling and suggestive contour lines.
His maturity as a portraitist is evident in his famous
series of images utilizing an oblique, personal symbol-
ism to render Jahangir as a world-conquering, spiritu-
ally elevated sovereign.[5] The accuracy of the likenesses
in this drawing combined with its dexterity are the
main reasons it has been attributed to Abu'l-Hasan.

A later, finished work illustrating the eventful lion
hunt was painted by Balchand for the *Pādshāhnāma*.[6]
Although the painting (fig. 23.1) is set in a naturalistic
landscape and includes more of the figures associated
with the attack, Balchand's indebtedness to this draw-
ing is evident. In fact, his rendering of the assaulting
lion is nearly identical. Balchand was an accomplished
draftsman, as is evident in his signed painting of the
dying Inayat Khan in the Bodleian Library, Oxford. He
may also be the author of the preparatory sketch
for that painting in the Museum of Fine Arts, Boston,
which is one of the most haunting and evocative of
all Mughal works (see Welch essay, fig. 3).[7] However,
Balchand's figures in the finished *Pādshāhnāma* page
lack the energy and movement seen in this sketch.
Thus, although Balchand was certainly aware of this
heroic drawing, we do not have convincing evidence
that he is its author. Another painter who addressed
the subject of a lion attack in a comparable manner was
Nanha. In *Lion Attacking a Man* (Free Library, Philadel-
phia), Nanha painted a strikingly similar lion mauling
a hapless victim.[8] The heroic events of the lion hunt
presented in Abu'l-Hasan's early image were transmit-

ted through tracings and copies in both Mughal and Hindu painting circles throughout the seventeenth and eighteenth centuries, granting a nearly iconic status to this powerful and exquisitely rendered scene.[9]

K M

A page of *shikasta* calligraphy has been mounted on the recto of this album folio (fig. 23.2). The Persian text, by an unidentified author, is a metaphorical description of the act of writing, interspersed with Arabic quotations from the Qur'an and Hadith. Abstract and florid in character, the text is difficult to render in English, but a sense of its meaning can be grasped as:

> The lone rider in the realm of creation is he who, mounted on the swift steed of the soul, has galloped into the arena of existence, and seated on a graceful horse has ridden into the avenue of the page. Sometimes he addresses "a form of poetry is magic," sometimes he honors "a form of poetry is wisdom," honored slogan of those who are in the vicinity of the shrine of prayer, and the pious ornament of those praying at *masjid al-haram* [Mecca], at times [honoring] not choosing distance from the sense of imagination and effort of the soul, purity of the breast, perforation of the door of the rubicund house of time, the surface of the pen, the black stone of the inkwell, the pillar of the book and the jewels in the border.[10]

The lone rider represents the mind. The black stone, pillar, and jewels (or rocks, *hajar*) are references to the Muslim's duty of making pilgrimage to Mecca.

M M

Notes

1. The Persian inscription includes the term *gūjer*, which may refer to the Indian clan that forms a kingdom in Rajasthan and western Uttar Pradesh. Sugata Bose suggests that this term may indicate that Anup Rai was a zamindar, or landholder, from the Gujer region.
2. These inscriptions were transliterated and interpreted by Lata Parwani and Kimberly Masteller.
3. Cited in Welch 1985, 186–87; Thackston 1999, 117–18.
4. *Saint John*, after Albrecht Dürer, dated A.H. 1009 / A.D. 1600–1601, Reitlinger Collection, Ashmolean Museum, Oxford, recently illustrated in Losty 1991, 71, fig. 2.
5. An excellent example of Abu'l-Hasan's mature portraits is *Jahangir's Dream of the Visit to Shah 'Abbas*, from the Leningrad Album, now in the Freer Gallery of Art, Washington, D.C., no. 45.9, reproduced, for example, in Ettinghausen 1961; Welch 1977; Losty 1991, 83, fig. 13.
6. The painting, *Prince Khurram Attacking a Lion*, from the *Pādshāhnāma*, fol. 135b (c. 1640), is in the Royal Library, Windsor Castle; discussed in Smart 1991, 144, fig. 12.
7. Ellen Smart has recently identified the painted-out signature of Balchand in the painting in the Bodleian Library. This causes one to question whether Balchand is also the artist of the drawing of Inayat Khan in the Museum of Fine Arts in Boston. See Smart 1999, 273–79.
8. Illustrated and discussed in Beach 1978, 148–49, cat. 50.
9. For an illustration of a later copy in the Berkeley Art Museum, no. 1998.42.12, see Del Bontá 2002, 159, fig. 11.
10. This translation reflects the combined efforts of Mahdokht Banoo Homaee, Mary McWilliams, and Sunil Sharma.

Attributed to Abu'l-Hasan
North India, c. 1610
Black ink, opaque watercolor, and gold on beige paper
10⅜ × 6½ in. (26.5 × 16.5 cm)
Promised Gift of Stuart Cary Welch, Jr.
76.1983

FRAMED between a spray of flowers and a leafy branch, a pair of pigeons scampers across the ground. The male stands proudly upright, his head held tight to his breast. His mate walks in front of him, bobbing low as if about to peck at a tasty morsel. Luscious vegetation surrounds them. A wide dome rises up at the back, creating a sense of spatial recession in an otherwise flatly rendered image. The pigeons are set off against the blank ground through an application of bluish gray wash, carefully controlled to suggest the darkened plumage at the crowns of their heads and the ornate striping of their wings. The same wash is used to model details of the dome in the background. A faint brown wash fills the upper third of the composition, suggesting a horizon and adding to the perception of space.

This delicate, finished drawing betrays the hand of a highly accomplished court artist. The seductively simple arrangement is in fact carefully organized. The artist played with repetitive forms, creating a sense of rhythm that pulls the composition together. The curving shapes of the full, fleshy leaves in the foreground are repeated in the silhouettes of the birds, the curve of the dome, and the gently arching branch above. Perhaps the most striking aspect is the exquisite use of line. Confident calligraphic strokes are linked together in a seemingly effortless fashion to create both flora and fauna. The lines are rendered in a lively and economical manner, without excess detail to clutter the image.

Few Mughal masters displayed the lightness and control necessary to create this lively scene. Mansur, a favorite of Emperor Jahangir, certainly comes to mind. He is best known for his carefully observed studies of animals, and he executed several animal portraits in the emperor's collection.[1] Mansur was concerned with accuracy, often depicting individual hairs and feathers. The artist of this work, however, was equally concerned with line and form. The strong calligraphic contour lines also betray a debt to the courtly styles of Safavid Persia. These elements have led Stuart Cary Welch to attribute this exquisite drawing to the hand of another of Jahangir's masters, Abu'l-Hasan.[2] Considered by scholars one of the preeminent Mughal portraitists of the early seventeenth century, Abu'l-Hasan was the creator of several allegorical images of Jahangir from about 1616 to 1620; however, his skills also extended to nature subjects.

Abu'l-Hasan's father, Aqa Riza Jahangiri, was one of the great Persian artists who graced the court atelier of Emperor Akbar. That Abu'l-Hasan was trained in Safavid approaches, including the use of calligraphic line, is evident in his early Persianate-style illustration *Dabshalim and Bidpa'y* for an *Anvār-i Suhaylī* in the collection of the British Library.[3] The controlled contours and harmonious composition of this tiny tinted drawing resonate with Persian sensibility, elements that were certainly evident within the oeuvre of Abu'l-Hasan.[4]

KM

Notes

1. For examples, see Mansur's paintings of a falcon and the copy after his study of a turkey cock, both in the Maharaja Sawai Man Singh II Museum in Jaipur, illustrated and discussed in Das 1991, 41–52.

2. Compare with cat. 23, *The Huntsman Anup Rai Freed from a Lion by Emperor Jahangir and Prince Khurram.*

3. Illustrated and discussed in Losty 1991, 72, fig. 3.

4. On Abu'l-Hasan, see Losty 1991; Verma 1994, 47–55 (includes a list of paintings).

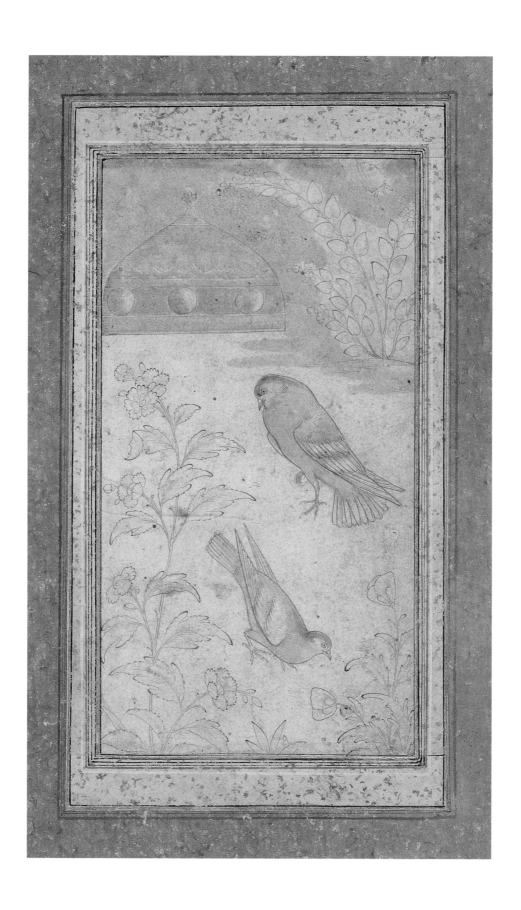

25 Woman Playing a Zither

Attributed to Govardhan
North India, c. 1610
Black ink, watercolor, and gold on beige paper
10⅝ × 7⅛ in. (27 × 18.1 cm)
Promised Gift of Stuart Cary Welch, Jr.
619.1983[r]

Published: Welch 1963b, pl. 6, fig. 10; Bailey 1998, 24, fig. 15

W HO MIGHT this young woman be, sitting in a lovely landscape, totally immersed in her playing? Female musicians were a fairly common subject in Islamic art: a number of early ceramics portray women playing an instrument, usually stringed. The fact that this player is not veiled but rather elegantly attired to attract the onlooker's interest proves that she is most likely a member of the so-called *tawa'if*. These women were a kind of *hetaere*, or courtesan, and played an important role in upper-class society. While a respectable woman had to be secluded—ideally, she needed to be not only invisible but unable to be heard by a stranger—the women in the *tawa'ifs* were highly educated, and formed the most expensive group of slaves. The *Arabian Nights* is replete with poems attributed to the singing slaves who entertained noblemen with their wit, scholarly expertise, and refined behavior, and a novel by the nineteenth-century Lucknow writer Ruswa, *Umrāo Jān Adā* (1905), describes the life of such a courtesan.[1]

Much of the poetry composed by women in the Islamic world in premodern times was the work of courtesans. An interesting example from the area where this miniature may have been executed is the late eighteenth- and early nineteenth-century poet Mahliqa Chanda, whose Urdu poetry—including typical Shi'a lamentations—made her famous and so wealthy that she was able to pay for the construction or repair of

FIG. 25.1
Calligraphy (verso of cat. 25), Iran or India. Ink, opaque watercolor, and gold on paper, 10⅝ × 7⅛ in. (27 × 18.1 cm). Promised Gift of Stuart Cary Welch, Jr., 619.1983[v].

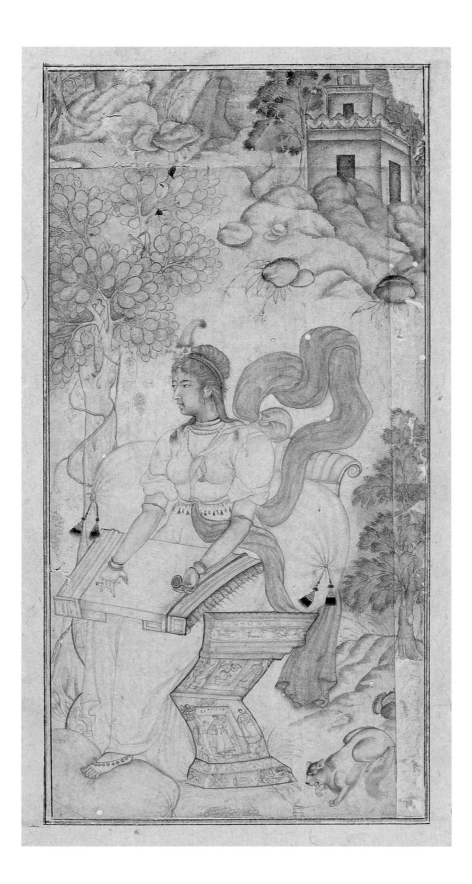

a number of religious buildings in her hometown of Hyderabad in the Indian Deccan. Perhaps the young musician in our drawing was, like her, not only a charming artist but also a benefactor.

A. SCHIMMEL

On the reverse of this album folio is a calligraphic composition (fig. 25.1) consisting of two couplets of Persian poetry written in a diagonal format (qit'a, described in cat. 2). The calligrapher who penned these lines in a confident nasta'līq script presumably signed his name in the lower left corner, but this section of the composition has been badly effaced. In the upper right corner is written in a very small hand, "He is the Giver of Power and Strength," a reference to one of the ninety-nine beautiful names of God.

The poetry reads, in translation:

May your pomp and rank increase daily.
May the whole world be your cavalry and army.
May every place be the dust of your path.
May your refuge be in the shadow of God's grace.[2]
MM

Notes

1. Ruswa 1996 is a recent translation of this novel.
2. Translation by Sunil Sharma.

26 Two Sufis: Two Temperaments

Dawlat
North India, c. 1610
Opaque watercolor, gold, and metallic silver paint over red ink and charcoal underdrawing on off-white paper
5¼ × 3⅝ in. (13.3 × 9.1 cm)
Gift of Stuart Cary Welch, Jr.
1999.296[r]

Published: Welch and Beach 1965, 61, fig. 8; Beach 1978, 114–16, fig. 38; discussed in Welch and Beach 1965, 35, 117, pl. 8

Inscription: "'Amal-i-faqīr Dawlat" (work of the poor Dawlat)

FIG. 26.1
Calligraphy (verso of cat. 26), Iran or India. Ink, opaque watercolor, and gold on paper, 5¼ × 3⅝ in. (13.3 × 9.1 cm). Gift of Stuart Cary Welch, Jr., 1999.296[v].

THIS richly modeled and tinted drawing introduces us to two common Sufi types. The figure on the left presents himself as a model of religious piety. He wears a dervish hat (a symbol of his sectarian affiliation) and a simple garment and open cloak, revealing his bruised arms, possibly scars from previous religious penance.[1] He is also barefoot, heightening his humble, ascetic appearance. The dervish gazes upward, his eyes partially rolled back into his head, completely self-absorbed.

The prancing musician on the right poses a wonderful contrast to the introverted mendicant. Leaning forward he intently fiddles away on his instrument. In some Sufi orders mysticism, music, and performance can be used to transport the practitioner into a state of religious ecstasy, which may be the goal of this figure's vigorous efforts. The musician wears a turban, pantaloons, and shoes, and sports a knife and a purse tied into his sash. His costume suggests that he has not renounced the world in the same manner as his companion.

Both figures, however, occupy the space of ascetic religious practice. The artist has intentionally placed them in a forest setting, complete with lush ground vegetation and trees, and populated by a pair of cranes

and a fawn. The small deer gazes at the two men as if entranced by them. In Indian tradition the wilderness is the realm of the religious renunciant. By situating both men here, the artist may be suggesting that the musician is also pursuing a spiritual path, simply using a different means to reach his goal.

A small rock at the bottom left of the composition bears the inscription "work of the poor Dawlat." A painter named Dawlat began an illustrious career at

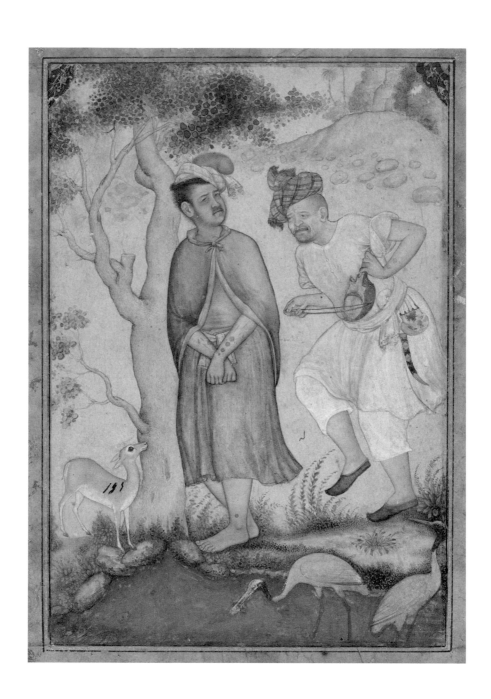

the court of Akbar, where he was influenced by the early master Basawan. Dawlat's style reached maturity during the reign of Jahangir, under whom he painted many portraits.[2] Through careful modeling and expressive poses, Dawlat was able to give these commonly stock characters flesh and personality. This drawing was evidently much appreciated by contemporary and subsequent artists as well, since two copies are known, one in the British Museum and one in the Musée Guimet, while a copy of the musician is found in a drawing in the Fondation Custodia, Paris.[3]

A final, intriguing addition to the composition is the insertion of two decorative clippings from a Persian manuscript page, which overlay the top corners of the composition. These were cut from an illumination that is stylistically similar to decorative paintings found in Persian manuscripts of the fifteenth and sixteenth centuries. Their inclusion here demonstrates the manner in which albums were assembled, which often involved the layering of drawings, paintings, or calligraphy within a framework of decorative elements and borders.

K M

A calligraphic composition (fig. 26.1) has been mounted on the reverse of the album folio that bears the *Two Sufis*. Written in a chancery hand in a diagonal format, the four lines of Persian verse have been set against a bright blue background filled with floriated scrolls. The verse reads in translation:

> If you have the sign of fortune,
> Sow the seed of succor.
> The people of the times are base,
> Do not sow the seed of oppression.[4]

M M

Notes

1. These marks may be from self-inflicted burns: see Beach 1978, 144.
2. Asok Kumar Das has questioned whether this work agrees stylistically with Dawlat's work for Jahangir. Das suggests that there may have been another painter named Dawlat, under Shah Jahan. See Das 1991, 103, fig. 20.
3. Referred to in Beach 1978, 38, cat. 38.
4. Translation by Sunil Sharma.

Attributed to Bishndas
North India, c. 1617
Black ink and watercolor on beige paper
7⅝ × 6⅛ in. (19.5 × 15.6 cm)
Gift of Stuart Cary Welch, Jr.
1999.304

Published: Hodgkin and McInerney 1983, fig. 2

IN 1613 Khan 'Alam traveled on a diplomatic mission for Emperor Jahangir to Isfahan to meet with the Safavid ruler Shah 'Abbas. Khan 'Alam did not travel alone. He was accompanied by an enormous retinue, comprising a thousand servants, two hundred falconers and hunters, and a party of royal elephants.[1] Khan 'Alam's most valuable companion, however, may have been the brilliant artist Bishndas.

Jahangir selected Bishndas for this journey because of his great skills as a portraitist. As a connoisseur Jahangir would certainly have recognized his talent. Through his selective dismissal of most of the artists from his father's enormous painting school, Jahangir had actively cultivated a distinctive, highly refined art. The veracity and liveliness of Bishndas's figures had earned him the respect of the emperor and an esteemed position with the envoy to Isfahan.

These prized qualities are readily evident in this spontaneous sketch of Shah 'Abbas. As Cary Welch describes in his essay in this catalogue, Khan 'Alam and Bishndas first encountered the Safavid emperor as he was returning from the polo field. The shah's loose turban and open shirt betray the unusual, informal nature of this portrait and serve to humanize this larger-than-life historical figure. This same drawing probably served as the source of several later images, such as the portrait *Shah 'Abbas Standing* in the Album of Ashraf Khan in the British Museum, that are more iconic but lack the emotional qualities of Bishndas's original.[2]

The artist's hand is visible in the emperor's softly drawn features. One can almost sense the lightness with which Bishndas sketched the tracery of wrinkles. Only the contours of the shah's face and garments are worked over with heavier, wetter lines. The profile is distinguished by overlapping of lines tinted with occasional traces of white paint, which together create a soft blended appearance reminiscent of European pastel drawing. The gentle portraits of Bishndas succeed through their attention to such fine details as the subtle lines, sagging eyes, and pronounced features of Shah 'Abbas in this likeness.[3]

Such close observation gave each of the artist's subjects an individualized and expressive quality, which is most evident in *The Birth of Jahangir* in the Museum of Fine Arts, Boston.[4] From a manuscript of the *Jahāngīrnāma*, this ambitious painting, generally attributed to Bishndas, is considered one of his greatest works. Each person in the crowded composition has a distinctive appearance and expression, yet all are lightly rendered, giving an airy and readable feeling to the densely packed scene.

Bishndas's successful employment of his artistic talents in Persia was not overlooked by Jahangir. Upon Bishndas's return, Jahangir granted him an elephant in honor of his services, a regal gift for one of the emperor's greatest painters of royalty.[5]

KM

Notes

1. A detailed description of the envoy is included in Rahim 1934–35, 651 (cited in Beach 1978, 107); also mentioned in Welch 1995; Das 1998, 113; Thackston 1999, 148.
2. British Museum, no. 1920, 9–17 013 (2), illustrated in Das 1998, 122, fig. 9. For illustrations of more comparative works, see Welch 1995, 424, figs. 1–2; Das 1998, figs. 6, 8, 10, 120–24.
3. For a discussion of the artist's style and major works, see Das 1998; Beach 1978, 63, 65 (cat. 15), 107–11.
4. This painting is illustrated in many books, including Beach 1978, 62, cat. 15; Desai 1985, 11, cat. 10; Welch 1985, 183, cat. 114; Das 1998, 118, fig. 5.
5. Thackston 1999, 319; Beach 1978, 108.

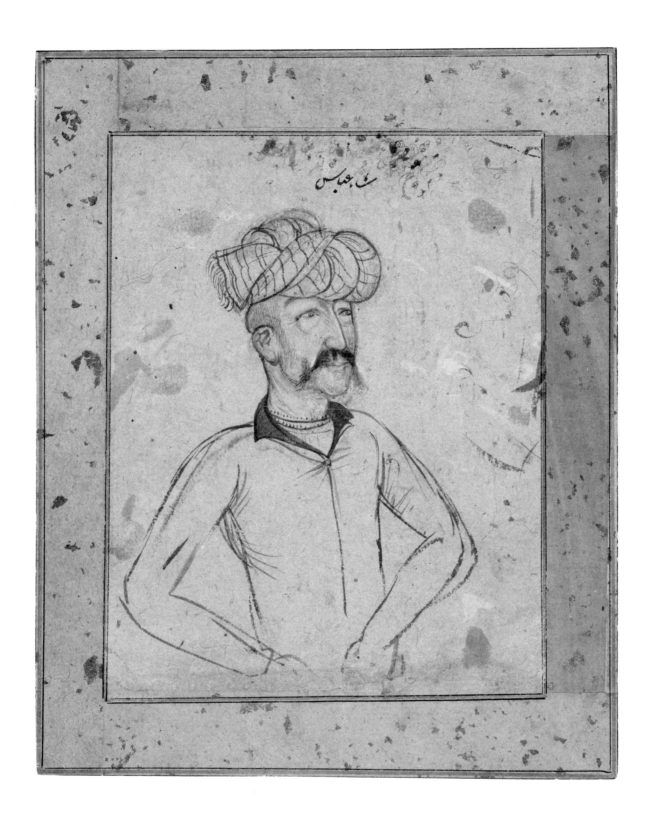

Attributed to Payag
North India, c. 1635–40
Gray-black ink on beige paper
5⅞ × 7¼ in. (15 × 18.5 cm)
Promised Gift of Stuart Cary Welch, Jr.
254.1983

Inscriptions: (right) "Miran Shah"; (left) "Fath 'Ali Shah"

QUICK, wet strokes lightly sketch out the forms of two cloaked men in this striking drawing. Both are seated cross-legged facing the viewer, but this is anything but a formal portrait. The man on the right, his eyes closed, draws on the mouthpiece of a hookah, while his companion glances sideways at him. The unflinching naturalism is remarkable. The hollow cheeks and wavy beard of the man on the right suggest his age and contrast with the fuller features of his younger companion. Their bodies have been carefully observed and rendered, their joints appearing to bend and their limbs resurfacing from the piles of heavy drapery that fall naturally around them.

There is a wonderful liveliness to the artist's lines, which swell and taper, revealing the range of his brush. Shading was achieved through applications of ink wash and by hatching, a European technique, which is visible on the front of the men's garments. In this preliminary drawing, incongruities that would have been corrected or painted over in a more finished work—such as the overlapping of the lines that form the legs of the figure on the right with the rocky platform on the left—remain visible. The attention to detail and loose drawing style may indicate that this was a study from life, perhaps for a later painting.

There is a grizzled realism here that is rare in Mughal art but common to the works of Payag, one of the greatest masters of Shah Jahan's reign. The brother of the painter Balchand, Payag distinguished himself in portraits and historical subjects.[1] The bulk of his known works date after 1630, including several pages of the *Pādshāhnāma* in the Royal Library at Windsor Castle, and the *Battle of Samugarh* included here (cat. 30). Holy men were common subjects for Payag, and in several of his group portraits he depicts them in settings far from court, at places where Sufis and ascetics themselves lived. In the center of the composition of his tenebrous night scene *Officers and Wise Men*, Payag placed an old Sufi and his attendant who are similar in appearance to the men depicted here.[2] Each of these sitters wears a patched shawl and rounded hat, accouterments that may indicate that they are Sufis as well. The garments may be examples of the *khirqa*, a robe passed from Sufi teacher to disciple, while their hats resemble those worn by Sufi dervishes.

Inscriptions beneath the figures identify the man on the left as Fath 'Ali Shah and the man on the right as Miran Shah. Although these are relatively common names, Indian sources do mention two Sufis named Miran Shah.[3] Shah Miranji Shams al-Ushshaq (d. 1499) founded an important line of Chishti Sufis at Shahpur Hill near Bijapur. In the *Khud-nivisht va Naslnāma* (*Autobiography and Genealogy*) attributed to Shah Miranji, the author states that he was born in Mecca and went to India after receiving a vision of the Prophet ordering him to find the "city of light," near Bijapur.[4] Chishti Sufis hope to achieve union with the divine even if it involves unorthodox or ecstatic means such as chanting or dancing. In Shah Miranji's verse below, the mystic addresses four stages of religious attainment in Sufism, from learning the basic doctrines and practice to finally seeing the divine and acquiring esoteric knowledge:

> One who hears (*Shari'at*), does (*Tariqat*);
> One who does, sees (*Haqiqat*);
> And one who sees, enjoys (*Ma'rifat*).
> At this place, if God is kind, what good fortune
> comes.[5]

Shah Miranji Khudanama (d. 1675) is less well known. He appears to have been a military officer who

served in Golconda and later was an ambassador in Bijapur.[6] He renounced his position and his belongings after meeting Amin al-Din, the second *pir*, or spiritual teacher, to follow Shah Miranji Shams al-Ushshaq. Shah Miranji Khudanama remained a follower of the Chishti lineage of Sufism and also lived on Shahpur Hill.[7] As the life dates of Miranji Khudanama overlap with the period in which Payag was active, it is possible that he is the Miran Shah identified by inscription on this drawing.

 KM

Notes

1. For more on Payag and his works, see Beach 1978, 151–54; Verma 1994, 327–29.

2. Illustrated and discussed in Beach 1978, 151–53, cat. 52.

3. I have not yet found a seventeenth-century historical reference to a Fath 'Ali Shah in India.

4. Cited in Eaton 1978, 75–77.

5. From the *Maghz-i marghūb*, in Hashim 'Ali, ed., *Maghz-i Marghūb and Chahār Shahādat*, 82, lines 3–4 (cited in Eaton 1978, 146).

6. Eaton 1978, 275–76.

7. Ibid., 276.

29 Yogi in Deep Meditation

North India, c. 1640
Black ink and watercolor on beige paper
7⅞ × 5¾ in. (20 × 14.5 cm)
Promised Gift of Stuart Cary Welch, Jr.
245.1983

Published: S. C. Welch 1976, 50–51, no. 19

SEATED on a grass mat, a hunched-over yogi is lost in meditation. His closed eyes and sagging posture suggest that he has been in this state for some time. The long fingernails snaking around his fists are a striking indicator of the time he has devoted to extreme asceticism. The yogi's matted hair is tied up atop his head, leaving only a wavy tendril hanging from his brow, visually echoing the curling nails. We are presented with an accurate rendering in thin, mostly contour lines of the ascetic's naked body, with its slender limbs and a fuller torso. The carefully drawn face and faint indications of the rib cage impart a sense of naturalism to this quiet figure: it is likely that the artist drew this study from life. This naturalism is a fundamental aspect of Mughal art, and the "exotic" yogis of Hindustan with their unusual practices were a favorite subject of Mughal patrons.

The practices depicted here are historically common to many sects within the Indian religions. Like this study, the earliest images of yogis also depict them seated in the lotus position (*padma asana*), with hands upon their folded knees. These meditating figures are found on tiny stamp seals from the Indus Valley civilization and were created roughly four thousand years ago. Since yoga's ancient origins, practitioners in Hindu, Buddhist, and Jain traditions have all employed the discipline. Our ascetic is demonstrating a combination of meditation and yogic postures. These activities often incorporate the recitation of powerful words (mantras) and the visualization of a divine being or energy. When practiced correctly, yoga is believed to awaken and transform energies within the body. The yogic postures facilitate the movement of these energies. Sacred texts suggest that expert practitioners could transform themselves alchemically, attain supernatural powers, and possibly achieve union with the godhead (*moksha*) or, in the case of Buddhism, enlightenment and release (nirvana).

K M

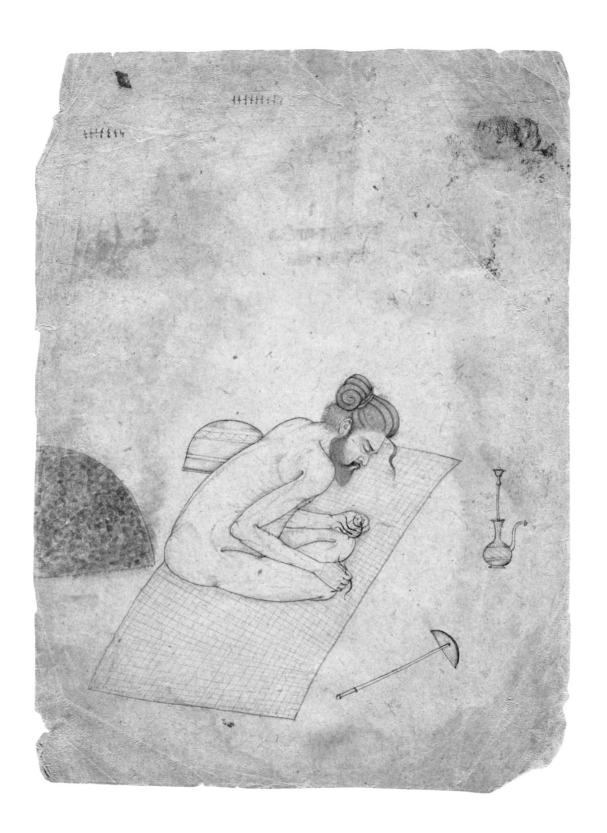

Attributed to Payag

North India, c. 1658

Gray-black ink, opaque watercolor, gold, and metallic
silver paint over white wash on off-white paper

11¼ × 15⅛ in. (28.5 × 38.5 cm)

Gift of Stuart Cary Welch, Jr.

1999.298

Published: S. C. Welch 1976, 54–55, no. 21; Beach 1978,
167–68, fig. 65; Quraeshi 1988, 93–95; McWilliams
2000, 12–14, fig. 5; Harvard University Art Museums
2000, 36

Inscriptions: (center group) "Dara Shukoh"; (right)
"Aurangzeb 'Alamgir Padshah, Bahadur Khan"; (bottom
right) "Murad Baksh"; (elephant above Aurangzeb)
"Najabat Khan"; (bottom center) "Ram Singh Rathor"
(top center) "Rustam Khan"

ONE OF the finest, most historically significant
drawings in the Welch collection is this fasci-
nating presentation of the Battle of Samugarh. Docu-
menting the pivotal battle between the princes Dara
Shukoh and Aurangzeb, this tinted drawing employs
a bold, sketchy realism recalling the haunting paint-
ings of Payag, to whom it is attributed. Probably com-
missioned by the victor, Aurangzeb, shortly after he
ascended the Mughal throne, *The Battle of Samugarh*
marks not only a high point in the genre of historical
documentation but also the beginning of the end of
the great early Mughals and the zenith of their painting
schools.

The drawing depicts the turning point in the battle
between the opposing armies of the brothers Dara
Shukoh and Aurangzeb. Dara Shukoh was the oldest
son and favorite of Emperor Shah Jahan. Dara Shukoh
indulged himself in the study of religion, philosophy,
and the arts. His frequent appearance in paintings,
coupled with a dearth of evidence that Shah Jahan was
interested in painting, suggest that this favorite son
may well have been the principal patron of the artists
at his father's court.[1]

Dara Shukoh's interest in philosophy did not,
however, branch into statecraft, and he was inade-
quately prepared to resist Aurangzeb's move to over-
throw their father and seize control of the empire. In
1658 Dara Shukoh twice raised armies to hold off
Aurangzeb. In the second, critical battle, fought at
Samugarh, Dara Shukoh is said to have fallen victim
to military protocol as much as to the actual fighting.
As leaders of their armies, both Aurangzeb (fig. 30.1)
and Dara Shukoh were mounted upon elephants. This
gave each leader a high position from which to view
the battle and to be seen by his armies. Although
accounts vary on the reason, it seems that Dara Shukoh
was persuaded to get down from his mount after it
was wounded and take to horseback (fig. 30.2). His
soldiers, assuming that their general's disappearance
from view was an indication that he had fallen,
retreated. Dara Shukoh was forced to flee to Sind, in
the extreme northwest of the empire. The victorious
Aurangzeb rode the few short miles to Agra to con-
front his father, who bestowed upon him the sword
'Alamgir, "seizer of the universe," recognizing him
as the successor to the Mughal throne.

The resulting history is well known. Aurangzeb
held his father under house arrest in the Agra Fort,
where he lived out the remainder of his life. Dara
Shukoh was even less fortunate. Before a year had
passed, he was captured by Aurangzeb's men, brought
to Delhi, judged a heretic, and executed, in August
1659.

This remarkable drawing presents a visually de-
tailed but politically charged interpretation of the
scene. The key figures of Aurangzeb, Dara Shukoh,
their younger brother Prince Murad, and several gener-
als are identified by inscriptions. The right half of the
scene is dominated by the superior forces of Aurangzeb.
He presides over the battle from his elephant inside a
central ring of cavalry. Facing his line of cannons
billowing smoke are the beleaguered soldiers of Dara
Shukoh. His surrounding troops look inward, watch-

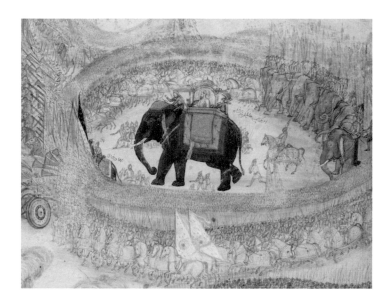

FIG. 30.1
Aurangzeb on an elephant,
detail of cat. 30

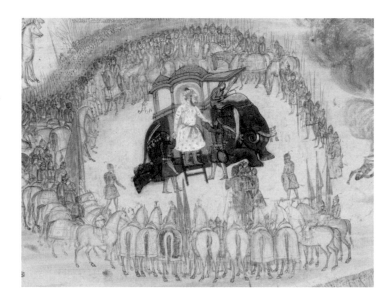

FIG. 30.2
Dara Shukoh dismounting,
detail of cat. 30

ing the prince's fateful dismount. Many members of Dara Shukoh's cavalry have already turned away and are streaming off the battlefield to the left. Further evidence of Dara Shukoh's unsuccessful campaign is found in the details of fallen men, wounded horses, and unmanned artillery strewn across the composition.

A poignant though historically inaccurate moment in the battle scene is the depiction of Prince Murad fleeing at the lower right. Prince Murad allied with Aurangzeb against their older brother, but he was defeated by Dara Shukoh's Rajput forces at Samugarh the day before and was not present at this decisive battle. Vishakha N. Desai suggests that the conflation of the two events into one historical moment even more forcefully presents Aurangzeb as victor and rightful Mughal heir.[2]

K M

Notes

1. Although his interest in grand architectural monuments in Agra and his construction of Shahjahanabad, in what is now Old Delhi, are well known, few records suggest that Shah Jahan was ever a great patron of painting; see Beach 1978, 167.
2. Desai 1985, 17–18, fig. 14.

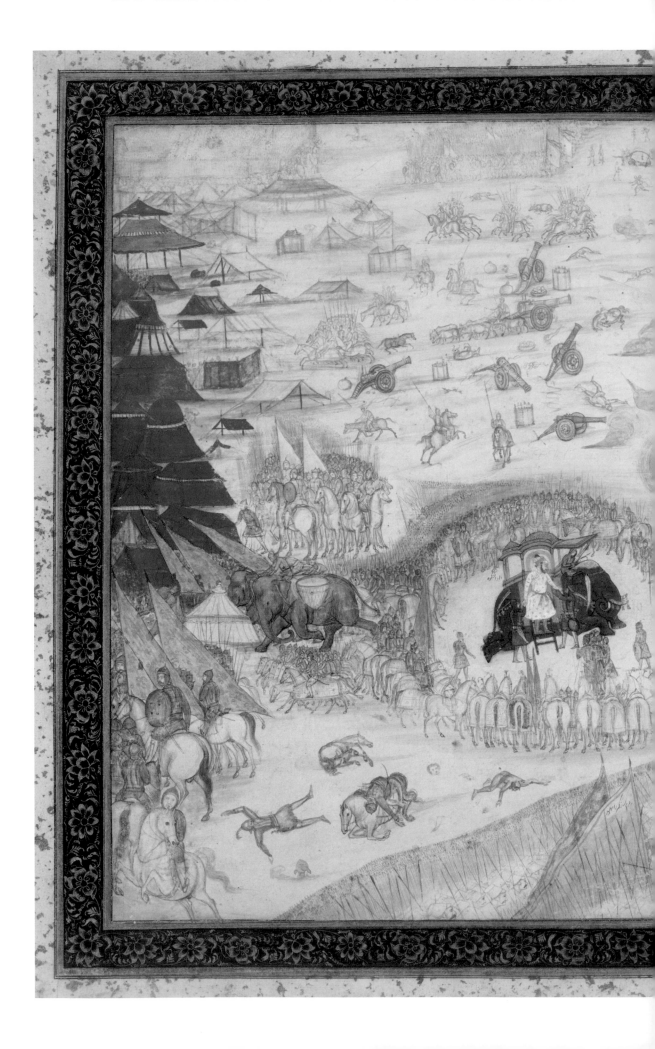

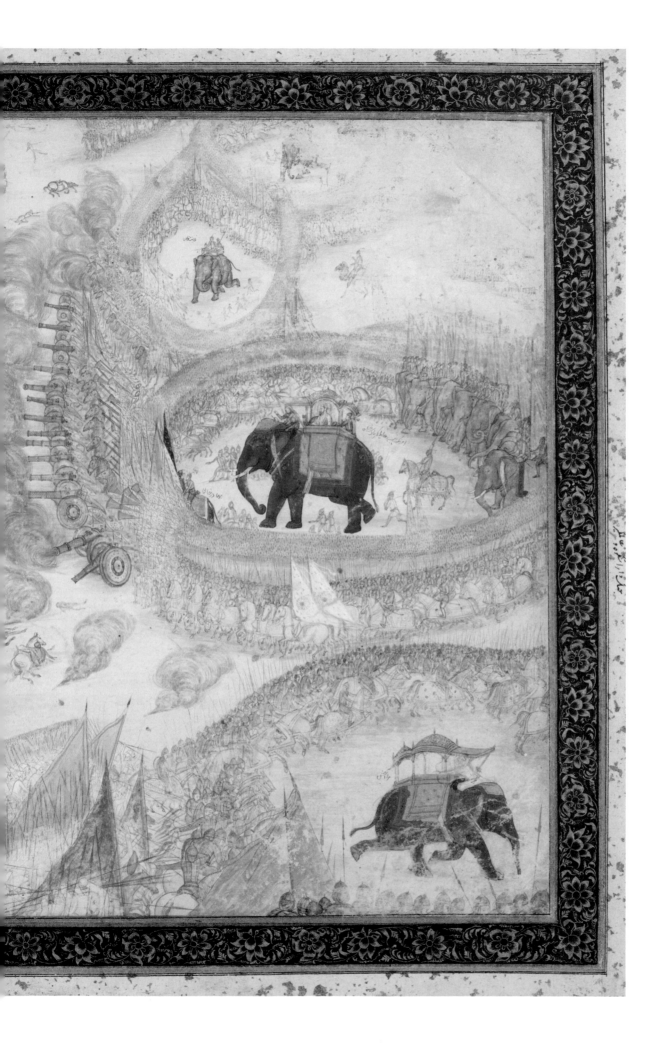

Attributed to Hunhar
North India, c. 1660
Black ink and opaque watercolor on paper
11⅝ × 3⅝ in. (29.4 × 9.1 cm)
Promised Gift of Stuart Cary Welch, Jr.
240.1983

T HIS unfinished portrait traces the slender and
recognizable profile of the Mughal emperor
Aurangzeb. The third son in line to inherit the Mughal
throne under Shah Jahan, Aurangzeb raised an army
against his oldest brother, Dara Shukoh, and their
critical battle for the throne at Samugarh is illustrated
here in cat. 30. After his victory, Aurangzeb advanced
on Agra, where Shah Jahan granted him the sword
'Alamgir, "seizer of the universe," and recognized him
as emperor. Aurangzeb quickly installed himself as
Emperor 'Alamgir and began a long, often difficult reign
that would extend the reach of the Mughal Empire deep
into the Deccan plains.

Relatively few court paintings of Aurangzeb were
made during his reign compared with those of his
predecessors. Shortly after becoming emperor, Aurang-
zeb disbanded the royal atelier, forcing Shah Jahan's
master painters to find work in other courts. Contem-
porary portraits that did survive, however, were used
subsequently as sources for copies.[1] This was certainly
a common practice by the nineteenth century, when
entire sets of paintings depicting Mughal rulers became
familiar commodities on the colonial art market.[2] It
is ironic that the reforming ruler most associated with
bringing an end to the great Mughal painting schools
of the sixteenth and seventeenth centuries should
himself become an almost iconic subject for later
artists.

This wonderfully lifelike drawing introduces us to
a rather young Aurangzeb. The drawing of his face is
nearly complete and reveals an alert individual with

large eyes and gently modeled features—a far cry from the more somber, severe-looking ruler of later depictions. Slight hints of color help articulate the jewels on his turban and the rosy pink of his lips. Light stippling and ink wash blend to give his profile a soft, almost chalky appearance. Aurangzeb's characteristically elongated and rigid body is sketched out, providing a full standing portrait of the ruler. The darkness and width of the lines vary, revealing that the artist had begun to trace over the faint underdrawing with more assured outlines.

The refined quality of line and observation of facial details have led Cary Welch to call this a contemporary portrait of the infamous ruler and attribute it to the hand of Hunhar, whose career spanned the reigns of both Shah Jahan and Aurangzeb.[3] His work consists mostly of portraits, including an attributed painting of Aurangzeb in a shaft of light now in the Freer Gallery of Art.[4] Hunhar was an acute draftsman, and his works exhibit a fineness and clarity that were much favored in the late Shah Jahan era.

The dating of the present work to roughly 1660 poses some interesting issues of historical interpretation. Prince Aurangzeb became Emperor 'Alamgir in 1658 at the age of forty. His relatively youthful appearance here could indicate that this portrait depicts him while he was still a prince. However, his regalia, as it is drawn, is generalized and could be appropriate for either a prince or a ruler.[5] The halo behind his head was a symbol of status usually reserved in Mughal art for saints and rulers.[6] Its inclusion here is probably an indication of imperial status; combined with the youthful face it suggests that this drawing belongs to the first few years of Aurangzeb's reign.

KM

Notes

1. For an almost identical image to this figure, see Martin 1912, pl. 186. Its only difference from the present drawing is the omission of a few details on the turban, such as the flower tucked into the side. Another, similar drawing belongs to the Harvard University Art Museums (*Portrait of Aurangzeb*, 1920.25). Cary Welch suggests that the latter portrait may also be by Hunhar and may be a slightly later drawing than the present image.

2. See, for example, the casket inlaid with depictions of Mughal rulers and monuments in the collection of the Victoria and Albert Museum, no. IS 290-1951, discussed in Archer 1992, 227, no. 282.

3. For a brief discussion of Hunhar and his works, see Verma 1994, 176–79.

4. Freer Gallery of Art, Washington, D.C., no. F1996.1, illustrated in Beach and Koch 1997, 124–25, fig. 18; Lawton and Lentz 1998, 188–89.

5. Aurangzeb does hold a prominently placed *talwar* scimitar before him; perhaps this is 'Alamgir, but it could be a more general attribute of rank.

6. See, for example, the discussion of the halo in Okada 1991, 39.

North India, late 17th century to early 18th century
Black ink, watercolor, opaque watercolor, gold pigment,
and metallic silver paint on beige laid paper
8½ × 6¾ in. (21.7 × 17.2 cm)
Promised Gift of Stuart Cary Welch, Jr.
37.1983

Inscription: "4½ rupees [?]"

THE quiet luxuries of court life are emphasized
in this unfinished drawing of a courtesan and
her two servants. The three women are seated upon a
carpet, and the courtesan reclines upon a large bolster.
She gazes, heavy-eyed, over her shoulder at one atten-
dant, who offers her a beverage. The other servant
kneels and massages her right hand, while she
dangles a flower garland (*mala*) in her left. Before them
is spread an array of delights: vases, saucers and
cups, and a plate of golden fruit. Although adorned
with opulent jewelry, the courtesan is nearly undressed,
wearing only a loose, transparent cloth draped across
her legs. It appears that we have encountered the
women during an intimate moment, as the courtesan
is being bathed.

The reclining beauty received much more of the
artist's attention than her companions. Her soft
hairline encloses a small, rounded head with gently
rendered features. Except for the slight modeling of
her face, she was created with contour lines, her form
accented only by cascades of pearls and her curling
hair. In contrast, the attendants are drawn in sharper
contour and appear flatter, less modeled. Both are
shown in profile and betray features reminiscent of
portraits from Bikaner—long, narrow noses, small
pursed lips, unpronounced chins, and high foreheads.
They are long-waisted and wear short *cholis* (blouses)
that are visible underneath their scarves.

Behind them nature flourishes, with three trees in
full bloom, each revealing curving branches that snake
through and disappear into clouds of leaves. The
silhouettes of the trees are nearly identical to one
another, rhythmically breaking up the flat background.
An artist began to fill in individual leaves at the tree-
tops, perhaps as an indication of how he would—or
another artist should—finish the painting. Similar
clues also point toward the intended coloration of
the finished work. Initial applications of pigment are
visible across the surface. Yellow is used to suggest
the fruit on the platter and the gold borders of textiles,
olive is seen on the cushion and the skirts, blue high-
lights the carpet and the mala, and orange flesh tone
dapples the courtesan's arm.

The treatment of the figures and the clarity of line
are familiar from several schools affiliated with or
influenced by the Mughal idiom. Cary Welch assigns
this drawing to the later Mughal school under Muham-
mad Shah. Muhammad Shah employed several artists,
including the masters Chitarman, Hunhar, Nidha Mar,
and Govardhan. These artists developed a refined
painting style that diverged from seventeenth-century
Mughal painting through an emphasis on subtle rather
than brilliant coloration, a preference for sharp linear
forms over modeled ones, and the placement of figures
in flattened spaces.[1] A wonderful stylistic comparison
can be found in the painting *Muhammad Shah Making
Love* signed by Chitarman in the collection of the
British Library.[2] There the emperor bestows his affec-
tions upon a reclining woman, attended by two female
servants who strikingly resemble the attendants in the
present drawing.

KM

Notes

Inscription: In a conversation in spring 2003, John Seyller
suggested that the valuation of an art object, in whole num-
bers and quarters, was represented in Hindi by numerals
and hashes, respectively. These marks followed by a slash
may have been used to indicate a price in rupees. In this
interpretation, the inscription may read "4½ rupees." For a
further discussion of the ranking and valuations of Indian
paintings, see Seyller 2000, 178–203, and Seyller 2001,
12–21.

1. For a detailed discussion of Mughal painting under
 Muhammad Shah, see Terence McInerney's article in
 Schmitz 2002.

2. Published and discussed in Desai 1985, 88–89, no. 71;
 Schmitz 2002, 21, fig. 7.

Attributed to Jivan Ram
North India, Delhi, c. 1835
Black ink and opaque watercolor on off-white paper
6¾ × 4½ in. (17 × 11.5 cm)
Promised Gift of Stuart Cary Welch, Jr.
253.1983[r]

THIS engaging portrait bears a strong resemblance to the nineteenth-century poet Hakim Momin Khan.[1] Often referred to as Momin, he was a contemporary of Ghalib and is considered one of the greatest composers of *ghazals* (poetic songs) in Urdu literature. Momin was born in Delhi in 1800 into a household of wealthy doctors; he himself was a student of Unani medicine. He was most drawn to Persian literature, however, and quickly distinguished himself within the aristocratic circles in Delhi as a writer. Momin's career was cut tragically short in 1851 when he fell from a roof and died of his injuries. Momin's

ghazals are evocative and melancholic, speaking often of unfulfilled love and loneliness, as evident in these heartbreaking verses:

> Seeing her frown
> My heart was twisted and wrung anew
> How could my heart's knots unravel
> When she untied her veil?[2]

The artist has portrayed his subject in a dignified manner. The poet sits cross-legged and erect, gazing directly at the viewer. Although his posture is proud, his expression is introspective. The artist's rendering captures the sparkle in his deep-set eyes and the luxuriousness of his wavy, unbound hair. Layers of tiny light brushstrokes were built up to create the soft, textured modeling of the swells and recesses of the facial features. This modeling style was common to Mughal school art production by the turn of the nineteenth century and was used in artworks ranging from imperial portraiture to high-end Company painting (as found in the William Frasier Album) to miniature painting on ivory.[3]

The comparison to portraits on ivory and paper is made more pertinent by the sketch on the verso of this page (fig. 33.1). The small oval portrait traced with faint outline appears to be a copy of a famous painting of Begam Samru (1751–1837), an infamous and powerful character in colonial circles. Although a Kashmiri

FIG. 33.1
Attributed to Jivan Ram, *Sketch of Begam Samru* (verso of cat. 33), North India, Delhi, c. 1835. Black ink and opaque watercolor on off-white paper, 6¾ × 4½ in. (17 × 11.5 cm). Promised Gift of Stuart Cary Welch, Jr., 253.1983[v].

by birth, she married two foreigners, the Austrian Walter Reinhardt, who had an estate at Sardhana, northeast of Delhi, and a Frenchman, Le Vassaoult.[4] Two oval-formatted portraits, one in the Victoria and Albert Museum and the other in the Chester Beatty Library, Dublin, present the same depiction of Samru, seated and holding the mouthpiece of a hookah, her head and shoulders draped with a Kashmiri shawl.[5] The image of the Begam on the present sheet is reversed, suggesting that it was transferred from a tracing rather than copied freehand from these or an original source. The artist of both the Victoria and Albert and Chester Beatty portraits was Jivan Ram, a Delhi artist favored by aristocratic and foreign patrons.[6] Ram had an active studio and had mastered both oil and miniature painting techniques. The Begam was a regular customer, and her estate in Sardhana was decorated with at least twenty-five oil portraits of herself, her family, and military officials, most of which were painted by Ram.[7]

The sketchy style along with certain features of this drawing, such as the squat hands and wide, stubby fingers, resemble those of the portrait on the recto of this page. This could indicate that the male portrait was rendered by the same artist, and this paper was reused in his studio. The life dates of both sitters cer-tainly support this possibility. Samru died in 1837, and her Victoria and Albert and Chester Beatty portraits have been dated between 1820 and 1830. In 1830 Momin would have been about thirty years old, a plausible age for the bold young man in this seated portrait. Along with its likeness to known portraits of Momin, the sketch of Begam Samru and her connection to the Jivan Ram studio strengthen the identification of the sitter as the great Urdu poet. This nexus also offers insights into artistic production in colonial Delhi, where foreign and Indian patrons both sought out the same painters to capture their fleeting images with brush and paper.

KM

Notes

1. Identification suggested by Stuart Cary Welch and Sunil Sharma.
2. Momin, ghazal 140, v. 4, published with translation in Petievich 1992, 106.
3. For an excellent example of this almost stippled modeling technique in paper, see *Tax Collectors and Village Elders* in Welch 1985, 95, cat. 49. Several examples of miniature portraiture are discussed and illustrated in Archer 1992, 215–27, cats. 244–47.
4. For more on Samru's life, see Leach 1995, 790–91; Banerji 1925; Lall 1997.
5. See Archer 1992, 164, 166, cat. 146; Leach 1995, 790, fig. 7.120.
6. Archer 1992, 166; and Leach 1995, 790–91.
7. Leach 1995, 791.

34 Vilaval Ragini

Rajasthan, Bundi, c. 1590–1600
Black ink and opaque watercolor on beige laid paper;
figures and architecture partially pricked
8⅞ × 5 in. (22.5 × 12.6 cm)
Promised Gift of Stuart Cary Welch, Jr.
60.1983

35 Bhopali Ragini

Rajasthan, Bundi, c. 1630–40
Gray-black ink, watercolor, and opaque watercolor on
beige laid paper; architecture pricked
10¼ × 5¾ in. (26 × 14.7 cm)
Promised Gift of Stuart Cary Welch, Jr.
21.1983

IN ancient India the visual and performing arts
not only coexisted, they served as sources of
mutual inspiration. Such is the case with the *Ragamala,*
or *Garland of Melodies,* which forms the foundation of
Indian classical music and has given rise to an entire
genre of miniature painting. The male and female
melodies, ragas and raginis, are some of the oldest
and most popular subjects in Indian painting.[1]
Regional iconographies for the depiction of individual
melodies had developed by the early seventeenth
century and quickly become standardized. Just as many
of the tunes evoke feelings of love, longing, and joyful
reunion, their illustrations often focus on romantic
relationships. But here the similarities between the
music and the imagery end. In the visual realm, *Ragamala* paintings take on a life of their own.

In an early illustration from Bundi (cat. 34), an
elegant lady listens intently to a female musician
playing the vina. She leans forward, resting her chin
on her hand, lost in dreamy contemplation. She is
attended by two other women, who hold a fly whisk
and a closed umbrella. The whisk bearer also appears
to be clutching a small, round mirror. Its inclusion
suggests this drawing may be an illustration of Vilaval
ragini, which usually features a lovely courtesan with
attendants looking at a mirror. The intimate concert in
this image is set inside a palace, where the patron sits
under the shelter of a covered porch. The building projects upward in an almost isometric view, revealing a
roof pierced by multiple windows and balconies. A
Persian-style awning drapes down from the roof at the
top left of the structure. Beyond it we catch a glimpse
of lush foliage.

This exuberantly detailed drawing comes from
Bundi, and was probably intended to be part of a *Ragamala* series. The bold lines, flattened forms, and attention to pattern are all characteristic of the Bundi idiom.
Through a series of contacts, artistic and otherwise,
Mughal and traditional Indian styles united in the
Bundi school. The architectural forms and tipped perspective are familiar from early Mughal painting. The
subject, however, is truly Indian. This drawing is strikingly similar to paintings from the so-called Chunar
Ragamala, dated 1591. One of its pages contains a colophon listing the date, the site of production, and the
artists. In 1576 the Bundi kings received Chunar, near
Varanasi, as a land grant, and it is assumed that they
commissioned the series there.

If the colophon is correct, then it places that syncretic manuscript in the Bundi court by the turn of the
seventeenth century, where it would help to forge the
revolutionary style expressed here.[2] This drawing's
closeness to the Chunar style suggests that it may be an
early interpretation based upon the Mughal set and one
of the earliest artworks to survive from the kingdom
of Bundi.

The delightful sketch of Bhopali ragini (cat. 35),
also from Bundi, provides much insight into the style
and production of manuscript paintings in a Rajput
workshop. The underdrawing of this scene was laid
down with pure contour line. The colors would then

CAT. 34

CAT. 35

have been filled in and the outline and details painted in again atop the opaque pigment. The entire composition is dappled with strokes of color and descriptive cues intended to instruct the painter on how the work should be colored. This is probably an indication of workshop production, where a master might design a painting and assign other artists to handle different aspects of the process. In their finished form, these swooning Bundi lovers would have been only slightly modeled, unlike contemporaneous Mughal counterparts. They would remain flat and boldly painted silhouettes; volume was not as high a priority as color. The figures do inhabit a real, if shallow, space, suggested by the receding side wall to the right of the composition. The playful combination of perspectives allows us to peer at once down on the roof, straight into the lower room with the lovers and at the outer wall of the house, and back up into the night sky.

Its lack of detail and less formal style suggests that this drawing was created sometime after the illustration of Vilaval ragini; it may even belong to the later seventeenth century. Its function may have been different from that of the Vilaval drawing as well. The Vilaval drawing is highly refined and finished, while this illustration of Bhopali ragini is much looser and more schematic. The pricking of the architecture in this drawing suggests that it served as a template for artists rendering the scene.[3] Capped with a series of three portrait studies in the upper margin, this fascinating pastiche seems also to have functioned as a sketchpad.

KM

Notes

1. Depictions of individual figures named after specific ragas and raginis have been identified in a western Indian manuscript dated to c. 1475, in the collection of Acharaya Jaya Simhasurji in Ahmadabad.

2. For more on the development of early Bundi painting, see Beach 1974, 5–22.

3. For a further discussion of the pricking and apparent use of the two drawings, see Craigen W. Bowen's essay in this volume.

36 Portrait of a Kotah Ruler, Madho Singh or Mukund Singh

Attributed to the Kotah Master
Rajasthan, Kotah, late 17th century
Gray-black ink and opaque watercolor on
off-white paper
8 × 4⅞ in. (20.2 × 12.5 cm)
Promised Gift of Stuart Cary Welch, Jr.
414.1983

Published: Bautze 1997, 39–60, 43, fig. 4

Inscriptions: (top center, in a typical Kotah variant of the
Devanagari script) "ap maku[m]d sighji, madho
sigh[ji] / ka" (Mukund Singh, [son] of Madho Singh);
(below, in a different hand) "kota ka ma/dho sighji / ka
vada veta" (eldest son of Madho Singh of Kotah)

THIS is a masterly, probably contemporary portrait study of Mukund Singh, the brave son of Madho Singh, under whom Kotah became independent in 1631. The pose of the sitter suggests that at some point the artist intended to show him with a straight-bladed sword, a typical Deccani *khanda* of the late sixteenth to early seventeenth century.

JKB

This fine drawing may be of Madho Singh, the first ruler of Kotah. Though the inscriptions state that the portrait is of Mukund Singh, the oldest son of Madho Singh, the face clearly resembles that of Madho Singh in several portraits in the collection of the Rao Madho Singh Trust Museum, Kotah, as well as an excellent picture in the *Pādshāhnāma.*

The face is well drawn and shaded, and the details of the turban (*pugri*) are filled in. Madho Singh is wearing the traditional shirt (*jama*) girded with a *kamarband* in which a push-dagger (*katar*) has been stuck. His scimitar (*talwar*) rests by his side. The picture appears to be a contemporary study.

Madho Singh, second son of Rao Ratan of Bundi, was an able prince and a great warrior, qualities that endeared him to his father. Rao Ratan was a grandee of the highest importance in Emperor Jahangir's court. He held the rank of five thousand *zat* (the number of soldiers under his command), and the honorific titles Sar Baland Rai and Rao Rai. It was Rao Ratan who, under Mughal orders, crushed Prince Khurram's rebellion and interned him in the fortress of Burhanpur, where he was governor. Since this was mostly owing to the efforts of Madho Singh, his indulgent father sought special favors for him from the emperor, in whose esteem he had risen still higher. In addition to being a valiant prince, Madho Singh was an astute diplomat. He extended full courtesy to his royal prisoner while he was in custody at Burhanpur. When Khurram acceded to the throne as Shah Jahan, he did not forget this good treatment, and as the new emperor he formalized in 1631 the grant of Kotah that was given earlier.

Madho Singh was the first prince of the Hara lineage to serve in Mughal armies beyond Attock and the Indus River, the traditional boundaries of medieval Hindustan. When the Pathan general Khan Jahan Lodi, also known as Pira, revolted against the emperor in 1631, Madho Singh killed him in single combat with a spear. He later campaigned in Badakshan and was made governor of Balkh.

SBS

This early portrait drawing provides a revealing window into the artistic processes of a Kotah court artist. Much attention was given to the careful portrayal of the ruler's facial features. The artist built up layers of line and pigment to render accurately the subject's furrowed brow and swelling cheeks. The end result—with its hints of white corrective paint that lend it the milky, blended qualities of a Western crayon or pastel drawing—is a sympathetic portrayal of the king's aging face. This naturalism was a key feature of Mughal portraiture, carried over to a greater or lesser degree in the local Rajput painting schools.

Clearly working in the style of the Bundi school

from which they originated, Kotah artists emphasized particular features such as the stamplike profile portrait, large eyes surrounded by deep rounded circles, and contour shading to indicate a full jawline. The figure here is likewise stylized, the stiffness of his formal pose balanced by the rounded contours that map out broad shoulders, a narrow waist, and tightly bent knees.

Whereas the critical facial portrait is nearly finished, in the network of outlines portraying the body we see layers of changes made to the hands, their position, and the limbs. Even the attributes have changed: the ruler no longer brandishes the sword in his left hand or the sprig of flowers in his right. Instead, his regal jewelry, turban, and push-dagger evoke his imperial status. The portrait bears a strong visual resemblance to Madho Singh, the first ruler of Kotah. However, as Joachim Bautze mentions, the inscription designates the sitter as Mukund Singh, Madho Singh's successor.[1]

KM

Notes

1. In Bautze 1997, 42–43, Bautze illustrates the present drawing as Mukund Singh, fig. 3, along with a portrait of a strikingly similar subject identified as Madho Singh, fig. 4, and notes that there are few surviving images of Mukund Singh.

37 Elephant Saluting a Prince (Madho Singh?)

Attributed to the Master of Elephants
Rajasthan, Kotah, c. 1625
Black ink and watercolor on beige laid paper
9½ × 11⅜ in. (24.2 × 29 cm)
Promised Gift of Stuart Cary Welch, Jr.
69.1983[r]

THIS damaged sketch (*khaka*) shows the royal tusker saluting a prince, presumably the rao of Kotah, at the city palace. It appears to be below the Bada Mahal—the place where the king lived. This early-seventeenth-century work shows a solemn action. The big bull elephant is being paraded with a simple adornment of silver or gold ornamental chains and the typical brass bells, denoting that this is the usual morning muster. The mahout, with his *ankush* (goad) in hand, looks anxiously at his royal master, who stands above, in the *jharoka*, a royal viewing window. The elephant raises its trunk, curled up in the usual mode of salutation, and perhaps also lets out a trumpeting call. Next to the big tusker, a baby elephant imitates the salute. Behind is another elephant, with two mahouts astride. Flanking the tusker is a female elephant whose mahout is talking to the *charakta*, a kind of attendant, behind. In front a water carrier (*bhishti*) sprinkles the ground with his waterskin to keep the dust down, flanked by a few attendants with spears.

A big bull tusker can weigh between four and six tons and would on average stand around ten to eleven feet tall at the shoulder. The tusks could weigh up to a hundred pounds each if allowed to grow to the usual length of eight or nine feet. In India elephants have been associated with royalty from time immemorial, serving as a ceremonial mount for the king, a mobile fortress in war, and a steadfast platform in the hunt (*shikar*). They were kept in the elephant stables (*fīlkhānas*) and were looked after by the mahout and several charaktas, who were assigned to each animal. Elephants formed a separate corps of the army. Fitted out with heavy plate or chain-mail armor, carrying up to four warriors in an armored howdah, and wielding a saber in its trunk, a war elephant was a frightening sight. The Mughal emperor Akbar was particularly fond of elephants and took delight in riding alone, even when the elephant was in musth. Emperor Jahangir's diary records that he had twelve thousand elephants in his stables. In the heyday of the Mughal Empire, a staggering number—about a hundred thousand—were kept by the emperor, kings, princes, maharajas, nawabs, and nobility in Hindustan. Until 1948 the state of Kotah maintained about twenty-five elephants in its fīlkhāna. Today there are estimated to be only about twenty-five thousand wild elephants in the whole of India.

SBS

Attributed to the Master of Elephants
Rajasthan, Kotah, late 17th century
Black ink and watercolor on off-white paper
16½ × 19¼ in. (42 × 49 cm)
Promised Gift of Stuart Cary Welch, Jr.
559.1983

THIS drawing shows a royal elephant fight at Kotah around the late seventeenth century. In India, as in other parts of the world, animal fighting was a popular mode of entertainment. Elephants in the East were traditionally associated with kings, princes, and the nobility. The large male elephants were used not only in ceremonials and processions as royal mounts but also in war and the hunt. Elephant fights were a prerogative of a king.

Here we see two large tuskers engaging in a trial of strength. They fight in a special arena separated by a low wall to ensure that they do not do grave harm to each other, since it was undesirable to wound or disable a prize beast. A big bull elephant did not come cheap, and its maintenance was quite costly, too. Each elephant had a mahout and about four charaktas (attendants), who gathered fodder, bathed it, and fed it.

One of the elephants here is fettered by chains on its feet while the other is free, perhaps indicating that the animal in chains is in musth and therefore in a wild mood. Without the restraining chains it could run amok. The mahouts on both elephants sit astride their necks holding an ankush (goad) to control them. When elephants fought, they would shove and push, trying to use their tusks to gore their opponent. For this reason the tusks were kept sawed off to blunt ends, as we see here. Fights were watched with great anticipation by spectators sitting on the walls, while the royal patron sat either in a special pavilion or in a jharoka window with his courtiers. Even the women of the zenana (secluded quarters for women of the royal court) took a keen interest in the fight.

In addition to fodder and green leaves, prized elephants were given a special diet consisting of rotis with ghee, gur (dried cane juice), and assorted medicinal ingredients. They were regularly bathed in a river or a tank, and scrubbed with a coconut husk brush. Treatment of elephant ailments and wounds was codified in ancient manuals.

Kotah artists were especially noted for their skill in depicting elephants. In miniature paintings and sketches the Kotah elephant is rendered in an unsurpassed manner, with flowing strokes and a rhythmic grace that beautifully capture the power, energy, and size of the animal.

SBS

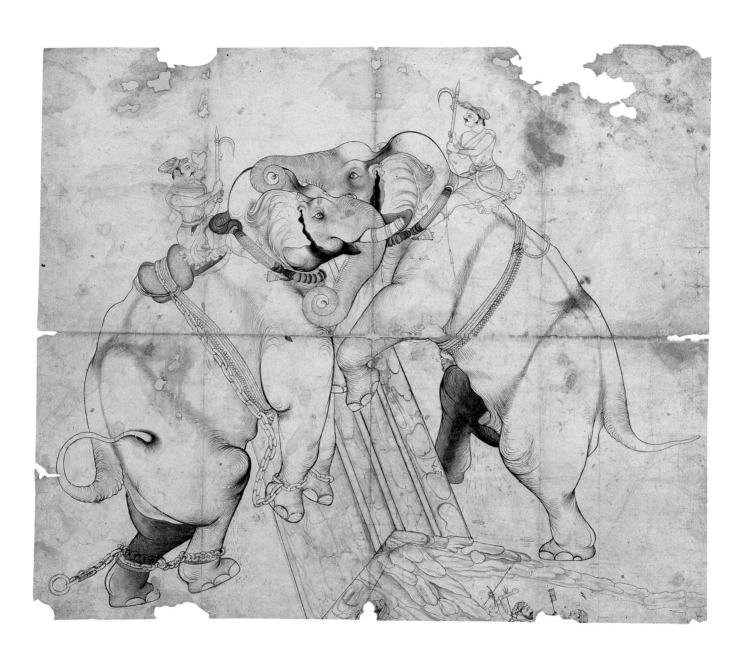

Attributed to the Kotah Master
Rajasthan, Kotah, early 18th century
Black ink and opaque watercolor on beige laid paper
17⅞ × 22⅞ in. (45.4 × 58 cm)
Promised Gift of Stuart Cary Welch, Jr.
74.1983

Published: Beach 1974, figs. 78, 79 (detail); S. C. Welch 1976, 90–91, no. 45 (detail)

L IFE in a Rajput kingdom featured more than grand court assemblies, elephant fights, and game hunts. In order to protect or expand their territories and ensure the steady flow of revenue that supported such lavish enterprises, Rajput kings were occasionally forced to wage war. This incredibly detailed though fragmentary drawing captures the violence and heroism of such a campaign. Two defiant armies surge toward each other. The artist has captured the exciting opening moments of battle, as opposing soldiers with raised spears and drawn bows collide. The vantage point allows us to peer down on a vast swath of the scene. This aerial view gives silent witness to the fury below, in a manner reminiscent of the great Japanese history picture-scrolls, like the *Burning of Sanjō Palace* in the Museum of Fine Arts, Boston.[1] The attention to fine detail is riveting. Individual metal plates and coils of mesh are visible in the uniforms and tack of the cavalry. And though they are rendered only in sketchy outline, the soldiers are individualized, each man embodied with a sense of vitality and steadfastness, even in the face of death.

This drawing of teeming armies comes from the art school of Kotah. Originally a family land grant within the kingdom of Bundi, Kotah became its own state in 1631. The close connections between this Rajput court and the Mughals are evident in subsequent Kotah art-

works. This drawing reveals its Mughal inspiration in its attention to naturalism, detail, and even the choice of subject, which falls into the genre of history painting. *The Battle of Samugarh* (cat. 30) serves as a good comparison. Both the Samugarh drawing and the present one address the exuberance and chaos of war in startling detail. Indian elements retained here include an interest in pattern, flatness, and line, for all of which Kotah painting is indebted to the earlier styles of Bundi. The accuracy achieved here, even with such quick use of line, has contributed to Cary Welch's attribution of this drawing to an unnamed draftsman he identifies as the Kotah Master.[2]

K M

Fragments of a similar, if not the same, battle scene exist in various private collections. Artistically, this and the other fragments are among the most vivid and exciting drawings the atelier of Kotah produced. But it is difficult to date these masterpieces for none of them bears a relevant contemporary inscription. The only datable object that offers direct comparison is a large painting on cloth in the collection of the Rao Madho Singh Trust Museum, Kotah, showing Maharao Bhim Singh's last battle, which was fought on 20 June 1720.[3] The unretouched areas of this large painting are stylistically homogeneous with the present drawing and related fragments. Hence a date around 1720 seems to be safe.

J K B

Notes

1. *Burning of Sanjō Palace*, from the *Heiji monogatari emaki*, Japan, Kamakura period, late 13th century, Museum of Fine Arts, Boston, no. 11.4000, frequently illustrated.

2. For other examples attributed to the Kotah Master in this catalogue, see nos. 36, 40–43, 45–47, 50, 51.

3. For historical details see Bautze 1992, 309–16. See also Peabody 1997, 75, for a reproduction of the (retouched) central scene.

40 Fish in the Chambal River

Attributed to the Kotah Master
Rajasthan, Kotah, c. 1700
Black and red inks on beige paper
1⅜ × 5⅜ in. (3.6 × 13.7 cm)
Promised Gift of Stuart Cary Welch, Jr.
144.1983

Published: S. C. Welch 1976, 97, no. 50;
Welch 1997, 17, fig. 2

41 Dragons and Birds from the Chambal River

Attributed to the Kotah Master
Rajasthan, Kotah, c. 1700
Black ink and white opaque watercolor on
beige paper
1¾ × 7⅜ in. (4.6 × 18.7 cm)
Promised Gift of Stuart Cary Welch, Jr.
126.1983

Published: S. C. Welch 1976, 97, fig. 50;
Welch 1983, 79, fig. 2; Welch 1997, 17, fig. 2

THESE tiny sketches of animals, real and imagined, contain some of the most lively and cosmopolitan imagery in this catalogue. The Chambal River, Rajasthan's greatest waterway, cuts a path through the capital city and would have been accessible to the artists at Kotah as a source for the fish and the birds in these pictures. The dragons that accompany them have traveled much farther. Their serpentine bodies and crocodilian heads have roots in the art of China. These forms were adopted in late Timurid and Safavid painting, especially in the city of Tabriz, and transmitted to India during the Mughal period.[1] The vivacious dragons illustrated here are close relatives of the wonderful creatures that weave their way through several of the scenes in the famous *Shāhnāma* of Shah

Tahmasp.[2] These images may have been intended as preparatory studies for mural paintings in the Kotah palace: the walls and ceilings of the royal buildings at Kotah—as well as at its parent kingdom of Bundi—abound with historical scenes and figures interlaced with animals and mythological imagery.

The artist's attention to detail and his loose, sketchy application of line give the appearance that he was working from life, even where that clearly was not the case. For example, notice the wonderful veracity in the rendering of the fish. At the left side of the fragment two large fish glide, one over the other, across the page. Their forms are carefully observed and the miscellaneous fins and tentacles that project from their bodies are included. Their snub heads are each capped with a pair of round unblinking eyes. While this stout pair appears almost to struggle against the cramped boundaries of the sheet, a third fish—smaller, and lightly drawn in profile—darts up to the right.

Two birds, perhaps cranes, from the second sketch display the same lively naturalism. Quick strokes give rise to their long, curving necks, full wings, and stubby bodies. They appear to have been caught during a moment of graceful descent. The most striking creatures, however, are the dragons that frame the birds. Extending from the left side of the composition, a ferocious beast rears its head and bellows swirling lines of flame. At the right, two fighting dragons tumble across the page, their bodies intertwined as each bites its opponent, their energetic, knotted forms reminiscent of the "animal style" imagery found in ancient Scythian art. Heavy, layered outlines and applications of white paint to disguise corrections set off the rollicking forms from the page. Other traces of ink and dry brush suggest that the birds and dragons were quickly worked up on a page intended for sketches, rather than as finished works. It is from the strength of these drawings and their connections to foreign sources that Cary Welch attributes these tiny fragments to the Kotah Master.[3]

KM

CAT. 40

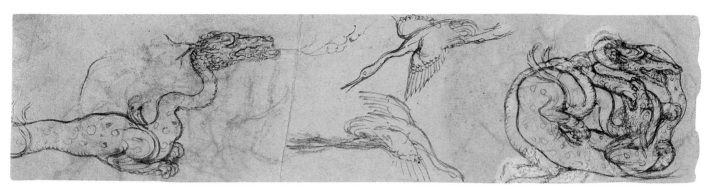

CAT. 41

Notes

1. Cary Welch outlines his ideas on the transmission of the styles and motifs of Tabriz in several sources, including Dickson and Welch 1981, 1:230–34; Welch 1983; and his introduction to Welch 1997.

2. See, for example, fol. 42v, *Faridun, in the Guise of a Dragon, Tests His Sons*, and fol. 434v, *Isfandiyar's Third Course: He Slays the Dragon*, both illustrated in Dickson and Welch 1981.

3. For a discussion of the artist, see Welch 1997, 15–38; Welch 1983, 79, fig. 2.

42 Soldiers Carousing

Attributed to the Kotah Master
Rajasthan, Kotah, c. 1710
Black ink and watercolor on off-white laid paper; several
figures pricked
7¾ × 4⅞ in. (19.6 × 12.5 cm)
Promised Gift of Stuart Cary Welch, Jr.
75.1983[r]

43 A Little Girl Dances before Spectators

Attributed to the Kotah Master
Rajasthan, Kotah, c. 1720
Purple-red ink and opaque watercolor over charcoal
underdrawing on tan laid paper
6¾ × 5⅛ in. (17 × 12.9 cm)
Promised Gift of Stuart Cary Welch, Jr.
154.1983

IN THE first, boisterous scene (cat. 42), a group of men, identifiable as soldiers, gather for a drink and meal with amusing consequences. At the top right of the page a man squats near some cooking pots, gazing at the raucous activities before him. In the center, six men sit hunched around a plate of food while a seventh holds a beverage pot and extends a cup to an eager patron. We can only assume that this is an alcoholic concoction, perhaps a toddy, from the comical antics that are unfolding. For example, two men seated at the top center of the page lunge at each other, one raising his arm to slap his accoster, who chokes him with both hands. Behind the seated group, two sketchy forms suggest that another soldier has chosen to wrap his arms around a young woman instead. In the foreground we see some hard-earned results of this merriment, as one figure bends over to vomit while another, possibly a woman, reclines, passed out. Below, the unrelated and faintly drawn forms of a horse and a

head rendered in profile also emerge from this messy page.

The liveliness of the scene comes not only from its festive subject but also from its loose manner of depiction. Quick, wet brushstrokes in black ink lightly map out forms. Careful proportional rendering has been sacrificed for calligraphic gestural lines and exaggerated, cartoonish figures. At least one figure, the seated man reaching for a drink, was considered successful enough to copy, as it is pricked for transfer.

This page was glued to a relatively modern paper backing, which was recently removed, revealing another composition filled with energetic, if unrelated, sketches (fig. 42.1). In the center of the page two men are framed between the massive forms of two running elephants. The corners and margins of the sheet are populated with various animals and figures, including a lion wrestling its prey, a rifle, and a horned bull in the upper left, a prancing cat or lion cub in the upper right, a kneeling woman at the middle right, a standard bearer and the heads and upper bodies of a man and a lion in the lower left side, and, at the bottom right corner, a flailing lion.

The page presents several different styles of drawing and kinds of media. The lower elephant in the bottom section is accurately drawn in gentle lines of faint, soft gray ink. Bolder, wetter black strokes trace out various other figures and animals. The light, quick lines used to render the lions at the lower left and right are thin and crisp, reminding viewers of the kind of mark made with pen and ink. The top and center of the page were also stained by flurries of ink and paint strokes. Swirls of gray, black, and bluish ink bleed across the figures while tiny, thin black spirals undulate up and down the sides of the page. Blots of red, yellow, brown, and olive-green paint enliven the left side of the composition, while the right side disappears in a haze of charcoal.

This smudgy, worm-eaten page was never intended to be finished. Instead, it was kept in the artist's workshop as a sheet for sketches, a template for pounce

CAT. 42

FIG. 42.1
Attributed to the Kotah
Master, *Sketches of Figures and
Animals* (verso of cat. 42),
Rajasthan, Kotah, c. 1710. Ink
and opaque watercolor on
paper, 7¾ × 4⅞ in. (19.6 ×
12.5 cm). Promised Gift of
Stuart Cary Welch, Jr.,
75.1983[v].

CAT. 43

transfers, for study, and, perhaps, even for amusement.

Another window into Rajput studio practices is provided by the second drawing (cat. 43), which depicts a young girl dancing before an eager audience amid swirls of brushstrokes. The spectators, perhaps the girl's family, consist of three women, a man, and another child who clap to the rhythm of her movements. With perfect posture and balance, the child bends her legs, turns her head, and raises her carefully posed arm. In doing so, she reveals her training in classical Indian dance, which is based upon a series of postures and gestures (mudras) that each represent a particular idea, action, or identity. Carefully choreographed dances string together sets of poses and mudras as a form of storytelling.

Although from the same school and period, this drawing differs from *Soldiers Carousing* in striking ways. The drawing of the figures is much tighter and more assured than that of the loosely rendered soldiers. The difference may have something to do with the sources of the drawings. In the case of the soldiers, the liveliness of line and unusual subject suggest that it was drawn freehand, perhaps even from life. The black smudges beneath the figures in *A Little Girl Dances* suggest that the dancing girl and her audience were drawn over the charcoal marks left from a pouncing. In this process, the outlines of a drawing that the artist wanted to copy were pricked, leaving small holes through which powdered charcoal could sift onto a new page. The underdrawing could be traced over the charcoal marks, and the evidence of the transfer would

be hidden under layers of opaque watercolor and ink in the final painting. Its clean lines and ghostly charcoal forms betray this drawing as a transferred copy rather than a life sketch.

Also revealing is the use of red pigment rather than black ink in the drawing of the figures in *A Little Girl Dances*. Red pigment was traditionally used for underdrawing in Indian painting. Examples of this practice are found across South Asia, from illustrations on twelfth-century palm-leaf manuscripts created in eastern India during the Pala dynasty (c. 760–1142) to the palace mural paintings of Kerala from the seventeenth and eighteenth centuries. We find evidence of red underdrawing in many seventeenth- and eighteenth-century works from Bundi and Kotah, revealing that this traditional practice persisted under the influence of Mughal court painting in the late sixteenth and early seventeenth centuries.

The drawn scene itself, however, is under a calligraphic assault, and the delicate figures of the dancer and her audience are overwhelmed by the energetic spirals of swelling lines that encroach from both sides. Strokes rendered in bold colors—yellow, red, blue, green, white, and black—burst forth and into their space. Here the artist has turned an old studio scrap into a place to test his brush, creating a delightful collage of controlled and expressionistic lines. As in European traditions, rough sketches like these offer key insights into the practices of Indian artists and provide examples of vibrant and immediate imagery that is often absent in carefully edited and highly finished court paintings.

KM

Rajasthan, Kotah, 18th century
Black and red inks over charcoal on tan laid paper
5 × 8¼ in. (12.6 × 21 cm)
Promised Gift of Stuart Cary Welch, Jr.
196.1983

Hunting (*shikar*) was one of the great pastimes of India's rulers. Associations between kings and the hunt have deep roots, reaching back as far as the ancient Near East; scenes of royal lion hunts appear on the reliefs from Assyrian palaces. In India the Mughal rulers staged grand hunts, and depictions of famous episodes from these expeditions became part of their illustrated histories. The subject quickly found its way into the royal iconography of Hindu court painting as well. Perhaps the most famous examples of Rajput hunt scenes come from Kotah. Kotah artists, like their patrons, had a particular predilection for the sport, and they rendered it in lively and innovative ways.

This small sketch hints at the vigor that the Kotah kings invested in the hunt and in being depicted hunting. The drawing captures the climactic moment: the quarry, in this case a group of antelope and lions,

has been driven by beaters into a small pen. The corral is being closed off by several men, who pull up a gate with a series of long ropes. The pen has conveniently been constructed beneath an elaborate tree stand, from which members of the hunting party can shoot or watch the proceedings. This royal aerie is guarded on the ground by troops armed with rifles and spears. A few of these bodyguards peer over the small barrier erected at the base of the tree to observe the unfolding events. On the ground, a hunter crouches behind a reed blind held by his companion and takes aim.

In contrast to the strategic arrangement of the hunters and the precision of their operation, chaos reigns inside the pen. Animals circle the walls frantically. Some antelope rush backward toward the gate while two lions attempt to scale the wall. The arcing contours of a lion and an antelope tumble through the air, cutting elegant forms that nearly mask the horror of their condition.

This fascinating sketch reveals a great deal; it is didactic in its presentation of the planning and execution of the hunt. Kotah artists were often so attentive to detail in hunt scenes that it seems likely that on occasion they were present to witness these elaborate activities.

KM

Attributed to the Kotah Master

Rajasthan, Kotah, c. 1725

Black ink, watercolor, opaque watercolor, and gold on off-white laid paper

20 × 27 in. (50.8 × 68.5 cm)

Gift of Stuart Cary Welch, Jr.

1999.290

Published: Welch and Beach 1965, 77, fig. 31; Dickson and Welch 1981, 1:233–34, figs. 283–84; Welch 1983, 84, figs. 9, 10; Welch 1985, 365–67, fig. 245; Brand 1995, 126, fig. 85; Kossak 1997, 62–63, fig. 31; McWilliams 2000, 13–14, fig. 6

ONE of the highlights of this exhibition is this robust painting depicting Rao Bhoj Singh hunting two massive lions in a forest. The rich swatches of pigment complement the tightly packed drawing of the leafy vegetation, evoking the feeling of the dense jungle environments of southeastern Rajasthan. Equally impressive is the detailed rendering of the startled lions—individual hairs billow from the mane of the snarling male targeted by Bhoj Singh's arrow. The king is treated in a more iconic, though no less dynamic, fashion. Bhoj Singh's form rises heroically from the underbrush, arms still splayed after releasing his shot, revealing his strength and prowess with the bow. Behind the lions the faces of various courtiers and beaters are interspersed through the foliage.

Hunting was a royal activity, and imagery depicting the hunt was part of the standard iconography of Indian court painting. This painting must have been considered exceptionally successful in communicating both the spirit of the hunt and the power of the royal hunter. It served as the model for the later unfinished drawing *Young Durjan Sal Slays a Lion*, the subject of the next entry (cat. 46).

It is no surprise that Rao Bhoj Singh, a Bundi king, should be immortalized in a Kotah painting. After a

Mughal land grant in 1631, the kingdom of Kotah was considered to be a small, semi-autonomous parcel of the Bundi kingdom through the early seventeenth century. In return for Madho Singh's loyal service, including his help in defeating Khan Jahan Lodi, Shah Jahan finally split the kingdom and appointed Madho Singh king of Kotah.[1] Yet even though these neighboring familial states eventually developed a rivalry, the symbolic importance of their shared Hara lineage had to be maintained. Rajputs claimed to have descended from divine origins, linking themselves to the gods of either the sun or the moon, or to a great fire sacrifice held at Mount Abu in southern Rajasthan. Each of these assertions served to legitimize their kingship and link them to the other great lines of *kshatriyas*, members of the princely warrior class (which the tribal Rajput clans were not), who likewise ruled on the authority granted from solar, lunar, or ritual sources.[2]

Although the Hara rulers had to negotiate within the symbolic and political networks established by Vedic and Puranic Hinduism and the imposing Mughal empire, the drawings and paintings they commissioned were anything but conventional. In their vigorous and obsessive application of line, leaving no surface without details, the bold hunt scenes from Kotah and Bundi are some of the most striking imagery in all of Rajput painting. This image of Bhoj Singh, in particular, is equal to the greatest examples of its genre, such as the exceptional painting *Brijnathji and Durjan Sal Sight a Pride of Lions* in the collection of the Rao Madho Singh Trust Museum in Kotah.[3] In that stunning example, the ruler and his prince happen upon a lions' den, replete with an adult male and female and their two cubs. The ferocious carnivores are caught in a gentle moment as the lioness rocks onto her back to suckle a hungry cub.

Cary Welch has attributed the present painting of Bhoj Singh's hunt to the Kotah Master, one of the two spirited artists he associates with the aforementioned scene in the Kotah collection. These paintings, and the later drawing of Durjan Sal slaying a lion, offer a

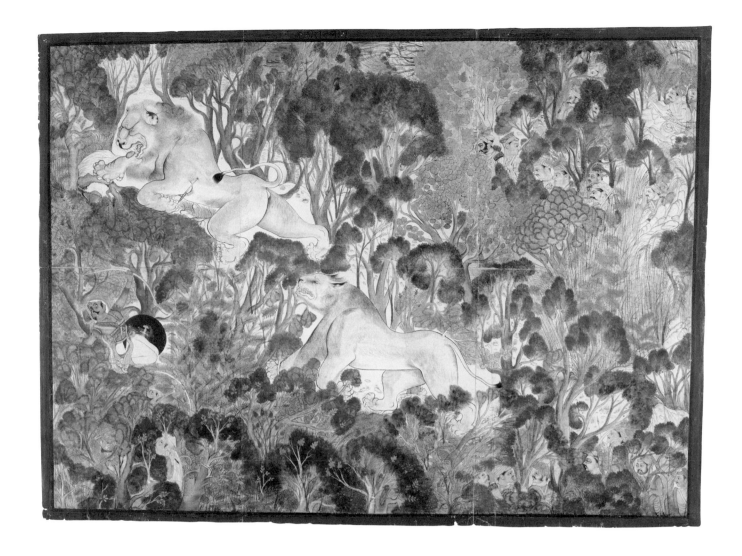

glimpse into the Kotah aesthetic. Similar scenes of rhythmic clusters of trees populated by bounding antelope and vicious predators vibrate across palace walls in both Bundi and Kotah. This imagery is regionally specific and deeply rooted in the local landscape, the creativity of the artists of the Hara school of Bundi and Kotah, and the continued and enthusiastic support of their royal patrons.

KM

Notes

1. See Bautze 1997, 42.
2. The mythic history of the Rajputs is well known; for a brief discussion see Huntington and Huntington 1985, 449.
3. For illustrations and discussion of this image, see Welch 1997, 134–37, no. 29.

46 Young Durjan Sal Slays a Lion (based on "Rao Bhoj Singh of Bundi Slays a Lion")

Attributed to the Kotah Master
Rajasthan, Kotah, c. 1735
Black ink and opaque watercolor over charcoal
underdrawing on beige laid paper
19½ × 21¼ in. (49.5 × 54 cm)
Gift of Stuart Cary Welch, Jr.
1999.285

Published: S. C. Welch 1976, 100–101, fig. 53; Welch
1997, 23, figs. 10–11

THIS is a striking study of lions in a hunt. It is perhaps a copy of the superb hunt painting of the early eighteenth century by a Kotah artist in which Rao Bhoj Singh of Bundi is shown slaying a lion (cat. 45). The hunter is young Maharao Durjan Sal of Kotah, who is shown concealed in a tree, firing arrows at the huge male lion. The wounded and enraged beast, filled with raw primeval energy and pain, gnaws the trunk of the tree. Only those who have been out in the wilderness and seen an angry, wounded lion know what a terrifying sight it is. The growls and roars shatter the peace of the jungle, and the very earth seems to tremble. This is what the Kotah artist successfully evoked. The lioness, alert and ready, follows her mate in the jungle, which is drawn with the accuracy so typical of Kotah hunting scenes, in which the shrubs and trees are rendered with near exactitude.

Maharao Durjan Sal was important at the Mughal court, a valiant prince and a great hunter who encouraged his royal ladies to accompany him on the hunt. In addition to being an excellent shot, he was a patron of art and a devout Hindu king: he organized the festivals and codified the ceremonials in the worship of Lord Shri Brijnathji, the tutelary deity of Kotah.

SBS

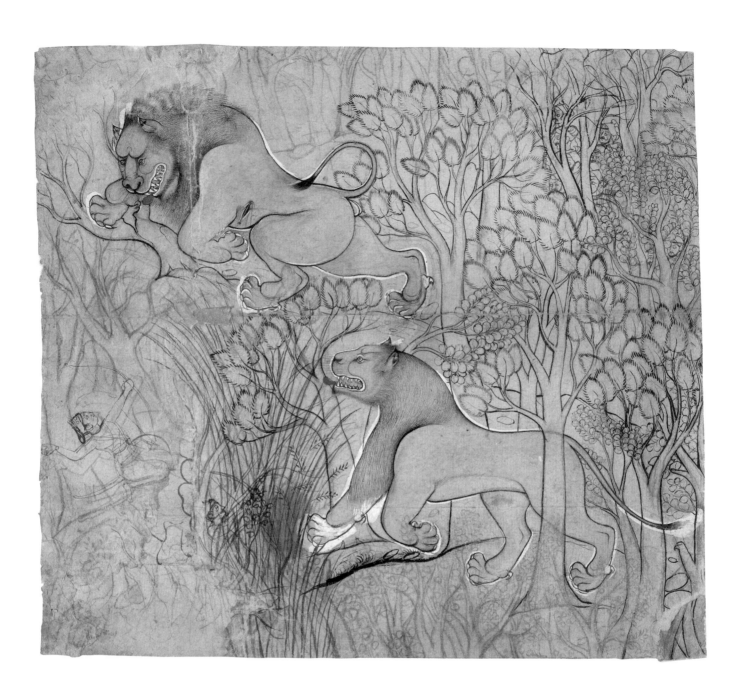

Attributed to the Kotah Master
Rajasthan, Kotah, c. 1730
Black ink over charcoal underdrawing on off-white
laid paper
11⅞ × 18¼ in. (30 × 46.3 cm)
Promised Gift of Stuart Cary Welch, Jr.
78.1983

THIS drawing is apparently one of the many copies of that most excellent fragment of a painting showing Rao Ram Singh of Kotah chasing a rhinoceros, riding an elephant as a mahout, with a companion behind him.[1] The face of the lad riding as the mahout in this example, with only a pad for a saddle, is definitely not the mature face of the rao Ram Singh, although Cary Welch believes it might represent him as a prince. Ram Singh was a seasoned warrior when he came to the throne; he fell fighting in the Battle of Jajav in 1707. In both the portion of a painting that is the likely model for this drawing and a similar painting on the wall of the Chattar Mahal in the City Palace of Kotah, the face of that redoubtable prince is that of a grown-up and is unmistakable, very different from the face here.

The rhino appears to be a young animal. An adult male rhino is bigger and bulkier and has a powerful horn; even the females are similar in size, although they lack the horn. Elephants have an instinctive fear of this cantankerous beast and usually give it a wide berth. This elephant is drawn with the distinctive Kotah touch, which displays mastery in draftsmanship and elegance in showing the power and movement of the large animal running full speed, with bells clanging. The elephant wears a determined yet gleeful expression in chasing the poor rhino, and his powerful trunk reaches out to curl around the young rhino's neck, trying to grab it. All in all, this is a rather racy and amusing composition.

In the seventeenth and eighteenth centuries the jungles of Kotah were vast, contiguous to the much larger and richer forests of central India, which stretched uninterrupted for hundreds of miles to the forests of Assam. It was common to find lions, wild buffaloes, and at times even rhinos along with tigers there. Wild elephants were found within two hundred miles of Kotah's border. So this scene may not be based on an artist's imagination; it is quite realistic.

SBS

Notes

1. The original is now in a private collection; see fig. 5 in Stuart Cary Welch's essay in this volume.

48 *Five Views of an Elephant Combat*

Attributed to Shaykh Taju
Rajasthan, Kotah, c. 1730
Black and red-brown inks over charcoal underdrawing
on beige laid paper
20¼ × 22⅜ in. (51.3 × 56.7 cm)
Gift of Stuart Cary Welch, Jr.
1999.286

Published: Hodgkin and McInerney 1983, fig. 29

THIS delightful eighteenth-century drawing by a
Kotah artist is a study of elephants in motion.
Pairs of elephants run full tilt, grapple with each other,
and butt each other, trying to lift their opponents and
overpower them through sheer brute strength. The
artist drew with a keen sense of observation and sure
and flowing brushstrokes; he had a remarkable ability
to draw the massive proportions of the elephant and
showed its movements with rare grace. Though impe-
rial Mughal paintings have some splendid studies of
elephants, the dynamism and draftsmanship of Kotah
elephants remain unsurpassed. This remarkable dis-
tinguishing feature continued with unabated vigor for
150 years. Based on such studies, Kotah artists rendered
elephants in paintings that were matchless in beauty
and exquisite in composition, features not found in
other schools.

SBS

Attributed to Shaykh Taju
Rajasthan, Kotah, c. 1735
Black ink and opaque watercolor over charcoal
underdrawing on beige laid paper
21 × 28¾ in. (53.5 × 73 cm)
Promised Gift of Stuart Cary Welch, Jr.
545.1983

Published: S. C. Welch 1976, 95, no. 49; Patnaik and
Welch 1985, 112, fig. 183

THE inscription below the balcony on which the bust of a man appears, facing left, identifies this fragment as a drawing of the fort of Gagraun, which is situated about forty-five miles southeast of Kotah city. The almost impregnable stronghold was given by the Mughal emperor to Maharao Bhim Singh of Kotah. The inscription below the man who looks from a window at a group of five people below refers to an unspecified conversation in this part of the Gagraun fort (*gagroni ka | kalam mahala ki | . . .*) (fig. 49.1). It does not mention Durjan Sal (who probably would have been shown with a halo), but the drawing was made during the earlier part of his reign. There are also scattered *Devanagari* identifications of the names of various features, such as the sun gate (if read as "bhanupol") or Shiva gate (if read as "bharupol").

J K B

This drawing represents an attempt by an eighteenth-century Kotah artist to draw the fort of Gagraun. The subject is complex: a vast fort with battlements, gates, a water gate, and palaces inside, and a village and the surrounding countryside with a river outside but encircled by a wall. It was a challenging piece of work and is drawn in the accepted medieval manner in which Indian artists rendered such complicated structures—without realistic perspective.

In the foreground the gate from which the inmates of the fort drew water from the Kali Sind River is clearly labeled. The gate is fortified, for water was crucial to the life of the compound. Left of the water gate, just behind the battlements, are "seven quarters," presumably for the guards, also clearly labeled. On the left side of the drawing, inside the fort proper, the main entrance, inscribed *Bhairav pol*, is shown clearly. Next to it is marked a small hillock or rise known as *Ghada parvat*. In the open grounds a group of people can be seen walking, and some offer salaams to the king, who sits in the *jharoka* window above. The inscriptions describe that portion as the palace of the king, with the women's palace (zenana) behind it. In the top right quarter of the drawing two elephants can be seen fighting—one of the usual pastimes of royalty (fig. 49.2; see cat. 38).

Gagraun is one of the finest fortresses of Rajasthan. It is situated astride the route from Agra to Malwa and Gujarat and lies southeast of Kotah on a low arm of the Mukandarah Hills. The Kali Sind River surrounds three

FIG. 49.1
Man looking through *jharoka* window, detail of cat. 49

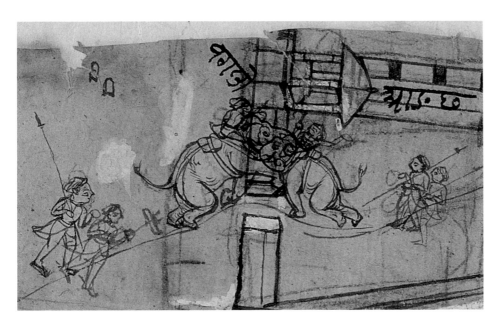

FIG. 49.2
Elephants in combat,
detail of cat. 49

sides and a jungle with high cliffs is on the other.
Gagraun is classified as both a river fort and a forest
fort—the best type of fort according to Kautilya in his
famous third century B.C. treatise, the Arthashāstra (Art
of Statesmanship). It was poetically described by 'Ali ibn
Muhammad al-Kirmani as "the middle pearl of the
necklace of Indian fortresses" in his Ma'āthir-i Mahmūd
Shāhī (Exploits of Mahmud Shahi) of circa 1468.

Gagraun is that rare fortress, one that lies hidden
by a forest and is so built that it is hardly distinguish-
able from the hill until travelers come very near it. It is
presumed that the first fortifications were built in the
early eleventh century. By 1195 it had come under the
control of the Khinchi Rajputs and was renamed
Gagavaran, which later evolved into Gagraun. Through
its location and military importance, Gagraun attracted
the attention of many kings, who naturally wanted to
add this middle pearl to their collection of powerful
fortresses. Sultan 'Alq' al-Din Khalji of Delhi unsuc-
cessfully tried to take it in 1300. Sultan Firuz Shah
Tughluq of Delhi attacked it in 1370, but once again
Gagraun remained unconquered. This attack occurred
during the reign of King Pipaji Khinchi, who was not
only a good ruler and warrior but a saintly person.

Pipaji was a disciple of Sant Ramanand, a spiritual
brother of Sant Kabir and a contemporary of Guru
Nanak, founder of the Sikh religion. The Granth Sahib,

the holy book of the Sikhs, contains many hymns com-
posed by Pipaji. His cenotaph lies outside the fort walls
and remains a place of deep veneration. There is also a
tomb at Gagraun of a pious Muslim Sufi divine called
Shaykh Hamid al-Din, who came from Khorasan in
the fourteenth century. There is an annual pilgrimage
to his tomb, and until 1948 a protective shawl for his
grave was offered every year on behalf of the maharao
of Kotah.

In 1423 Sultan Hushang Shah of Malwa captured
Gagraun, and the Rajput noblewomen performed the
rite of jauhar (immolation by fire to escape dishonor).
This was the first sack of Gagraun. The Rajputs re-
gained control of Gagraun soon after, only to lose it
once again in 1444. Another jauhar took place after this
second sack. In 1504 it came once more under Rajput
rule, in the person of Rana Sanga of Mewar. In 1531 it
fell to Sultan Bahadur Shah of Gujarat. Finally, in April
1561, the fort came under the Mughal imperium when
Emperor Akbar seized it. The Ā'īn-i Akbarī (Statutes of
Akbar) describes Gagraun as an important fort of the
empire; it was a subdivision under the province of
Malwa. It remained so until 1715, when it was granted
by Emperor Farrukhsiyar to Maharao Bhim Singh I of
Kotah. Gagraun remained part of Kotah until the inte-
gration of the princely states in 1948. A royal mint
established there in the eighteenth century was in oper-
ation until 1930, and legend claims that a huge hoard
of treasure lies buried beneath the fort.

SBS

50 Composite Elephant

Attributed to the Kotah Master
Rajasthan, Kotah, c. 1730
Black ink and opaque watercolor over black chalk
underdrawing on tan laid paper
9 × 9⅞ in. (23 × 25 cm)
Promised Gift of Stuart Cary Welch, Jr.
76.1999.37

A COLORFUL assemblage of animals is woven together to create this trumpeting elephant. Knotted masses of animal bodies intersect, revealing a variety of textures created by scales, fur, and feathers. The silhouettes of several animals are creatively employed to suggest part of the outline of the elephant, like the arcing fish that forms the trunk. The prancing pachyderm is saddled, with a macaque as its mahout.

This Kotah elephant descends from a popular genre of composite imagery that may have developed within Persianate art. Certainly the familiar motif of the predatory cat attacking its prey, visible in the center of this elephant's body, has its origins in the art of the Middle East. In the sixteenth and seventeenth centuries Mughal artists explored the potential of composite images, as is evident in the wonderful Mughal drawing of a composite elephant and rider in a landscape in the collection of the Bibliothèque Nationale, Paris.[1] By adopting the elephant as its subject and incorporating many native animals, like the writhing cobras in the foreground, the Bibliothèque Nationale image reveals how quickly this theme was localized. Composite imagery soon found its way into the courts of the Deccan and the Hindu kingdoms of Rajasthan as well.

The present drawing is a bold example of this genre. Each animal was carefully designed and tinted with opaque watercolor, creating an abstract overall appearance that is reminiscent of marbled paper, another foreign import to India. Several drawings and murals from Kotah, including *Dragons and Birds from the Chambal River* (cat. 41), also bear evidence of close connections with Persian sources funneled through contact with art of the Mughals and the Deccan. Cary Welch makes a strong case for the lineage of a Deccani painter working in the Kotah atelier whom he calls the Kotah Master, to whom he attributes this delightful image.

K M

Notes

1. The c. 1600 drawing *Eléphant composite monté par un génie à tête de bouquetin*, no. 247, fol. 32v, is illustrated in Okada 1989, 122–23, cat. 23.

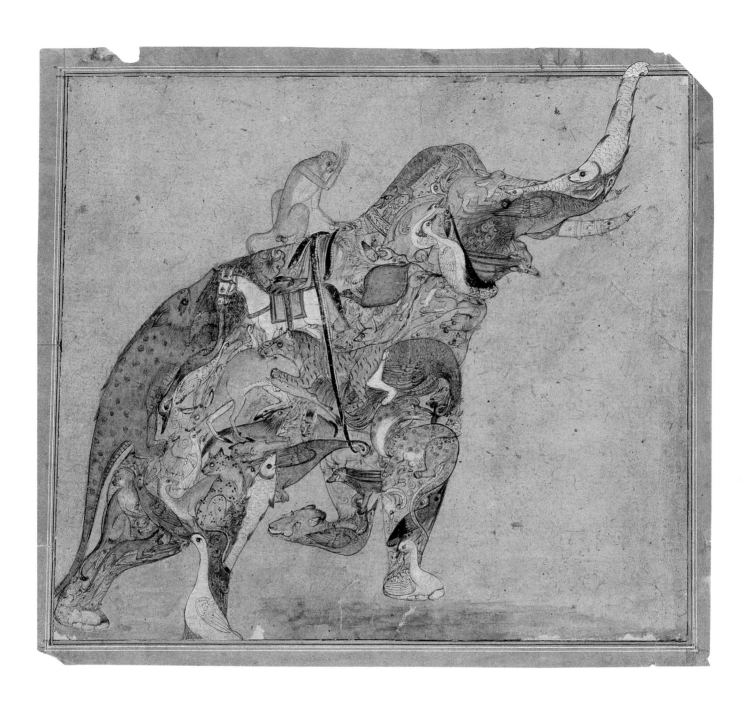

51 Pet Antelope

Attributed to the Kotah Master
Rajasthan, Kotah, c. 1730
Gray-black ink and opaque watercolor over charcoal
underdrawing on off-white laid paper
5⅜ × 5¼ in. (13.7 × 13.4 cm)
Promised Gift of Stuart Cary Welch, Jr.
133.1983

Published: S. C. Welch 1976, 98, fig. 51

GRACEFUL and alert, a captive antelope made a
striking subject for a Kotah artist. The painter's
attentive naturalism is apparent in the careful observa-
tion of the contours and curves in the animal's body.
Notice, for example, the rendering of the antelope's
raised rear leg, which hinges on a series of four joints.
This anatomy could easily have been overlooked by
another draftsman. The volumes and musculature of
the antelope's form are hinted at in the light shading
of the shoulder and hindquarter. Most of the detailed
treatment, however, was reserved for the animal's
head, which exhibits various brushstrokes that differ-
entiate its rich coat, smooth horns, and velvety ears. In
contrast, the halter and tether are suggested by just a
few faint, sketchy lines. The fresh style of this drawing
links it to several other sketches and finished works in
this catalogue. Because they appear to share the same
hand and sentiment, they have been attributed to a
single highly skilled but otherwise unidentified painter
we call the Kotah Master.

From the flurry of vigorous ink and paint strokes
that encroach upon the antelope from behind, we can
infer that this lively little drawing was to remain a study.
The sheet appears to have served as a kind of palette
where artists could test out colors and strokes and
adjust the amount of pigment held in their brushes.
 KM

Attributed to Shaykh Taju
Rajasthan, Kotah, c. 1730
Purple-red ink and opaque white watercolor over
charcoal underdrawing on beige laid paper
10⅞ × 22½ in. (27.5 × 57 cm)
Promised Gift of Stuart Cary Welch, Jr.
76.1999.30

THIS delightful sketch shows a game of *chaughan*
played in Kotah in about the eighteenth century.
The modern term for this ancient equestrian game is
polo (the word *polo* derives from the Tibetan word *pulu*,

Be that as it may, the game was played in all Eastern courts by the emperors of China, the khans of Mongolia, the shahs of Persia, the sultans of Delhi, the Mughal emperors, and the maharajas of Hindustan.

Polo has three basic features—the horse and rider, the ball, and the stick to strike the ball. All other elements are variable. Shah 'Abbas I of Persia created the Maydan-i-Shah, the grand royal parade ground in Isfahan, for the game, known then as *changhan*. The poet Firdawsi described it as a highly organized game. Later, in India, Emperor Akbar, known to be an accomplished player, codified and perfected it. Abu'l-Fazl describes in detail the rules, the number of players, and the size of the field. The game was also played by the women of the royal court under moonlight, using an ingenious luminescent ball. Music sounded during the chukkars (periods of play), and kettle drums (*nakkaras*) were beaten when a goal was scored.

In the royal courts polo remained a game of power and skill played according to the rules of etiquette. A Persian couplet states: "Let other people play at other things; the King of Games is still the game of kings." In the mountains and steppes it still remains a crude and brutish game of raw power.

Many beautiful miniature paintings show this magnificent sport. A large painting in the collection of the Rao Madho Singh Trust Museum, Kotah, shows Rao Ram Singh of Kotah playing polo with his nobles at the Gagraun Fort, using a red ball.

This sketch shows six riders chasing the ball. The artist depicted the action with wonderful skill—the fluid grace of horse and rider sweeping in, players tangling for possession of the ball. The whole composition exudes energy. One can easily imagine the cries of the players and their shouts to make way. The medieval stick was L-shaped, while today's mallet has a T at the striking end; it is still made of cane. The ball used then, as today, was made of wood. The modern game was modified by the British after they first saw it played in Manipur in the late nineteenth century. It is now played widely in the Americas, in Britain and Europe, in Australia, and of course in India.

S B S

a ball made out of willow root), and the *Encyclopaedia Britannica* describes it as a "game played on horseback between two teams of four players each who use mallets with long, flexible handles to drive a wooden ball down a grass field and between two goal posts. It is the oldest of equestrian sports." In all probability polo originated in the steppes of Central Asia, the cradle of the equestrian nomadic tribes, although many authorities believe that the sport originated in India among its mountain tribes, from whom it was picked up by the Persian cavalry of Darius and then patronized in Iran.

53 Seated Man

Rajasthan, Kotah, c. 1740
Black, red, and orange inks and watercolor on beige
laid paper
7⅝ × 4⅞ in. (19.3 × 12.3 cm)
Promised Gift of Stuart Cary Welch, Jr.
111.1983

THIS lively page contains a variety of sketches
and scribbles from an eighteenth-century Kotah
workshop. The most finished study is of a seated man
operating a hand loom in the lower right corner of the
composition. He works intently, holding the back of
the loom with his left hand and directing the shuttle
with his right. He is finely rendered, with delicate
brushstrokes that delineate his features all the way
down to individual strands of hair. The dexterity
evident in this figure belongs to the hand of a master
draftsman, such as the Kotah Master. The weaver and
his loom are drawn in deep red ink, the medium used
for underdrawings in traditional Indian painting, with
corrections around his hands indicated by applications
of off-white paint. Light orange strokes arise as in a
plume from the figure, and they resurface faintly
throughout the composition.

Above and to the left of the weaver, a squat, fleshy
figure, perhaps a child or *gana* (dwarflike minor divin-
ity), tugs on a rope with both hands. Below, energetic
red lines trace out the forms of a running elephant, his
mahout, and two galloping horses. The artist focused
on the horse's legs at the bottom of the drawing,
retracing their position and creating a believable sense
of the animal's gait and speed. Swirling spirals of
brushstrokes frame these sketches from above and to
each side. These billowing lines are made up of multi-
ple hues—red, orange, blue, and green—dominated by
clouds of black ink. Serving as both sketch paper and
blotter, this wonderful little page documents various
stages of an artwork's evolution from mind and brush.

KM

54 A Floozy

Rajasthan, Kotah, c. 1830
Gray-black ink and opaque watercolor on beige laid paper
5¼ × 6¼ in. (13.3 × 16 cm)
Promised Gift of Stuart Cary Welch, Jr.
132.1983

Published: S. C. Welch 1976, 105, no. 57

A WOMAN in a relaxed mood rests against a huge pillow. She holds a bottle in her left hand while she raises her right hand above her head, shown *en face.* Her dreamy expression and the comparatively indecent position of her legs indicate that we are sharing a rather intimate view of the woman. She is enjoying the close company of a lover, of whom, however, only the left hand on her left shoulder and a part of the face near her right cheek remain.

In Kotah, depictions of women shown en face with untied hair and a somewhat seductive countenance are extremely rare. An inscription on the back of an earlier, finished portrait of such a woman identifies her as a prostitute (*bhagtana*).[1] The present subject, however, is apparently married, as indicated by the red-colored part in her hair.

JKB

Notes

1. See Bautze 1995b, 123–80, 273–79, 287–92, 295–306, col. pl. 142.

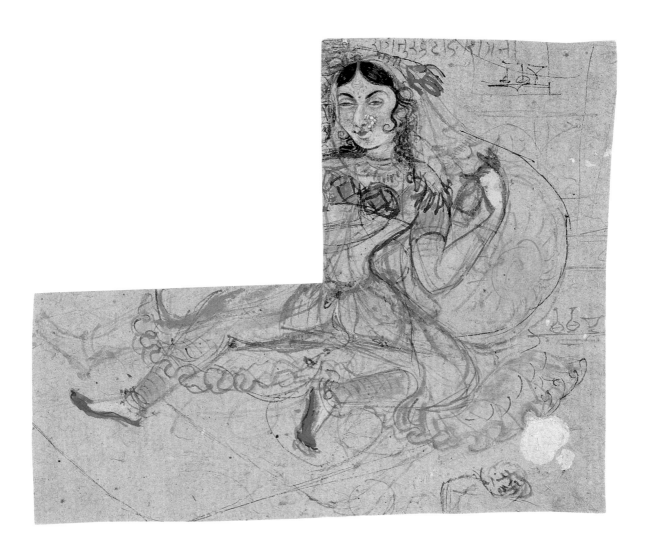

Rajasthan, Kotah or Nathadwara, c. 1835
Black ink and watercolor on beige laid paper
24 × 19½ in. (61.2 × 49.5 cm)
Promised Gift of Stuart Cary Welch, Jr.
76.1999.32

THIS symmetrical composition shows an imaginary assembly of priests (Gosvamis) and dignitaries of the Vallabhacharya Sampradaya, a bhakti religious tradition, during worship. Those on the left half are all facing right, those opposite are all facing left. In front (at the bottom) is a row of seated women, each of whom is indicated in outline.

The page is inscribed at various places with the names of the persons portrayed. The priest heading the assembly and depicted at the largest scale, top left, is Damodarji Maharaj, or Tilkayat Damodarji, best known under his name Dauji II (head priest 1797–1826). He is shown in the act of waving a raised lamp, a position he assumes in numerous similar depictions in paintings on cloth (*pichvais*).[1] Next to him—reading from left to right—stand "[Tilkayat] Gobindji," who is probably Dauji's successor, Gobindji (head priest 1821–44).[2] Gobindji stands behind "Lachmanji," who has long hair and a thin mustache. Facing them stand "Dvarkesji" and "Chalsamji(?)" holding a peacock fan (*morchal*) with his right hand. Below are twenty-nine persons on the left and thirty on the right, most of whom are identified by name. Increasingly fewer figures are identified toward the bottom part of this fragmentary drawing.

The number and arrangement of Gosvamis portrayed here correspond to the number of priests shown in a Nathdvara pichvai dated 1846, in which women also appear in the lower section.[3] The similarities between the two suggest that the present drawing consists of two joined parts that in the finished product would not face each other precisely but would be separated by the various cult images and *puja* (ritual) utensils of the Vallabhacharya Sampradaya, as in the 1846 painting.

JKB

Notes
1. Skelton 1973, nos. 12–14; Sotheby's 1979, lot 161.
2. For the dates, see Ambalal 1987, 167.
3. Ibid., 66, col. pl.

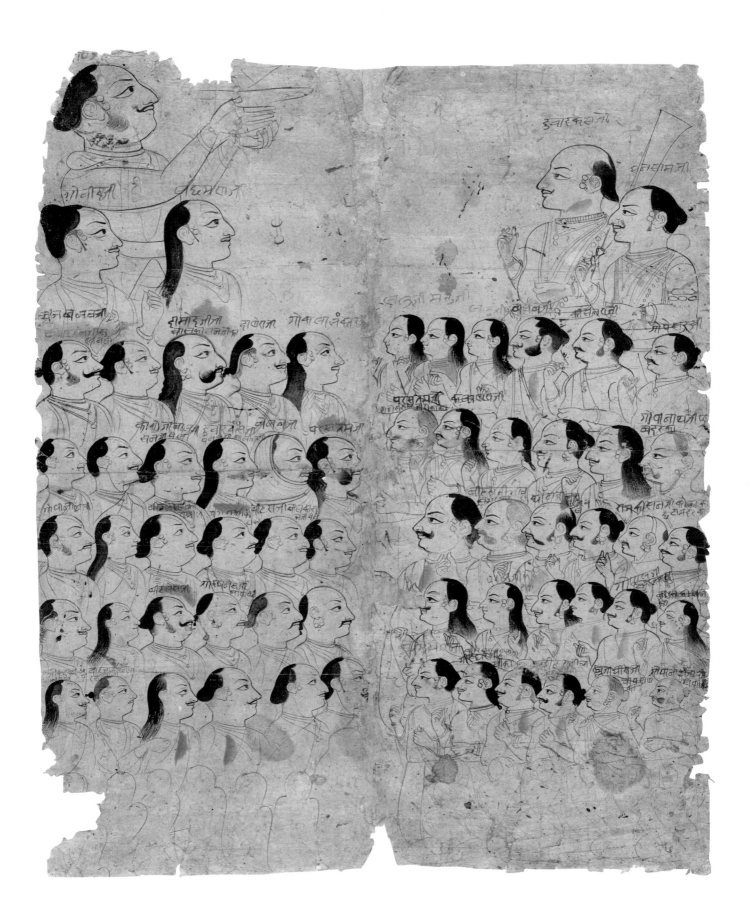

Rajasthan, Kotah, c. 1840
Green-brown ink on blue-gray paper; pricked
5⅞ × 5¾ in. (14.8 × 14.5 cm)
Promised Gift of Stuart Cary Welch, Jr.
226.1983

Published: Rawson 1969, col. pl. VI

A MAN sexually stimulates five women at once in this drawing, which is a fragment of a sketch for a larger composition dating to 1850–60. A closely related, though mirror-reversed, finished painting of this scene shows that a more complete drawing would have represented the man copulating with one woman in his lap while he stimulates the clitorises of four others with his hands and feet.[1] Another finished version omits the round mirror held by one woman, of whom only a hand remains here.[2] In another picture the man is wrongly identified as "Maharaja [sic] Ram Singh of Kotah."[3] Maharao Ram Singh II of Kotah (r. 1827–66) is conventionally shown with a halo, which the painter could omit only when depicting the maharao engaged in a religious ceremony facing the tutelary deity. Comparison to authentic contemporary portraits shows the maharao's likeness to be completely different.[4]

Depictions of one man in conjunction with five women as shown here are known in Indian art from the first century B.C. onward and usually represent a particular idealized situation, rather than historical persons.

JKB

Notes
1. Rawson 1969, col. pl. VI, facing p. 61.
2. Rawson 1977, col. pl. 2.
3. Sinha 1980, 73, col. pl.
4. Cf. Bautze 1988–89, 316–50; Bautze 2000, 123–38.

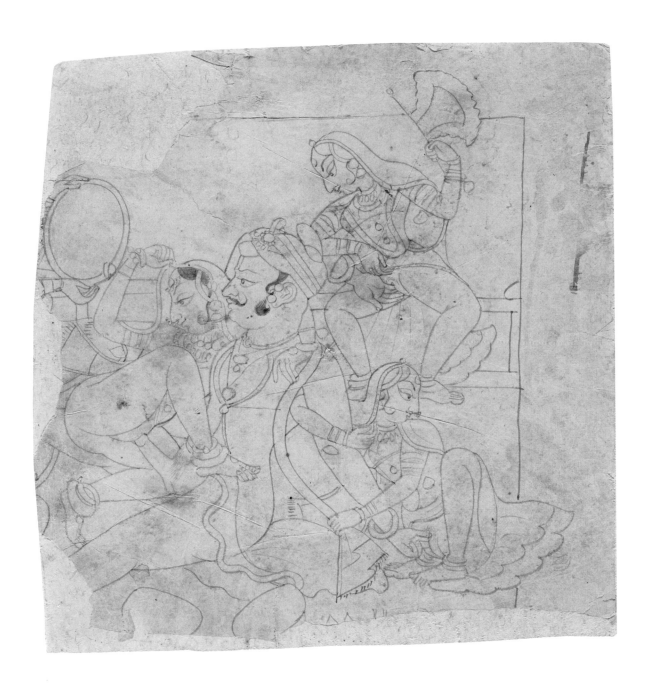

Rajasthan, Kotah, c. 1850
Gray-black and brown inks and watercolor on beige
laid paper
8¼ × 7⅞ in. (21 × 20 cm)
Promised Gift of Stuart Cary Welch, Jr.
158.1983

Published: Beach 1974, fig. 109; S. C. Welch 1976, 102,
no. 54; Welch and Sagstetter 1994, 78, fig. 1

INCLUDING images of women and the head of a
mythical beast at the feet of a Vaishnava deity, this
is a fragment of a larger sheet used for exercises, on
which are juxtaposed scenes that stand in no apparent
relation to each other. At the top right is the lower part
of a cosmological rendering of the image of Shri Math-
ureshji, one of the seven manifestations (*sapta svarupas*)
of the god Shri Nathji of the Vallabhacharya Sampra-
daya housed at Kotah. The image is identifiable by the
conch (*shankha*) held in his right hand.[1]

On the lower left is a woman whose female servant
scrubs her feet with a scrubber. This theme in Indian
painting (and drawing) is not new, but the woman who
receives this treatment usually looks more pleased.[2]
The artist sketched the servant in two different
positions. In each, she squats at the bowl, treating the
sole of one of the woman's feet. A globular ewer,
visible behind the servant's back, may be carried by a
second servant, no longer present in this fragment.

The woman, who has a disgusted expression and a
piercing gaze, is also shown in two different positions.
The artist worked more on the view in which she is
turning around. In this position, her body appears
twisted as the sole of her left foot is being scrubbed.
In an earlier attempt, the woman was shown in a more
comfortable position, in which the servant would be
treating her right foot. In the variation sketched above,
the woman does not twist her body and is shown in a
pose that is closer to the position in other paintings
and drawings of the subject. Of the servant, only the
hands are indicated.

The head of a *makara*, a kind of mythical crocodile
based on the Indian gharial and the sweetwater
dolphin of the rivers Indus and Ganga, is executed in
bright green. If it is at all related to the drawing, it
seems to sniff the lower part of the woman's body.[3]

The sheet is inscribed at various places in *Devana-
gari* script. The inscriptions explain what the artist
should do as the next step in the preparation of the
painting.

JKB

Notes
1. For more complete drawings that include the image of Shri
 Mathureshji, see Bautze 2000, 123–38, figs. 5–8.
2. For a related Pahari drawing formerly with A. K.
 Coomaraswamy and related paintings, see Bautze 1996,
 76–92, cat. 49; 88 and notes.
3. For an interpretation of this playful, multilayered sketch see
 Stuart Cary Welch's discussion in his essay in this volume.

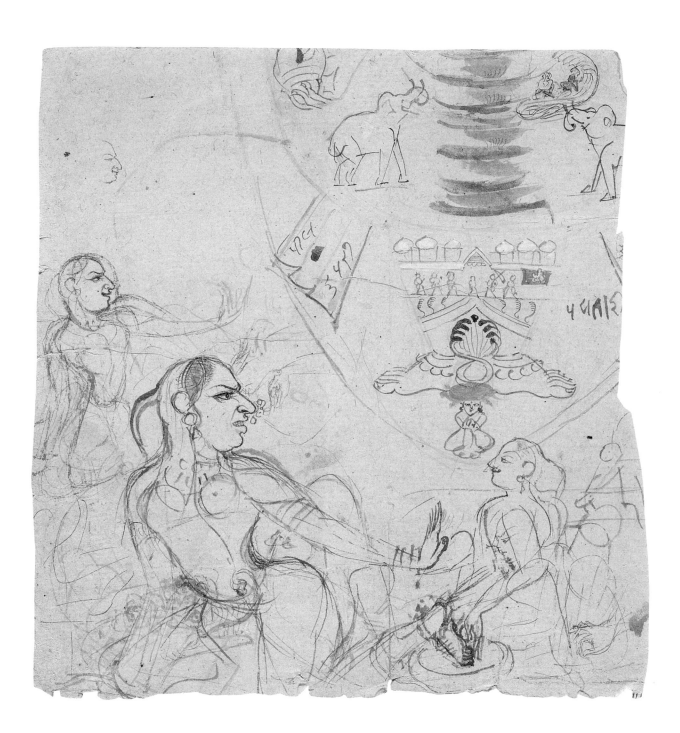

58 Maharao Ram Singh with a Girl in a Cabriolet

Rajasthan, Kotah, late 1850s to early 1860s
Black ink, watercolor, and opaque watercolor on off-white paper
10 × 16½ in. (25.3 × 42 cm)
Promised Gift of Stuart Cary Welch, Jr.
80.1983

Published: Archer 1959, fig. 51; Beach 1974, fig. 106

AN elderly Maharao Ram Singh drives an English cabriolet in the company of a woman, shown in a considerably smaller size, seated on his proper left. The heads of both the woman and the maharao are surrounded by a radiating halo. Three women bearing royal insignias—a peacock fan and fly whisks—are dashing after the vehicle, while another woman is seen running next to the horse.

The carriage is based on the eighteenth-century French cabriolet, which according to a contemporary author was "a very convenient vehicle for unmarried men to go out in at night, and return either from dinner, or from the theatre or opera, or houses of parliament. . . . It saves the inconvenience of . . . two horses, a coachman and footman, which, when out late at night, involve a large amount of troubles as well as expense."[1] (In 1836 the Hansom Cab company introduced an abbreviated version of this cabriolet, which internationally became known as a taxi.) Carriages were considered of some importance at Kotah, and the amount of money spent on their maintenance and on the construction of new models is specifically mentioned in nineteenth-century Kotah documents.

Carriages were not the only fancy items the maharao acquired from Europe. In a "Kotah Agency Report" dated 28 April 1879 we read, "A steam launch was got out from England and launched on the river last month. She cost in England about £480. She is 33 feet long and capable of seating 20 people. She is also used as a tug for the M[aha] R[ao']s boat, and is apparently much appreciated by the Durbar."[2]

The young woman at the maharao's side is probably the daughter of Thakur Hanvant Singhji of Nantori (in the Jaipur State); she became the maharao's wife in the late 1850s.[3]

JKB

This sketch of about 1850 shows Maharao Ram Singh II of Kotah riding in a carriage with a pretty young woman seated next to him. Three other young women walk briskly behind in attendance, wearing traditional dress and carrying the royal regalia of the *chauri* fly whisk made from yak tails, and the *morchal*, peacock feathers bunched up in a braided quiver. One also carries a matchlock. In front, another damsel trots along holding the royal scimitar (*talwar*) and the rhino-skin shield (*dhal*). The maharao drives a splendid, spirited horse, resting his straight-bladed sword (*khanda*) on his shoulder. The nimbus denotes that he is a king. He wears the traditional shirt (*jama*) with a *kamarband* as well as bejeweled armlets (*bhujbands*), bracelets (*kadas*), and a necklace (*haar*). His turban (*pagri*) is adorned by an ornament (*sarpech*). The horse is beautifully drawn. The women have the distinctive Kotah face: rather beautiful, with pretty lips and lovely eyes. They wear the customary flowing skirt with bodice and small, sarilike wrap (*ghaghra-odni*). They are adorned with a vermilion mark on forehead (*tiki*), a *rakhi* (amulet) on the head, earrings (*jhumkas*), a small necklace (*kanthali* or *hansli*), bangles (*choories*), and anklets (*kadas*). One can clearly discern the British influence here; the carriage is not Indian.

During Maharao Ram Singh II's reign there was a second flowering of the Kotah school of painting, with greater emphasis on ceremonial scenes in addition to the favorite subject of hunting. Ram Singh was a king

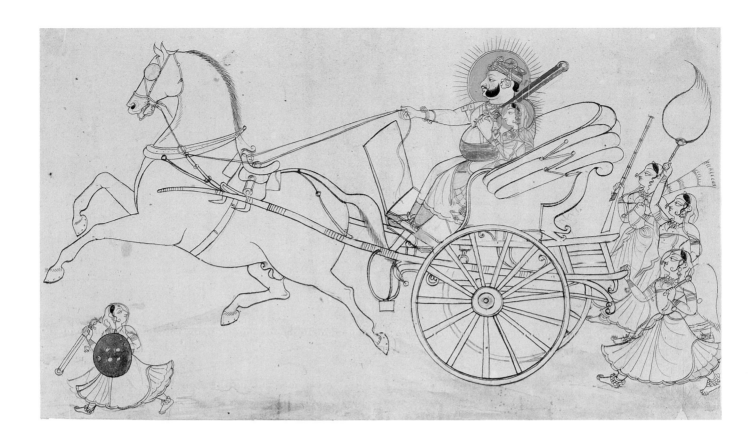

who enjoyed life with zest and made sure that episodes in his life, however whimsical, were faithfully recorded by his artists. The most famous of such illustrations shows the maharao riding the state elephant in a procession with a dancing girl performing on a small platform fixed on the elephant's tusks. One version of the painting is in the collection of the Victoria and Albert Museum, London, while another remains in the Kotah collection. Such scenes were not fantasies but depictions of actual events—just like this simple but sparkling scene of his ride in the carriage.

SBS

Notes
1. Adams 1837, cited in Dinkel 1981, 178.
2. Powlett 1880, 107.
3. Sharma 1939, 2:588.

59 Shatru Sal II and Two Ladies

Rajasthan, Kotah, c. 1860
Black ink and opaque watercolor on off-white laid paper
6¾ × 9⅞ in. (17.2 × 25.2 cm)
Promised Gift of Stuart Cary Welch, Jr.
119.1983

Published: Bearce and Welch 1963, no. 21 (not reproduced)

A NOBLEMAN whose profile bears some resemblance to Maharao Shatru Sal II of Kotah (r. 1866–1889) sits on a chair, holding a bottle and a beverage cup, apparently enjoying an alcoholic drink. Another bottle and cup sit on a small table nearby. The woman standing behind in attendance holds a bottle in her left hand while she moves a kind of fan (morchal) with her raised right hand. A tall woman is apparently walking out of the scene while turning her head back toward the seated man. She seems to be arranging her unbound hair. A third woman stands on the threshold of an open door in the distance, holding a bottle in each hand.

This drawing is by an artist with whom only a few works can be identified. His figures are characterized by large eyelids, giving them a somewhat sleepy appearance. His representations of women's profiles are somewhat unconvincing, although his portraits of men show the usual facility found among artists in the royal atelier of Maharao Ram Singh and his son and successor, Maharao Shatru Sal. This work dates to circa 1860 to 1880, largely within Shatru Sal's reign. But the man is not Shatru Sal, as can be seen by comparison with known portraits. In addition, in such a situation the maharao would have been shown with his customary halo.[1]

JKB

Notes
1. Cf. Bautze 1995a, 84–91; Bautze 1997, 39–60, 56, fig. 16.

Rajasthan, Kotah, c. 1875
Black ink and opaque watercolor on off-white laid paper
9⅝ × 15¾ in. (24.5 × 40 cm)
Promised Gift of Stuart Cary Welch, Jr.
223.1983

Published: Welch 1978b, 139, no. 61d, under a
different title

A ROUGHLY contemporary rendering of what is probably the same railway scene shown here can be found in an uncolored mural in the Kanwarpada ka Mahal within the old palace of Kotah.[1] The train in the present drawing seems to be moving into a building, which in the mural at Kotah is identified as Agra haltage house (*agra sarahalghar*), that is, a depot or station. The large caravanserai that existed at Agra between the Agra Fort (Agraqila) and the Great Friday Mosque (Jama Masjid) was demolished in 1875 in order to make way for the railway line. The drawing was hence probably done around this date. The uncol-

ored murals within the Kanwarpada ka Mahal were executed in the late 1860s or early 1870s although they record earlier events. One, for example—an elephant fight at the sun gate (*surajpol darvaza*)—bears a date in the Samvat Era ("1911") corresponding to A.D. 1854. Another mural in the same room records the procession of Maharao Ram Singh through the bazaar of Rampura during the festival of Holi in 1863. It was only in 1906 that the city of Kotah was connected with the railway line.[2]

The page is inscribed at various places in *Devanagari* script. The inscriptions indicate, for example, that the train is executed in the Agra manner ("agra sucal") and that it is shown at night ("ralvai rat ma"). The telegraph wire is described as a whiplike thread for communicating news ("tar ka galka samacar").

J K B

Notes

1. Compare Singh 1985, figs. 41–42.

2. For details, see Gupta 1982, 214.

61 Maharana Amar Singh II at Worship

Rajasthan, Mewar, c. 1698–1710
Black ink, opaque watercolor, and gold on beige paper
21¼ × 16 in. (54 × 40.6 cm)
Promised Gift of Stuart Cary Welch, Jr.
543.1983

Published: S. C. Welch 1976, 80–81, no. 39; Hodgkin and McInerney 1983, fig. 10; Patnaik and Welch 1985, 87, fig. 24

Inscription: "Maharaja sri Raj Sri Amar Singhji doing japa at important worship"

THE maharana, descended from the sun, and the premier ruler among the Rajputs, is shown at prayer, seated in the lotus position. Naveen Patnaik effectively sets the stage:

> The maharana rose before dawn and performed his ritual ablutions. Wrapping his body in a length of unstitched fabric known as a dhoti, he left his private apartments for his private temple, which stood by water, as stipulated by the sacred texts. Gold and silver lamps lit the interior of the temple, and incense and camphor already burned before the deities. As the maharana entered the temple, a conch shell was blown and the temple bells were rung to announce the commencement of the morning prayers.
>
> The maharana seated himself before his Isht Devta, or personal godhead. Turmeric was smeared on the deity's forehead and garlands of marigolds hung around its neck. Between the fingers of his right hand the maharana held a rosary made of *rudraksh*, or forest seed beads, hidden in a *gomukhi*, or prayer gauntlet. The prayer gauntlet prevented the rosary, or *mala*, from being contaminated by the evil eye. The maharana recited the holy words of his mantra, or incantation, silently, as the text was too sacred to be spoken aloud. By the time the maharana had completed his lengthy sequence of prayers and meditations it was dawn, and the first reflections of the rising sun could be seen in the water outside the temple.[1]

This sensitive yet elegant profile, formal as a portrait of Emperor Aurangzeb, is unusually large in size and so finely drawn and painted that each hair is a separate brushstroke, and the whites of the jewels are in relief. It was painted by a remarkable artist who must have been born and trained in the Deccan, probably at Golconda. Like many Deccani masters, he would have suffered from loss of patronage during the last quarter of the seventeenth century, when Emperor Aurangzeb's vast armies defeated both Golconda and Bijapur. Men of talent, including artists, sought work at Aurangabad, the burgeoning imperial outpost and "hiring hall" in the Deccan, where Mughal and Rajput officers vied for their services. Princes from Kotah, Kishangarh, and Bikaner found artists who breathed new life into their artistic traditions at home, as did this anonymous genius who moved to Udaipur, capital of Mewar.

He is known to me from three other remarkable pictures: a splendid, almost life-sized painting of a South American monkey from the maharana's private zoo; a magnificent depiction of Maharana Amar Singh II playing at Holi with his Sardars; and the outlandish *Lovely Chinese Ladies* (fig. 61.1).[2] This fascinating and comical cross-cultural picture shatters time, and its motifs play a visual ping-pong game centered around the two "chinoiseries." Its theatrical architecture was traced from seventeenth-century European engravings of a documentary sort encountered more often on bedroom walls than in reputable public or private collections. One of the two standing women in the drawing carries a tray with four cups (left); the other holds a complicated ewer. Like the dragon in the Mewar painting's multicultural grab bag of motifs, these Chinese servants can be traced to Golconda's Turkman heritage. Subjects of this sort abound in Istanbul's Turkman albums.[3] Through a cathedral door sharp Indian eyes were shocked to discover a European couple embracing and kissing before the altar. From the distant horizon, a goat hungrily defies space by munching leaves from a tree in the foreground. High in the crotch of a tree to the left of the ladies is another borrowed motif, a Chinese dragon that—along with

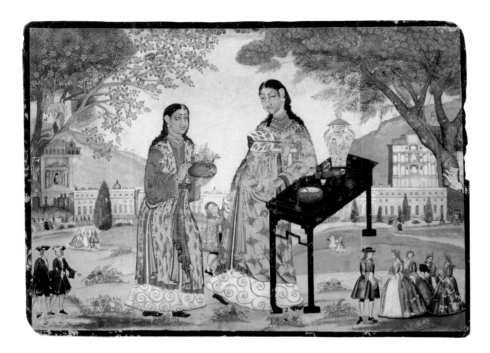

FIG. 61.1
Lovely Chinese Ladies, Rajasthan, Mewar, c. 1700. Opaque watercolor and gold on paper. Private collection.

drawings or tracings of the Chinese ladies—must have been brought by the Tabriz-born Turkman founder of Golconda under the Bahmanids.[4] With him would have come not only Turkman works of art but also artists, thereby enriching indigenous traditions for generations to come.

One of the beneficiaries was the painter of these pictures, whose sense of composition, use of fine line, technique, and grandeur of scale are markedly personal. He gave roundness to his figures with subtle stippling and banks of short, parallel lines. Another telltale sign of his work is his treatment of hands, whether human or simian, with long, tapering, elegant fingers. One hopes that signed work by this delightful and impressive Indian artist will be discovered.

SCW

Notes

1. Patnaik and Welch 1985, 86, pl. 87.
2. For *The South American Monkey*, see Welch 1985, 360–61, no. 243. According to an inscription on the verso, the engaging animal's name was Husayn. For *Maharana Amar Singh II Playing Holi with His Sardars*, see Topsfield 1980, 62, no. 58, pl. 12, dust jacket. Admire the superb play with symmetry and the "color field" of massed upright cypresses and staccato red flowers in this picture, which was conceived and mostly painted by Mewar's master from the Deccan. His innovations set the standard for infinite numbers of later large Mewar paintings of royal gatherings, religious and secular.
3. Such as Topkapı Sarayı Müzesi no. H. 2153.
4. For Turkman art, see Dickson and Welch 1981, vol. 1, chapter 3. See also Grube et al. 1981: women, figs. 104–10, 113, 152–55, 159–62, 448, 449; dragons, figs. 459–61, 464–69. See also Isiroglu 1976, pls. 54, 67b, 67c, 73. For the impact of Turkman and Deccani (Golconda) art at Kotah, see Welch 1997, 15–38.

Rajasthan, Devgarh, late 18th century
Black ink and watercolor over traces of charcoal on
off-white laid paper
7⅛ × 12⅝ in. (18 × 32 cm)
Promised Gift of Stuart Cary Welch, Jr.
197.1983

Published: S. C. Welch 1976, 106, no. 58

ON occasion the kings of Hindustan used animals to assist them in their pursuit of game. In this remarkable sketch we follow the movements of a domesticated cheetah as it brings down its prey. At the beginning of the sequence, a cheetah sits attentively with its handler in a cart. Reading the continuous narrative, we see the cat lunge for a rearing buck and bring it to the ground. The hunt is set in a rolling landscape, backed by a dense wood. The elegant curving and calligraphic lines used by the artist add to the graceful and swift appearance of the cheetah and its quarry.

Hunting with trained cheetahs is a subject common to Persian and Indian painting. An exquisite Persian depiction of a mounted hunter with his cheetah appears elsewhere in this catalogue (cat. 12). The subject made its way into the Mughal painting schools, as is evident by the illustration *A Hunting Cheetah on a Cart*, dated to 1610–20, from the Johnson Album.[1]

Rising above the horizon behind the hunt we can make out an equestrian sketch of a bearded raja and his attendant. This has been identified as Gokul Das, one of the ravats of Devgarh (r. 1786–1821).[2] Devgarh (Deogarh) was the most powerful feudatory in the Mewar kingdom. In the early 1760s the Devgarh ruler Jaswant Singh broke off from Mewar to form an autonomous state.[3] Within a few years several Mewar artists also left and went to serve the Devgarh court. Bakhta, the best-known of these painters, established a school there.[4]

The artwork from the Mewar-Devgarh schools employs bold colors, strong outlines, and figures rendered in a flattened, crisp profile. The archetypal eighteenth-century Mewar style is certainly evident in this portrait of the ruler. In its looseness and dynamism, the hunt scene stands in sharp contrast to the portrait.[5] This sketchy scene is close in both style and spirit to *Sketches of Dogs*, also illustrated here (cat. 63).

K M

Notes

1. Johnson Album 67, fol. 6, in the collection of the British Library, published in Ashton 1947–48, 156, no. 702, pl. 133.
2. See S. C. Welch 1976, 106, no. 58.
3. Discussed in Desai 1985, 42, no. 37.
4. Andrew Topsfield discusses Bakhta's work in detail in Topsfield 2001, 192–93, 200–202, 217–20.
5. For a thorough discussion of Devgarh painting and its relation to that of Mewar, see Beach 1970–71, 23–35; Topsfield 1981.

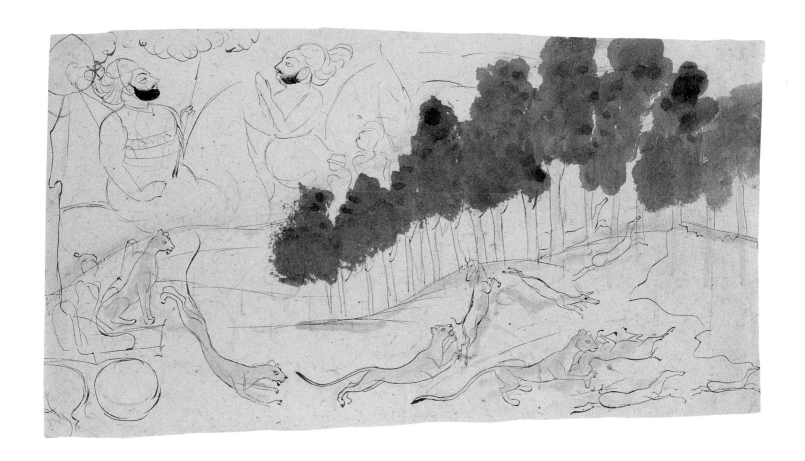

63 Sketches of Dogs

Rajasthan, Devgarh, late 18th century
Black and brown inks on beige laid paper
10⅝ × 6⅞ in. (27.1 × 17.4 cm)
Promised Gift of Stuart Cary Welch, Jr.
29.1983[r]

ONE of the great benefits of looking at sketches and preparatory drawings is that they offer the viewer a direct presentation of the thoughts and observations of a working artist. Such immediacy is wonderfully evident in this page of sketches. In the foreground the artist documents a variety of poses and activities of a dog. Moving across the page, we see him sit, stand alertly, run and bound, defecate, and curl up for a nap. Although the dog is sketched lightly, with exaggerated features, the artist has observed enough detail to convey his doglike nature. Above the frisky canines on the left a bull stretches and twists in the air, while on the right two quickly rendered hands appear to point to something. Behind them, a sprawling landscape unfolds, filled with processions of figures and horses that extend into the far distance. Along the horizon at the top of the page an elephant and rider are followed by a man on foot. They move across a receding hillside against the backdrop of the setting sun.

On the verso the artist sketched various types of weapons and metal fixtures (fig. 63.1). In the top center an elegant fork, perhaps from a spearhead, with prongs emerging from a lion's mouth is flanked by two *khandas*, the long, straight swords with wide tips that were favored by Rajputs.[1] Accompanying them is a weapon with a double-edged curving blade and two tall objects that bend and curve outward, in a form similar to that of an *ankush* (elephant goad).[2] To the left are a series of small objects, perhaps metal buckles and tack ornaments. Below are two lightly sketched portraits of a figure in three-quarter view and seated, seen from the rear. To the right is an elegant arching hilt from a sword or dagger with organic decoration that attracted

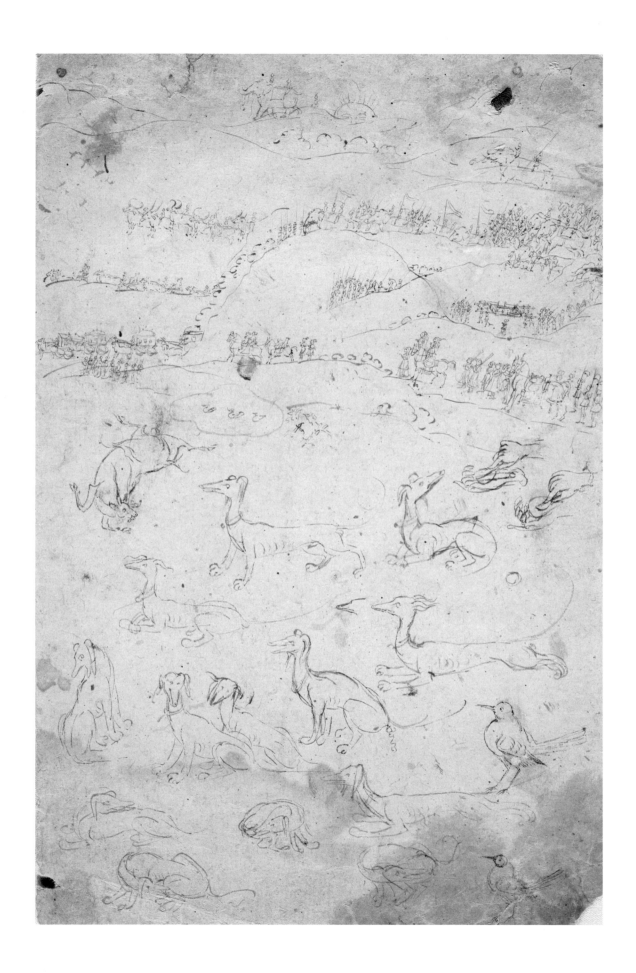

the attention of the artist, who playfully drew a tiny figure leaning up against the hilt, linking these two otherwise separate images. The bottom margin of the page is filled with a calligraphic rendering of scrolling vines.

The page has been attributed to Devgarh, a feudatory state that broke off from Mewar during the 1760s under the ravat Jaswant Singh. Several Mewar court artists, including Bakhta, left the capital at Udaipur to work for the fledgling Devgarh court. Bakhta's images are freer and more spontaneous during his time there, and the loose, lively style of these drawings suggests they may be from his hand.[3] The light, playful brushwork is also similar to another Devgarh drawing from the Welch collection, *The Ravat Hunts with Cheetah* published here (cat. 62).

K M

Notes

1. For a brief discussion of the *khanda* and other Rajput weapons, see Paul 1995, 64.

2. Although the overall shape of the object is similar to an ankush, most goads portrayed in Indian paintings consist of a rod with a hook projecting from the top, so the identification of these objects is unclear.

3. For a detailed discussion of Bakhta's work, see Topsfield 2001, 192–93, 200–202, 217–20. For a comparative sketch by Bakhta, see Ehnbom 1985, cat. 53.

FIG. 63.1
Sketches of Various Objects and Figures (verso of cat. 63), Rajasthan, Devgarh, late 18th century. Black and brown inks on beige laid paper, 10⅝ × 6⅞ in. (27.1 × 17.4 cm). Promised Gift of Stuart Cary Welch, Jr., 29.1983[v].

64 Procession at Datia

Bundelkhand, late 18th century
Black ink and opaque watercolor over charcoal
underdrawing on off-white laid paper
16⅝ × 32¼ in. (42.3 × 82 cm)
Promised Gift of Stuart Cary Welch, Jr.
230.1983

Published: S. C. Welch 1976, 124–25, no. 70

IN the center of this procession, which mainly consists of riders and foot soldiers, trots an elephant driven by a mahout with an *ankush* (goad) in his left hand and a *chauri* fly whisk in his raised right hand. Behind him, on a peculiar elephant seat that closely resembles a saddle for a horse, sits a man holding a *talwar* scimitar with both hands. As this man does not have a halo, either the drawing forms part of a larger composition that included a ruler of superior rank— hence, shown with a halo—or the man is not yet a ruler. It is unlikely that the halo, customary by the mid-eighteenth century, would not have been drawn in at this stage of the work.

Stylistically the closest comparison is offered by drawings done in the mid-eighteenth century, particularly by the Jaipur artist Ramjidas.[1]

JKB

Although today most people know of Datia only as a sleepy little stop on the Agra-Delhi rail line, it was a thriving Rajput center in the sixteenth through eighteenth centuries. In the early years of his reign, the Bundela raja Bir Singh Deo (r. 1605–27) is said to have built a magnificent palace there, along with several temples and palaces in his nearby capital, Orchha, and the immense fortress at Jhansi. Bir Singh is as famous for his conspiracies, however, as he is for his monuments. In particular, he conspired with Prince Salim to kill Akbar's biographer and friend Abu'l-Fazl; after Salim succeeded Akbar as Emperor Jahangir, he rewarded Bir Singh with a high Mughal appointment. In return Bir Singh built the Jahangir Mahal (palace) in Orchha to honor the emperor during a state visit. Although no later Orchha rulers outshone the legendary Bir Singh Deo, they were themselves successful.

The Bundela dynasty remained a presence in Orchha and Datia through the eighteenth century.

It was in honor of a descendant of Bir Singh, the maharaja Shatrujit (r. 1762–1801), that this drawing was made. Shatrujit may be the monarch shown here seated on an elephant in the midst of a sea of princes and soldiers, all of whom wear the low, sagging turban associated with Datia imagery. This work most likely dates to the late eighteenth century, before Shatrujit's untimely death at the hands of his warring Maratha neighbors. Several of the riders behind Shatrujit are identified with *Devanagari* inscriptions. Subtle variations in the riders' appearance suggest that the images are actual portraits. Naturalism, however, may not have been the artist's chief concern. Identical silhouettes of prancing steeds are repeated in stacked rows, indicating that the artist retraced the same cartoons again and again. The figures are flat, rendered only in contour. Subtle details, however, reveal that the artist reworked the image and shifted the figures around. For example, the elephant carrying the ruler has two visible sets of eyes. Like scenes of durbars (royal audiences) and hunting parties, paintings of royal processions served as symbols of a ruler's status and political authority. Thus, this stately assembly is as iconic as it is representational.

Although the large size of this image required that it be pieced together from three sheets of paper, we should still consider this drawing to be part of an even larger composition. *Procession at Datia* is probably a working cartoon for a wall painting (indeed, fragments of murals still grace the walls of the Datia palace). Several unfinished elements here, like the partial application of decoration to the elephant's saddle cloth, would be permissible in a cartoon because final details could be resolved in the wall painting itself. With its patches of white paint indicating corrections, this ambitious drawing should be considered a work in progress and an insightful guide to the elaborate process of mural painting in the Rajput courts.

KM

Notes

1. Compare Das 1981, 317–23.

65 A Prince at Prayer

Rajasthan, Kishangarh, mid-18th century
Black ink and opaque watercolor on beige laid paper
4⅞ × 2⅜ in. (12.3 × 6 cm)
Promised Gift of Stuart Cary Welch, Jr.
518.1983

THROUGH the course of the eighteenth century, the Kishangarh school produced many paintings and drawings of saints, holy men and women, and figures at worship, especially figures connected with the Vaishnava tradition. Often these were simple studies, executed in ink with thin washes of color rather than richly painted compositions. Landscape elements were usually kept to a minimum, and a concentrated focus was maintained on the subject itself.[1] This delicate but intense study of a man who seems to be setting off to prayer falls into the genre. He wears what appears to be a saffron dhoti with a transparent veil wrapped around his head and upper body, is barefoot, and carries a lotus in one hand and an unidentified object (perhaps an offering) in the other.

Below his simple garments and garland of flowers, the figure wears several items of jewelry. These include earrings, necklaces, an armband (bazuband), and bracelets. Neither the quantity nor the style of the jewelry is typical for commoners, implying that he could be of noble birth or high standing and his simple robes are intended for ritual or prayer. Depictions of bejeweled princes dressed in ritual clothes and performing worship are known in other schools of Rajput painting.[2]

In this case, the figure could be a member of the Kishangarh royal family, although his appearance does not match any known studies of particularly devout individuals, such as Prince Savant Singh. Although the man cannot be identified with certainty, his portraitlike features appear to have been based on observation, particularly the sharp nose and full lips.

The impression of an earlier unfinished headdress in a reddish outline can be seen under his transparent veil. This helmet-shaped head covering is a distinguishing feature of the attire of the fourteenth-century Vaishnava saint Namdeva, whose name probably derives from his devotion to the name (nama) of God (deva). A painting in the Victoria and Albert Museum, London, illustrates an idealized gathering of important Hindu saints observing a samā' (ecstatic singing and dancing of Muslim mystics); among the frieze of holy men, who are identified in accompanying Persian inscriptions, is a portrait of Namdeva wearing a headdress similar to the one partially visible here.[3] Presumably Namdeva's later followers, images of whom are sometimes seen in Rajput and Pahari painting, wore such headdresses as a distinguishing feature of the sect.

NHH

Notes
1. Goswamy and Bhatia 1999, 178, fig. 139, illustrates a comparable portrait of a Radhavallabhi priest; Haidar 1995, pls. 129, 130, 141, show further examples of similar images.
2. Topsfield 1994, fig. 18, depicts Prince Ram Singh of Amber similarly clad and at prayer.
3. Gadon 1986, 154, fig. 1.

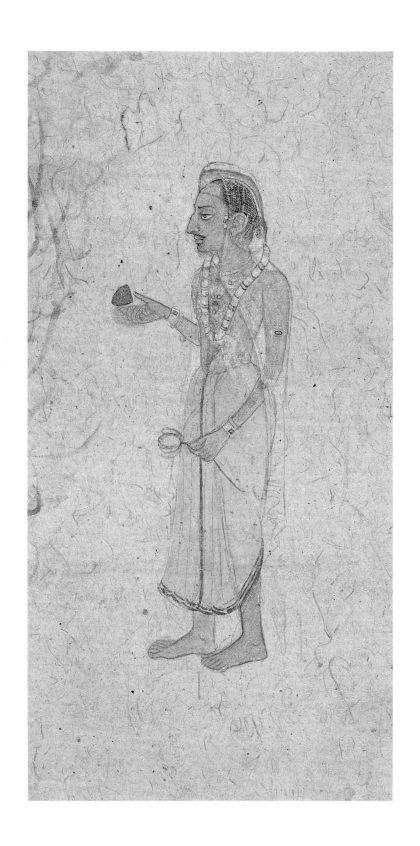

66 Krishna and Radha after Exchanging Clothes (chadma lila)

Attributed to Nihal Chand
Rajasthan, Kishangarh, c. 1760
Black ink over charcoal underdrawing on off-white
laid paper
10½ × 12⅝ in. (26.8 × 32 cm)
Promised Gift of Stuart Cary Welch, Jr.
59.1983[r]

Published: S. C. Welch 1976, 120–21, no. 68

THIS delicately drafted line drawing is closely
related to an unpublished, fully painted version
of the same composition in the National Museum, New
Delhi, illustrating the exchange of clothes between
Radha and Krishna, a well-known subject in painting
and poetry (fig. 66.1).[1] Here the central figure, wearing
a Krishna-type headdress and seated on a cusped-back
throne, reveals herself to be Radha by the feminine
bodice (choli) that can be seen below her attire.[2] An
attendant offers her a tray from which she takes a betel
nut (pan), while two more attendants stand behind
the throne holding fans (morchals). Grouped on the left
side of the composition are a number of female musi-
cians, most of whom are only partly delineated in out-
line form or rough sketch. Chief among them is a
standing figure with outstretched arm, who in the Na-
tional Museum painting seems to have blue skin and
can thus be identified as Krishna in female attire (fig.
66.2). Boats in the background, from which women
release fireworks and provide further musical enter-
tainment, indicate a lakeside setting.

The celebrated style associated with the artist Nihal
Chand is apparent here in the classical Kishangarh
narrow-waisted figures with extended, leaf-shaped
eyes, attenuated forms, and refined brushwork.
Datable to the middle of the eighteenth century, this
drawing may be by the master himself, to whom an
earlier work of the same theme has been attributed.[3]
Close followers, particularly Nihal's son Sitaram, also

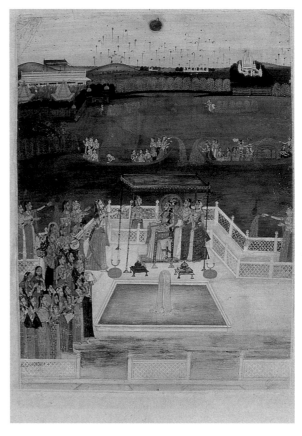

FIG. 66.1
Krishna and Radha in an Exchange of Clothes (chadma lila),
India, Kishangarh, 1755–65. National Museum, New
Delhi, 63.1768.

worked in his style. It is not clear whether the drawing
was made as a preparatory study for the National
Museum painting or whether it followed later.

The *chadma lila* (exchange of clothes or disguise)
occurs in the theology of the Vallabhacharya Sampra-
daya, a religious tradition of which the rulers of Kish-
angarh were devout followers. Krishna sometimes
dresses up as a female in order to trick girls, to convey
a message to Radha, or to have access to her.[4] In paint-
ing and poetry, the exchange of clothes between Radha
and Krishna is meant to symbolize their unity. This

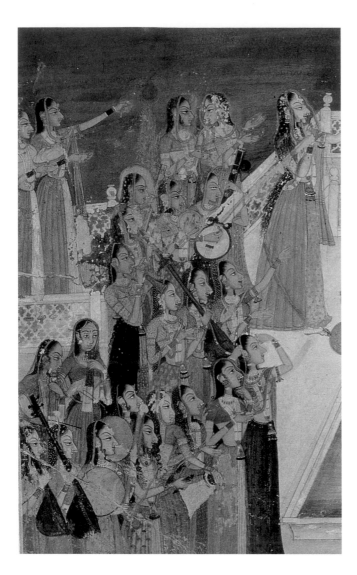

FIG. 66.2
Central figures, detail of fig. 66.1

idea is also related to the custom of *sanjhi*, performed traditionally by unmarried girls during the dark half of the month (*asvina*). Typically, the walls of houses are decorated with designs that are worshiped in honor of a goddess called *Sanjhi* (Twilight), in hopes of finding a suitable husband.

The *sanjhi* theme was taken up by poets and also practiced in temples as an episode in the courtship of Radha and Krishna.[5] The Kishangarh prince Savant Singh (r. 1748–57), who wrote devotional poetry under the pen name Nagaridas, has been credited with the institution of *sanjhi* practices at Brahmkund, in Brindaban.[6] Apparently images of Radha and Krishna were placed under kiosks overlooking the temple tank, and poems, including compositions by Nagaridas, were recited for five days. One particular recited work, the *Utsav mala (Garland of Festivals)*, describes Krishna dressing up in women's clothes in order to infiltrate a party of flower gatherers and accost Radha. This theme in Nagaridas's poetry is obviously close to that of the drawing under discussion. Although a direct link with his verses is not clearly demonstrable, Nagaridas must certainly have commissioned illustrations of this theme that was dear to him.[7]

The reverse of this drawing depicts an architectural cityscape in a very loose manner (fig. 66.3).

NHH

Cityscape (verso of cat. 66),
Rajasthan, Kishangarh,
c. 1760. Ink on paper,
10½ × 12⅝ in. (26.8 ×
32 cm). Promised Gift of
Stuart Cary Welch, Jr.,
59.1983[v].

Notes

1. National Museum, New Delhi, no. 63.1768; Haidar 1995, fig. 176, illustrates another drawing of the same theme from a private collection in Udaipur.

2. Illustrated and discussed in S. C. Welch 1976, 120, no. 68.

3. Dickinson and Khandalavala 1959, 32, pl. VII.

4. Entwhistle 1987, 56. In the *Gopālakelī candrikā sakhī*, a devotional work, Lalita encourages Krishna to dress up as a *gopi* (female cowherd) in order to gain entry to Radha's home. There he manages to see her, play with her dolls, and meet her mother.

5. Bahadur 1972, 93. In the *Rasikapriyā* the lovers make love after exchanging their garments:

 > When the lover and the loved one devise
 > As one another to be clothed
 > And so make love; then doth arise

 > The sentiment of amorous sport:
 > Says Keshavdasa, where both sojourn
 > As blissful lovers so engaged,
 > There amusement's emotion born
 > Is—thus do skillful poets say.

 In Pahari painting the exchange of clothes is explained in relation to the concept of *hava*, "external indications of emotion." Among the thirteen types of *hava*, the *lila-hava*, enjoyment of amorous caresses, is expressed in the exchange of clothes between Radha and Krishna (Randhawa 1962, 52–54, fig. 22).

6. Entwhistle 1991, 87, citing the nineteenth-century writer Gopal Kavi.

7. Dickinson and Khandalavala 1959, 36, pl. IX, is an earlier work illustrating the verses of Nagaridas; see Haidar 1995, 115–44, for a full discussion of the relationship between Nagaridas's verses and Kishangarh paintings.

Rajasthan, Kishangarh, c. 1740
Gray-black ink, watercolor, and gold over charcoal on
beige paper
5⅛ × 7⅞ in. (13 × 20 cm)
Promised Gift of Stuart Cary Welch, Jr.
28.1983

Published: S. C. Welch 1976, 118, no. 66; Welch and
Sagstetter 1994, 98, fig. 17; Haidar 2000, 88, fig. 8

Humorous and satirical paintings form a well-known genre at Kishangarh, contributing some of the most intriguing and least understood themes in Indian painting. This drawing ranks among the more curious productions at Kishangarh, depicting two women on their hands and knees, each holding one end of a winged fish in her mouth. The figures are on a terrace, set against a curving horizon with an assortment of small vessels and musical instruments in front of them, including a platter which they both grasp. The artist is unknown, but his individualistic touch is apparent in the rendering of details such as the eager females' savagely bared teeth. Although the precise meaning of this scene remains obscure, the image with its elaborate setting suggests that this may have been an illustration to an anecdote or proverb that is no longer current.

Such seemingly humorous subjects were first produced at Kishangarh in the second quarter of the eighteenth century and flourished during much the same time as the more elevated Krishna-Radha themes in devotional painting. The drawing displays features characteristic of the classic Kishangarh style, such as the slender figures with curved, elongated eyes; tiered landscape with long, narrow boats; and refined brushwork, which together suggest a date of about 1740–45. Although this particular drawing is not inscribed, such works frequently are. From surviving inscriptions on paintings it appears that these images served multiple purposes—to express humor, convey moral or didactic points, illustrate stories or poems, and in some cases caricature a legendary or historical figure.

As in other genres of Kishangarh painting, there exist contemporary and perhaps earlier examples in Mughal painting, as well as at Aurangabad and Bikaner, for the humorous treatment of particular subjects, to which Kishangarh painters may be indebted.[1] Pictorial evidence suggests that the chief patron and possible instigator of such works at Kishangarh was the prince Savant Singh, a devotional poet and religious-minded patron of bhakti painting. This is indicated by at least one surviving highly individualistic and comic drawing by Savant Singh himself, which reveals him to have been an accomplished draftsman with a taste for unconventional subjects.[2]

NHH

Notes

1. Haidar 2000, 78–79, figs. 9, 10; for similar themes, see also Coomaraswamy 1926, 59, pl. CXVIII; Ehnbom 1985, 152, pl. 70.
2. Haidar 2000, 90, fig. 11, illustrates an inscribed drawing of a horse and rider by Savant Singh.

Rajasthan, Kishangarh, mid-18th century
Black ink and watercolor on off-white laid paper
11⅛ × 8½ in. (28.3 × 21.7 cm)
Promised Gift of Stuart Cary Welch, Jr.
32.1983

Published: S. C. Welch 1976, 119, fig. 67

UNDER the active patronage of Birad Singh
(r. 1781–88) at Kishangarh, equine images
assumed an extravagant stylization and distinctive
form, leading to some of the most striking accomplish-
ments in the genre. In this example an elegant stallion
is drawn with a graceful, fluid line, giving the horse a
curvaceously arching back, narrow, down-turned head,
splayed legs, and raised tail. Devoid of color and
shading, the image's stark simplicity highlights its
sinuous form. The inflated chest and deep arch of the
horse's back are elements that can also be seen in
human subjects in Kishangarh painting of the same
period. This marked stylization came to be a hallmark
of the Kishangarh school by the mid-eighteenth
century, distinguishing the art of this state from that
of its more powerful Rajput neighbors.

Horse portraits were a well-established genre in
Kishangarh from the second quarter of the eighteenth
century, when they were first introduced from Mughal
painting. Under the influential artist Bhavanidas, who
joined the Kishangarh atelier from the Mughal court
at Delhi in the early eighteenth century, a subtle styliza-
tion came to characterize these images.[1] This initial
innovation was taken up and developed by later artists,

culminating in more exaggerated compositions such as
the swanlike stallion portrayed here. Although there is
an overall paucity of dated images, indications of the
stylistic development of horse subjects—whose popu-
larity endured until the early nineteenth century—are
found in larger compositions that include horses. A
painting in a private collection, depicting Birad Singh
as a prince in about 1765 inspecting a horse similar in
form to the stallion here, helps to date the present
piece to the third quarter of the eighteenth century.[2]
Several further highly stylized images of horses are
known; they form a distinct group belonging to this
period, although this line drawing ranks among the
most simplified and striking among them.

The creation of horse portraits appears to have
served several purposes in Kishangarh painting. As in
the Mughal tradition, capturing unusual or spectacular
animals on paper was practiced as a sign of esteem
for the subject itself. Valued gifts were also recorded in
this manner, both as a means of record-keeping and
as a way to mark the importance of the gift or its
donor. Images of horses purchased by the state trea-
sury were sometimes accompanied by inscriptions
recording details of the financial transaction and infor-
mation about the physical features of the animal, its
speed, and its cost.[3]

NHH

Notes

1. Mason et al. 2001, 120, cat. 45, illustrates an earlier horse
 portrait attributed to Bhavanidas with comparable stylistic
 features.
2. Haidar 1995, fig. 152; further comparable horse portraits
 of the Birad Singh period can be seen in figs. 154–59.
3. Sotheby's 1977, lot 69.

69　The Wind Palace (Hawa Mahal) of Jaipur

Rajasthan, Jaipur, 1848
Black ink, opaque watercolor, and gold on
off-white laid paper
9⅞ × 8⅝ in. (25 × 22 cm)
Promised Gift of Stuart Cary Welch, Jr.
50.1983

Inscriptions: (lower center of building) "madha ko[?]
mahal" (the center of the mahal); (lower left corner of
building) "mahara ph[?] ni / agra naran [narayan?]"
(Maharani agra nara[ya?] n); (large inscription, lower
center) "sawai-i japar ki hawaa mal" (the Wind Mahal of
Sawai['s?] Jaipur / "vasash 1905") (equal to Vesak[?] the
month of April–May, 1848); (bottom) "bajaar havaa mal
a niche" (bazaar below the Hawa Mahal)

JAIPUR, Rajasthan's "pink city," was founded by
the Kachwaha ruler Jai Singh II. In 1727 he moved
his capital from the small fortress of Amber to the dry,
sheltered lake bed seven miles to the south. The Hawa
Mahal, or Wind Palace, was a later addition to the
Jaipur skyline. This graceful monument was built by
the maharaja Sawai Pratap Singh in 1799 and adjoins
the immense City Palace complex at the center of the
original walled city. Until Indian independence
brought an end to the princely states, the Hawa Mahal
was part of the zenana, or living quarters for the
women associated with the Jaipur court. The multiple
stories of open bays not only allowed cool breezes to
pass inside but, more important, also enabled the
sequestered women to gaze out onto the city below.
This tall, narrow structure is, in fact, not much more
than a false front applied to the more conservative
building behind it and served, appropriately, as an
elegant screen to protect the private gendered space
inside.

This detailed architectural rendering of the facade
of the Hawa Mahal captures much of the intricacy and
grace of its subject. The artist carefully positioned each
tier and bay, lightly tracing the arching window forms.
Each window is articulated by elongated columns
supporting either squat domes or the curving *bangala*
(Bengali) roofs that were popularized in the architec-
ture of Shah Jahan and adopted by the Rajputs. The
artist emphasized the roofs and certain windows
through the application of white paint. A light wash
was used to designate the small recessions that divide
the vertical tiers of windows, as well as the horizontal
stone awnings that project above the first level. It
appears that the artist chose not to render the intricate
lattice screens, opting instead to provide two square
openings at each window, as are found in other monu-
ments in the City Palace. Many of these openings have
been filled with green pigment in the right half of the
drawing. Beneath the more confident outlines, sketchy
underdrawing remains visible, revealing that the artist
played with the position of various elements before
settling on the present form.

Architectural studies like this became popular
during the nineteenth century. In Delhi and Agra,
entire workshops of Indian artists were employed to
accurately render local monuments.[1] The increase in
production of these subjects was certainly driven by
foreign patronage, and there was a strong foreign pres-
ence in the city of Jaipur, which was governed under
the watchful eye of a British regent during the reign of
Sawai Ram Singh II, when this image was drawn.
During this period, Western tastes probably had a
similar impact on local art production.

KM

Notes

1. For a discussion of art production in Delhi and Agra, see
Archer 1992, 129–68.

सवाई जयपुरको हवामहल

जमाद
९५·५

70 Seated Courtesan

Rajasthan, Jaipur, mid-19th century
Gray-black ink, watercolor, opaque watercolor, and
gold over graphite on beige modern laid paper
(watermark: R & C)
8¼ × 6¼ in. (21 × 16 cm)
Promised Gift of Stuart Cary Welch, Jr.
580.1983

SITTING comfortably in a stylish European chair, a complacent courtesan poses for her portrait. She gazes glassy-eyed to the viewer's left, offering a three-quarter view of her oval face, which is the focus of most of the artist's attention. Subtle modulations of flesh tones suggest the recesses under the sitter's eyes and the rise of her chin. This woman must have held a high position in court for she is luxuriously adorned, decked with heavy, jewel-encrusted earrings and necklaces and crowned with an extravagant head pendant (bindi mang tika).[1] Away from her face, the drawing becomes increasingly unfinished. The position of the body and limbs is only roughed in, and light washes of color suggest the vibrant red of her blouse and the golden ocher of her skirt and scarf. The modeling seen in the rendering of the face is absent in the treatment of the body, where flat colors fill the space between hard, unmodulated contour lines. The least complete section of the drawing, from the subject's knees to her bare feet, is also the most lively. Here faint, curving strokes lightly trace out the folds and borders of her skirt and the metal segments of her anklets.

The various stages of completion reveal something of the artist's practice. The accuracy of the subject's face is one of his chief concerns. Whether working from life or copying another image, the artist would probably have put the most effort into this critical area. The body, however, could be sketched in and completed later, an especially common practice when dealing with a weary sitter. The quick, nearly transparent applications of yellow and red paint on the garments here were most likely intended to guide the artist or workshop later in finishing the painting.

The inclusion of the Western-style chair firmly places this drawing in the nineteenth century. Traditional depictions of Indian royals show them seated against cushions or upon squat, bed-shaped thrones. Through increasing contact with Europeans in the late eighteenth and nineteenth centuries Indian courts began to acquire furniture like this spindle-legged chair as luxurious symbols of their wealth and cosmopolitan tastes.

KM

Notes

1. The title "courtesan" may be somewhat misleading here as the term is synonymous with prostitute in modern usage. An earlier Italian root, cortigiana, identifies the wider category of "woman courtier." Indian zenanas were populated by family members: wives, mothers, and daughters, as well as "kept women." As the sitter here appears to have held some status, this broader reading of courtesan may be more appropriate.

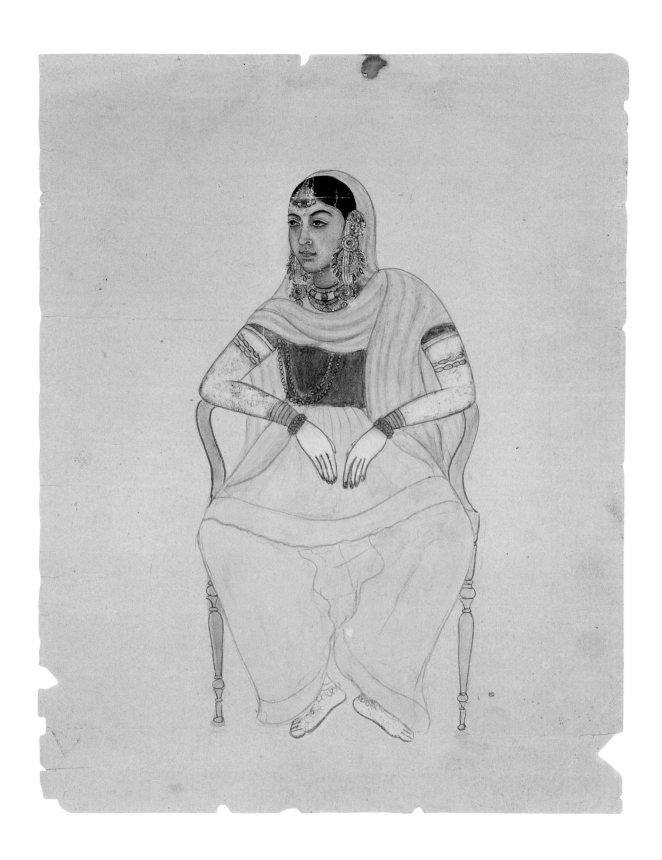

71 Lovers Embrace

Himachal Pradesh, Guler, c. 1745
Black ink and watercolor over orange-red ink, with
incised lines (architecture) on off-white laid paper
4⅛ × 6¼ in. (10.5 × 16 cm)
Promised Gift of Stuart Cary Welch, Jr.
76.1999.19

ALONE inside a palace, two lovers entwine on the
floor. The man sits up, leaning against a bolster.
His beloved rests against him, wrapping her left arm
back around his neck while twisting her lower body
forward in a manner that is not physically possible. Her
young lover cradles her, while grasping her breast with
one hand and raising a cup to his lips with the other.
The sparse, angular interior and absence of color help
create a sense of stillness and quiet, disturbed only by
the explosion of vegetation outside. Through the
windows behind the lovers we see exuberant branches
plump with leaves. In contrast to the more controlled
treatment of the figures and interior, the foliage is
drawn with energetic, calligraphic strokes. Tinted
washes of black, green, and tan—the only colors used
in the drawing—help push the trees forward, where
they nearly dominate the scene in the foreground.
Filling the space created by the window frames, the
lush foliage provides a vibrant curtain that helps to
shield, and complement, the intimate activities inside.

The clean lines and airy composition are common
to the later Pahari painting schools, and the figural
style closely resembles the painting associated with
the kingdom of Guler. Familiar Guler characteristics
include the orb-shaped heads of the couple, with
rounded foreheads and short faces, the large eyes, and
the curving brow. While the woman's features are
sharply delineated, the man has a fuller, softer profile.
A relative degree of naturalism was achieved in the
faces through the inclusion of light washes to create
soft shadows, like those that demarcate transitions
from lip to cheek. The modeling is accurate and con-
sistent across the faces and necks but stops abruptly at
the neckline of the garments.

The overall shape of the figures and their relative
naturalism, along with the juxtaposition of soft model-
ing against crisp lines, are particularly associated with
the paintings of the Pandit Seu family.[1] Their works
betray a combination of late Mughal design, local
painting traditions, and careful observation. The por-
traits of these lovers, in particular, are most like the
figures in paintings of the mid-eighteenth century
executed by Pandit Seu's sons Manaku and Nainsukh.
These artists were employed at the larger kingdom of
Kangra, where their innovative imagery became the
foundation of the great Kangra style of the late
eighteenth and early nineteenth centuries.

KM

Notes
1. For detailed explorations of the school descended from
Pandit Seu, see Goswamy 1968 and 1997, and Goswamy and
Fischer 1992.

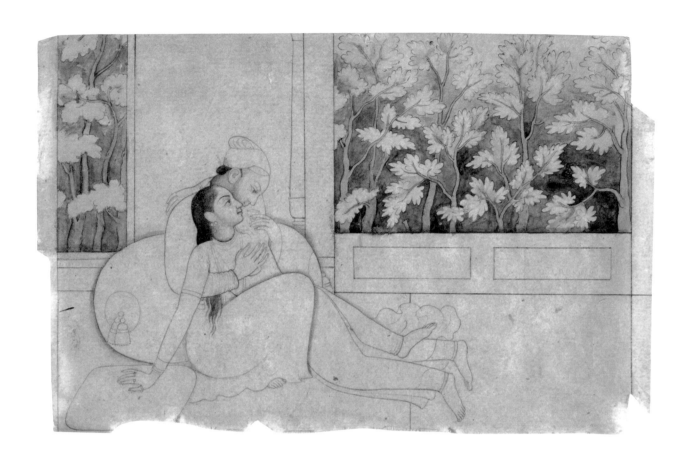

Himachal Pradesh, Guler, c. 1750
Gray-black ink, watercolor, and opaque watercolor over
red ink on beige paper
11⅝ × 8½ in. (29.5 × 21.5 cm)
Promised Gift of Stuart Cary Welch, Jr.
76.1999.14

Published: Hodgkin and McInerney 1983, fig. 14

A BULKY figure dominates the center of this com-
position, attended by two older men. We assume
him to be a raja or another high-ranking courtier for
he is seated upon a small throne, holds the pipe of a
hookah to his mouth, and cradles a sword against his
lap. What is ironic, however, is that despite these royal
attributes, the sitter hardly projects a vision of kingly
authority. This carefully observed drawing is perhaps
too human for a royal portrait in most Indian courts
and could have come only from the freer climate of the
hill states. The man's diaphanous *kurta* reveals a plump
figure, while his face bears the weight of many years.
The noble sitter is accompanied by two attendants, an
old man with a staff who sits by his side, and a figure
standing in front who is reviewing a document with
him. Both these men are aged and gaunt, and the crisp
shading of their features and garments further accentu-
ates their already exhausted appearance. Faint outlines
of two other standing figures are visible through a
cloud of white paint that was meant to conceal them.
This wonderful detail reveals the artist's mind at work
as he rearranged the composition, pushing the hover-
ing attendants back to the margins and giving the
sitter the space and visual prominence his position
commanded.

The naturalism of this portrait helps us associate
it with an illustrious family of artists working in the
Himalayan state of Guler. Pandit Seu and his sons
Manaku and Nainsukh produced some of the greatest
paintings from the Punjab Hills.[1] Seu's career appears

to have spanned much of the first half of the eighteenth
century. He and his sons were adept at many styles,
ranging from vibrant and abstract Indic modes to airy,
naturalistic Mughalized imagery. Seu's second son,
Nainsukh, was especially accomplished at portraiture
and became the personal artist of Balwant Singh, the
raja of Jasrota. A small, partially finished portrait of
Pandit Seu in the Government Museum of Chandigarh
bears a striking resemblance to the present drawing.[2]
The Chandigarh study is ascribed to Nainsukh, who
was active in the mid-eighteenth century. If not for the
pronounced nose of our sturdy noble, his features and
those of Seu in the Chandigarh painting would be
nearly identical.

Another portrait by Nainsukh, in the Prince of
Wales Museum, Mumbai, is also similar in composi-
tion to the present image.[3] There Balwant Singh sits
on a low throne holding a hookah pipe and facing
several courtiers. He appears to have a fuller figure
than in other portraits, and even wears a Muslim-styled
pointed hat (*kulah*) similar to the one traced out in the
Welch drawing. In its unforgiving realism and confi-
dent line, the present drawing betrays its associations
with the Seu family and could conceivably belong to the
hand of Nainsukh himself.[4]

K M

Notes

1. B. N. Goswamy has done a remarkable job tracing the his-
 tory of the Pandit Seu family and examining their work. See
 Goswamy 1972; Goswamy and Fischer 1992; Goswamy
 1997.

2. No. D-115, illustrated in Goswamy and Fischer 1992, 213,
 fig. 62; Goswamy 1997, 18, fig. 3; 51, cat. 2.

3. No. 33.103, illustrated in Goswamy 1997, 178–79, cat. 65.

4. One concern regarding this attribution to Nainsukh derives
 from the Balwant Singh portraits. In those paintings,
 Singh's form appears more flattened and iconic than the
 other figures in the same compositions. Still, we should
 remember that here we are looking at an underdrawing of
 an unfinished painting. These figures might have appeared
 less naturalistic once they were brought to completion.

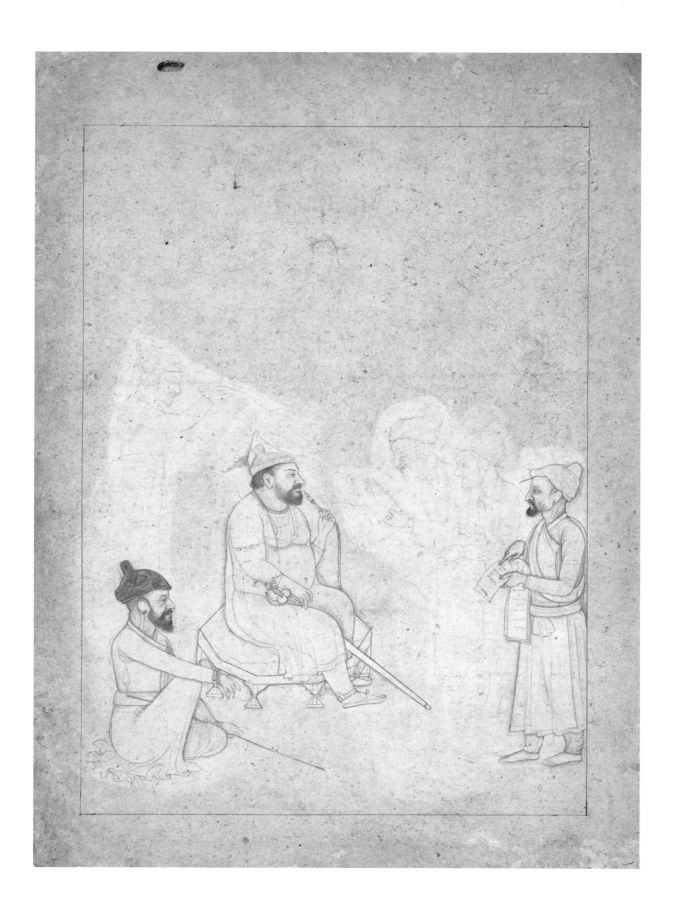

73 A Row of Sadhus

Himachal Pradesh, Guler, c. 1765
Black and red-brown inks and gold on beige paper
6½ × 9 in. (16.5 × 23 cm)
Promised Gift of Stuart Cary Welch, Jr.
76.1999.28

SEATED beneath a long thatch canopy supported by bowing tree posts, twelve Hindu holy men, or sadhus, are actively engaged in spiritual pursuits. The group is made up of old and young men, including an adolescent disciple at the center whose small, boyish figure and short hair reveal his status as a novice. The drawing may represent a Hindu *math* (monastery), a common establishment in medieval India.[1]

All the sadhus are practicing rigorous asceticism, involving yoga, meditation, and renunciation. The few belongings they possess, such as water pots and gourds, lie strewn before them. Most have even given up the comforts of clothing: only three figures are draped, one with a dhoti and two with animal skins. The long, matted hair of the yogis is also a sign of their spiritual endeavors. Hair was a powerful symbol of social status in traditional Indian culture. Noblemen often wore their hair long, but it would be neatly pulled back. Married women also combed and tied back their hair, as allowing it to hang loose was an indication that they were polluted or dangerous.[2] The matted hair of the ascetic shows that he (or she) is operating outside the boundaries prescribed by social convention.

Various asanas (seated or standing postures) and mudras (hand gestures) are employed in yoga to facilitate the movement of energy through the body. Most of the yogis here are shown seated in the lotus position (*padma asana*), created by tightly folding the legs over and into each other. Several of the figures also display the *dhyana mudra*, a meditation gesture, by cupping an open hand on their laps. The fourth figure from the left reads scriptures while seated, straightbacked and alert, in a yogic mode.

The Himalayan regions of India were rich with sacred sites, temples, and patrons, and they attracted important teachers from various sects. By the ninth century a major form of Tantrism called Kashmiri Shaivism was flourishing in the hills. In the cosmology of this tradition, the god Shiva, the individual soul, and the material world are conceived to be one. The teachings reveal that through asceticism, adepts could recognize the nondual nature of the universe and unite with the godhead.[3] Although Kashmiri Shaivism was a regionally popular sect, the sadhus illustrated here are more generalized and could represent practitioners of several traditions. The artist's intention appears to lie in recording ascetic practices, rather than accurately representing individual followers from any one sect.

Through slight variations in the appearance and placement of the figures, the Pahari artist created an engaging composition from rather static and similar forms. Each sadhu appears to be based on one of a handful of stock figures, perhaps tracings, whose poses are minutely adjusted and individualized. Moving from left to right: the first slouching sadhu finds his counterparts in the sixth and last figures, the third matches the second-to-last ascetic, and the fourth, eighth, and tenth figures are nearly identical but for their arm positions and turn of the head. Between them, the second, fifth, seventh, and eleventh yogis face toward the right, each rotated slightly more than the previous figure. This repetition creates a sense of overall rhythm, which is accentuated further by the vertical posts that divide them. By overlapping the bodies of the yogis and varying their height on the page, the artist also gives a suggestion of depth in an otherwise flat image.

The figural style is reminiscent of paintings associated with Guler and the workshop of Pandit Seu and

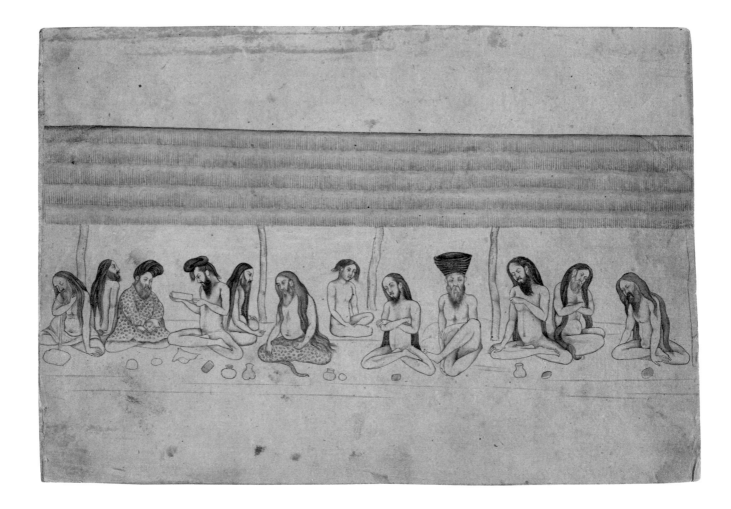

his family. The rounded torsos and short, soft faces of the sadhus are similar to the features of figures found in several paintings from the Punjab Hills during the last decades of the eighteenth century. A reasonable comparison can be drawn between the present drawing and an illustration, *Rama Converses with Hermits,* from a *Ramayana* series in a private collection.[4] This series has been attributed to an artist working in the Seu school a generation after the painter Nainsukh.[5] Although they are not identical in style, the *Ramayana* painting and this drawing of sadhus appear to belong to the same broader category of later Guler painting.

KM

Notes

1. Architectural examples of Shaivite *maths* survive in Central India, each arranged with rows of colonnades and cells encircling a central courtyard. The long, shallow space of this thatched pavilion, visually divided by timbers, playfully—even if unintentionally—mimics this architectural form.

2. Wearing her hair loose was often a sign, for example, that a woman was menstruating and therefore polluted. During her menses, her movements, participation in care of the home and preparation of meals, and contact with the men of the household were all restricted.

3. For a brief discussion of Kashmiri Shaivism, see, e.g., Bhattacharyya 1982, 247–48.

4. Published in Goswamy and Fischer 1992, 342, cat. 144.

5. Ibid.

Himachal Pradesh, Kangra, late 18th century
Black and red-brown inks and white opaque watercolor
on beige paper
11⅜ × 8¼ in. (29 × 21 cm)
Promised Gift of Stuart Cary Welch, Jr.
76.1999.25

Bowing her head demurely and positioning her wrap across her shoulder, this lovely young woman embodies the Indian ideal of feminine beauty. She is centered in an oval composition, her face turned in profile while her body is presented in a three-quarter view. Her elongated figure situates her within the Himalayan painting schools of northern India, and the continuous gentle run of her forehead into her small nose places her firmly in the Kangra tradition. Other features that betray a Kangra origin include her long, narrowing eye and exaggerated, arcing brow. The depiction of wispy locks of hair that fall loosely over her ear while the rest remains tucked behind it is also characteristic of Kangra paintings.[1]

This woman's long arms are accentuated by lovely bracelets, and her ears and neck are adorned with jewelry. She wears a North Indian dress and is draped in a shawl. With her graceful form and elegant dress she is the epitome of luxury.

The subject of this very finished sketch is pictured alone on a balcony overlooking a hilly landscape. As a woman of privilege, she would inhabit a palatial home, akin to this setting. The viewer encounters her in a moment of contemplation. Her model beauty as well as her mood identify her generally as a *nayika*, a heroine of romantic tales and a favorite subject in Hindu painting.

The oval composition occurs in later Kangra paintings, and is seen from the late eighteenth century on. The delightful scrollwork in the corners would be painted in contrasting colors, often with gold paint, to form a sophisticated border for the finished painting.

K M

Notes

1. It may be possible to pinpoint her origins a little further. Our subject's features are most common to works that B. N. Goswamy and Eberhard Fischer attribute to the first generation of artists working in the school of Nainsukh. Compare the similarly rendered woman in *The Beloved's Toilette*, illustrated in Goswamy and Fischer 1992, 248–49, cat. 149.

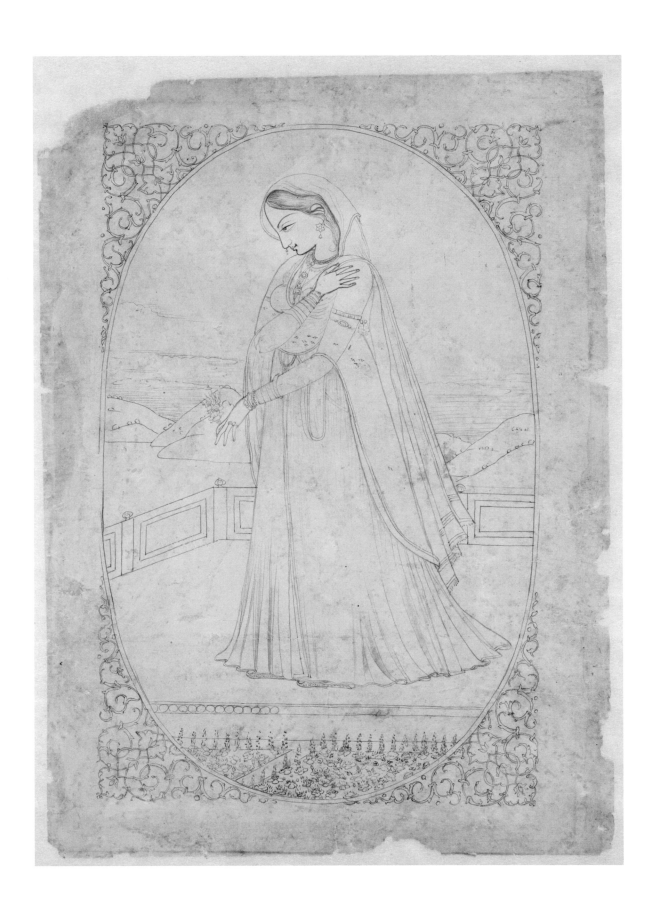

75 Man with Two Dogs on a Leash

North India or Pakistan, Punjab, c. 1800–1850
Black ink and opaque watercolor over graphite on tan
laid paper
9½ × 7¾ in. (24 × 19.7 cm)
Promised Gift of Stuart Cary Welch, Jr.
76.1999.42

Inscriptions: (top) "mū shi [?]"; (lower right)
"RS 13" (thirteen rupees)

THE impact of the Western colonial presence in India is clearly evident in this mid-nineteenth-century drawing. Over the course of the nineteenth century the crisp, refined contours and flat, linear clarity of Mughal-style painting from centers like Lahore evolved into a rough, grizzly realism akin to European drawing and printmaking, as seen here. Also absent in this drawing is the conventional Indian subject matter. Portraits of heroes and nobles gave way to the commonplace, and a humble, sympathetic servant commands our attention here. The subject matter of Indian art changed dramatically during the colonial era. In the late eighteenth and throughout the nineteenth century, new foreign patrons sought out local artists and workshops to address their interests. Their works, often called Company School paintings, explore nontraditional subjects that were of interest to Western clients.[1] A major genre of Company School painting was the documentation of everyday life in colonial India. Patrons employed highly skilled artists to portray themselves, their surroundings, their property, and their staffs. This drawing of two European purebreds in the custody of an Indian handler certainly falls within this category.

The man and dogs isolated in the center of the page are the sole subjects. Only a few strokes of light wash were applied to suggest a ground plane in an otherwise empty composition. Yet the elements the artist has chosen to include in this sparse composition are revealing. The man wears the traditional Muslim-influenced dress of North India: tight-fitting white cotton pants, slippers, a turban, and a large woolen shawl. He stands attentively, holding the dogs' leashes in one hand while clutching a bamboo cane in the other. The handler turns slightly toward the left and looks away into the distance, not meeting the viewer's gaze. The deeply cut profile and shading of the man's face give him a haggard, gaunt appearance. His loose, slightly disheveled turban accentuates these features, suggesting a proud if beleaguered individual drawn from life rather than an idealized stock figure traced from a cartoon.

What received the most attention, however, was the shawl. Through careful observation, the artist captured the naturalistic fall of the cloth as it cascades across the man's shoulders and chest and hangs in loose folds from his raised arm. Line, modeling, and light applications of color combine to create the repetitive patterns of blocks and stripes woven into his heavy garment.

The dogs are also rendered in a realistic fashion. Behind the man the artist traced the elegant silhouette of a lanky, short-haired hound. Standing alert, this graceful animal makes a watchful companion to his keeper. In contrast, a small, bristly haired dog sits attentively facing them. Its thick, wavy coat is suggested through multiple short brushstrokes, creating a visual complement to the dense patterns and textures of the handler's shawl.

The sketchy naturalism of this drawing is a far cry from the traditional artistic styles found in the Punjab, which, until its annexation in 1849, was isolated from foreign interests and artistic influences. Company School painting developed much later and to a lesser degree there than in other centers in North India.[2]

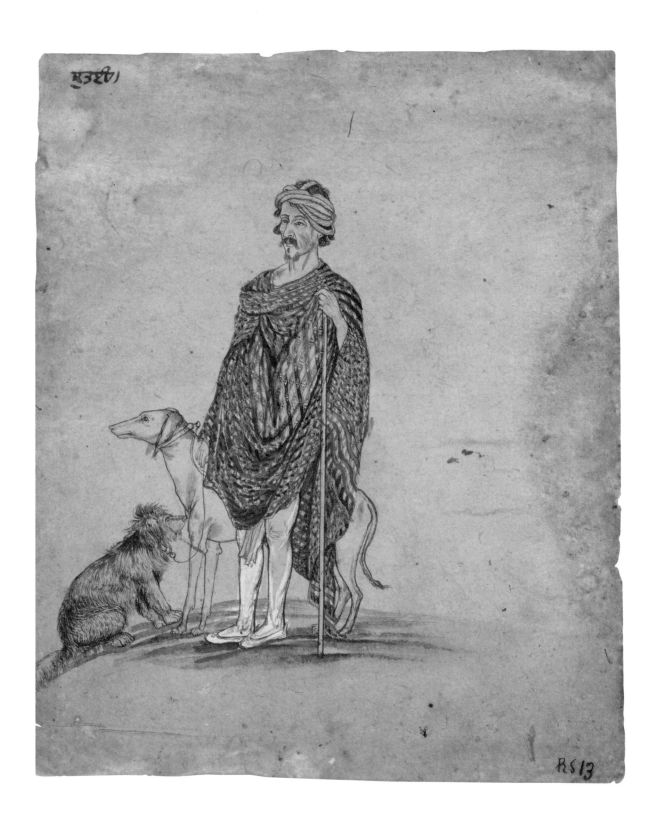

Thus, if this tinted drawing did originate from the Punjab Hills as Cary Welch's attribution here suggests, it gives a rare and wonderful glimpse of the speed and adeptness with which local artists were able to assimilate these new styles. The verisimilitude of the drawing suggests that it may have been a portrait of a specific loyal servant and two prized companions. But as the price in the lower right corner illustrates, the subjects were later reduced to anonymity as their representations attained the more generalized status of "exotica" in a burgeoning art market.

KM

Notes

1. For general discussions of Company School painting, see Archer 1992, 11–19; Welch 1978b.
2. Archer 1992, 169.

Bengal, Calcutta, 19th century
Graphite and watercolor on off-white machine-made wove paper
8 ¼ × 10 ⅝ in. (21 × 27 cm)
Promised Gift of Stuart Cary Welch, Jr.
657.1983.B[r]

Published: Welch and Zebrowski 1973, 123, fig. 73, as *No. 5 Park Street, Chauringhi, Calcutta*

WHEN William Hunter sailed into Calcutta for the first time to take up a job as a junior clerk in the East India Company at the beginning of the nineteenth century, he wrote home, "Imagine everything that is glorious in nature combined with everything that is beautiful in architecture and you can faintly picture to yourself what Calcutta is."[1] And his enthusiasm wasn't just because (as one cruel commentator has suggested) he was in love—and had arrived fresh from Peckham.

In the early nineteenth century Calcutta was at the height of its golden age. Known as the City of Palaces or the St. Petersburg of the East, the British bridgehead in Bengal was unquestionably the richest, largest, and most elegant colonial city in Asia. Here a nabob like Philip Francis could boast in the 1770s that he was "master of the finest house in Bengal, with a hundred servants, a country house, and spacious gardens, horses and carriages." Francis's "wine book," which survives in the India Office Library, gives an indication of the style in which such men lived: in one typical month, chosen at random, Francis, his family, and his guests drank 75 bottles of Madeira, 99 bottles of claret, 74 bottles of porter, 16 bottles of rum, 3 bottles of brandy, and 1 bottle of cherry brandy—some 268 bottles in all, though part of the reason for such consumption was the noxious state of the Calcutta drinking water and the widespread belief that it should always be "purified" by the addition of alcohol, and especially a little tot of brandy.[2]

Nor was it just the British who did well and lived extravagantly: Bengali merchant dynasties also flour-ished. The Mullick family, for example, had rambling baroque palaces strewn around the city and used to travel around Calcutta in an ornate carriage drawn by two zebras.[3]

Many images of Calcutta date from this period. There are the splendid oils by British artists like William and Thomas Daniel, and the prints of Henry Salt and James Fraser. But it is perhaps the Company School pictures that come closest to evoking the curiously cosmopolitan and even multicultural feel of the time. For these images—commissioned by British patrons but painted by Indian artists—are not the romantic imaginings of the eighteenth-century picturesque seen through occidental eyes but the product of the curious stare of Indians, usually Bengalis, viewing, sometimes for the first time, the foreign colonial buildings rising in their midst. These artists had usually been trained in the old Mughal techniques of miniature painting, but, working for new European patrons, using English watercolors on English paper, and taking English landscapes or botanical still lifes as their models, they created an extraordinary fusion of English and Indian artistic currents, a fusion that resulted in an entirely new type of painting.

The account of the Shi'a Muslim traveler Abdul Latif Shushtari gives us a hint of how Calcutta must have appeared to such men: "The city now contains around five thousand imposing two or three storey houses of stone or brick and stucco," he wrote.

> Most are white but some are painted and coloured like marble. Seven hundred pairs of oxen and carts are appointed by the Company to take rubbish daily from streets and markets out of the city and tip it into the river. Houses stand on the road and allow passers-by to see what is happening inside; at night camphor candles are burned in upper and lower rooms, which is a beautiful sight. Grain and rice are plentiful and cheap. . . . There is no fear of robbers nor highwaymen, no one challenges you where you are going nor where you have come from; all the time, big ships come from Europe and China and the New World filled with precious goods and fine cloths, so that velvets and satins, porcelains and glassware have

CAT. 76

FIG. 76.2
The Holroyd House on Park Street: From the Holroyd Album,
Bengal, Calcutta, 19th century. Ink and opaque watercolor
on paper, 14⅛ × 20½ in. (36 × 52 cm). Promised Gift of
Stuart Cary Welch, Jr., 657.1983.A.

FIG. 76.1
"*No. 5 Park Street*" (verso of
cat. 76), Bengal, Calcutta, 19th
century. Brown ink on off-white
machine-made wove paper,
8¼ × 10⅝ in. (21 × 27 cm).
Promised Gift of Stuart Cary
Welch, Jr., 657.1983.B[v].

become commonplace. In the harbour at Calcutta
there are constantly over 1000 ships at anchor.[4]

Many Company School artists were employed by
British nabobs to paint Calcutta scenes and characters,
as well as house and animal portraits, all to order, as
their whims dictated. Foremost among these was a
remarkable artist named Shaykh Muhammad Amir of
Karraya. The shaykh could do anything: he was equally
at home painting a Palladian house or thoroughbred
horse, a group of *dhobis* (launderers), or a pair of dogs.
His single figures are sometimes shown in profile, in
the Mughal tradition, but when he wished to, Amir
could paint in a more European style than any of his
rivals. He had completely mastered perspective, fore-
shortening, and shading, which gave his work a natu-
ralism unique among Indian artists of his generation.
Yet while in anatomical accuracy his horse portraits can
stand comparison even with Stubbs's, there is still an
indefinable Indian warmth about his work, a Mughal
application of the heart as well as the head, and in his
finest work, such as the wonderful *Two Dogs in a
Meadow Landscape* (Victoria and Albert Museum),[5] Amir
shows that, like Mansur, he had the ability to convey an
animal's character and mood with uncanny immediacy.

This schematic rendering of Holroyd's house at
number 5 Park Street possesses all of the clarity of a
European architectural drawing, although its lineage
is more cosmopolitan. Unmodulated lines and light
washes map out the contours of the house, while its
footprint is mapped with a surprisingly sketchy hand

on the reverse (fig. 76.1). The drawing is clearly a
product of the Company School and similar to a water-
color painting of the same elegant address (fig. 76.2).
The artist who created the painted version of the
Holroyd House—with its bow front and classical flour-
ishes, blinding white and all shuttered up against the
midsummer heat—worked in a similar tradition to
Shaykh Muhammad Amir's, though his sense of per-
spective is perhaps less developed. The brilliance and
simplicity of the colors, the meticulous attention to
detail, the way the picture seems to glow, all these
point unmistakably toward the artist's provincial
Mughal training. Yet no artist working in a normal
Mughal atelier would ever have been commissioned to
paint a Palladian villa in watercolor. This is an art of
fusion—and shows, at a time when we are constantly
being told about Clashes of Civilizations, how fruitful
it can be when civilizations fuse rather than clash,
when they come together in art rather than in war. This
is an important subject, and one that Cary has always
felt strongly about. It is hardly surprising that these
concerns are reflected by his eye, and that they have
clearly dictated the choice of many of the finest images
in his collection.

WD

Notes

1. Kincaid 1938, 22, 95.
2. Burton 1993, 208.
3. Moorhouse 1971, 23.
4. Shushtari 1847, 427.
5. The picture is reproduced by Cary Welch in his pathbreaking
 catalogue *Room for Wonder* (Welch 1978b).

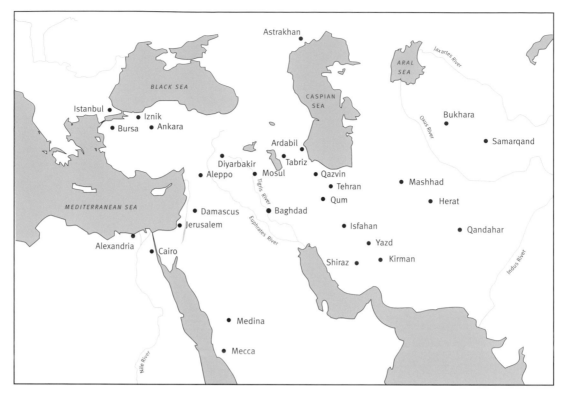

WEST ASIA

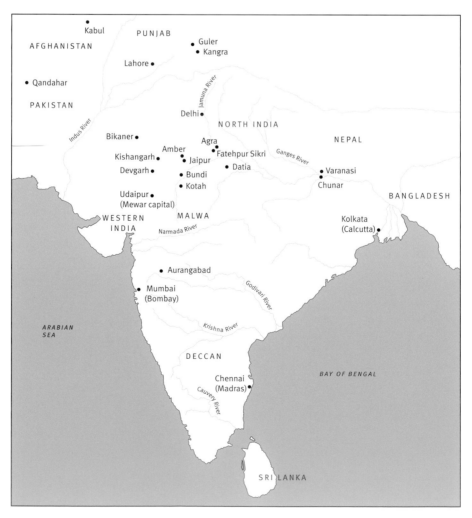

SOUTH ASIA

CHRONOLOGIES OF REGIONS

This chronology provides a summary of the numerous courts and dynasties whose art is represented in this catalogue, although in its highly condensed format, the text may in some cases appear more definitive than a lengthier discussion would countenance. In keeping with the conventions adopted for the catalogue entries, the contemporary names of Iran, Turkey, India, and Pakistan are used. For the Iranian chronology, however, the broader cultural region sometimes referred to as Persia is more appropriate for the historical period under review. This chronology also addresses territories that have traditionally been considered part of the Indian cultural sphere. Since the partition of India and Pakistan in 1947, important sites like the northern Mughal capital of Lahore are no longer within the political borders of India. However, these centers are relevant to this discussion of Indian history and artistic patronage and are therefore included here.

Sources: Archer 1992, Archer 1959, Atil 1987, Blair and Bloom 1994, Bosworth 1967, Burgess 1972, Canby 1996, Canby 1998, Canby 2000, Diba et al. 1998, *Encyclopaedia of Islam* 1993, Keddie and Matthee 2002, Lapidus 2002, Leach 1995, Lentz and Lowry 1989, Lewis 1995, Manz 1991, Mitter 2001, Philips 1951, Smith 1958, Thackston 1999, Titley 1983, A. Welch 1973, Welch 1972a, Welch 1979, Welch 1985, Wilber 1981, Wolpert 1989, Zebrowski 1983, www.mewarindia.com/history/indexanc4.html; www.uq.net.au/~zzhsoszy/ips/k/kangra.html; and www.almanach.be/search/i/indi_bundi.html.

To date the most complete discussion of the Turko-Indo-Iranian artistic tradition appears in Dickson and Welch 1981.

IRAN

1370 Timur (Tamerlane), a Turko-Mongol chieftain whose family claims descent from Genghis Khan, launches a series of military campaigns that will carry his armies into Central Asia, India, Iran, Armenia, Georgia, Iraq, and Anatolia. The so-called Timurid period lasts until 1506, during which time Timur's descendants rule varying regions, chiefly of Transoxiana, Afghanistan, Iran, and Iraq. Timur transfers artists and craftsmen from some of the conquered cities to his capital at Samarqand.

1402 Timur captures the Ottoman sultan Bayezid at the Battle of Ankara. In gratitude for their military assistance, he grants the city of Diyarbakir, on the Tigris, to the Aq Qoyunlu (White Sheep) Turkmans. A confederation of Turkman clans (Turkish people who originated in Central Asia), the Aq Qoyunlu establish rule in eastern Anatolia and Kurdistan, and compete for power in parts of Iran.

1405 Timur dies. His sons and grandsons struggle for control of his vast empire, which they divide into four territories. Shah Rukh, a son of Timur and governor of the eastern section of the empire, maintains control of his area and establishes his capital at Herat. His sons Ulughbeg, Baysonghor, and Ibrahim Sultan rule adjoining areas. The Timurids of the fifteenth century transform their princely capitals, particularly the cities of Herat and Shiraz, into cultural centers and preside over one of the most brilliant periods of Persian painting. The renown of the Timurid rulers as patrons of art and poetry becomes widespread in the eastern Islamic world. Their cultural example will be emulated by the Safavids in Iran, the Shaybanids in Uzbekistan, the Mughals in India, and the Ottomans throughout their empire.

1406 The Qarā Qoyunlu (Black Sheep) Turkmans wrest their former stronghold of Tabriz from Timurid control, establish rule in Iraq, and compete for power in Azerbaijan and Iran with the Aq Qoyunlu and the Timurids. Over the course of the fifteenth century, a vigorous and expressive style of painting for manuscript illustration develops in the Turkman courts.

1420 Baysonghor, son of Shah Rukh, retakes Tabriz in western Persia from the Aq Qoyunlu. There he finds painters still working in the lyrical style developed under the Jalayirids in the late fourteenth century and brings them back to Herat. Baysonghor establishes his own academy in Herat, integrating the Tabriz painters with artists who had worked in Shiraz for his brother Ibrahim Sultan. Before the death of their patron in 1433, the artists in Baysonghor's academy produce illustrated manuscripts of superb quality.

1447 Shah Rukh dies; western and central Persia are in political upheaval as the Qarā Qoyunlu and Aq Qoyunlu move eastward to take over Herat and southward to conquer Shiraz. The Shaybanids, who trace their descent from the Mongols, take Khwarazm from the Timurids.

1468 The Qarā Qoyunlu dynasty comes to an end and its remaining territories are absorbed by the Aq Qoyunlu. Fine manuscripts illustrated in the Turkman style are produced in the Shiraz atelier of Abu'l-Fath Sultan Khalil, son of the Aq Qoyunlu ruler Uzun Hasan.

1470 Husayn Bayqara, great-grandson of Timur and the last great figure among the Timurids, again captures Herat, reasserting Timurid control over all of Khurasan. He creates a brilliant court, widely admired for its sophistication and artistic accomplishments. Husayn Bayqara's atelier employs Bihzad, one of Iran's greatest artists, as court painter and produces illustrated manuscripts of superb quality. Compared with the spirited Turkman style of painting, the Herat style employs a subtler palette, more harmonious compositions, and an engaging naturalism.

1499 Turkman tribes in eastern Anatolia begin to organize around the twelve-year-old Isma'il ibn Haydar, descendant of the Sufi Shaykh Safi al-Din (d. 1334). Propaganda campaigns on Isma'il's behalf are waged to subvert the power of the Aq Qoyunlu. His followers soon number in the thousands.

1500 Muhammad Shaybani takes Transoxiana from the Timurids. During the sixteenth century, the Sunni Shaybanids will carry on almost continuous warfare with the Shi'a Safavids of Iran. Sometimes referred to as the Uzbeks, the Shaybanids will rule in Bukhara until 1598.

1501 Isma'il ibn Haydar, later Isma'il I, seizes Azerbaijan from the Aq Qoyunlu Turkman rulers. In Tabriz he is crowned as the first ruler of the Safavid dynasty. He establishes Shi'ism as the state religion and within a few years controls all of Iran except Timurid Khurasan. Isma'il's atelier in Tabriz produces illustrated manuscripts in the Turkman style.

1514 Ottoman-Safavid War: the Ottoman ruler Selim I defeats Isma'il I at the Battle of Chaldiran. He briefly occupies the northern territories of the Safavid Empire, including Tabriz.

1522–24 Isma'il I recalls his son Tahmasp, who had served since infancy as nominal governor of Herat, to Tabriz. Bihzad, Herat's senior artist, also moves to Tabriz, where he serves as director of the royal library. For two years before Isma'il's death in 1524, father and son share in the patronage of painting, a matter of intense interest to both. Bihzad and the rulers together preside over the merging of the dynamic and visionary style of Tabriz with the more cerebral, infinitely detailed, and more naturalistic style of Herat, creating a new artistic synthesis of the two styles. Without loss of vitality, Shah Isma'il's senior artist, Sultan Muhammad, soon adjusts his robust, transcendental mode, favored by Isma'il before 1522, to the finesse and nuances admired by the shah's Herat-educated son.

1534, 1548–49 The Ottoman ruler Süleyman I invades Iran and occupies Tabriz.

1544–45 Tahmasp I turns away from painting to devote himself to statecraft and piety. He withdraws patronage from most of the royal artists, some of whom travel to India with Humayun, second Mughal emperor.

1545 Tahmasp I captures the Fort of Qandahar from the Mughals. Control of Qandahar is a source of ongoing tension between the Mughals and the Safavids, and the cause for numerous skirmishes.

1553–55 War between the Ottomans and the Safavids. It ends with the Treaty of Amasya, which reestablishes borders between the two empires for thirty years. The Safavids and Ottomans develop a diplomatic relationship, and extravagant gifts are exchanged between the two rulers, including magnificent illustrated manuscripts, carpets, and textiles.

1555 Tahmasp I moves the Safavid capital from Tabriz further east to Qazvin. The shah's declining interest in the arts, manifested in the Edict of Sincere Repentance, results in the disbanding of the royal library. Some court painters travel to India, some move to the Ottoman courts, and some find other patrons in Iran.

1576 Tahmasp I dies. The Safavid Empire subsequently weakens militarily and politically during the unstable reigns of Isma'il II and Muhammad Khudabanda. During his brief rule, Isma'il II reconstitutes the royal atelier in Qazvin, gathering again some of the Safavid painters who had been dispersed in the later years of Tahmasp I's rule. Benefiting from Safavid weakness and instability, the Ottomans in the west and the Uzbeks in the east renew hostilities and capture Safavid territories.

1588 'Abbas I, second son of Muhammad Khudabanda, takes the Safavid throne at the age of sixteen. He revitalizes the Safavid Empire, recapturing territories lost to the Uzbeks and the Ottomans and securing his borders. He establishes friendly relations with India and European nations, leading to diplomatic and commercial exchanges.

1597–98 ‘Abbas I relocates the Safavid capital to Isfahan. He largely rebuilds the city, which blossoms into a major center of Safavid culture and art. Among the finest and most characteristic expressions of Isfahan culture are the works of the painter Riza ‘Abbasi.

1602–38 The Ottoman and Safavid wars resume. ‘Abbas I retakes Tabriz for Persia, but the Ottomans retain eastern Anatolia.

1604–05 To increase state revenue, ‘Abbas I establishes the silk trade as a royal monopoly. To assist trade with Christian Europe, he incorporates Armenian merchants, familiar with the silk trade, into his scheme. As part of this strategy, he forcibly relocates to Isfahan Armenian merchants and their families from the town of Julfa Aras. Housed in New Julfa, a separate suburb of Isfahan, these Armenians play a major role in Safavid trade with Europe and serve as an important channel for the entry of European art into Iran.

1613 Ambassadors travel from the court of Jahangir, ruler of Mughal India, to the court of ‘Abbas I. The rulers exchange royal gifts, despite continued tension over the contested Fort of Qandahar in Afghanistan.

1616 The British East India Company expands its trade routes into Iran. Portuguese traders already established there unsuccessfully attempt to block the British. The British later aid the Safavids in expelling the Portuguese from the island of Hormuz. The Dutch and the French also establish bases in Iran for their trading companies.

1642 ‘Abbas II takes the Safavid throne, briefly arresting the decline of the dynasty that set in with the death of ‘Abbas I. Although not on the scale of his namesake, he is nevertheless a significant patron of the arts. The increasing eclecticism seen in the arts

in this period reflects the ruler’s interest in the artistic and political trends of Europe and India.

1722 Mahmud Khan of Afghanistan captures Isfahan, effectively ending the Safavid Empire. The Afghans occupy much of Iran and bring to nominal power various members of the Safavid family as puppet rulers. The collapse of the Safavid Empire plunges Iran into a period of political chaos, fragmentation, and tribal violence.

1729 Nadir Shah, of the Afshar Turkman tribe in Khurasan, expels the Afghan invaders from Iran. Initially serving the Safavid puppet ruler Tahmasp II, he proclaims himself shah in 1736 and establishes the short-lived Afsharid dynasty.

1733, 1743–47 Iran continues to battle the Ottoman Empire.

1738–39 Nadir Shah invades Mughal India, sacking Delhi and seizing royal treasures, including the famed Peacock Throne. The Mughal emperor Muhammad Shah agrees to cede all his provinces north and west of the Indus to Iran and pay enormous tribute.

1747 Nadir Shah is murdered. In the chaos following his death, various military chiefs seize power in the splintered country. Two of his nephews reign briefly, and a grandson holds Khurasan until 1795.

1750 Karim Khan Zand establishes the Zand dynasty in central and southern Iran. As regent for a defunct Safavid prince, he presides over a period of relative peace and prosperity from his capital at Shiraz. Music, painting, and poetry flourish at his court. The later Zand rulers struggle with the increasing strength of the Qajars, a Turkman tribe that has been growing in prominence since the disintegration of Safavid rule.

1779 Aqa Muhammad Khan, a Qajar tribal chief, establishes Tehran as his capital. Overcoming rifts among the clans, he is able to consolidate power among the Qajars and affiliated tribes in northern Iran, and push southward against the Zands.

1794 Lutf ‘Ali Khan, the last Zand ruler, is captured at Kirman and murdered by Aqa Muhammad Khan Qajar. With this, the majority of Iran falls under Qajar rule.

1797 Fath ‘Ali Shah, nephew of Aqa Muhammad Khan Qajar, becomes the second ruler of the Qajar dynasty in Tehran. Diplomatic relations with European powers increase dramatically during his reign because of Iran’s strategic position across the routes to the East. Tsarist Russia will prove a constant threat during the nineteenth century. Fath ‘Ali Shah is more aware than his uncle of the refinements of court life and the importance of promoting a royal image through art.

1803–13 First Russo-Persian War, ending with the Treaty of Gulistan, which gives control of part of the Caucasus to Russia. Persia signs a short-lived alliance with Britain. This increased internationalism greatly influences art and culture during the Qajar period. While traditional Persian arts continue to flourish, they are employed in new formats to serve the purposes of rulers competing with Western powers. Fath ‘Ali Shah commissions murals of himself for his palaces as well as life-sized portraits of himself to send to rulers in Europe and India.

1826–28 Second Russo-Persian War, ending with the Treaty of Turkmanchai, which gives full control of the Caucasus to Russia.

1851–1906 Qajars engage in battles with the Russians and the British, ultimately losing control of Central Asia

to the Russians and Afghanistan to the British.

1906 An Iranian parliament is established and draws up a constitution in an attempt to introduce a democratic government. A civil war erupts two years later between the reigning shah and the supporters of the constitution.

1924 The Qajar dynasty is deposed by the Iranian National Assembly.

1925 The former commander-in-chief of the army ascends the throne as Riza Shah Pahlavi, first ruler of the Pahlavi dynasty.

1935 The country's name is changed from Persia to Iran.

TURKEY

c. 1299? An Ottoman principality is founded in Anatolia by Osman, a member of a Turkish tribe from Central Asia. The state will eventually develop into the Ottoman Empire, which at its peak will extend onto the continents of Asia, Africa, and Europe.

1402 Timur (Tamerlane) defeats the Ottoman emperor Bayezid I at Ankara. The Ottoman Empire is divided among Bayezid's sons, who rule under Timur.

1405 Timur dies; civil war erupts between Bayezid's sons.

1413 Mehmed I, Bayezid's youngest son, is established as sultan of the Ottoman Empire.

1453 Mehmed II conquers Constantinople, ending the Byzantine Empire. Constantinople, renamed Istanbul, becomes the new Ottoman capital. Mehmed II expands the empire to the west and east. He becomes famous as a patron of Turkish, Persian, and European writers, who flock to his court. From the 1460s onward,

Istanbul is a major center of book production.

1474 Mehmed II defeats the Aq Qoyunlu (White Sheep) Turkmans, who control eastern Anatolia and Kurdistan, and forcibly brings Persian artisans from Tabriz to Istanbul.

1514 Ottoman-Safavid War; Selim I defeats Isma'il I of Iran and takes the northern territories of the Safavid Empire, including the city of Tabriz. The Ottomans seize Iranian treasuries and transport some one thousand skilled artisans from Tabriz to Istanbul, thus increasing the presence of Iranian artists and works of art at the Ottoman court. Many of these artisans are put to work in the imperial studios.

1517 Ottomans conquer Syria and Egypt, ending the rule of the Mamluks (descendants of former slaves who established an empire covering Egypt, Syria, western Arabia, and parts of Turkey). With this victory the Ottomans assume the protection of the holy cities of Mecca and Medina.

1520–66 Süleyman I "the Magnificent" rules the Ottoman Empire. He leads numerous military campaigns in eastern Europe, the Middle East, and the Mediterranean. He is a passionate patron of the arts and oversees a complex network of artists and workshops. The various far-flung imperial workshops together create a distinct Ottoman style—including the unique *saz* style of exuberant and expressive floral decoration—which spreads throughout the empire and beyond.

1548–49 Süleyman invades Iran, again capturing Tabriz.

1553–55 War between the Ottomans and the Safavids. It ends with the Treaty of Amasya, which reestablishes borders between the two empires.

The Safavids and Ottomans develop a diplomatic relationship and extravagant gifts are exchanged between the two rulers, including magnificent manuscripts, carpets, and textiles.

1559 Civil war between Süleyman's sons Bayezid and Selim II. Bayezid is defeated and retreats to the Persian court of Shah Tahmasp. He is later returned to the Ottomans and executed.

1602–38 The Ottomans and Safavids battle over lands between the two empires. Shah 'Abbas I retakes Tabriz for Iran, but the Ottomans retain eastern Anatolia.

1733, 1743–47 The Ottomans resume wars with Iran.

1768–92 The Ottomans engage in wars with Russia over disputed borderlands.

1854–56 Crimean War between the Ottomans and Russia. Britain and France support the Ottomans, lending troops for the first time to fight for Turkey. The war ends with the Treaty of Paris, in which Turkey is inducted into the Concert of Europe.

1889 Germany undertakes political negotiations with the Ottomans, resulting in the beginning of the Baghdad Railway project to connect Berlin and the Persian Gulf through Turkey and Iraq.

1923 After years of resistance against the Ottoman sultan Mehmed VI, Kemal Atatürk becomes president of the new Republic of Turkey and the Ottoman Empire is brought to an end. Atatürk abolishes the caliphate and begins to modernize the republic. He replaces Islamic law with adaptations of European penal and civil policies, expands women's rights, and institutes the use of a modified Roman script in place of Arabic script.

INDIA

1100–1200 Establishment of Islam in India by foreign dynasties, although there is evidence of earlier contact with the Arab people in western India. Turkish and Afghan peoples make successive invasions into Pakistan and North India during the late twelfth century.

1206 Establishment of an Islamic sultanate seat in Delhi, which remains the capital of numerous Muslim rulers until the mid-sixteenth century.

1290 Beginning of the Khalji Sultanate in Delhi. The Khalji battle southward, making inroads into Gujarat and the Deccan region.

1320 The Khalji dynasty collapses, and the Tughluqs come to power in Delhi.

1347 The Bahmani Sultanate is established at Bijapur in the Deccan after years of insurrection against the Delhi sultans.

1398 Timur (Tamerlane), founder of Persia's Timurid dynasty, invades North India and conquers Delhi. He defeats the Tughluqs, but they retain fragile control of the Delhi region until 1414.

1411 Ahmad Shah I captures the city Karnavati, founding a regional sultanate in Gujarat. He establishes Ahmadabad ("the city of Ahmad") as his capital the same year.

1414 The Sayyids replace the Tughluq Sultanate in Delhi.

1451 The Lodis rise to power.

1498 Vasco da Gama of Portugal sails around Africa to India and establishes a European-Indian ocean trade route, initially dominated by the Portuguese based in Goa.

c. 1500 Local Muslim rulers in the Deccan seize power from the Bahmani sultan and divide the Deccan into five sultanates, which maintain close ties to Persia and Turkey and enjoy healthy relations with the wider Arab world through an active ocean trade.

1522 Babur, who claims to be a descendant of both Timur and Genghis Khan, captures the Fort of Qandahar in Afghanistan. Control of this strategic site will switch between Babur's Mughal descendants and the Safavids at least nine times between 1522 and 1738.

1526 Babur invades Pakistan and North India from his capital in Kabul, overthrowing the Lodi sultan in Delhi and establishing the Mughal Empire. Babur establishes his seat of power in Agra.

1530 Babur dies and is succeeded by his son Humayun.

1540–55 Forced from his throne by one of his father's former officers, Humayun escapes to Sind (in present-day Pakistan) and later takes refuge at the Safavid court of Tahmasp in Tabriz. When in 1544–45 the shah withdraws patronage from most of the royal artists, Humayun is encouraged to hire several, including both Mir Musavvir and his brilliant son, Mir Sayyid-'Ali. With Tahmasp's support, Humayun moves his court first to Qandahar, thence to Kabul, and finally, in 1555, back to India.

1556–1605 On the death of Humayun, his fourteen-year-old son Akbar comes to the Mughal throne. Later known as Akbar the Great, this extraordinary statesman, warrior, and patron in effect refounds the empire, which he ultimately expands to include lands stretching from the western to the eastern coasts of India. A great supporter of the arts, he establishes

workshops with indigenous Indian artists working under the instruction of the Persian artists brought from the Safavid court.

1559 Udai Singh, the independent Hindu ruler of Mewar, founds the city of Udaipur. The previous Mewari capital, Chittor, is sacked by Akbar in 1567. Although Akbar now controls Rajasthan, Mewari rulers never accept his sovereignty.

1573 Akbar defeats the Gujarati Sultanate based at Ahmadabad and incorporates those territories into his empire.

1579 Akbar invites foreign missionaries of various religions to his court, including Jesuit priests from Portuguese-held Goa.

1595–1602 The Dutch begin to enter the trading market in India. They establish the Dutch United East India Company in 1602.

1599 The British East India Company is founded in London. One year later Queen Elizabeth grants the company a charter to conduct trade in India and the Far East.

1605 Jahangir, Akbar's son, succeeds to the Mughal throne. Artists working under him include Aqa Riza Jahangiri, Balchand, Basawan, Dawlat, and Manohar.

1613 Jahangir sends a diplomatic embassy to the court of 'Abbas I of Iran, including his great portraitist Bishndas. The embassy is cordially received despite continued tension over the contested Fort of Qandahar in Afghanistan.

1625 Jahangir separates the Rajput kingdoms of Bundi and Kotah, making Kotah an independent state. Kotah is ruled by Madho Singh, son of the

ruler of Bundi. The rulers of Kotah cultivate a strong painting tradition influenced by Mughal and indigenous styles.

1628 Shah Jahan becomes the Mughal emperor. An avid patron of the arts, particularly architecture, he commissions the famous Peacock Throne, the Taj Mahal, and the Red Fort at Delhi. He employs Govardhan and Payag, two of the most talented painters of the time. Paintings created during his reign reflect increasing contact with European art as well as a renewed interest in indigenous Indian styles.

1638 Shah Jahan transfers his capital to Delhi, seat of the Mughal Empire until its demise in 1857, and begins construction of the Red Fort.

1658 Shah Jahan's son Aurangzeb defeats his brother, the Mughal heir Dara Shukoh, in battle and seizes control of the empire from his father. He is less interested in the arts than his father and focuses on the subjugation of Rajasthan and the Deccan. The Mughal Empire reaches its greatest expanse during his rule, but nearly exhausts its resources.

1690 The trading colony of Calcutta is founded by the British.

1700–1800 Western patrons commission Indian artists to document local scenery. These Company School paintings and drawings present new synthesized imagery resulting from the influence of these foreign patrons and styles.

1708–48 The Mughals' territorial control lessens after the death of Aurangzeb. Power splinters among local rulers. The Sikhs rise in Punjab, the Rajputs in Rajasthan, and the Marathas in western India.

1727 The city of Jaipur is founded by Jai Singh II, of the Kachhwaha Rajput lineage.

1739 Nadir Shah Afshar of Iran defeats Mughal emperor Muhammad Shah in a battle not far from Delhi. He plunders the city and carries immeasurable riches, including the Peacock Throne of Shah Jahan, back to Persia. The weakened Mughal Empire thereafter suffers repeated attacks from Afghan invaders as well as internal insurrections from its loosely held states.

1773 The British Parliament passes the Regulating Act that establishes the right of the East India Company, headquartered in Calcutta, to govern the territories of India.

1784 The India Act establishes dual control over British territories in India by the East India Company and the British crown.

1813 The Charter Act asserts Parliament's control over the East India Company territories.

1817–23 The British assert power over the Rajput states and create alliances in 1817 with Kotah and in 1818 with Mewar, Bundi, Kishangarh, Bikaner, and Jaipur.

1851 Art schools are founded in Bombay, Calcutta, and Madras, following an academic curriculum that emphasizes naturalism. This Western-derived style is spearheaded later by the influential artist Raja Ravi Varma.

1853 The first railroad is constructed between Calcutta and Raniganj. Within twenty years it reaches Delhi and Bombay.

1857 The Indian Uprising against the British begins with rebellious soldiers in Bengal and spreads to Delhi, where it is led by the last Mughal emperor, Bahadur Shah II. The British suppress the uprising and exile Bahadur Shah II to Rangoon.

1858 The British crown declares control of the East India Company and the government of India.

1877 Queen Victoria is declared Empress of India and the British-held Indian states officially become part of the British Empire.

c. 1900 Bengali artist Abanindranath Tagore and English educator E. B. Havell develop the Bengal School artistic style based upon Asian rather than Western models.

1911 The seat of colonial power shifts from Calcutta to the old Mughal capital of Delhi. The construction of New Delhi begins.

1947 The British relinquish India, bringing an end to the colonial era. India declares its independence and is divided into states based upon the religious majority of the local population. The lines of partition are determined by outgoing Viceroy Lord Mountbatten. The map creates the modern states of East Pakistan, West Pakistan, and India. The partition is violent, uprooting millions from their homelands and creating the largest displacement of people in the twentieth century.

1972 East Pakistan declares independence from West Pakistan, becoming Bangladesh.

DYNASTIC CHRONOLOGIES

As with the chronologies of regions, these lists of dynasties from Turkey, Iran, and India are limited in scope and in places incomplete, but they provide some historical context for the production of the artworks included in this catalogue.

RULERS IN PERSIA, C. 1400–C. 1900

Timurid Dynasty, 1370–1506

Following the death of Timur, the empire was never again united under a supreme ruler but was divided among his many descendants in shifting alliances and rivalries. This list includes only the major princes and governors of the Timurid line.

Timur (r. 1370–1405)
Shah Rukh (r. 1405–47)
Iskandar Sultan (r. 1409–14), governor of Shiraz
Baysonghor (regent under Shah Rukh, 1418–33)
Ibrahim Sultan (r. 1414–35), governor of Shiraz
Ulughbeg (r. 1447–49), Transoxiana and Samarqand
Abu Sa'id (r. 1451–68), northern Iran
Husayn Bayqara (r. 1470–1506), Herat

Aq Qoyunlu Dynasty (Turkman; western Iran and eastern Turkey), 1378–1508

Qarā Qoyunlu Dynasty (Turkman; western Iran and Iraq), 1380–1468

Safavid Dynasty, 1501–1722

Isma'il I (r. 1501–24), Tabriz
Tahmasp (r. 1524–76), Qazvin
Isma'il II (r. 1576–77)

Muhammad Khudabanda (r. 1578–88)
'Abbas I (r. 1588–1629), Isfahan
Safi (r. 1629–42)
'Abbas II (r. 1642–66)
Sulayman I (Safi II) (r. 1666–94)
Husayn (r. 1694–1722)

Interregnum

Mahmud Khan of Afghanistan (r. 1722)
Mir Ashraf (r. 1725–29)

Afsharid Dynasty, 1736–95

Nadir Shah (r. 1736–47)
Adil Shah (r. 1747)
Ibrahim (r. 1748)
Shah Rukh (r. 1748–95)

Zand Dynasty, 1750–94

Karim Khan (r. 1750–79), Shiraz
Abu'l-Fath Khan (r. 1779)
Muhammad Ali Khan (r. 1779)
Muhammad Sadiq Khan (r. 1779–81)
'Ali Murad Khan (r. 1779–85), Isfahan
Ja'far Khan (r. 1785), Isfahan and Shiraz
Lutf 'Ali Khan (r. 1789–94), Shiraz

Qajar Dynasty, 1779–1924, Tehran

Aqa Muhammad Khan (r. 1779–97)
Fath 'Ali Shah (r. 1797–1834)
Muhammad Shah (r. 1834–48)
'Ali (in rebellion) (r. 1834)
Husayn 'Ali (in rebellion) (r. 1834–35)
Nasir al-Din (r. 1848–96)
Muzaffar al-Din (r. 1896–1907)
Muhammad 'Ali Shah (r. 1907–09)
Ahmad Shah (r. 1909–24)

RULERS IN TURKEY, C. 1300–C. 1900

Ottoman Dynasty, c. 1300–1923

Osman I (r. 1299?–1324?)
Orhan (r. 1324?–1362?)

Murad I (r. 1362?–1389)
Bayezid I (r. 1389–1402)
Interregnum (1402–13)
Mehmed I (r. 1413–21)
Murad II (r. 1421–51)
Mehmed II (r. 1451–80)
Bayezid II (r. 1481–1512)
Selim I (r. 1512–20)
Süleyman I (r. 1520–66)
Selim II (r. 1566–74)
Murad III (r. 1574–95)
Mehmed III (r. 1595–1603)
Ahmed I (r. 1603–17)
Mustafa I (r. 1617–18, 1622–23)
Osman II (r. 1618–22)
Murad IV (r. 1623–40)
Ibrahim (r. 1640–48)
Mehmed IV (r. 1648–87)
Süleyman II (r. 1687–91)
Ahmed II (r. 1691–95)
Mustafa II (r. 1695–1703)
Ahmed III (r. 1703–30)
Mahmud I (r. 1730–54)
Osman III (r. 1754–57)
Mustafa III (r. 1757–74)
Abdülhamid I (r. 1774–89)
Selim III (r. 1789–1807)
Mustafa IV (r. 1807–08)
Mahmud II (r. 1808–39)
Abdülmecid I (r. 1839–61)
Abdülaziz I (r. 1861–76)
Murad V (r. 1876)
Abdülhamid II (r. 1876–1909)
Mehmed V (r. 1909–18)
Mehmed VI (r. 1918–22)

RULERS IN INDIA, C. 1200–1900

Delhi Sultanates, c. 1206–c. 1526

MU'IZZI SULTANATE, 1206–90
KHALJI SULTANATE, 1290–1320
TUGHLUQ SULTANATE, 1320–1401
SAYYID SULTANATE, 1414–51

LODI SULTANATE, 1451–1526

SURI SULTANATE, 1540–55

Mughal Dynasty, 1526–1858

Babur (r. 1526–30)

Humayun (r. 1530–40 and 1555–56)

Sher Shah Sur (r. 1540–55), Afghan
 ruler who temporarily deposes
 Humayun

Akbar (r. 1556–1605)

Jahangir (r. 1605–27)

Shah Jahan (r. 1628–57)

Aurangzeb ('Alamgir I) (r. 1658–1707)

Bahadur Shah (Shah 'Alam I)
 (r. 1707–12)

Jahandar (r. 1712)

Farrukhsiyar (r. 1713–19)

Muhammad Shah (r. 1719–48)

Ahmad Shah Bahadur (r. 1748–54)

'Alamgir II (r. 1754–59)

Shah 'Alam II (r. 1760–1806)

Akbar Shah II (r. 1806–37)

Bahadur Shah II (r. 1837–58)

*Sultanates of the Deccan, c. 1340–
c. 1680*

BAHMANI SULTANATE, 1347–1527

BIDAR SULTANATE, 1487–1619

BIJAPUR SULTANATE, 1489–1686

AHMADABAD SULTANATE, 1490–1636

BERAR SULTANATE, 1491–1574

GOLCONDA SULTANATE, 1512–1687

*Hindu Kingdoms of Rajasthan,
c. 1400–c. 1900*

MEWAR DYNASTY

Lakha (r. 1382–1421)

Mokal (r. 1421–33)

Rana Kumbha (r. 1433–68)

Ooda (r. 1468–73)

Raimal (r. 1473–1509)

Sangram Singh (r. 1509–27)

Ratan Singh (r. 1527–31)

Vikram Singh (r. 1531–37)

Udai Singh (r. 1537–72)

Pratap Singh (r. 1572–97)

Amar Singh I (r. 1597–1621)

Karan Singh (r. 1621–28)

Jagat Singh I (r. 1628–52)

Raj Singh I (r. 1652–80)

Jai Singh (r. 1680–98)

Amar Singh II (r. 1698–1710)

Sangram Singh (r. 1710–34)

Jagat Singh II (r. 1734–51)

Pratap Singh II (r. 1751–54)

Raj Singh II (r. 1754–61)

Ari Singh II (r. 1761–73)

Hamir Singh II (r. 1773–78)

Bhim Singh (r. 1778–1828)

Jawan Singh (r. 1828–38)

Sardar Singh (r. 1838–42)

Swaroop Singh (r. 1842–61)

Shambhu Singh (r. 1861–74)

Sajjan Singh (r. 1874–84)

Fateh Singh (r. 1884–1930)

DEVGARH

Dwarka Das (r. 1669–1706)

Sangram Singh I (r. 1706–37)

Jaswant Singh (r. 1737–76)

Ragho Das (r. 1776–86)

Gokul Das II (r. 1786–1821)

Nahar Singh I (r. 1821–47)

Ranjit Singh (r. 1847–67)

AMBER AND JAIPUR

Man Singh (r. 1589–1614)

Jagat Singh (r. 1614)

Bhao Singh (r. 1614–22)

Jaya Singh (r. 1622–67)

Rama Singh (r. 1667–88)

Bisham Singh (r. 1688–1700)

Jai Singh II (r. 1700–1743)

Ishvari Singh (r. 1743–50)

Madho Singh (r. 1751–68)

Prithvi Singh (r. 1768–78)

Pratap Singh (r. 1778–1803)

Jagat Singh II (r. 1803–19)

Jai Singh III (r. 1820–35)

Ram Singh II (r. 1835–80)

Madho Singh II (r. 1880–1922)

Man Singh II (r. 1922–49)

BUNDI

Surjan Singh (r. 1555–86)

Bhoj Singh (r. 1586–1608)

Ratan Singh (r. 1608–32)

Rao Chattarsal (Chatra Singh)
 (r. 1632–58)

Bhao Singh (r. 1658–82)

Anirudh Singh (r. 1682–96)

Budh Singh (r. 1696–1735)

Dalel Singh (r. 1735–49)

Usmaid Singh (r. 1749–c. 1773)

Bishen Singh (r. 1804–21)

Ram Singh (r. 1821–89)

Raghubir Singh (r. 1889–1927)

KOTAH

Madho Singh (r. 1625–48)

Mukund Singh (r. 1648–58)

Jagat Singh (r. 1658–83)

Kishor Singh (r. 1684–96)

Ram Singh (r. 1696–1707)

Bhim Singh I (r. 1707–20)

Arjun Singh (r. 1720–23)

Durjan Sal (r. 1724–56)

Himmat Singh (regent of the court
 responsible for Durjan Sal's safety
 during the 1720s to the 1750s)

Zalim Singh (regent of the Kotah court
 after his uncle, Himmat Singh)

Ajit Singh (r. 1756–58)

Shatru Sal I (r. 1758–64)

Guman Singh (r. 1764–71)

Umed Singh (r. 1771–1819)

Kishor Singh (r. 1819–27)

Ram Singh II (r. 1827–66)

Shatru Sal II (r. 1866–89)

Umed Singh II (r. 1889–1940)

KISHANGARH

Kishan Singh (r. 1611)

Man Singh (r. 1658–1700)

Prince Savant Singh (r. 1748–57)

Birad Singh (r. 1781–88)

*Rulers of Himachal Pradesh and
Punjab Hills*

GULER

Jagdish Chand (r. 1570–1605)

Bikram Singh (r. 1661–85)

Gopal Chand (r. 1687)

Dalip Chand (r. 1695–1730)

Govardhan Chand (r. 1741–73)

Prakash Chand (r. 1773–90)

KANGRA

Hamir Chand (r. 1700–1747)

Abhay Chand (r. 1747–50)

Shringar Chand (r. 1750)

Ghamir Chand (r. 1750–51)

Ghamand Chand (r. 1751–74)

Tegh Chand (r. 1774–75)

Sansar Chand II (r. 1775–1823)

CHECKLIST

1999 Gift of Stuart Cary Welch to the Harvard University Art Museums

1983 NUMBERS

1.1983[r]
Views of a Palace
Rajasthan, Kotah, 18th century
Ink and opaque watercolor on paper
9 7/8 × 6 7/8 in. (25.2 × 17.4 cm)
Promised Gift of Stuart Cary Welch, Jr.

9.1983
Design for a Shawl
Kashmir, 19th century
Ink and opaque watercolor on paper
8 5/8 × 9 1/8 in. (21.8 × 23.2 cm)
Promised Gift of Stuart Cary Welch, Jr.

14.1983
Seated Holy Man
Punjab Hills, c. 1820
Ink and opaque watercolor on paper
8 7/8 × 7 in. (22.5 × 18 cm)
Promised Gift of Stuart Cary Welch, Jr.

21.1983
Bhopali Ragini
Rajasthan, Bundi, c. 1630–40
Gray-black ink, watercolor, and opaque watercolor on beige laid paper; architecture pricked
10 1/4 × 5 3/4 in. (26 × 14.7 cm)
Promised Gift of Stuart Cary Welch, Jr.
Cat. 35

23.1983
Bhainsrorgarh Gorge and Brahmuti River, with Palace on Cliff Above
Rajasthan, Kotah, 18th century
Ink and opaque watercolor on paper
7 × 10 3/4 in. (17.8 × 27.2 cm)
Promised Gift of Stuart Cary Welch, Jr.

24.1983
Two Priests before a Shrine of Shrinathji
Rajasthan, Kotah, c. 1840
Ink on paper
4 3/4 × 7 1/4 in. (12 × 18.5 cm)
Promised Gift of Stuart Cary Welch, Jr.

25.1983
An Ascetic (Shri Ram Vallabhai) and Other Sketches
Rajasthan, Kotah, c. 1800
Ink and opaque watercolor on paper
7 3/8 × 6 3/8 in. (18.8 × 16.2 cm)
Promised Gift of Stuart Cary Welch, Jr.

26.1983
Gauri Ragini: Preparatory drawing for a "Ragamala" series folio
Rajasthan, 18th century
Ink and opaque watercolor on paper
9 1/4 × 6 in. (23.4 × 15.2 cm)
Promised Gift of Stuart Cary Welch, Jr.

28.1983
Strange Happenings on a Terrace
Rajasthan, Kishangarh, c. 1740
Gray-black ink, watercolor, and gold over charcoal on beige paper
5 1/8 × 7 7/8 in. (13 × 20 cm)
Promised Gift of Stuart Cary Welch, Jr.
Cat. 67

29.1983[r]
Sketches of Dogs
Rajasthan, Devgarh, late 18th century
Black and brown inks on beige laid paper
10 5/8 × 6 7/8 in. (27.1 × 17.4 cm)
Promised Gift of Stuart Cary Welch, Jr.
Cat. 63

29.1983[v]
Sketches of Various Objects and Figures
Rajasthan, Devgarh, late 18th century
Black and brown inks on beige laid paper
10 5/8 × 6 7/8 in. (27.1 × 17.4 cm)
Promised Gift of Stuart Cary Welch, Jr.
Cat. 63, fig. 1

30.1983
Winged Female astride a Composite Camel Made of Three Girls
Rajasthan, 18th century
Ink and opaque watercolor on paper; pricked
6 3/4 × 6 3/8 in. (17 × 16.2 cm)
Promised Gift of Stuart Cary Welch, Jr.

32.1983
Line Drawing of a Horse
Rajasthan, Kishangarh, mid-18th century
Black ink and watercolor on off-white laid paper
11 1/8 × 8 1/2 in. (28.3 × 21.7 cm)
Promised Gift of Stuart Cary Welch, Jr.
Cat. 68

33.1983
Architectural Drawings: Facade and Bangala
Rajasthan, early 19th century
Ink and opaque watercolor on paper
27 × 18 1/4 in. (68.5 × 46.5 cm)
Promised Gift of Stuart Cary Welch, Jr.

37.1983
La Toilette
North India, late 17th century to early 18th century
Black ink, watercolor, opaque watercolor, gold pigment, and metallic silver paint on beige laid paper
8 1/2 × 6 3/4 in. (21.7 × 17.2 cm)
Promised Gift of Stuart Cary Welch, Jr.
Cat. 32

40.1983
Woman Nursing a Baby
Rajasthan, Bundi or Kotah, c. 1800
Ink and opaque watercolor on paper; pricked
10 3/4 × 8 1/4 in. (27.3 × 21 cm)
Promised Gift of Stuart Cary Welch, Jr.

47.1983
Seated Lady with Attendant
Rajasthan, Uniara, c. 1800
Ink on paper
8 1/4 × 5 7/8 in. (21 × 14.8 cm)
Promised Gift of Stuart Cary Welch, Jr.

50.1983
The Wind Palace (Hawa Mahal) of Jaipur
Rajasthan, Jaipur, 1848
Black ink, opaque watercolor, and gold on off-white laid paper
9 7/8 × 8 5/8 in. (25 × 22 cm)
Promised Gift of Stuart Cary Welch, Jr.
Cat. 69

52.1983
Seated Prince and Lady
Rajasthan, 18th century
Ink on paper
7½ × 5¾ in. (19 × 14.7 cm)
Promised Gift of Stuart Cary Welch, Jr.

56.1983
Seated Holy Man with Prayer Beads
Rajasthan, Jaipur, 18th century
Opaque watercolor on paper
6⅛ × 3⅝ in. (15.5 × 9 cm)
Promised Gift of Stuart Cary Welch, Jr.

59.1983[r]
Krishna and Radha after Exchanging Clothes
(chadma lila)
Attributed to Nihal Chand
Rajasthan, Kishangarh, c. 1760
Black ink over charcoal underdrawing on
off-white laid paper
10½ × 12⅝ in. (26.8 × 32 cm)
Promised Gift of Stuart Cary Welch, Jr.
Cat. 66

59.1983[v]
Cityscape
Rajasthan, Kishangarh, c. 1760
Ink on paper
10½ × 12⅝ in. (26.8 × 32 cm)
Promised Gift of Stuart Cary Welch, Jr.
Cat. 66, fig. 3

60.1983
Vilaval Ragini
Rajasthan, Bundi, c. 1590–1600
Black ink and opaque watercolor on beige
laid paper; figures and architecture
partially pricked
8⅞ × 5 in. (22.5 × 12.6 cm)
Promised Gift of Stuart Cary Welch, Jr.
Cat. 34

62.1983
Lovers on a Charpoi
Rajasthan, 18th century
Ink on paper
9⅝ × 6⅝ in. (24.5 × 16.7 cm)
Promised Gift of Stuart Cary Welch, Jr.

66.1983
Textile Designs
Rajasthan, 18th century
Ink and opaque watercolor on paper
8½ × 4¾ in. (21.5 × 12 cm)
Promised Gift of Stuart Cary Welch, Jr.

67.1983
Military Procession
Rajasthan, Jaipur, c. 1800
Ink on paper
13¼ × 9½ in. (33.5 × 24 cm)
Promised Gift of Stuart Cary Welch, Jr.

68.1983
Jain Saint
Rajasthan, Bikaner, mid-18th century
Ink on paper
8¾ × 6⅜ in. (22 × 16 cm)
Promised Gift of Stuart Cary Welch, Jr.

69.1983[r]
Elephant Saluting a Prince (Madho Singh?)
Attributed to the Master of Elephants
Rajasthan, Kotah, c. 1625
Black ink and watercolor on beige laid
paper
9½ × 11⅜ in. (24.2 × 29 cm)
Promised Gift of Stuart Cary Welch, Jr.
Cat. 37

69.1983[v]
Pricked Drawing
Rajasthan, Kotah, c. 1625
Ink on paper
9½ × 11½ in. (24.2 × 29 cm)
Promised Gift of Stuart Cary Welch, Jr.
Cat. 37

71.1983
Madho Singh on Horseback with Three
Attendants
Attributed to the Master of Elephants
Rajasthan, Kotah, 17th century
Ink and opaque watercolor on paper
7⅜ × 7⅜ in. (18.8 × 18.8 cm)
Promised Gift of Stuart Cary Welch, Jr.

72.1983
Maharaja Ram Singh Contemplates the
Monsoon
Rajasthan, Kotah, c. 1835
Ink and opaque watercolor on paper
19¾ × 24¾ in. (50.1 × 62.9 cm)
Promised Gift of Stuart Cary Welch, Jr.

74.1983
The Heat of Battle
Attributed to the Kotah Master
Rajasthan, Kotah, early 18th century
Black ink and opaque watercolor on beige
laid paper
17⅞ × 22⅞ in. (45.4 × 58 cm)
Promised Gift of Stuart Cary Welch, Jr.
Cat. 39

75.1983[r]
Soldiers Carousing
Attributed to the Kotah Master
Rajasthan, Kotah, c. 1710
Black ink and watercolor on off-white laid
paper; several figures pricked
7¾ × 4⅞ in. (19.6 × 12.5 cm)
Promised Gift of Stuart Cary Welch, Jr.
Cat. 42

75.1983[v]
Sketches of Figures and Animals
Attributed to the Kotah Master
Rajasthan, Kotah, c. 1710
Ink and opaque watercolor on paper
7¾ × 4⅞ in. (19.6 cm × 12.5 cm)
Promised Gift of Stuart Cary Welch, Jr.
Cat. 42, fig. 1

76.1983
Two Pigeons
Attributed to Abu'l-Hasan
North India, c. 1610
Black ink, opaque watercolor, and gold on
beige paper
10⅜ × 6½ in. (26.5 × 16.5 cm)
Promised Gift of Stuart Cary Welch, Jr.
Cat. 24

77.1983
Ascetics Making Bhang
Attributed to Basawan
North India, c. 1585–1620
Black ink on off-white paper
6⅝ × 3½ in. (16.7 × 8.8 cm)
Promised Gift of Stuart Cary Welch, Jr.
Cat. 19

78.1983
A Prince Slays a Rhinoceros from an Elephant
Attributed to the Kotah Master
Rajasthan, Kotah, c. 1730
Black ink over charcoal underdrawing on
off-white laid paper
11⅞ × 18¼ in. (30 × 46.3 cm)
Promised Gift of Stuart Cary Welch, Jr.
Cat. 47

80.1983
Maharao Ram Singh with a Girl in a Cabriolet
Rajasthan, Kotah, late 1850s to early 1860s
Black ink, watercolor, and opaque water-
color on off-white paper
10 × 16½ in. (25.3 × 42 cm)
Promised Gift of Stuart Cary Welch, Jr.
Cat. 58

81.1983
Reclining Lady
Rajasthan, Kotah, 18th century
Ink and opaque watercolor on paper
6 × 4 in. (15 × 10 cm)
Promised Gift of Stuart Cary Welch, Jr.

82.1983
Erotic Drawing
Rajasthan, Kotah, 19th century
Ink and opaque watercolor on paper
7 × 6¼ in. (17.8 × 15.9 cm)
Promised Gift of Stuart Cary Welch, Jr.

83.1983
Courtier Holding a Spear
Rajasthan, Kotah, 18th century
Ink on paper
5½ × 4⅞ in. (14 × 12.5 cm)
Promised Gift of Stuart Cary Welch, Jr.

84.1983
*Shri Raga: Preparatory drawing for a
"Ragamala" series folio*
Rajasthan, Kotah, 18th century
Ink on paper
8⅞ × 6⅓ in. (22.7 × 16 cm)
Promised Gift of Stuart Cary Welch, Jr.

85.1983
*Ruler and an Attendant Conversing with a
British Resident*
Rajasthan, Kotah, early 19th century
Ink and opaque watercolor on paper
8⅔ × 7⅜ in. (22 × 18.7 cm)
Promised Gift of Stuart Cary Welch, Jr.

87.1983
*Ram Singh II of Kotah with Attendants and
Two Englishmen*
Rajasthan, Kotah, c. 1840
Ink and opaque watercolor on paper
10⅜ × 17⅞ in. (26.5 × 45.5 cm)
Promised Gift of Stuart Cary Welch, Jr.

89.1983
*Studies of Heads and Hands (after European
Prints)*
Rajasthan, Kotah, early 19th century
Ink on paper
4¾ × 9⅛ in. (12 × 23.2 cm)
Promised Gift of Stuart Cary Welch, Jr.

90.1983
Dragon, Deer, and Two Seated Women
Rajasthan, Kotah, 18th century
Ink on paper
6⅜ × 4⅞ in. (16.2 × 12.5 cm)
Promised Gift of Stuart Cary Welch, Jr.

91.1983
A Family of Monkeys
Rajasthan, late 18th century
Ink on paper
4½ × 10½ in. (11.5 × 26.8 cm)
Promised Gift of Stuart Cary Welch, Jr.

92.1983
Krishna Offered Delicacies by a Peri
Attributed to the Kotah Master
Rajasthan, Kotah, early 18th century
Ink and opaque watercolor on paper
7¾ × 5⅜ in. (19.7 × 13.6 cm)
Promised Gift of Stuart Cary Welch, Jr.

93.1983
Two Seated Men with Red Turbans
Rajasthan, c. 1800
6⅞ × 6½ in. (17.4 × 16.5 cm)
Ink and opaque watercolor on paper
Promised Gift of Stuart Cary Welch, Jr.

95.1983
*A Ruler on a Litter Drawn by a Horse, with
Women Attendants*
Rajasthan, Kotah, c. 1730
Ink and opaque watercolor on paper
4⅜ × 6 in. (11 × 15 cm)
Promised Gift of Stuart Cary Welch, Jr.

96.1983
*Seated Ruler Holding a Shield with Four Atten-
dants in Red*
Rajasthan, Kotah, mid-19th century
Ink and opaque watercolor on paper
7⅞ × 7⅛ in. (20 × 18 cm)
Promised Gift of Stuart Cary Welch, Jr.

97.1983
Krishna and Radha in a Pavilion
Rajasthan, 18th century
Ink and opaque watercolor on paper
6⅛ × 5¼ in. (15.5 × 13.2 cm)
Promised Gift of Stuart Cary Welch, Jr.

98.1983
*The Maharajah of Kotah and Attendants,
Including the Englishman James Tod*
Rajasthan, Kotah, early 19th century
Ink and opaque watercolor on paper
8 × 12¾ in. (20.2 × 32.5 cm)
Promised Gift of Stuart Cary Welch, Jr.

99.1983
Drawing of a Portal
Rajasthan, Kotah, 18th century
Ink and opaque watercolor on paper;
pricked
10⅛ × 6⅛ in. (25.7 × 15.4 cm)
Promised Gift of Stuart Cary Welch, Jr.

100.1983
Battle Scene with Many Warriors on Horseback
Rajasthan, Kotah, 18th century
Ink and opaque watercolor on paper
11 × 8⅞ in. (28 × 22.5 cm)
Promised Gift of Stuart Cary Welch, Jr.

101.1983
Soldiers at a Gate
Rajasthan, Kotah, 18th century
Ink and opaque watercolor on paper
8⅜ × 3½ in. (21.4 × 9 cm)
Promised Gift of Stuart Cary Welch, Jr.

102.1983
Hunting by Boat on the Chambal River
Attributed to the Kotah Master
Rajasthan, Kotah, 18th century
Ink and opaque watercolor on paper
5¾ × 13½ in. (14.5 × 34.2 cm)
Promised Gift of Stuart Cary Welch, Jr.

103.1983
Seated Man with a Hookah and Shield
Rajasthan, Kotah, early 19th century
Ink and opaque watercolor on paper
5⅝ × 4⅜ in. (14.2 × 11 cm)
Promised Gift of Stuart Cary Welch, Jr.

104.1983
Equestrian Portrait of Arjun Singh
Rajasthan, Kotah, c. 1740
Ink and opaque watercolor on paper
10 × 7¾ in. (25.5 × 19.8 cm)
Promised Gift of Stuart Cary Welch, Jr.

105.1983.A–B
*Sketches: Sleeping Figures, Cattle and Head of
Priest (two folios mounted together)*
Rajasthan, Kotah, c. 1825–50
Ink and opaque watercolor on paper
7¼ × 9⅞ in. (18.5 × 25 cm)
Promised Gift of Stuart Cary Welch, Jr.

106.1983
Seated Youth Leaning on a Round Shield
Rajasthan, Kotah, late 18th century
Ink and opaque watercolor on paper
3½ × 4 in. (8.9 × 10 cm)
Promised Gift of Stuart Cary Welch, Jr.

107.1983
Seated Man with a Beard
Rajasthan, early 19th century
Ink and opaque watercolor on paper
5¾ × 4⅝ in. (14.7 × 11.8 cm)
Promised Gift of Stuart Cary Welch, Jr.

108.1983
A Sword-Bearing Prince with Three Attendants
Rajasthan, Kotah, 18th century
Ink on paper; pricked
6⅞ × 4⅝ in. (17.4 × 11.8 cm)
Promised Gift of Stuart Cary Welch, Jr.

109.1983
Soldier Giving Water to a Seated Soldier
Rajasthan, Kotah, 18th century
Ink and opaque watercolor on paper
6¾ × 5 in. (17.3 × 12.8 cm)
Promised Gift of Stuart Cary Welch, Jr.

110.1983
Seven Ladies
Attributed to the Kotah Master
Rajasthan, Kotah, early 18th century
Ink on paper
6⅛ × 4⅛ in. (15.4 × 10.5 cm)
Promised Gift of Stuart Cary Welch, Jr.

111.1983
Seated Man
Rajasthan, Kotah, c. 1740
Black, red, and orange inks and watercolor
on beige laid paper
7⅝ × 4⅞ in. (19.3 × 12.3 cm)
Promised Gift of Stuart Cary Welch, Jr.
Cat. 53

112.1983
*A Holy Man Seated in a Hut beneath a Tree
during the Monsoon*
Attributed to the Kotah Master
Rajasthan, Kotah, c. 1735
Ink on paper
5¾ × 3⅛ in. (14.5 × 8 cm)
Promised Gift of Stuart Cary Welch, Jr.

113.1983.1
*Seated Man with Hookah and Weapons
Drinking from a Lotus*
Rajasthan, Kotah, 18th century
Ink on paper
3½ × 2⅝ in. (8.8 × 6.7 cm)
Promised Gift of Stuart Cary Welch, Jr.

113.1983.2
*Seated Man with Stringed Instrument Drinking
from a Lotus*
Rajasthan, Kotah, 18th century
Ink on paper
3⅛ × 3⅜ in. (7.8 × 8.7 cm)
Promised Gift of Stuart Cary Welch, Jr.

114.1983
Seated Man with Dagger
Rajasthan, Kotah, 18th century

Ink on paper
7⅜ × 5 in. (18.8 × 12.6 cm)
Promised Gift of Stuart Cary Welch, Jr.

115.1983[r]
Milking a Water Buffalo
Rajasthan, Kotah, 19th century
Ink and opaque watercolor on paper
6½ × 6⅞ in. (16.5 × 17.6 cm)
Promised Gift of Stuart Cary Welch, Jr.

115.1983[v]
Men and Cows
Rajasthan, Kotah, 19th century
Ink and opaque watercolor on paper;
portions pricked
6½ × 6⅞ in. (16.5 × 17.6 cm)
Promised Gift of Stuart Cary Welch, Jr.

117.1983
*Rama and Sita with Lakshman and Hanuman:
Scene from the "Ramayana"*
Attributed to the Kotah Master
Rajasthan, Kotah, early 18th century
Ink and opaque watercolor on paper
6⅞ × 6¼ in. (17.5 × 16 cm)
Promised Gift of Stuart Cary Welch, Jr.

118.1983
*Men Fleeing from an Escaped Elephant (an
assembly of fragments)*
Rajasthan, Kotah, early 18th century
Ink and opaque watercolor on paper
8⅛ × 8⅝ in. (20.5 × 21.8 cm)
Promised Gift of Stuart Cary Welch, Jr.

119.1983
Shatru Sal II and Two Ladies
Rajasthan, Kotah, c. 1860
Black ink and opaque watercolor on off-
white laid paper
6¾ × 9⅞ in. (17.2 × 25.2 cm)
Promised Gift of Stuart Cary Welch, Jr.
Cat. 59

120.1983
*Sketches of Two Charioteers with Four Horses and
Two Men*
Rajasthan, Kotah, 19th century
Ink and opaque watercolor on paper
7⅝ × 11½ in. (19.5 × 29 cm)
Promised Gift of Stuart Cary Welch, Jr.

121.1983
*Elephant Trainers with Charkhis and a Rider
Unhorsed (fragment)*
Rajasthan, Kotah, 17th century
Ink on paper
10 × 4¾ in. (25.3 × 12 cm)
Promised Gift of Stuart Cary Welch, Jr.

122.1983
*Arjun Singh Shooting Arrows from a Pavilion
before a Pool*
Rajasthan, Kotah, early 18th century
Ink on paper
10¾ × 5⅛ in. (27.2 × 13.2 cm)
Promised Gift of Stuart Cary Welch, Jr.

123.1983
*Rama, Sita, Lakshman, and Hanuman in a
Boat Drawn by Birds*
Rajasthan, Kotah, 18th century
Ink and opaque watercolor on paper;
pricked
4⅛ × 7⅞ in. (10.4 × 20 cm)
Promised Gift of Stuart Cary Welch, Jr.

124.1983
*Sketches: Head of a Man and Woman, A Fish, A
Bird on Its Back, Two Pigeons*
Attributed to the Kotah Master
Rajasthan, Kotah, early 18th century
Ink on paper
9⅞ × 2 in. (25 × 5.2 cm)
Promised Gift of Stuart Cary Welch, Jr.

125.1983
Lions and a Buck
Attributed to the Kotah Master
Rajasthan, Kotah, early 18th century
Ink and opaque watercolor on paper
5⅜ × 9⅞ in. (13.6 × 25 cm)
Promised Gift of Stuart Cary Welch, Jr.

126.1983
Dragons and Birds from the Chambal River
Attributed to the Kotah Master
Rajasthan, Kotah, c. 1700
Black ink and white opaque watercolor on
beige paper
1¾ × 7⅜ in. (4.6 × 18.7 cm)
Promised Gift of Stuart Cary Welch, Jr.
Cat. 41

127.1983
Elephant Combat
Rajasthan, Kotah, c. 1740
Ink and opaque watercolor on paper
6¾ × 6 in. (17 × 15 cm)
Promised Gift of Stuart Cary Welch, Jr.

128.1983
*Sketches: Animal Combat, A Goddess astride a
Fanciful Animal*
Rajasthan, 18th century
Ink on paper
6 × 4½ in. (15.2 × 11.5 cm)
Promised Gift of Stuart Cary Welch, Jr.

129.1983
A Chained Elephant Drinking
Rajasthan, Kotah, 18th century
Ink on paper
5¼ × 9⅞ in. (13.2 × 25 cm)
Promised Gift of Stuart Cary Welch, Jr.

130.1983
Sketch: Englishmen and Indians
Rajasthan, Kotah, dated 1862
Ink and opaque watercolor on paper
5¼ × 7⅜ in. (13.4 × 18.8 cm)
Promised Gift of Stuart Cary Welch, Jr.

131.1983
Krishna with the Gopis
Attributed to the Kotah Master
Rajasthan, Kotah, c. 1730
Ink and opaque watercolor on paper
9 × 6¼ in. (23 × 16 cm)
Promised Gift of Stuart Cary Welch, Jr.

132.1983
A Floozy
Rajasthan, Kotah, c. 1830
Gray-black ink and opaque watercolor on
beige laid paper
5¼ × 6¼ in. (13.3 × 16 cm)
Promised Gift of Stuart Cary Welch, Jr.
Cat. 54

133.1983
Pet Antelope
Attributed to the Kotah Master
Rajasthan, Kotah, c. 1730
Gray-black ink and opaque watercolor
over charcoal underdrawing on off-white
laid paper
5⅜ × 5¼ in. (13.7 × 13.4 cm)
Promised Gift of Stuart Cary Welch, Jr.
Cat. 51

135.1983
*Nat Ragini: Preparatory drawing for a
"Ragamala" series folio*
Rajasthan, Kotah, 18th century
Ink and opaque watercolor on paper
9⅛ × 6 in. (23.2 × 15.3 cm)
Promised Gift of Stuart Cary Welch, Jr.

136.1983
*Procession with Humans, Demons, and Animal-
Headed Soldiers*
Rajasthan, Kotah, 18th century
Ink and opaque watercolor on paper
5⅜ × 7¾ in. (13.7 × 19.8 cm)
Promised Gift of Stuart Cary Welch, Jr.

138.1983
A Group of Sixteen Men behind a Wall
Rajasthan, Kotah, 19th century
Ink and opaque watercolor on paper
5⅜ × 8¾ in. (13.5 × 22.2 cm)
Promised Gift of Stuart Cary Welch, Jr.

139.1983
*A Hunting Prince Steadies His Gun on His
Servant's Shoulder*
Rajasthan, 19th century
Ink and opaque watercolor on paper
5½ × 8⅞ in. (14 × 22.7 cm)
Promised Gift of Stuart Cary Welch, Jr.

140.1983
*Sketches: Bird, Seated Man, and A Girl on Bed
with Attendant*
Attributed to the Kotah Master
Rajasthan, Kotah, early 18th century
Ink on paper
5¼ × 6¾ in. (13.2 × 17.2 cm)
Promised Gift of Stuart Cary Welch, Jr.

141.1983
Seated Man
Rajasthan, Kotah, 18th century
Ink and opaque watercolor on paper
6 × 1⅝ in. (15.2 × 4.2 cm)
Promised Gift of Stuart Cary Welch, Jr.

142.1983[r]/[v]
*Nobleman Peering in Window at Ladies Eating
a Meal (recto); Sketches of Elephant and Dogs
(verso)*
Rajasthan, Kotah, 18th century
Ink on paper
4¾ × 4⅜ in. (12 × 11 cm)
Promised Gift of Stuart Cary Welch, Jr.

144.1983
Fish in the Chambal River
Attributed to the Kotah Master
Rajasthan, Kotah, c. 1700
Black and red inks on beige paper
1⅜ × 5⅜ in. (3.6 × 13.7 cm)
Promised Gift of Stuart Cary Welch, Jr.
Cat. 40

145.1983
Baba Atma Ram of Agra
Rajasthan, Kotah, c. 1840
Ink and opaque watercolor on paper
5⅝ × 4⅝ in. (14.4 × 11.7 cm)
Promised Gift of Stuart Cary Welch, Jr.

147.1983
Hunters and Vina Players Stalking Deer
Attributed to the Kotah Master

Rajasthan, Kotah, early 18th century
Ink on paper
6 × 10⅝ in. (15.4 × 27 cm)
Promised Gift of Stuart Cary Welch, Jr.

148.1983
A Bear (fragment)
Attributed to the Kotah Master
Rajasthan, Kotah, early 18th century
Ink on paper
8⅝ × 11⅞ in. (22 × 30.2 cm)
Promised Gift of Stuart Cary Welch, Jr.

149.1983
Flower Motifs in a European Style
Rajasthan, 19th century
Opaque watercolor on paper
10⅜ × 12⅝ in. (26.5 × 32 cm)
Promised Gift of Stuart Cary Welch, Jr.

150.1983
*Chatarao Duhajan, a Muslim Dandy
from Agra*
Rajasthan, Kotah, c. 1840
Ink and opaque watercolor on paper
8¼ × 6¼ in. (21 × 16 cm)
Promised Gift of Stuart Cary Welch, Jr.

151.1983
Mast Elephant under a Tree
Attributed to Shaykh Taju
Rajasthan, Kotah, 18th century
Ink and opaque watercolor on paper
11⅞ × 15⅜ in. (30 × 39.1 cm)
Promised Gift of Stuart Cary Welch, Jr.

153.1983
Girl Spinning
Attributed to the Kotah Master
Rajasthan, Kotah, c. 1740
Ink on paper
5⅛ × 6¼ in. (13 × 16 cm)
Promised Gift of Stuart Cary Welch, Jr.

154.1983
A Little Girl Dances before Spectators
Attributed to the Kotah Master
Rajasthan, Kotah, c. 1720
Purple-red ink and opaque watercolor over
charcoal underdrawing on tan laid paper
6¾ × 5⅛ in. (17 × 12.9 cm)
Promised Gift of Stuart Cary Welch, Jr.
Cat. 43

157.1983
Lady on a Couch with Two Maidservants
Rajasthan, Bundi, 18th century
Ink on paper
4⅝ × 5⅝ in. (11.7 × 14.3 cm)
Promised Gift of Stuart Cary Welch, Jr.

158.1983
The Woman Who Dared Visit an Artist
Rajasthan, Kotah, c. 1850
Gray-black and brown inks and watercolor
on beige laid paper
8¼ × 7⅞ in. (21 × 20 cm)
Promised Gift of Stuart Cary Welch, Jr.
Cat. 57

159.1983
Lovers in a Wood
Rajasthan, Kotah, c. 1740
Ink on paper
11¾ × 7½ in. (29 × 19 cm)
Promised Gift of Stuart Cary Welch, Jr.

161.1983
Tiger Hunt
Rajasthan, Kotah, c. 1780
Ink on paper
21⅝ × 28⅞ in. (55 × 73.5 cm)
Promised Gift of Stuart Cary Welch, Jr.

162.1983[r]
Napoleon and a Napoleonic Soldier
Rajasthan, Kotah, early 19th century
Ink and opaque watercolor on paper
14¾ × 5 in. (37.5 × 12.6 cm)
Promised Gift of Stuart Cary Welch, Jr.

162.1983[v]
Woman and a Man Carrying a Keg
Rajasthan, Kotah, early 19th century
Ink and opaque watercolor on paper
14¾ × 5 in. (37.5 × 12.6 cm)
Promised Gift of Stuart Cary Welch, Jr.

163.1983[r]
Seven and One-Half Heads
Rajasthan, Kotah, c. 1825–50
Ink and opaque watercolor on paper
3⅝ × 6¾ in. (9.3 × 17.2 cm)
Promised Gift of Stuart Cary Welch, Jr.

163.1983[v]
Four Heads
Rajasthan, Kotah, c. 1825–50
Ink and opaque watercolor on paper
3⅝ × 6¾ in. (9.3 × 17.2 cm)
Promised Gift of Stuart Cary Welch, Jr.

165.1983
Lovers in a Pavilion
Attributed to the Kotah Master
Rajasthan, Kotah, c. 1760
Ink on paper
7¾ × 6 in. (19.6 × 15.4 cm)
Promised Gift of Stuart Cary Welch, Jr.

168.1983
A Horse
Rajasthan, Kotah(?), 18th century
Ink on paper
4¾ × 6½ in. (12 × 16.5 cm)
Promised Gift of Stuart Cary Welch, Jr.

169.1983
Palanquin or Sedan Chair (tamjham)
Rajasthan, Kotah, 19th century
Ink and opaque watercolor on paper
5¾ × 12⅛ in. (14.5 × 30.7 cm)
Promised Gift of Stuart Cary Welch, Jr.

172.1983
*Prince and Lady Playing Chess on a Rooftop
while Bed Is Prepared in a Room Below*
Rajasthan, Kotah, 18th century
Ink and opaque watercolor on paper
9⅞ × 5⅜ in. (25.2 × 13.7 cm)
Promised Gift of Stuart Cary Welch, Jr.

174.1983
Frontal View of an Elephant
Rajasthan, 19th century
Ink and opaque watercolor on paper
8⅜ × 5¾ in. (21.2 × 14.6 cm)
Promised Gift of Stuart Cary Welch, Jr.

175.1983
*Krishna and Radha Ride a Camel Composed
of Dancers*
Rajasthan, Kotah, 18th century
Ink and opaque watercolor on paper
6 × 4½ in. (15.2 × 11.3 cm)
Promised Gift of Stuart Cary Welch, Jr.

176.1983
Young Girl Holding Her Skirt
Rajasthan, Kotah, 18th century
Ink and opaque watercolor on paper
5½ × 2⅛ in. (14 × 5.5 cm)
Promised Gift of Stuart Cary Welch, Jr.

177.1983
Erotic Composite Horse
Rajasthan, 19th century
Ink and opaque watercolor on paper
5½ × 5⅝ in. (14 × 14.2 cm)
Promised Gift of Stuart Cary Welch, Jr.

178.1983
A Matchlock
Rajasthan, 18th century
Opaque watercolor on paper
3⅛ × 9½ in. (7.8 × 24.2 cm)
Promised Gift of Stuart Cary Welch, Jr.

179.1983
*Study of a British Officer (after a European Print)
and Other Sketches*
Rajasthan, Kotah, 19th century
Ink and opaque watercolor on paper
5⅞ × 3¾ in. (14.8 × 9.4 cm)
Promised Gift of Stuart Cary Welch, Jr.

180.1983.1
Noblemen with Animal Combat
Rajasthan, c. 1860
Ink and opaque watercolor on paper
9½ × 14⅛ in. (24 × 36 cm)
Promised Gift of Stuart Cary Welch, Jr.

180.1983.2
Addorsed Tigers with Tails Crossed
Rajasthan, c. 1860
Ink and opaque watercolor on paper
9½ × 14⅛ in. (24 × 36 cm)
Promised Gift of Stuart Cary Welch, Jr.

180.1983.3
Wrestlers
Rajasthan, c. 1860
Ink and opaque watercolor on paper
9½ × 14⅛ in. (24 × 36 cm)
Promised Gift of Stuart Cary Welch, Jr.

180.1983.4
Elephant Combat
Rajasthan, c. 1860
Ink and opaque watercolor on paper
9½ × 14⅛ in. (24 × 36 cm)
Promised Gift of Stuart Cary Welch, Jr.

180.1983.5
Animal Combat
Rajasthan, c. 1860
Ink and opaque watercolor on paper
9½ × 14⅛ in. (24 × 36 cm)
Promised Gift of Stuart Cary Welch, Jr.

180.1983.6
Tiger Attacking a Hunter and His Elephant
Rajasthan, c. 1860
Ink and opaque watercolor on paper
9½ × 14⅛ in. (24 × 36 cm)
Promised Gift of Stuart Cary Welch, Jr.

181.1983
Cows and a Lady in a Landscape
Rajasthan, Kotah, 18th century
Ink and opaque watercolor on paper
10½ × 7½ in. (26.7 × 19.2 cm)
Promised Gift of Stuart Cary Welch, Jr.

184.1983
Bust of a Prince
Rajasthan, Kotah, 18th century

Ink on paper
3 × 2⅝ in. (7.7 × 6.7 cm)
Promised Gift of Stuart Cary Welch, Jr.

185.1983[r]
Full-Length Portrait of a Rajput Prince
Rajasthan, 18th century
Ink on paper
4 × 3 in. (10.2 × 7.6 cm)
Promised Gift of Stuart Cary Welch, Jr.

185.1983[v]
Portrait of a Lady
Rajasthan, 18th century
Ink on paper
4 × 3 in. (10.2 × 7.6 cm)
Promised Gift of Stuart Cary Welch, Jr.

186.1983
Four Sketches of Musicians and Dancers
Rajasthan, Kotah, 18th century
Ink on paper
5⅜ × 5½ in. (13.6 × 14 cm)
Promised Gift of Stuart Cary Welch, Jr.

187.1983
Scenes from a Wedding: Prince with Ladies and Musicians
Rajasthan, Kotah, 18th century
Ink and opaque watercolor on paper; pricked
6⅛ × 14⅛ in. (15.7 × 36 cm)
Promised Gift of Stuart Cary Welch, Jr.

188.1983
A Barber and His Client
Rajasthan, 18th century
Ink and opaque watercolor on paper
5¼ × 3½ in. (13.4 × 8.8 cm)
Promised Gift of Stuart Cary Welch, Jr.

193.1983
Women Worshipping at a Shrine of a Deity Mounted on an Elephant, while a Prince Looks On
Rajasthan, Kotah, 18th century
Ink and opaque watercolor on paper
6⅜ × 3⅞ in. (16.2 × 9.9 cm)
Promised Gift of Stuart Cary Welch, Jr.

195.1983.1
Elderly Seated Courtier (one of two drawings mounted together)
Rajasthan, Kotah, 18th century
Ink and opaque watercolor on paper
6 × 4¾ in. (15.4 × 12.2 cm)
Promised Gift of Stuart Cary Welch, Jr.

195.1983.2
Study of Standing Kotah Ruler and Courtiers (one of two drawings mounted together)
Rajasthan, Kotah, 18th century
Ink and opaque watercolor on paper
4⅝ × 4⅜ in. (11.8 × 11 cm)
Promised Gift of Stuart Cary Welch, Jr.

196.1983
Sketches: Hunt Scene
Rajasthan, Kotah, 18th century
Black and red inks over charcoal on tan laid paper
5 × 8¼ in. (12.6 × 21 cm)
Promised Gift of Stuart Cary Welch, Jr.
Cat. 44

197.1983
The Ravat Hunts with Cheetah
Rajasthan, Devgarh, late 18th century
Black ink and watercolor over traces of charcoal on off-white laid paper
7⅛ × 12⅝ in. (18 × 32 cm)
Promised Gift of Stuart Cary Welch, Jr.
Cat. 62

203.1983
Fourteen Black Bucks
Rajasthan, Kotah(?), early 18th century
Ink and opaque watercolor on paper
6⅞ × 5¾ in. (17.5 × 14.5 cm)
Promised Gift of Stuart Cary Welch, Jr.

208.1983
Deer in a Wood (fragment)
Rajasthan, Kotah, c. 1745
Ink and opaque watercolor on paper
7⅞ × 6 in. (20 × 15.2 cm)
Promised Gift of Stuart Cary Welch, Jr.

209.1983[r]
Tigress Licking Her Chops
Rajasthan, Kotah, late 18th century
Ink and opaque watercolor on paper
7⅜ × 11 in. (18.9 × 27.8 cm)
Promised Gift of Stuart Cary Welch, Jr.

209.1983[v]
Elephants
Rajasthan, Kotah, late 18th century
Ink and opaque watercolor on paper
7⅜ × 11 in. (18.9 × 27.8 cm)
Promised Gift of Stuart Cary Welch, Jr.

210.1983
Leaping Antelopes
Rajasthan, Kotah, c. 1745
Ink and opaque watercolor on paper
3½ × 7 in. (9 × 17.8 cm)
Promised Gift of Stuart Cary Welch, Jr.

211.1983
Drummer with White Turban and Beard
Rajasthan, Kotah, 18th century
Ink and opaque watercolor on paper
5½ × 4⅝ in. (14 × 11.9 cm)
Promised Gift of Stuart Cary Welch, Jr.

212.1983
An Army with Elephants and Horses in Two Boats
Rajasthan, Kotah, c. 1730
Ink on paper
5½ × 10⅞ in. (14 × 27.5 cm)
Promised Gift of Stuart Cary Welch, Jr.

213.1983
Monkey Family
Rajasthan, Kotah, c. 1830
Ink on paper
3⅝ × 4¼ in. (9.2 × 10.7 cm)
Promised Gift of Stuart Cary Welch, Jr.

214.1983
Sketches: A Lion, A Girl, and Horsemen
Rajasthan, Kotah, c. 1735
Ink on paper
5¾ × 5⅝ in. (14.5 × 14.38 cm)
Promised Gift of Stuart Cary Welch, Jr.

215.1983
Elephant Composed of Animals and Fish
Rajasthan, 18th century
Ink on paper
4⅛ × 6¾ in. (10.5 × 17 cm)
Promised Gift of Stuart Cary Welch, Jr.

216.1983
A Cross-Eyed Elephant
Rajasthan, Kotah, c. 1785
Ink on paper
7⅝ × 5⅞ in. (19.5 × 14.8 cm)
Promised Gift of Stuart Cary Welch, Jr.

217.1983
Family Group: Man, Woman, and Child
Rajasthan, Kotah, 18th century
Ink on paper
5½ × 4¾ in. (14 × 12.1 cm)
Promised Gift of Stuart Cary Welch, Jr.

218.1983
Falconer
Rajasthan, Kotah, c. 1720–30
Ink on paper; pricked
6⅞ × 4⅜ in. (17.5 × 11.1 cm)
Promised Gift of Stuart Cary Welch, Jr.

219.1983
Intercourse of Elephants
Rajasthan, Kotah, early 19th century
Ink and opaque watercolor on paper
6⅛ × 4¾ in. (15.5 × 12 cm)
Promised Gift of Stuart Cary Welch, Jr.

220.1983
*Sketches: Intercourse of Women with Animals
and a Man*
Rajasthan, Kotah(?), 19th century
Ink and opaque watercolor on paper
7½ × 6⅞ in. (19 × 17.5 cm)
Promised Gift of Stuart Cary Welch, Jr.

221.1983
Sketches: Copulating Couples
Rajasthan, Kotah, early 19th century
Ink and opaque watercolor on paper
8⅝ × 7½ in. (22 × 19.2 cm)
Promised Gift of Stuart Cary Welch, Jr.

222.1983
An Amorous Couple
Rajasthan, Kotah, early 18th century
Ink and opaque watercolor on paper
5⅜ × 4¼ in. (13.5 × 10.8 cm)
Promised Gift of Stuart Cary Welch, Jr.

223.1983
The Night Train to Agra
Rajasthan, Kotah, c. 1875
Black ink and opaque watercolor on off-
white laid paper
9⅝ × 15¾ in. (24.5 × 40 cm)
Promised Gift of Stuart Cary Welch, Jr.
Cat. 60

225.1983
Lady Artist at Work
Rajasthan, Kotah, c. 1830
Ink and opaque watercolor on paper
3⅞ × 4⅛ in. (9.7 × 10.6 cm)
Promised Gift of Stuart Cary Welch, Jr.

226.1983
Royal Pleasures
Rajasthan, Kotah, c. 1840
Green-brown ink on blue-gray paper;
pricked
5⅞ × 5¾ in. (14.8 × 14.5 cm)
Promised Gift of Stuart Cary Welch, Jr.
Cat. 56

227.1983.1–2
Two Ceiling Designs (mounted on one sheet)
Rajasthan, c. 1800
Ink on paper
12⅝ × 10 in. (32.2 × 25.5 cm)
Promised Gift of Stuart Cary Welch, Jr.

228.1983[r]
Sketches: European Ladies
Rajasthan, Kotah, 19th century
Ink and opaque watercolor on paper
6¾ × 9⅝ in. (17 × 24.5 cm)
Promised Gift of Stuart Cary Welch, Jr.

228.1983[v]
*Sketches: Embracing Couple, Inscribed "Dresses
Worn in the Month of Kartik"*
Rajasthan, Kotah, 19th century
Ink and opaque watercolor on paper
6¾ × 9⅝ in. (17 × 24.5 cm)
Promised Gift of Stuart Cary Welch, Jr.

230.1983
Procession at Datia
Bundelkhand, late 18th century
Black ink and opaque watercolor over
charcoal underdrawing on off-white laid
paper
16⅝ × 32¼ in. (42.3 × 82 cm)
Promised Gift of Stuart Cary Welch, Jr.
Cat. 64

235.1983[r]
Scenes from the "Ramayana"
Orissa, Puri, 19th century
Ink and opaque watercolor on palm leaf
2 × 15¾ in. (5 × 40 cm)
Promised Gift of Stuart Cary Welch, Jr.

235.1983[v]
Scene from the "Ramayana"
Orissa, Puri, 19th century
Ink and opaque watercolor on palm leaf
2 × 15¾ in. (5 × 40 cm)
Promised Gift of Stuart Cary Welch, Jr.

236.1983[r]
*Dasharatha Goes to Fetch Rishi Shringa: Scene
from the "Ramayana"*
Orissa, Puri, 19th century
Ink and opaque watercolor on palm leaf
2 × 16 in. (5 × 40.5 cm)
Promised Gift of Stuart Cary Welch, Jr.

236.1983[v]
*Dasharatha's Sacrifice: Scene from the
"Ramayana"*
Orissa, Puri, 19th century
Ink and opaque watercolor on palm leaf
2 × 16 in. (5 × 40.5 cm)
Promised Gift of Stuart Cary Welch, Jr.

240.1983
Portrait of Aurangzeb
Attributed to Hunhar
North India, c. 1660

Black ink and opaque watercolor on paper
11⅝ × 3⅝ in. (29.4 × 9.1 cm)
Promised Gift of Stuart Cary Welch, Jr.
Cat. 31

241.1983
Landscape
North India, c. 1600
Ink and opaque watercolor on paper
5⅝ × 4 in. (14.3 × 10.2 cm)
Promised Gift of Stuart Cary Welch, Jr.

242.1983
Master and Pupil (Prince Salim?)
Attributed to Aqa Riza Jahangiri
North India, late 16th century
Black ink and watercolor on beige paper
10¼ × 6½ in. (26.2 × 16.5 cm)
Promised Gift of Stuart Cary Welch, Jr.
Cat. 17

243.1983
Portrait of Shah Abu'l-Ma'ali
Attributed to Mir Sayyid 'Ali
North India, c. 1545
Black ink, opaque watercolor, and gold on
beige paper
10 × 6½ in. (25.3 × 16.5 cm)
Promised Gift of Stuart Cary Welch, Jr.
Cat. 16

244.1983
Five Botanical Studies
Rajasthan, 18th century
Ink on paper
5¾ × 4¼ in. (14.5 × 10.8 cm)
Promised Gift of Stuart Cary Welch, Jr.

245.1983
Yogi in Deep Meditation
North India, c. 1640
Black ink and watercolor on beige paper
7⅞ × 5¾ in. (20 × 14.5 cm)
Promised Gift of Stuart Cary Welch, Jr.
Cat. 29

248.1983.A–B
Ceiling Designs (recto and verso)
Rajasthan, Kotah, 19th century
Ink and opaque watercolor on paper
29 × 18½ in. (73.7 × 47 cm)
Promised Gift of Stuart Cary Welch, Jr.

252.1983
Portrait Head of a Man
North India, c. 1630
Ink and opaque watercolor on paper
3⅛ × 2⅜ in. (8.1 × 6 cm)
Promised Gift of Stuart Cary Welch, Jr.

253.1983[r]
Hakim Momin Khan, Portrait of the Poet
Attributed to Jivan Ram
North India, Delhi, c. 1835
Black ink and opaque watercolor on off-
white paper
6¾ × 4½ in. (17 × 11.5 cm)
Promised Gift of Stuart Cary Welch, Jr.
Cat. 33

253.1983[v]
Sketch of Begam Samru
Attributed to Jivan Ram
North India, Delhi, c. 1835
Black ink and opaque watercolor on off-
white paper
6¾ × 4½ in. (17 × 11.5 cm)
Promised Gift of Stuart Cary Welch, Jr.
Cat. 33, fig. 1

254.1983
Fath 'Ali Shah and Miran Shah, Two Holy Men
Attributed to Payag
North India, c. 1635–40
Gray-black ink on beige paper
5⅞ × 7¼ in. (15 × 18.5 cm)
Promised Gift of Stuart Cary Welch, Jr.
Cat. 28

259.1983[r]
Tethered Camel and Rider
Attributed to Mir Sayyid 'Ali
Iran, Tabriz, c. 1535
Black ink, watercolor, and gold on off-
white paper; pricked (man and most of
camel)
6⅞ × 9 in. (17.5 × 23 cm)
Promised Gift of Stuart Cary Welch, Jr.
Cat. 2

259.1983[v]
Calligraphy
Signed by Mir 'Ali Haravi
Iran or Uzbekistan, 16th century
Black ink, opaque watercolor, and gold
with marbled paper border
9 × 6⅞ in. (23 × 17.5 cm)
Promised Gift of Stuart Cary Welch, Jr.
Cat. 2, fig. 1

260.1983
A Dragon
Attributed to Siyavush
Iran, Isfahan, c. 1590
Ink on paper
3⅜ × 5⅞ in. (8.5 × 15 cm)
Promised Gift of Stuart Cary Welch, Jr.

262.1983
Drawing: Man of Letters, folio from an album
Attributed to Aqa Riza (Riza 'Abbasi)
Iran, Isfahan, c. 1590
Ink and gold on paper
3 × 1⅞ in. (7.5 × 4.7 cm)
Promised Gift of Stuart Cary Welch, Jr.

263.1983
Proud Prince, Humble Sufi
Attributed to Sultan Muhammad
Iran, Tabriz, c. 1535–40
Black ink on off-white paper
4⅞ × 7⅞ in. (12.5 × 20 cm)
Promised Gift of Stuart Cary Welch, Jr.
Cat. 3

265.1983
Black-Bearded Sufi
Attributed to Muhammad Qasim
Iran, Isfahan, c. 1650
Ink on paper
5½ × 4 in. (14 × 10.2 cm)
Promised Gift of Stuart Cary Welch, Jr.

269.1983
Falcons, Dragons, and Other Creatures
Attributed to Sadiqi Beg
Iran, Isfahan, late 16th century
Black ink on off-white laid paper
12⅝ × 8⅛ in. (32 × 20.5 cm)
Promised Gift of Stuart Cary Welch, Jr.
Cat. 8

270.1983
A Lame Man of Arts and Letters
Attributed to Shaykh Muhammad
Iran, Tabriz, mid-16th century
Black and red-brown inks, opaque water-
color, and gold on off-white paper
4 × 3¾ in. (10.3 × 9.5 cm)
Promised Gift of Stuart Cary Welch, Jr.
Cat. 4

271.1983
Cheetah Trainer
Attributed to Aqa Riza (Riza 'Abbasi)
Iran, Isfahan, c. 1590
Gray-black ink on silver-flecked off-white
paper
5⅜ × 4 in. (13.6 × 10.1 cm)
Promised Gift of Stuart Cary Welch, Jr.
Cat. 12

273.1983
A Camel Fore and Aft
Signed by Mu'in Musavvir
Iran, Isfahan, c. 1678

Brown-black ink and watercolor on off-
white laid paper
11 × 7½ in. (28 × 19 cm)
Promised Gift of Stuart Cary Welch, Jr.
Cat. 14

274.1983
Seated Sufi
Attributed to Aqa Riza (Riza 'Abbasi)
Iran, Qazvin, c. 1595
Black ink on off-white paper
12⅝ × 7⅞ in. (32 × 20 cm)
Promised Gift of Stuart Cary Welch, Jr.
Cat. 10

275.1983[r]
A Maiden Reclines
Attributed to Aqa Riza (Riza 'Abbasi)
Iran, Qazvin, late 16th century
Black ink on off-white paper
9⅜ × 13⅜ in. (23.7 × 34 cm)
Promised Gift of Stuart Cary Welch, Jr.
Cat. 9

275.1983[v]
Calligraphy
Ahmad al-Husayni (Mir Sayyid Ahmad al-
Mashhadi)
Iran, 16th century
Ink, opaque watercolor, and gold on paper
9⅜ × 13⅜ in. (23.7 × 34 cm)
Promised Gift of Stuart Cary Welch, Jr.
Cat. 9, fig. 2

360.1983
Spear point
Deccan, 17th century
Steel
19⅝ in. (49.75 cm)
Promised Gift of Stuart Cary Welch, Jr.

399.1983
Dagger hilt
North India, c. 1650
Quartz crystal
6⅛ in. (15.5 cm)
Promised Gift of Stuart Cary Welch, Jr.

414.1983
*Portrait of a Kotah Ruler, Madho Singh or
Mukund Singh*
Attributed to the Kotah Master
Rajasthan, Kotah, late 17th century
Gray-black ink and opaque watercolor on
off-white paper
8 × 4⅞ in. (20.2 × 12.5 cm)
Promised Gift of Stuart Cary Welch, Jr.
Cat. 36

424.1983[r]
Folio from a manuscript of the "Khamsa" (Quintet) of Amir Khusraw Dihlavi
India, 15th century
Opaque watercolor on paper
12⅝ × 9 in. (32 × 22.8 cm)
Promised Gift of Stuart Cary Welch, Jr.

424.1983[v]
Folio from a manuscript of the "Khamsa" (Quintet) of Amir Khusraw Dihlavi
India, 15th century
Opaque watercolor on paper
12⅝ × 9 in. (32 × 22.8 cm)
Promised Gift of Stuart Cary Welch, Jr.

429.1983
Ranjit Singh's Horse with a One-Eyed Groom
North India or Pakistan, Punjab,
c. 1825–50
Opaque watercolor and gold on paper
7⅛ × 8⅞ in. (18 × 22.6 cm)
Promised Gift of Stuart Cary Welch, Jr.

436.1983
Raja Ram Singh of Jammu
Kashmir, Jammu, c. 1835
Opaque watercolor and gold on paper
13 × 10⅞ in. (33 × 27.6 cm)
Promised Gift of Stuart Cary Welch, Jr.

437.1983
Shah Jahan Receives the Ruler of Chamba
Punjab Hills, c. 1650
Opaque watercolor and gold on paper
7½ × 7⅛ in. (19 × 18 cm)
Promised Gift of Stuart Cary Welch, Jr.

439.1983
Baz Bahadur and Rupmati
Himachal Pradesh, c. 1800
Ink, opaque watercolor, and gold on paper
6⅝ × 9 in. (17 × 22.8 cm)
Promised Gift of Stuart Cary Welch, Jr.

442.1983
Bankers Receive News from a Dak Runner
South India, c. 1850
Opaque watercolor and gold on paper
7½ × 9½ in. (19 × 24 cm)
Promised Gift of Stuart Cary Welch, Jr.

446.1983
A Sikh Ruler Playing Parcheesi
North India or Pakistan, Punjab, 19th century
Opaque watercolor on paper
6⅝ × 8¼ in. (16.8 × 21 cm)
Promised Gift of Stuart Cary Welch, Jr.

448.1983
Krishna Dancing with the Gopis: Illustration from the "Gita Govinda"
Himachal Pradesh, Kulu, dated 1799
Opaque watercolor and gold on paper
7¾ × 9¾ in. (19.7 × 24.7 cm)
Promised Gift of Stuart Cary Welch, Jr.

455.1983.1[r]
Erotic painting from a Jain manuscript
West India, 15th century
Opaque watercolor on paper
4⅛ × 10¼ in. (10.5 × 26 cm)
Promised Gift of Stuart Cary Welch, Jr.

455.1983.1[v]
Erotic painting from a Jain manuscript
West India, 15th century
Opaque watercolor on paper
4⅛ × 10¼ in. (10.5 × 26 cm)
Promised Gift of Stuart Cary Welch, Jr.

455.1983.2[r]
Erotic painting from a Jain manuscript
West India, 15th century
Opaque watercolor on paper
4⅛ × 10¼ in. (10.5 × 26 cm)
Promised Gift of Stuart Cary Welch, Jr.

455.1983.2[v]
Erotic painting from a Jain manuscript
West India, 15th century
Opaque watercolor on paper
4⅛ × 10¼ in. (10.5 × 26 cm)
Promised Gift of Stuart Cary Welch, Jr.

456.1983[r]
Erotic painting from a Jain manuscript
West India, 15th century
Opaque watercolor on paper
4 × 10¼ in. (10.3 × 26 cm)
Promised Gift of Stuart Cary Welch, Jr.

456.1983[v]
Erotic painting from a Jain manuscript
West India, 15th century
Opaque watercolor on paper
4 × 10¼ in. (10.3 × 26 cm)
Promised Gift of Stuart Cary Welch, Jr.

472.1983
Colonel Mordaunt's Cockfight (after Zoffany)
Uttar Pradesh, Lucknow, c. 1800
Opaque watercolor on paper
17⅝ × 26⅛ in. (44.7 × 66.2 cm)
Promised Gift of Stuart Cary Welch, Jr.

473.1983
Suza Geer Berah Geer, the Famous Sheep Eater
Bengal, Calcutta, c. 1785–90

Ink and opaque watercolor on paper
13 × 21⅝ in. (33 × 55 cm)
Promised Gift of Stuart Cary Welch, Jr.

476.1983
Designs for a Stained Glass Window
Rajasthan, 19th century
Opaque watercolor and gold on paper
10⅞ × 7½ in. (27.5 × 19.1 cm)
Promised Gift of Stuart Cary Welch, Jr.

489.1983
Prince Hunting from a Pavilion within a Lotus Pond
Rajasthan, Kotah, 19th century
Ink and opaque watercolor on paper
8 × 11 in. (20.3 × 28 cm)
Promised Gift of Stuart Cary Welch, Jr.

490.1983
Mother and Child
Rajasthan, Kotah, c. 1840
Ink and opaque watercolor on paper
5½ × 3½ in. (14 × 9 cm)
Promised Gift of Stuart Cary Welch, Jr.

495.1983
Floral Design
Rajasthan, Kotah, early 18th century
Opaque watercolor on paper
7½ × 6⅜ in. (19 × 16.2 cm)
Promised Gift of Stuart Cary Welch, Jr.

496.1983
Villagescape in English Style
Rajasthan, Kotah, c. 1840
Opaque watercolor on paper
5⅝ × 3⅞ in. (14.4 × 10 cm)
Promised Gift of Stuart Cary Welch, Jr.

498.1983
The British Resident's Chair
Rajasthan, Kotah, mid-19th century
Ink and opaque watercolor on paper
5⅞ × 4½ in. (15 × 11.5 cm)
Promised Gift of Stuart Cary Welch, Jr.

511.1983
Bust Portrait of a European Girl
Rajasthan, early 19th century
Ink and opaque watercolor on paper; pricked
7⅞ × 7 in. (20 × 18 cm)
Promised Gift of Stuart Cary Welch, Jr.

512.1983
Garden Scene with Pavilion
Rajasthan, 19th century
Ink and opaque watercolor on paper
10¼ × 14¾ in. (26.2 × 37.6 cm)
Promised Gift of Stuart Cary Welch, Jr.

518.1983
A Prince at Prayer
Rajasthan, Kishangarh, mid-18th century
Black ink and opaque watercolor on beige
laid paper
4⅞ × 2⅜ in. (12.3 × 6 cm)
Promised Gift of Stuart Cary Welch, Jr.
Cat. 65

523.1983
*Vishnu Saves Gajendra the Elephant King from
the Crocodile Demon*
Rajasthan, c. 1640
Ink, opaque watercolor, and gold on paper
12 × 8⅛ in. (30.5 × 20.8 cm)
Promised Gift of Stuart Cary Welch, Jr.

527.1983
Dipak Raga
Attributed to the Kotah Master
Rajasthan, Kotah, c. 1720
Opaque watercolor on paper
10⅝ × 7⅝ in. (27 × 19.5 cm)
Promised Gift of Stuart Cary Welch, Jr.

530.1983
A Banana Tree
Rajasthan, Kotah, c. 1830
Opaque watercolor on paper
15⅜ × 11½ in. (39.2 × 29.2 cm)
Promised Gift of Stuart Cary Welch, Jr.

543.1983
Maharana Amar Singh II at Worship
Rajasthan, Mewar, c. 1698–1710
Black ink, opaque watercolor, and gold on
beige paper
21¼ × 16 in. (54 × 40.6 cm)
Promised Gift of Stuart Cary Welch, Jr.
Cat. 61

545.1983
Fort of Gagraun
Attributed to Shaykh Taju
Rajasthan, Kotah, c. 1735
Black ink and opaque watercolor over
charcoal underdrawing on beige laid paper
21 × 28¾ in. (53.5 × 73 cm)
Promised Gift of Stuart Cary Welch, Jr.
Cat. 49

555.1983
*St. Peter's European Church (Arched Nave with
Small Figures)*
Rajasthan, 19th century
Opaque watercolor on paper
10⅜ × 13⅝ in. (26.3 × 34.5 cm)
Promised Gift of Stuart Cary Welch, Jr.

559.1983
Elephant Combat
Attributed to the Master of Elephants
Rajasthan, Kotah, late 17th century
Black ink and watercolor on off-white
paper
16½ × 19¼ in. (42 × 49 cm)
Promised Gift of Stuart Cary Welch, Jr.
Cat. 38

560.1983
Ornamental Patterns
Rajasthan, Kotah, 19th century to 20th
century
Opaque watercolor on paper
5½ × 26¼ in. (14 × 66.7 cm)
Promised Gift of Stuart Cary Welch, Jr.

561.1983
Dancing Gadis
Himachal Pradesh, Chamba, c. 1740
Ink and opaque watercolor on paper
7¾ × 10⅜ in. (19.8 × 26.3 cm)
Promised Gift of Stuart Cary Welch, Jr.

576.1983[r]
Feast at a Shrine
Attributed to the Mughal Master of Amber
Rajasthan, Amber, 17th century
Charcoal on paper; pricked
16⅛ × 13⅜ in. (41.1 × 34 cm)
Promised Gift of Stuart Cary Welch, Jr.

576.1983[v]
Feast at a Shrine
Attributed to the Mughal Master of Amber
Rajasthan, Amber, 17th century
Charcoal on paper; pricked
16⅛ × 13⅜ in. (41.1 × 34 cm)
Promised Gift of Stuart Cary Welch, Jr.

578.1983
Two Llamas
Rajasthan, Jaipur, c. 1870
Opaque watercolor on paper
8⅝ × 11⅞ in. (22 × 30 cm)
Promised Gift of Stuart Cary Welch, Jr.

579.1983
Portrait of Ahmad Saba Sint
Signed by Burdha Ram
Rajasthan, Jaipur, dated 1868
Opaque watercolor on paper
6¾ × 5⅛ in. (17 × 13 cm)
Promised Gift of Stuart Cary Welch, Jr.

580.1983
Seated Courtesan
Rajasthan, Jaipur, mid-19th century

Gray-black ink, watercolor, opaque water-
color, and gold over graphite on beige
modern laid paper (watermark: R & C)
8¼ × 6¼ in. (21 × 16 cm)
Promised Gift of Stuart Cary Welch, Jr.
Cat. 70

600.1983
The Zamorin of Calicut
South India, mid-19th century
Opaque watercolor on paper
13¾ × 9⅞ in. (35 × 25 cm)
Promised Gift of Stuart Cary Welch, Jr.

604.1983
*Sita Discovered: From a "Razmnama" made
for the Khan Khanan*
Attributed to Fazl
North India, c. 1616
Ink, opaque watercolor, and gold on paper
15⅛ × 9¼ in. (38.5 × 23.5 cm)
Promised Gift of Stuart Cary Welch, Jr.

605.1983
*Dancing Girl Applying Kohl: From an album
assembled for Emperor Jahangir*
North India, c. 1590
Ink, opaque watercolor, and gold on paper
6¾ × 3¾ in. (17.2 × 9.6 cm)
Promised Gift of Stuart Cary Welch, Jr.

610.1983
Girl at Prayer by Moonlight
Attributed to Hunhar
North India, c. 1650–60
Opaque watercolor on paper
5½ × 6⅞ in. (14 × 17.5 cm)
Promised Gift of Stuart Cary Welch, Jr.

616.1983
Satirical Portrait of Four Ascetics
North India, c. 1600
Gray-black ink, watercolor, and gold over
traces of charcoal on off-white paper
8½ × 8 in. (21.7 × 20.2 cm)
Promised Gift of Stuart Cary Welch, Jr., in
memory of Nasli and Alice Heeramaneck
Cat. 22

619.1983[r]
Woman Playing a Zither
Attributed to Govardhan
North India, c. 1610
Black ink, watercolor, and gold on beige
paper
10⅝ × 7⅛ in. (27 × 18.1 cm)
Promised Gift of Stuart Cary Welch, Jr.
Cat. 25

619.1983[v]
Calligraphy
Iran or India
Ink, opaque watercolor, and gold on paper
10⅝ × 7⅛ in. (27 × 18.1 cm)
Promised Gift of Stuart Cary Welch, Jr.
Cat. 25, fig. 1

622.1983
Muslim Nobleman in White
North India, c. 1580–85
Ink, opaque watercolor, and gold on paper
9⅛ × 5⅞ in. (23.3 × 15 cm)
Promised Gift of Stuart Cary Welch, Jr.

628.1983
Kanphata Yogi and Dog
Attributed to Basawan
North India, c. 1590
Black ink and watercolor on beige paper
10¼ × 10½ in. (26.2 × 26.6 cm)
Promised Gift of Stuart Cary Welch, Jr.
Cat. 21

657.1983.A
The Holroyd House on Park Street: From the Holroyd Album
Bengal, Calcutta, 19th century
Ink and opaque watercolor on paper
14⅛ × 20½ in. (36 × 52 cm)
Promised Gift of Stuart Cary Welch, Jr.
Cat. 76, fig. 2

657.1983.B[r]
A Sketch of the Holroyd House from a Different View
Bengal, Calcutta, 19th century
Graphite and watercolor on off-white machine-made wove paper
8¼ × 10⅝ in. (21 × 27 cm)
Promised Gift of Stuart Cary Welch, Jr.
Cat. 76

657.1983.B[v]
"No. 5 Park Street"
Bengal, Calcutta, 19th century
Brown ink on off-white machine-made wove paper
8¼ × 10⅝ in. (21 × 27 cm)
Promised Gift of Stuart Cary Welch, Jr.
Cat. 76, fig. 1

658.1983
The Dog Wallah
Bengal, Calcutta, c. 1825
Opaque watercolor on paper
10⅞ × 8½ in. (27.6 × 21.5 cm)
Promised Gift of Stuart Cary Welch, Jr.

661.1983
Portraits of Five Seated Englishmen
Rajasthan, Kotah, 19th century
Opaque watercolor on paper
8½ × 11⅜ in. (21.5 × 30.3 cm)
Promised Gift of Stuart Cary Welch, Jr.

679.1983
Small Dragon in Foliage
Turkey, Istanbul, late 16th century
Black ink on off-white gold-flecked paper
3¾ × 4 in. (9.5 × 10.3 cm)
Promised Gift of Stuart Cary Welch, Jr.
Cat. 7

691.1983
Floral-patterned textile
Turkey, 16th century
Lampas weave with silk and metal threads
15¾ × 20¾ in. (40 × 52.7 cm)
Promised Gift of Stuart Cary Welch, Jr.

701.1983
Mafsaw with Surrounding Hills
Attributed to Sita Ram
Bihar, Patna, c. 1830
Opaque watercolor on paper
14 × 21 in. (35.5 × 53.3 cm)
Promised Gift of Stuart Cary Welch, Jr.

707.1983
Colonel G. N. Malleson
Rajasthan, Kotah, mid-19th century
Ink and opaque watercolor on paper
3⅞ × 2¾ in. (10 × 7 cm)
Promised Gift of Stuart Cary Welch, Jr.

720.1983[r]
Bizhan and Manizha (Painting): Folio from a manuscript of the "Shāhnāma" of Firdawsi
Iran, c. 1410
Opaque watercolor and gold on paper
3⅜ × 2 in. (8.5 × 5.2 cm)
Promised Gift of Stuart Cary Welch, Jr., in memory of Adrienne Minassian

720.1983[v]
Bizhan and Manizha (Text): Folio from a manuscript of the "Shāhnāma" of Firdawsi
Iran, c. 1410
Opaque watercolor on paper
3⅜ × 2 in. (8.5 × 5.2 cm)
Promised Gift of Stuart Cary Welch, Jr., in memory of Adrienne Minassian

721.1983
Solomon and His Court (Unfinished Painting): Folio from a manuscript
Circle of Mirza 'Ali
Iran, Qazvin, c. 1560

Opaque watercolor and gold on paper
12¾ × 7⅞ in. (32.3 × 20.2 cm)
Promised Gift of Stuart Cary Welch, Jr.

728.1983
Sprig of Rose Blossoms
Iran, first half of 19th century
Black ink on oiled(?) paper
5⅛ × 4⅝ in. (13 × 11.8 cm)
Promised Gift of Stuart Cary Welch, Jr.
Cat. 15

1983.92
Krishna and Radha Enthroned with Five Maidservants
Rajasthan, Kishangarh, c. 1750
Opaque watercolor on paper
6 × 4⅛ in. (15.24 × 10.48 cm)
Gift of Stuart Cary Welch, Jr., in honor of Benjamin Rowland

1983.93
A Lady at Her Toilet with Two Maids
Rodu
Rajasthan, Bikaner, 1678
Opaque watercolor on paper
7¾ × 5½ in. (19.7 × 14 cm)
Gift of Stuart Cary Welch, Jr.

1983.94
A Prince and Retainers in a Hunting Pavilion with a Deep Landscape and Animals
Rajasthan, Kotah, c. 1730
Opaque watercolor on paper
11⅞ × 14⅛ in. (30 × 36 cm)
Gift of Stuart Cary Welch, Jr.

1999 NUMBERS

76.1999.1
Enraged Elephant with Mahout
Rajasthan, Kotah, c. 1730
Ink and opaque watercolor on paper
19¾ × 23¼ in. (50 × 59 cm)
Promised Gift of Stuart Cary Welch, Jr.

76.1999.2[r]
Lion Hunt
Rajasthan, Kotah, early 18th century
Ink and opaque watercolor on paper
20¾ × 22¾ in. (52.8 × 57.9 cm)
Promised Gift of Stuart Cary Welch, Jr.

76.1999.2[v]
Tigers and Soldiers
Rajasthan, Kotah, early 18th century
Ink and opaque watercolor on paper; pricked
20¾ × 22¾ in. (52.8 × 57.9 cm)
Promised Gift of Stuart Cary Welch, Jr.

76.1999.3
Elephant and Rider
Rajasthan, Kotah, c. 1730
Ink and opaque watercolor on paper
12⅝ × 19¼ in. (32.2 × 49 cm)
Promised Gift of Stuart Cary Welch, Jr.

76.1999.4
Elephant Hunt
Rajasthan, Kotah, 18th century
Ink and opaque watercolor on paper
19⅛ × 22¾ in. (48.5 × 57.7 cm)
Promised Gift of Stuart Cary Welch, Jr.

76.1999.5
Two Rulers Hunting
Rajasthan, Kotah, 17th century
Ink and opaque watercolor on paper
10⅛ × 6⅝ in. (25.8 × 16.7 cm)
Promised Gift of Stuart Cary Welch, Jr.

76.1999.6
Battle between Ghatotkacha and Karna: Folio from a "Mahabharata" manuscript
South India, Mysore or Thanjavur, c. 1670
Ink, opaque watercolor, and gold on paper
7⅛ × 16⅜ in. (18 × 41.7 cm)
Promised Gift of Stuart Cary Welch, Jr.

76.1999.7
Krishna Disporting with the Gopas
Himachal Pradesh, Guler, c. 1750–60
Ink and opaque watercolor on paper
12 × 6¾ in. (30.5 × 17.2 cm)
Promised Gift of Stuart Cary Welch, Jr.

76.1999.8
Rajput Hunter Batters a Leaping Tiger from a Tree
Attributed to Fazl
Rajasthan, Bundi or Kotah, c. 1625
Opaque watercolor and gold on paper
7⅞ × 10 in. (20 × 25.5 cm)
Promised Gift of Stuart Cary Welch, Jr.

76.1999.9
Two European Men in White Hats
Rajasthan, Kotah, 19th century
Opaque watercolor on paper
4⅜ × 3⅛ in. (11 × 7.8 cm)
Promised Gift of Stuart Cary Welch, Jr.

76.1999.10
Sketches: Two Horsemen, European Ladies' Heads
Rajasthan, Kotah, 19th century
Ink on paper
3⅜ × 7¼ in. (8.5 × 18.5 cm)
Promised Gift of Stuart Cary Welch, Jr.

76.1999.11
Lovers
Rajasthan, c. 1800
Ink and opaque watercolor on paper
5⅝ × 3⅞ in. (14.3 × 9.7 cm)
Promised Gift of Stuart Cary Welch, Jr.

76.1999.12
Kneeling Woman with a Halo
Rajasthan, Kotah, 19th century
Ink and opaque watercolor on paper
5⅜ × 3¾ in. (13.7 × 9.6 cm)
Promised Gift of Stuart Cary Welch, Jr.

76.1999.13
Girl Dancing
Rajasthan, Kotah, c. 1840
Ink and opaque watercolor on paper
6 × 3½ in. (15.1 × 8.9 cm)
Promised Gift of Stuart Cary Welch, Jr.

76.1999.14
A Nobleman with Attendants
Himachal Pradesh, Guler, c. 1750
Gray-black ink, watercolor, and opaque watercolor over red ink on beige paper
11⅝ × 8½ in. (29.5 × 21.5 cm)
Promised Gift of Stuart Cary Welch, Jr.
Cat. 72

76.1999.15
Plan of Fort
Rajasthan, 18th century
Ink and opaque watercolor on paper
17 × 13¼ in. (43.2 × 33.5 cm)
Promised Gift of Stuart Cary Welch, Jr.

76.1999.16
Nur Jahan: Portrait to Be Worn as a Jewel
Attributed to Abu'l-Hasan
North India, c. 1620
Opaque watercolor and gold on paper
1¾ × 2⅛ in. (4.5 × 5.3 cm)
Promised Gift of Stuart Cary Welch, Jr.

76.1999.17
Cenotaph cover
Turkey, 17th century
Silk, lampas weave
54⅜ × 26⅝ in. (138 × 67.5 cm)
Promised Gift of Stuart Cary Welch, Jr.

76.1999.18
Demons before a Ruler: Preparatory drawing for a Hindu epic
Rajasthan, Kotah, c. 1625–30
Ink and opaque watercolor on paper
6 × 7¾ in. (15.3 × 19.8 cm)
Promised Gift of Stuart Cary Welch, Jr.

76.1999.19
Lovers Embrace
Himachal Pradesh, Guler, c. 1745
Black ink and watercolor over orange-red ink, with incised lines (architecture) on off-white laid paper
4⅛ × 6¼ in. (10.5 × 16 cm)
Promised Gift of Stuart Cary Welch, Jr.
Cat. 71

76.1999.20
Elephant Combat
Rajasthan, Kotah, 18th century
Ink and opaque watercolor on paper
12¼ × 26⅝ in. (31.2 × 67.5 cm)
Promised Gift of Stuart Cary Welch, Jr.

76.1999.21
Spherical-Headed mace
North India, c. 1585
Steel
30⅜ in. (77 cm)
Promised Gift of Stuart Cary Welch, Jr.

76.1999.22
Rama and Sita Enthroned
Orissa, 19th century
Ink and opaque watercolor on paper
5¼ × 7¾ in. (13.3 × 19.7 cm)
Promised Gift of Stuart Cary Welch, Jr.

76.1999.23
Chariot of Love
Orissa, 19th century
Ink and opaque watercolor on paper
17½ × 11⅜ in. (44.5 × 29 cm)
Promised Gift of Stuart Cary Welch, Jr.

76.1999.24
Courtier Awaiting Akbar's Command
Attributed to Basawan
North India, c. 1575
Opaque watercolor and gold on paper
5⅜ × 4½ in. (13.5 × 11.5 cm)
Promised Gift of Stuart Cary Welch, Jr.

76.1999.25
A Lady of Fashion
Himachal Pradesh, Kangra, late 18th century
Black and red-brown inks and white opaque watercolor on beige paper
11⅜ × 8¼ in. (29 × 21 cm)
Promised Gift of Stuart Cary Welch, Jr.
Cat. 74

76.1999.26
*Nala Entertained: From a "Nala Damayanti"
series*
Himachal Pradesh, Kangra, late 18th
century
Ink and opaque watercolor on paper
8⅞ × 12⅛ in. (22.7 × 30.7 cm)
Promised Gift of Stuart Cary Welch, Jr.

76.1999.27
*A Holy Man Meditates (Shrine with Sleeping
Ascetic)*
Attributed to Daswanth
North India, c. 1560
Black ink and watercolor over traces of
charcoal on beige laid paper
7¼ × 4¾ in. (18.5 × 12 cm)
Promised Gift of Stuart Cary Welch, Jr.
Cat. 18

76.1999.28
A Row of Sadhus
Himachal Pradesh, Guler, c. 1765
Black and red-brown inks and gold on
beige paper
6½ × 9 in. (16.5 × 23 cm)
Promised Gift of Stuart Cary Welch, Jr.
Cat. 73

76.1999.29
Blade inscribed by Asad Allah
Iran, Isfahan, 17th century
Watered steel with gold
39⅛ in. (99.3 cm)
Promised Gift of Stuart Cary Welch, Jr.

76.1999.30
A Polo Game
Attributed to Shaykh Taju
Rajasthan, Kotah, c. 1730
Purple-red ink and opaque white
watercolor over charcoal underdrawing on
beige laid paper
10⅞ × 22½ in. (27.5 × 57 cm)
Promised Gift of Stuart Cary Welch, Jr.
Cat. 52

76.1999.31
Buffalo Hunt
Attributed to Shaykh Taju
Rajasthan, Kotah, c. 1730
Ink and opaque watercolor on paper
21⅛ × 22 in. (53.5 × 56 cm)
Promised Gift of Stuart Cary Welch, Jr.

76.1999.32
A Panoply of Priests
Rajasthan, Kotah or Nathadwara, c. 1835

Black ink and watercolor on beige laid
paper
24 × 19½ in. (61.2 × 49.5 cm)
Promised Gift of Stuart Cary Welch, Jr.
Cat. 55

76.1999.33[r]
The Bagpipe Player
Circle of Aqa Riza (Riza 'Abbasi)
Iran, Isfahan, c. 1600
Black ink and watercolor on off-white
paper
14 × 9 in. (35.5 × 23 cm)
Promised Gift of Stuart Cary Welch, Jr.
Cat. 11

76.1999.33[v]
Calligraphy
Shah Mahmud al-Nishapuri
Iran, 16th century
Ink, opaque watercolor, and gold on paper
14 × 9 in. (35.5 × 23 cm)
Promised Gift of Stuart Cary Welch, Jr.
Cat. 11, fig. 1

76.1999.34
Flanged mace
North India, 15th–16th centuries
Steel
20¼ in. (51.5 cm)
Promised Gift of Stuart Cary Welch, Jr., in
memory of Eric Schroeder

76.1999.35
*Dagger blade, etched with arabesques and shah's
name*
Iran, Isfahan, 17th century
Steel
10 in. (25.5 cm)
Promised Gift of Stuart Cary Welch, Jr.

76.1999.36
Opium cup
North India, c. 1675
Jade
¾ × 3⅛ in. (2 × 7.9 cm)
Promised Gift of Stuart Cary Welch, Jr.

76.1999.37
Composite Elephant
Attributed to the Kotah Master
Rajasthan, Kotah, c. 1730
Black ink and opaque watercolor over
black chalk underdrawing on tan laid
paper
9 × 9⅞ in. (23 × 25 cm)
Promised Gift of Stuart Cary Welch, Jr.
Cat. 50

76.1999.38
*Vaishnavite manuscript and cover in the shape
of a fish*
Orissa, 18th century
Opaque watercolor on palm leaf with
wood or palm bark cover
3⅞ × 1¾ in. (9.8 × 4.5 cm)
Promised Gift of Stuart Cary Welch, Jr., in
memory of Nasli and Alice Heeramaneck

76.1999.39
Pierced railing
Delhi, c. 1655
Marble
13⅜ × 25¼ in. (34 × 64 cm)
Promised Gift of Stuart Cary Welch, Jr.

76.1999.40
Raja Setupathy of Ramnad
Tamil Nadu, c. 1640
Opaque watercolor and gold on paper
14⅜ × 10⅞ in. (36.5 × 27.6 cm)
Promised Gift of Stuart Cary Welch, Jr.

76.1999.41
A Monkey Eavesdrops
Himachal Pradesh, Guler, c. 1765
Opaque watercolor on paper
9¼ × 8⅛ in. (23.6 × 20.5 cm)
Promised Gift of Stuart Cary Welch, Jr.

76.1999.42
Man with Two Dogs on a Leash
North India or Pakistan, Punjab,
c. 1800–1850
Black ink and opaque watercolor over
graphite on tan laid paper
9½ × 7¾ in. (24 × 19.7 cm)
Promised Gift of Stuart Cary Welch, Jr.
Cat. 75

76.1999.43
A Hero in Combat with a Dragon
Attributed to Mir Sayyid Muhammad al-
Naqqash
Iran, Tabriz, c. 1550
Black ink and watercolor on beige paper
12⅝ × 8⅛ in. (32 × 20.6 cm)
Promised Gift of Stuart Cary Welch, Jr.
Cat. 5

76.1999.44
Shatru Sal I Watching an Elephant Combat
Attributed to Shaykh Taju
Rajasthan, Kotah, mid-18th century
Ink and opaque watercolor on paper
16¾ × 12⅝ in. (42.6 × 32 cm)
Promised Gift of Stuart Cary Welch, Jr.

76.1999.45
Shaivite Saint on an Animal Throne
Orissa, 18th century
Opaque watercolor on paper
8 × 7¼ in. (20.3 × 18.3 cm)
Promised Gift of Stuart Cary Welch, Jr.

76.1999.46
Dancing Deity on a Lotus
Orissa, 18th century
Opaque watercolor on paper
8 × 7¼ in. (20.3 × 18.3 cm)
Promised Gift of Stuart Cary Welch, Jr.

76.1999.47
Swooning Sufi
Attributed to Mir Sayyid 'Ali
Iran, Tabriz, c. 1535
Ink and gold on paper
2¼ × 1⅝ in. (5.7 × 4 cm)
Promised Gift of Stuart Cary Welch, Jr.

76.1999.48
Yashoda and Krishna
Tamil Nadu, Thanjavur, 19th century
Opaque watercolor on paper
11 × 7¾ in. (28 × 19.6 cm)
Promised Gift of Stuart Cary Welch, Jr.

76.1999.49
Designs for a Wall
Rajasthan, Kotah, c. 1840
Ink and opaque watercolor on paper
6 × 9⅞ in. (15.2 × 25 cm)
Promised Gift of Stuart Cary Welch, Jr.

76.1999.50
Rhinoceros Hunt
Rajasthan, Kotah, mid-18th century
Ink on paper
6⅞ × 11⅜ in. (17.5 × 28.8 cm)
Promised Gift of Stuart Cary Welch, Jr.

76.1999.51
Krishna's Fluting Attracts the Animals
Rajasthan, Kotah, c. 1625–30
Ink and opaque watercolor on paper
7⅞ × 9⅞ in. (20 × 25 cm)
Promised Gift of Stuart Cary Welch, Jr.

76.1999.52
Running Prince with Flintlock
Attributed to the Kotah Master
Rajasthan, Kotah, c. 1730
Ink and opaque watercolor on paper
7⅝ × 8⅞ in. (19.5 × 22.6 cm)
Promised Gift of Stuart Cary Welch, Jr.

76.1999.53
A Christian Saint
Attributed to Manohar
North India, c. 1600
Ink, opaque watercolor, and gold on paper
4¾ × 3½ in. (12 × 9 cm)
Promised Gift of Stuart Cary Welch, Jr.

1999.285
*Young Durjan Sal Slays a Lion (based on
"Rao Bhoj Singh of Bundi Slays a Lion")*
Attributed to the Kotah Master
Rajasthan, Kotah, c. 1735
Black ink and opaque watercolor over
charcoal underdrawing on beige laid paper
19½ × 21¼ in. (49.5 × 54 cm)
Gift of Stuart Cary Welch, Jr.
Cat. 46

1999.286
Five Views of an Elephant Combat
Attributed to Shaykh Taju
Rajasthan, Kotah, c. 1730
Black and red brown inks over charcoal
underdrawing on beige laid paper
20¼ × 22⅜ in. (51.3 × 56.7 cm)
Gift of Stuart Cary Welch, Jr.
Cat. 48

1999.287
Arabesque with Dragon and Parrot
Western Iran, 15th century
Black ink and watercolor on off-white
paper; pricked (dragon only)
8¾ × 13⅝ in. (22.2 × 34.7 cm)
Gift of Stuart Cary Welch, Jr.
Cat. 1

1999.288[r]
Dragon in Foliage
Signed by Mir Sayyid Muhammad
al-Naqqash
Turkey, Istanbul, c. 1565
Black ink, watercolor, and gold on off-
white paper
7⅞ × 13⅝ in. (20.1 × 34.5 cm)
Gift of Stuart Cary Welch, Jr.
Cat. 6

1999.288[v]
Calligraphy
'Ali al-Katib
Iran, 16th century
Ink, opaque watercolor, and gold on paper
13⅝ × 7⅞ in. (34.5 × 20.1 cm)
Gift of Stuart Cary Welch, Jr.
Cat. 6, fig. 1

1999.289[r]
Figures from the Annunciation
Sadiqi Beg

Iran, Yazd, c. 1590
Black ink and watercolor on off-white
paper
12¼ × 8⅛ in. (31 × 20.8 cm)
Gift of Stuart Cary Welch, Jr.
Cat. 13

1999.289[v]
Calligraphy
Muhammad 'Ali
Iran, 1725
Ink, opaque watercolor, and gold on paper
12¼ × 8⅛ in. (31 × 20.8 cm)
Gift of Stuart Cary Welch, Jr.
Cat. 13, fig. 2

1999.290
Rao Bhoj Singh of Bundi Slays a Lion
Attributed to the Kotah Master
Rajasthan, Kotah, c. 1725
Black ink, watercolor, opaque watercolor,
and gold on off-white laid paper
20 × 27 in. (50.8 × 68.5 cm)
Gift of Stuart Cary Welch, Jr.
Cat. 45

1999.291
Tibetan Yak
Attributed to Abu'l-Hasan
North India, c. 1610
Opaque watercolor on paper
3¼ × 6¼ in. (8.2 × 16 cm)
Gift of Stuart Cary Welch, Jr.

1999.292
A Wounded Buck
Attributed to Abu'l-Hasan
North India, c. 1610
Opaque watercolor and gold on paper
6 × 6¼ in. (15.2 × 16.1 cm)
Gift of Stuart Cary Welch, Jr.

1999.293
*Khan 'Alam, Emperor Jahangir's Falconer and
His Ambassador to Persia*
Attributed to Govardhan
North India, c. 1617
Opaque watercolor and gold on paper
12¼ × 9⅜ in. (31.2 × 23.9 cm)
Gift of Stuart Cary Welch, Jr.

1999.294.A–B
*Two Illustrations from the "Gulistān" of Sa'di
(mounted together)*
Attributed to Manohar
North India, c. 1610
Opaque watercolor and gold on paper
10⅜ × 7¾ in. (26.5 × 19.8 cm)
Gift of Stuart Cary Welch, Jr.

1999.295
A Mughal and a Rajput Converse at Dusk
Attributed to Basawan
North India, late 16th century
Opaque watercolor and gold on paper
8 × 4½ in. (20.3 × 11.5 cm)
Gift of Stuart Cary Welch, Jr.

1999.296[r]
Two Sufis: Two Temperaments
Dawlat
North India, c. 1610
Opaque watercolor, gold, and metallic
silver paint over red ink and charcoal
underdrawing on off-white paper
5¼ × 3⅝ in. (13.3 × 9.1 cm)
Gift of Stuart Cary Welch, Jr.
Cat. 26

1999.296[v]
Calligraphy
Iran or India
Ink, opaque watercolor, and gold on
paper
5¼ × 3⅝ in. (13.3 × 9.1 cm)
Gift of Stuart Cary Welch, Jr.
Cat. 26, fig. 1

1999.297
*Akbar Observing an Animal Combat while
Hunting*
Attributed to Miskin
North India, c. 1585
Black ink, watercolor, opaque watercolor,
and gold (with punchwork) on off-white
paper
12⅜ × 8⅛ in. (31.5 × 20.6 cm)
Gift of Stuart Cary Welch, Jr.
Cat. 20

1999.298
The Battle of Samugarh
Attributed to Payag
North India, c. 1658
Gray-black ink, opaque watercolor, gold,
and metallic silver paint over white wash
on off-white paper
11¼ × 15⅛ in. (28.5 × 38.5 cm)
Gift of Stuart Cary Welch, Jr.
Cat. 30

1999.299
Shah Jahan in Old Age
Signed by Hashim
North India, c. 1650
Opaque watercolor and gold on paper
15 × 10¼ in. (38 × 26 cm)
Gift of Stuart Cary Welch, Jr.

1999.300.1[r]
*Text folio 76r from a "Dīvān" (Collected Works)
of Hafiz*
Iran, Tabriz, c. 1526–27
Ink, opaque watercolor, and gold on paper
11⅜ × 7⅛ in. (28.9 × 18 cm)
Gift of Stuart Cary Welch, Jr.

1999.300.1[v]
*Text folio 76v from a "Dīvān" (Collected Works)
of Hafiz*
Iran, Tabriz, c. 1526–27
Ink, opaque watercolor, and gold on paper
11⅜ × 7⅛ in. (28.9 × 18 cm)
Gift of Stuart Cary Welch, Jr.

1999.300.2[r]
*Incident in a Mosque from a "Dīvān" (Collected
Works) of Hafiz*
Attributed to Shaykh Zada
Iran, Tabriz, c. 1526–27
Ink, opaque watercolor, gold, and silver
on paper
11⅜ × 7⅛ in. (29 × 18.2 cm)
Gift of Stuart Cary Welch, Jr.

1999.300.2[v]
*Text folio 77v from a "Dīvān" (Collected Works)
of Hafiz*
Iran, Tabriz, c. 1526–27
Ink and gold on paper
11⅜ × 7⅛ in. (29 × 18.2 cm)
Gift of Stuart Cary Welch, Jr.

1999.301[r]
Calligraphy
Iran or India, 17th century
Ink, opaque watercolor, and gold on paper
7 × 7¼ in. (17.9 × 18.5 cm)
Gift of Stuart Cary Welch, Jr., in memory
of Philip Hofer
Cat. 23, fig. 2

1999.301[v]
*The Huntsman Anup Rai Freed from a Lion by
Emperor Jahangir and Prince Khurram*
Attributed to Abu'l-Hasan
North India, c. 1610
Black ink over charcoal on beige laid paper
7 × 7¼ in. (17.9 × 18.5 cm)
Gift of Stuart Cary Welch, Jr., in memory
of Philip Hofer
Cat. 23

1999.302
*Day of Judgment (Painting): Folio from a manu-
script of the "Fālnāma" (Book of Omens)*
Attributed to Aqa-Mirak
Iran, Tabriz, c. 1555
Opaque watercolor and gold on paper
23 × 17¼ in. (58.5 × 43.7 cm), sight
Gift of Stuart Cary Welch, Jr.

1999.303
*Maharana Bhim Singh of Udaipur Ties
His Turban*
Attributed to Chokha
Rajasthan, Mewar, c. 1810
Opaque watercolor and gold on paper
11 × 14¾ in. (28 × 37.5 cm)
Gift of Stuart Cary Welch, Jr.

1999.304
Portrait of Shah 'Abbas I
Attributed to Bishndas
North India, c. 1617
Black ink and watercolor on beige paper
7⅝ × 6⅛ in. (19.5 × 15.6 cm)
Gift of Stuart Cary Welch, Jr.
Cat. 27

CONTRIBUTORS

JOACHIM K. BAUTZE [JKB]
Professor, Faculty of Representational
Studies in the Department of Image
Culture, Wako University, Tokyo

STEPHANIE BECK
Curatorial Assistant, Department of
Islamic and Later Indian Art, Arthur
M. Sackler Museum, Harvard University
Art Museums

CRAIGEN W. BOWEN
Philip and Lynn Straus Conservator of
Works of Art on Paper and Deputy
Director, Straus Center for Conservation,
Harvard University Art Museums

SHEILA R. CANBY [SRC]
Assistant Keeper and Curator-in-Charge
of Islamic Art and Antiquities, The
British Museum

WILLIAM DALRYMPLE [WD]
Author and Fellow of the Royal Society of
Literature

WALTER B. DENNY [WBD]
Professor of Art History, Adjunct
Professor of Middle Eastern Studies,
University of Massachusetts, Amherst

LAYLA S. DIBA [LSD]
Independent scholar, former Curator of
Islamic Art at The Brooklyn Museum of
Art

AFSANEH FIROUZ-ARDALAN
Norma Jean Calderwood Intern, Depart-
ment of Islamic and Later Indian Art,
Arthur M. Sackler Museum, Harvard
University Art Museums

NAVINA HAIDAR HAYKEL [NHH]
Assistant Curator, Department of Islamic
Art, The Metropolitan Museum of Art

KIMBERLY MASTELLER [KM]
Assistant Curator of Islamic and Later
Indian Art, Arthur M. Sackler Museum,
Harvard University Art Museums

MARY McWILLIAMS [MM]
Norma Jean Calderwood Curator of
Islamic and Later Indian Art, Arthur M.
Sackler Museum, Harvard University Art
Museums

BASIL W. ROBINSON [BWR]
Retired Keeper, Victoria and Albert
Museum, and President of the Royal
Asiatic Society

ANNEMARIE SCHIMMEL (D. 2003)
Professor of Indo-Muslim Culture
Emerita, Harvard University, and
Professor of Arabic and Islamic Studies,
University of Bonn

SUNIL SHARMA [SS]
Research Fellow in the Arbeitskreis
Moderne und Islam at the
Wissenschaftskolleg, Berlin

SHRI BRIJRAJ SINGH [SBS]
Maharao of Kotah, independent scholar
and collector

ABOULALA SOUDAVAR
Independent scholar and collector

DR. MARIE L. SWIETOCHOWSKI
[MLS]
Retired Associate Curator and Research
Associate, Department of Islamic Art,
The Metropolitan Museum of Art

STUART CARY WELCH [SCW]
Curator emeritus, Department of Islamic
and Later Indian Art, Harvard University
Art Museums; former instructor in
Islamic and Indian painting at Harvard
University; former Special Consultant to
the Department of Islamic Art, The
Metropolitan Museum of Art

Abul-Fazl Allami. 1867–77. Reprint 1977. *Ā'īn-i Akbarī* [*The Statutes of Akbar*]. 2nd ed. 2 vols. Edited by H. Blockmann. New Delhi.

Adams, William Bridges. 1837. *English pleasure carriages. Their origin, history, varieties, materials, construction, defects, improvements, and capabilities: with an analysis of the construction of common roads and railroads and the public vehicles used on them: together with descriptions of new inventions.* London.

Aghdashloo, Aydin. 1977. *Aqa Lutf 'Ali Suratgar.* Tehran.

Ahmad, Qadi. 1959. *Calligraphers and Painters.* Translated by V. Minorsky. Freer Gallery of Art Occasional Papers, vol. 3, no. 2. Washington, D.C.

Ambalal, Amit. 1987. *Krishna as Shrinathji: Rajasthani Paintings from Nathdvara.* Ahmadabad.

Archer, Mildred. 1992. *Company Paintings: Indian Paintings of the British Period.* London and Ahmadabad.

Archer, William George. 1959. *Indian Painting in Bundi and Kotah.* London.

Ashrafi-Aini, M. M. 1979. "The School of Bukhara to ca. 1550." In *The Arts of the Book in Central Asia.* Edited by Basil Gray. Paris and London.

Ashton, Sir Leigh, ed. 1947–48. *The Art of India and Pakistan: A Commemorative Catalogue of the Exhibition Held at the Royal Academy of Arts, London, 1947–48.* Contributions by K. de B. Codrington, Basil Gray, and John Irwin. Exh. cat. London.

Aslanapa, Otkay. 1954. "Türkische Miniaturmalerei am Hofe Mehmet der Eroberes in Istanbul." *Ars Orientalis* 1.

———. 1979. "The Art of Bookbinding." In *The Arts of the Book in Central Asia.* Edited by Basil Gray. Paris and London.

Atasoy, Nurhan, and Julian Raby. 1989. *Iznik: The Pottery of Ottoman Turkey.* London.

Atil, Esin. 1978. *The Brush of the Masters: Drawings from Iran and India.* Washington, D.C.

———. 1987. *The Age of Sultan Süleyman the Magnificent.* Exh. cat. Washington, D.C.

Atil, Esin, ed. 1980. *Turkish Art.* Washington, D.C., and New York.

Bahadur, K. P., trans. 1972. *Rasikapriyā of Keshavdāsa.* New Delhi.

Bailey, Gauvin Alexander. 1994. "In the Manner of the Frankish Masters: A Safavid Drawing and Its Flemish Inspiration." *Oriental Art* 40, no. 4.

———. 1998. *The Jesuits and the Grand Mogul: Renaissance Art at the Imperial Court of India, 1580–1630.* Freer Gallery of Art and Arthur M. Sackler Gallery Occasional Papers, vol. 2. Washington, D.C.

———. 2000. "Supplement: The Sins of Sadiqi's Old Age." In *Persian Painting from the Mongols to the Qajars: Studies in Honor of Basil W. Robinson.* Edited by Robert Hillenbrand. New York.

Banerji, B. 1925. *Begam Samru.* Calcutta.

Bautze, Joachim K. 1988–89. "Portraitmalerei unter Maharao Ram Singh von Kota." *Artibus Asiae Supplementum* 49, nos. 3–4.

———. 1992. "Victory and Death of Maharao Bhim Singh of Kota." In *South Asian Archaeology, 1989: Papers from the Tenth International Conference of South Asian Archaeologists in Western Europe.* Edited by Catherine Jarrige. Paris and Madison, Wis.

———. 1995a. "Portraits of Maharao Shatru Sal of Kota." In *Padmashri Ram Gopal Vijaivargiya Felicitation Volume.* Edited by Vijai Shankar Srivastava and M. L. Gupta. Jaipur.

———. 1995b. "Die Welt der höfischen Malerei." In *Rajasthan, Land der Könige.* Edited by Gerd Kreisel. Stuttgart.

———. 1996. "Indische Malerei islamischer Zeit im Staatlichen Museum für Völkerkunde München." In *Rosenduft und Säbelglanz: Islamische Kunst und Kultur der Moghulzeit.* Edited by Jürgen W. Frembgen. Munich.

———. 1997. "The History of Kotah in an Art-Historical Context." In *Gods, Kings, and Tigers: The Art of Kotah.* Edited by Stuart Cary Welch. Exh. cat. New York, Cambridge, Mass., and Munich.

———. 2000. "Scenes of Devotion and Court Life: Painting under Maharao Ram Singh of Kota." In *Court Painting in Rajasthan.* Edited by Andrew Topsfield. Mumbai.

Beach, Milo. 1970–71. "Painting at Devgarh." *Archives of Asian Art* 24.

———. 1974. "Rajput Painting at Bundi and Kota." *Artibus Asiae Supplementum* 32.

Beach, Milo, and Ebba Koch. 1997. *King of the World: The Padshahnama, an Imperial Mughal Manuscript from the Royal Library, Windsor Castle.* Exh. cat. London.

Beach, Milo, with contributions by Stuart Cary Welch and Glenn D. Lowry. 1978. *The Grand Mogul: Imperial Painting in India, 1600–1660.* Exh. cat. Williamstown, Mass.

Bearce, George Donham, and Stuart Cary Welch. 1963. *Painting in British India, 1757–1857*. Brunswick, Maine.

Beg, Sadiqi. 1981. "The Canons of Painting." In *The Houghton Shahnameh*. Translated by Martin Bernard Dickson and Stuart Cary Welch. Cambridge, Mass.

Bhattacharyya, N. N. 1982. *History of the Tantric Religion: A Historical, Ritualistic, and Philosophical Study*. New Delhi.

Biggs, Sharon. 2002. "Ancient Treasure." *Horse Illustrated*, October.

Binyon, L. 1928. *The Poems of Nizami*. London.

Binyon, Laurence, J. V. S. Wilkinson, and Basil Gray. 1933. *Persian Miniature Painting: Including a Critical and Descriptive Catalogue of the Miniatures Exhibited at Burlington House, January–March 1931*. London.

Blair, Sheila S., and Jonathan M. Bloom. 1994. *The Art and Architecture of Islam, 1250–1800*. New Haven, Conn., and London.

Blochet, E. 1929. *Musulman Painting, XII–XVIIc*. Translated by Cicely M. Binyon. London.

Bloom, Jonathan. 2001. *Paper before Print: The History and Impact of Paper in the Islamic World*. New Haven, Conn., and London.

Bosworth, Clifford E. 1967. *The New Islamic Dynasties: A Chronological and Genealogical Manual*. New York.

Bowen, Craigen W. 1997. "Line and Color: Painting Materials and Techniques in Kotah." In *Gods, Kings, and Tigers: The Art of Kotah*. Edited by Stuart Cary Welch. Exh. cat. New York, Cambridge, Mass., and Munich.

Brand, Michael. 1995. *The Vision of Kings: Art and Experience in India*. Exh. cat. Canberra.

Brand, Michael, and Glenn D. Lowry. 1985. *Akbar's India: Art from the Mughal City of Victory*. New York.

Burgess, James. 1972. *The Chronology of Modern India*, A.D. 1494–1894. 2nd ed. Shannon, Ireland.

Burton, David. 1993. *The Raj at Table*. London.

Canby, Sheila R. 1993. *Persian Painting*. London.

———. 1996. *The Rebellious Reformer: The Drawings and Paintings of Riza-yi ʿAbbasi of Isfahan*. London.

———. 1998. *Princes, Poets, and Paladins: Islamic and Indian Paintings from the Collection of Prince and Princess Sadruddin Aga Khan*. Exh. cat. London.

———. 2000. *The Golden Age of Persian Art, 1501–1722*. New York.

Chandra, Pramod. 1984. "Hindu Ascetics in Mughal Painting." In *Discourses on Shiva: Proceedings of a Symposium on the Nature of Religious Imagery*. Edited by Michael W. Meister. Philadelphia.

Coomaraswamy, A. K. 1926. *Catalogue of the Indian Collections in the Museum of Fine Arts, Boston: Part V*. Cambridge, Mass.

Das, Asok Kumar. 1981. "Ramjidas Chatera, an Eighteenth-Century Portrait Painter from Jaipur." In *Cultural Contours of India: Dr. Satya Prakash Felicitation Volume*. Edited by Vijai Shankar Srivastava. New Delhi.

———. 1991. "Daulat." In *Master Artists of the Imperial Mughal Court*. Edited by Pratapaditya Pal. Bombay.

———. 1998. "Bishandas: Unequalled in His Age in Taking Likenesses." In *Mughal Masters: Further Studies*. Mumbai.

Del Bontá, Robert J. 2002. "Late or Faux Mughal Painting: A Question of Intent." In *After the Great Mughals: Painting in Delhi and the Regional Courts in the Eighteenth and Nineteenth Centuries*. Edited by Barbara Schmitz. Mumbai.

Denny, Walter. 1998. *Gardens of Paradise: Sixteenth-Century Turkish Ceramic Tile Decoration*. Istanbul.

Desai, Vishakha N. 1985. *Life at Court: Art for India's Rulers, Sixteenth to Nineteenth Centuries*. Exh. cat. Boston.

Diba, Layla S. 1989. "Persian Painting in the Eighteenth Century: Tradition and Transmission." *Muqarnas* 6.

———. 2003. "Gol o Bolbol." *Encyclopaedia Iranica*. Vol. 11. London and Boston.

Diba, Layla, et al. 1998. *Royal Persian Paintings: The Qajar Epoch, 1785–1925*. Exh. cat. London.

Dickinson, E., and Karl Khandalavala. 1959. *Kishangarh Painting*. New Delhi.

Dickson, Martin Bernard, and Stuart Cary Welch. 1981. *The Houghton Shahnameh*. 2 vols. Cambridge, Mass., and London.

Dinkel, Joseph. 1981. *Wagenmoden im Biedermeier: Stadtwagen, Reise- und Sport-fahrzeuge zwischen 1830 und 1840*. Dortmund.

Dynasties out of Europe. "Bundi." www.almanach.be/search/i/indi_bundi.html.

Eaton, Richard Maxwell. 1978. *Sufis of Bijapur, 1300–1700: Social Roles of Sufis in Medieval India*. Princeton, N.J.

Edwards, Elwyn Hartley. 1993. *Horses*. New York.

Egger, Gerhart. 1974. *Hamza-nama: Vollständige Wiedergabe der bekannten Blätter der Handschrift aus den Beständen aller erreichbaren Sammlungen*. Graz.

Ehnbom, Daniel James, with essays by Robert Skelton and Pramod Chandra. 1985. *Indian Miniatures: The Ehrenfeld Collection*. Exh. cat. New York.

Encyclopaedia of Islam. 1993. New ed. Leiden.

Entwhistle, A. W. 1987. *Braj: Centre of Krishna Pilgrimage*. Groningen.

———. 1991. "The Cult of Krishna-Gopal as a Version of the Pastoral." In *Devotion Divine: Bhakti Traditions from the Regions of India: Studies in Honor of Charlotte Vaudeville*. Paris.

Ettinghausen, Richard. 1961. *Paintings of the Sultans and Emperors of India in American Collections*. New Delhi.

Ferber, Stanley. 1975. *Islam and the Medieval West: A Loan Exhibition at the University Art Gallery, April 6–May 4, 1975*. Exh. cat. Binghamton, N.Y.

Gadon, E. W. 1986. "Dara Shikuh's Mystical Vision of Hindu-Muslim Synthesis." In *Facets of Indian Art*. Edited by Robert Skelton. London.

Gardet, L. 1960. Reprint 1967, 1979, 1986. "al-Asmāʿ al-Husnā." In *The Encyclopaedia of Islam*. Vol. 1. New ed. Leiden.

Glück, Heinrich. 1925. *Die indischen Miniaturen des Haemzae-Romanes im Österreichischen Museum für Kunst und Industrie in Wien und in anderen Sammlungen.* Leipzig, Zurich, and Vienna.

Goswamy, B. N. 1968. *Six Kangra Paintings.* New Delhi.

———. 1972. "On Two Portraits of Pahari Artists." *Artibus Asiae* Supplementum 34, nos. 2–3.

———. 1997. *Nainsukh of Guler: A Great Indian Painter from a Small Hill-State.* Zurich.

Goswamy, B. N., and U. Bhatia. 1999. *Painted Visions: The Goenka Collection of Indian Paintings.* Mumbai.

Goswamy, B. N., with Eberhard Fischer. 1992. *Pahari Masters: Court Painters of Northern India.* Zurich.

Gray, Basil. 1959. "An Album of Designs for Persian Textiles." In *Aus der Welt der Islamischen Kunst, Festschrift für Ernst Kühnel zum 75. Geburtstag am 26.10.1957.* Berlin.

———. 1961. *Treasures of Asia: Persian Painting.* Geneva.

Gray, Basil, ed. 1979. *The Arts of the Book in Central Asia.* Paris and London.

Grube, Ernst. 1962. *Muslim Miniature Paintings from the XIII to XIX Century from Collections in the United States and Canada.* Exh. cat. Venice.

———. 1995. *Studies in Islamic Painting.* London.

Grube, Ernst, et al. 1981. *Islamic Art I. The Islamic Art Foundation.* New York.

Gupta, Savitri. 1982. *Rajasthan District Gazetteers: Kota.* Gazetteer of India. Jaipur.

Haidar, Navina N. 1995. "The Kishangarh School of Painting, c. 1680–1850." Ph.D. diss. University of Oxford.

———. 2000. "Satire and Humor in Kishangarh Painting." In *Court Painting in Rajasthan.* Edited by Andrew Topsfield. Mumbai.

Hartnell and Eyre. 1972. *Indian Painting for the British, 1770–1880.* Sale catalogue (July). London.

Harvard University Art Museums. 2000. "A Decade of Collecting: Recent Acquisitions by the Harvard University Art Museums." *Harvard University Art Museums Bulletin* 7, no. 2.

Heinrichs, W. 1995. "Radjaz." In *The Encyclopaedia of Islam.* Vol. 8. New ed. Leiden.

Hodgkin, Howard, and Terence McInerney. 1983. *Indian Drawing.* London.

House of Mewar. www.mewarindia.com/history/index anc4.html.

Hunter, Dard. 1939. *Papermaking by Hand in India.* New York.

Huntington, Susan, and John C. Huntington. 1985. *The Art of Ancient India: Buddhist, Hindu, Jain.* New York.

Indian Princely States. "Kangra." www.uq.net.au/~zzhsoszy/ips/k/kan gra.html.

Isiroglu, Mazhur S. 1976. *Siyah Qalem: Vollst. Faks-Ausg. d. Blätter des Meisters Mehmed Siyah Qalem aus dem Besitz des Topkapi Sarayi Müzesi, Istanbul, u.d. Freer Gallery of Art, Washington.* Graz.

"Islamic Painting." 1978. *Metropolitan Museum of Art Bulletin* 36, no. 2.

Ivanov, A., and O. Akimushkin. 1962. *Album of Indian and Persian Miniatures of the Sixteenth through Seventeenth Centuries.* Moscow.

Karabacek, Josef. 2001. *Arab Paper.* London.

Keddie, Nikki R., and Rudi Matthee, eds. 2002. *Iran and the Surrounding World: Interactions in Culture and Cultural Politics.* Seattle.

Kincaid, Dennis. 1938. *British Social Life in India up to 1938.* London.

Kossak, Steven. 1997. *Indian Court Painting: Sixteenth to Nineteenth Century.* Exh. cat. New York.

Kühnel, Ernst. 1967. "History of Miniature Painting and Drawing." In *A Survey of Persian Art from Prehistoric Times to the Present.* Edited by Arthur Upham Pope and Phyllis Ackerman. Vol 5. Tehran, London, New York, and Tokyo.

Kühnel, Ernst, and Herman Goetz. 1923. *Indische Buchmalerein, aus dem Jahángîr-Album der Staatsbibliothek zu Berlin.* Buchkunst des Orients, 2. Berlin.

Lahawri, Abd al-Hamid. 1865–72. *Padshahnamah.* Edited by Mawlawies Kabir al-Din Ahmad and Abd al-Rahim. Calcutta.

Lall, John S. 1997. *Begam Samru: Fading Portrait in a Gilded Frame.* Delhi.

Lapidus, Ira M. 2002. *A History of Islamic Societies.* 2nd ed. Cambridge.

Lawton, Thomas, and Thomas Lentz. 1998. *Beyond the Legacy: Anniversary Acquisitions for the Freer Gallery of Art and the Arthur M. Sackler Gallery.* Washington, D.C.

Leach, Linda York. 1995. *Mughal and Other Indian Paintings from the Chester Beatty Library.* Vol. 2. London.

Lentz, Thomas W., and Glenn D. Lowry. 1989. *Timur and the Princely Vision: Persian Art and Culture in the Fifteenth Century.* Exh. cat. Los Angeles and Washington, D.C.

Lewis, Bernard. 1995. *The Middle East: A Brief History of the Last 2,000 Years.* New York.

Losty, Jeremiah P. 1991. "Abu'l-Hasan." In *Master Artists of the Imperial Mughal Court.* Edited by Pratapaditya Pal. Bombay.

Loveday, Helen. 2001. *Islamic Paper: A Study of the Ancient Craft.* London.

Lowry, Glenn D., and Susan Nemazee. 1988. *A Jeweler's Eye: Islamic Arts of the Book from the Vever Collection.* Washington, D.C., and Seattle.

Maggs Bros. 1962. *Oriental Miniatures and Illuminations.* Bulletin 3. Sale catalogue (June). London.

Manz, Beatrice F. 1991. *The Rise and Rule of Tamerlane.* Cambridge.

Martin, F. R. 1912. Reprint 1971. *The Miniature Painting and Painters of Persia, India, and Turkey from the Eighth to the Eighteenth Century.* London.

Mason, Darielle, et al. 2001. *Intimate Worlds: Masterpieces of Indian Painting from the Alvin O. Bellak Collection.* Exh. cat. Philadelphia.

Matthee, Ruth, ed. 2000. "Prostitutes, Courtesans, and Dancing Girls: Women Entertainers in Safavid Iran." In *Iran and Beyond.* Costa Mesa, Calif.

McWilliams, Mary. 2000. "Welch Gift of Indian, Iranian, and Turkish Art to the Arthur M. Sackler Museum." *Apollo,* December.

Mitter, Partha. 2001. *Indian Art*. Oxford History of Art. Oxford.

Monshi, Eskandar Beg. 1978. *History of Shah 'Abbas the Great*. Translated by Roger M. Savory. Persian Heritage Series 28, vol. 1. Boulder, Colo.

Moorhouse, Geoffrey. 1971. *Calcutta: The City Revealed*. London.

Okada, Amina. 1989. *Miniatures de l'Inde impériale: Les peintres de la cour d'Akbar, 1556–1605*. Exh. cat. Paris.

———. 1991. "Basawan." In *Master Artists of the Imperial Mughal Court*. Edited by Pratapaditya Pal. Bombay.

Patnaik, Naveen, and Stuart Cary Welch. 1985. *A Second Paradise: Indian Courtly Life, 1590–1947*. London.

Paul, E. Jaiwant. 1995. *By My Sword and Shield: Traditional Weapons of the Indian Warrior*. New Delhi.

Peabody, Norbert. 1997. "The King Is Dead, Long Live the King! Karmic Kin(g)ship in Kotah." In *Gods, Kings, and Tigers: The Art of Kotah*. Edited by Stuart Cary Welch. New York, Cambridge, Mass., and Munich.

Petievich, Carla. 1992. *Assembly of Rivals: Delhi, Lucknow, and the Urdu Ghazal*. Delhi.

Philips, C. H., ed. 1951. *Handbook of Oriental History*. London.

Pope, Arthur Upham, and Phyllis Ackerman, eds. 1967. *A Survey of Persian Art from Prehistoric Times to the Present: Painting*. Vol. 10. Tehran, London, New York, and Tokyo.

Powlett, P. W. 1880. "1880 Kotah Agency Report" [No. 150, dated Kotah, 28 April 1879]. In *Report on the Political Administration of the Rajputana State for 1878–79. Selections from the Records of the Government of India, Foreign Department, no. 162.* Calcutta.

Premchand, Neeta. 1995. *Off the Deckle Edge: A Paper-Making Journey through India*. Bombay.

Quraeshi, Samina, with an essay by Annemarie Schimmel. 1988. *Lahore: The City Within*. Singapore.

Rabino, Hyacinth L. 1917. *Les provinces caspiennes de la Perse: Le Guilan*. Paris.

Rahim, Abdur. 1934–35. "Mughal Relations with Persia and Central Asia." In *Islamic Culture*. Vols. 8, 9.

Randhawa, Mohindar Singh. 1962. *Kangra Paintings on Love*. New Delhi.

Rawson, Philip. 1969. *Die Erotische Kunst des Ostens*. Originally published as *Erotic Art of the East*, 1968. Hamburg.

———. 1977. *Erotic Art of India*. London.

Rich, Claudius James. 1836. *Narrative of a Residence in Koordistan on the site of ancient Nineveh; with journal of a voyage down the Tigris to Bagdad and an account of a visit to Shirauz and Persepolis*. Vol. 2. Edited by his widow. London.

Robinson, Basil William. 1965. *Drawings of the Masters: Persian Drawings from the Fourteenth through the Nineteenth Century*. New York.

Roxburgh, David J. 2002a. "The Pen of Depiction: Drawings of Fifteenth and Sixteenth-Century Iran." In *Studies in Islamic and Later Indian Art from the Arthur M. Sackler Museum, Harvard University Art Museums*. Cambridge, Mass.

———. 2002b. "Persian Drawings, ca. 1400–1450: Materials and Creative Procedures." *Muqarnas* 19.

Ruswa, Mirza Muhammad Hadi. 1996. *Umrāo Jān Adā*. Translated by David Matthews. Calcutta.

Safwat, Nabil F., with a contribution by Mohamed Zakariya. 1996. *The Art of the Pen: Calligraphy of the Fourteenth to Twentieth Centuries*. London and Oxford.

Sakisian, Armenag Beg. 1929. *La miniature persane du XIIe au XVIIe siècle*. Paris.

Schafer, Edward H. 1985. *The Golden Peaches of Samarkand: A Study of T'ang Exotics*. Los Angeles.

Schmitz, Barbara, ed. 2002. *After the Great Mughals: Painting in Delhi and the Regional Courts in the Eighteenth and Nineteenth Centuries*. Mumbai.

Schroeder, Eric. 1942. *Persian Miniatures in the Fogg Museum of Art*. Cambridge, Mass.

Seidensticker, T. 2002. "Tardiyya." In *The Encyclopaedia of Islam*. Vol. 10. New ed. Leiden.

Seyller, John. 2000. "A Mughal Code of Connoisseurship." *Muqarnas* 17.

———. 2001. "For Love or Money: The Shaping of Historical Painting Collections in India." In *Intimate Worlds: Indian Paintings from the Alvin O. Bellak Collection*. Edited by Darielle Mason. Philadelphia.

———. 2002. *The Adventures of Hamza: Painting and Storytelling in Mughal India*. Washington, D.C., and London.

Sharma, Mathura Lal. 1939. *Kota rajya ka itihas (History of Kota State)*. Kota.

Shushtari, Sayyid Abdul Lateef. 1847. *Kitab Tuhfat ul Alam*. Translated by Bruce Wannell. Bombay.

Silver, Caroline. 1976. *Guide to the Horses of the World*. Oxford.

Simpson, Marianna Shreve. 1980. *Arab and Persian Painting in the Fogg Art Museum*. Cambridge, Mass.

Simpson, Marianna Shreve, with contributions by Massumeh Farhad. 1997. *Sultan Ibrahim Mirza's "Haft Awrang."* Washington, D.C.

Singh, Brijraj. 1985. *The Kingdom That Was Kotah: Paintings from Kotah*. New Delhi.

Sinha, Indra. 1980. *The Love Teachings of Kama Sutra. With Extracts from "Koka Shastra, Anangra Ranga," and Other Famous Indian Works on Love*. London.

Skelton, Robert. 1973. *Rajasthani Temple Hangings of the Krishna Cult from the Collection of Karl Mann, New York*. Exh. cat. New York.

———. 2000. "Ghiyath al-Din 'Ali-yi Naqshband and an Episode in the Life of Sadiqi Beg." In *Persian Painting from the Mongols to the Qajars: Studies in Honor of Basil W. Robinson*. Edited by Robert Hillenbrand. New York.

Smart, Ellen. 1991. "Balchand." In *Master Artists of the Imperial Mughal Court*. Edited by Pratapaditya Pal. Bombay.

———. 1999. "The Death of Ināyat Khān by the Mughal Artist Bālchand." *Artibus Asiae* 58, nos. 3–4.

Smith, G. Rex. 1990. "Hunting Poetry (Tardiyyat)." In *The Cambridge History of Arabic Literature: 'Abbasid Belles-Lettres*. Edited by J. Ashtiany et al. New York.

Smith, Vincent A. 1958. *The Oxford History of India*. 3rd ed. London and New York.

Sotheby's. 1977. *Fine Oriental Miniatures and Manuscripts*. Sale catalogue (10 October). Lot 69. London.

———. 1979. *Fine Oriental Miniatures, Manuscripts, Islamic Works of Art, and Nineteenth-Century Paintings*. Sale catalogue (14 December). Lot 161. New York.

Soudavar, Abolala. 2000. "The Age of Muhammadi." *Muqarnas* 17.

Soudavar, Abolala, with a contribution by Milo Cleveland Beach. 1992. *Art of the Persian Courts: Selections from the Art and History Trust Collection*. New York.

Stchoukine, Ivan. 1964. *Les peintures des manuscrits de Shah 'Abbas Ier à la fin des Safavis*. Paris.

———. 1971. *La peinture turque d'après les manuscrits illustrés*. Paris.

Swietochowski, M. L., and Sussan Babaie. 1989. *Persian Drawings in The Metropolitan Museum of Art*. Exh. cat. New York.

Tezcan, Hülya, Patricia L. Baker, and Jennifer Wearden. 1996. *Silks for the Sultans: Ottoman Imperial Garments from Topkapi Palace, Istanbul*. Istanbul.

Thackston, Wheeler, ed. 1999. *The Jahangirnama: Memoirs of Jahangir, Emperor of India*. Washington, D.C., and New York.

Titley, Norah M. 1983. *Persian Miniature Painting and Its Influence on the Art of Turkey and India: The British Library Collections*. London.

Topsfield, Andrew. 1980. *Paintings from Rajasthan in the National Gallery of Victoria: A Collection Acquired through the Felton Bequests' Committee*. Melbourne.

———. 1981. "Painting for the Rajput Courts." In *The Arts of India*. Edited by Basil Gray. Oxford.

———. 1994. *Indian Paintings from Oxford Collections*. Oxford.

———. 2001. "Court Painting at Udaipur: Art under the Patronage of the Maharanas of Mewar." *Artibus Asiae Supplementum* 44. Zurich.

Treasures from the Fitzwilliam: "The increase of learning and other great objects from that noble foundation." 1989. Exh. cat. Cambridge and New York.

Vaughan, Phillippa. 1991. "Miskin." In *Master Artists of the Imperial Mughal Court*. Edited by Pratapaditya Pal. Bombay.

Verma, Som Prakash. 1994. *Mughal Painters and Their Work: A Biographical Survey and Comprehensive Catalogue*. Delhi.

Viré, F. 1991. "Fahd." In *The Encyclopaedia of Islam*. Vol. 2. New ed. Leiden.

von Habsburg, Francesca, et al. 1996. *The St. Petersburg Muraqqa' Album of Indian and Persian Miniatures from the Sixteenth Century through the Eighteenth Century and Specimens of Persian Calligraphies by 'Imād al-Hasanī*. Edited by Toby Falk. Lugano and Milan.

Welch, Anthony. 1973. *Shah Abbas and the Arts of Isfahan*. New York.

———. 1976. *Artists for the Shah: Late Sixteenth-Century Painting at the Imperial Court of Iran*. New Haven, Conn., and London.

Welch, Anthony, and Stuart Cary Welch. 1982. *Arts of the Islamic Book: The Collection of Prince Sadruddin Aga Khan*. Exh. cat. Ithaca, N.Y.

Welch, Stuart Cary. 1961. "The Paintings of Basawan." *Lalit Kalā*, October. India.

———. 1963a. *The Art of Mughal India: Painting and Precious Objects*. Exh. cat. New York.

———. 1963b. "Mughal and Deccani Miniature Paintings from a Private Collection." *Ars Orientalis* 5.

———. 1972a. *A King's Book of Kings: The Shah-nameh of Shah Tahmasp*. New York.

———. 1972b. "Two Drawings, a Tile, a Dish, and a Pair of Scissors." In *Islamic Art in The Metropolitan Museum of Art*. Edited by Richard Ettinghausen. New York.

———. 1976. *Indian Drawings and Painted Sketches: Sixteenth through Nineteenth Centuries*. New York.

———. 1977. *Imperial Mughal Painting*. New York.

———. 1978a. "Pictures from the Hindu and Muslim Worlds." *Apollo*, May.

———. 1978b. *Room for Wonder: Indian Painting during the British Period, 1760–1880*. Exh. cat. New York.

———. 1979. *Wonders of the Age: Masterpieces of Early Safavid Painting, 1501–1576*. Exh. cat. Cambridge, Mass.

———. 1983. "Return to Kotah." In *Essays on Near Eastern Art and Archaeology in Honour of Charles Kyrle Wilkinson*. Edited by Prudence Harper and Holly Pittman. New York.

———. 1985. *India: Art and Culture, 1300–1900*. Exh. cat. New York.

———. 1995. "The Emperor's Shah: Emperor Jahangir's Two Portraits from Life of Shah 'Abbas." In *Shop Talk: Studies in Honor of Seymour Slive Presented on His Seventy-Fifth Birthday*. Edited by Alice Davies, William Robinson, and Cynthia Schneider. Cambridge, Mass.

Welch, Stuart Cary, ed. and contributor. 1997. *Gods, Kings, and Tigers: The Art of Kotah*. Exh. cat. New York, Cambridge, Mass., and Munich.

Welch, Stuart Cary, and Milo Beach. 1965. *Gods, Thrones, and Peacocks*. Exh. cat. New York.

Welch, Stuart Cary, and Karen Sagstetter. 1994. "A Matter of Empathy: Comical Indian Pictures." *Asian Art and Culture* 3, no. 3.

Welch, Stuart Cary, and Mark Zebrowski. 1973. *A Flower from Every Meadow: Indian Paintings from American Collections*. New York.

White, David Gordon. 1996. *The Alchemical Body: Siddha Traditions in Medieval India*. Chicago.

Wilber, Donald N. 1981. *Iran Past and Present: From Monarchy to Islamic Republic*. 9th ed. Princeton, N.J.

Wolpert, Stanley. 1989. *A New History of India*. 3rd ed. Oxford and New York.

Zebrowski, Mark. 1983. *Deccani Painting*. Berkeley and Los Angeles.

Index